REPORTED SIGHTINGS

Carcanet publish John Ashbery's

Selected Poems
Self-Portrait in a Convex Mirror
As We Know
Shadow Train
A Wave
April Galleons
Three Plays

and his and James Schuyler's novel

A Nest of Ninnies

REPORTED SIGHTINGS

ART CHRONICLES, 1957–1987

JOHN ASHBERY

edited by David Bergman

First published in Great Britain by
CARCANET PRESS LIMITED
208–212 Corn Exchange Buildings
Manchester M4 3BQ

Many of the author's essays on art were originally published
in *Art in America, Arts Magazine, House & Garden,
The New Republic,* and *New York.*

OR 2/93

Owing to limitations of space, all acknowledgments of
permission to reprint previously published material will
be found on p. x; all acknowledgments of permission
to use illustrations will be found following the index.

British Library Cataloguing in Publication Data
 Ashbery, John 1927–
 Reported sightings: art chronicles, 1957–1987
 1. Arts. Criticism
 I. Title
 700'.1
 ISBN 0-85635-807-X

*The Publisher acknowledges financial assistance
from the Arts Council of Great Britain.*

Manufactured in the United States of America
First Edition

CONTENTS

ILLUSTRATIONS

GRATEFUL ACKNOWLEDGMENT IS MADE TO THE FOLLOWING FOR

PERMISSION TO REPRINT PREVIOUSLY PUBLISHED MATERIAL:

ARTnews: "They Came from Inner Space" ("Space and Dream") December 1967; "Cornell: The Cube Root of Dreams" ("Joseph Cornell"), Summer 1967; "The Romance of Reality" ("French Painting, 1820–1870"), April 1966; "American Sanctuary in Paris," *ARTnews Annual,* 1966; "An Expressionist in Paris" ("Joan Mitchell", April 1965; "Post-painterly Quattrocento" ("James Bishop"), December 1966; "G. M. P." ("Gertrude Stein"), February 1971; "Joys and Enigmas of a Strange Hour" ("Max Klinger"), *ARTnews Annual,* October 1966; "Willem de Kooning," *ARTnews Annual,* October 1971; "Tomlin: The Pleasures of Color" ("Bradley Walker Tomlin"), October 1957; "Bell: Virtuosity Without Self-Interest" ("Leland Bell"), February 1970; "Absence and Illusion" ("Esteban Vicente"), May 1972; "Grey Eminence" ("Brice Marden"), March 1972; "Saul Steinberg: The Stamp of Genius," November 1969, and "Saul Steinberg: Callibiography," *ARTnews Annual,* October 1970 ("Saul Steinberg"); "All the Birds and the Beasts Were There" ("Joseph Shannon"), March 1971; "The Invisible Avant-Garde," *ARTnews Annual,* October 1968; "Henri Michaux: Painter Inside Poet" ("An Interview with Henri Michaux"), March 1961, originally published in ARTnews. Reprinted by permission.

Nell Blaine: Introduction by John Ashbery from the *Nell Blaine Sketchbook,* published by The Arts Publisher, New York, 1986. Reprinted by permission of Nell Blaine.

Harcourt Brace Jovanovich, Inc. and *Faber and Faber Limited*: Excerpts from "The Waste Land" and "A Song for Simeon" in *Collected Poems, 1909–1962* by T. S. Eliot. Copyright 1936 by Harcourt Brace Jovanovich, Inc., copyright © 1963, 1964 by T. S. Eliot. Rights outside the U.S. administered by Faber and Faber Limited. Reprinted by permission of Harcourt Brace Jovanovich, Inc. and Faber and Faber Limited.

I. H. T. Corporation: Essays on art by John Ashbery, originally published in the *New York Herald-Tribune,* Paris Edition. Reprinted by permission of I. H. T. Corporation.

Sidney Janis Gallery: Introduction ("The New Realists") by John Ashbery for the exhibition catalogue to International Exhibition of "New Realists," Sidney Janis Gallery, Nov. 1–Dec. 1, 1962. Reprinted courtesy of Sidney Janis Gallery, New York.

Alfred A. Knopf, Inc.: Excerpts from "13 Ways of Looking at a Blackbird," "Anecdote of the Jar" and "The Man with the Blue Guitar" in *The Collected Poems of Wallace Stevens.* Copyright 1923 and renewed 1951 by Wallace Stevens. Reprinted by permission of Alfred A. Knopf, Inc.

Museum of Fine Arts, Boston: "Respect for Things as They Are" ("Fairfield Porter") by John Ashbery in *Fairfield Porter: Realist Painter in an Age of Abstraction,* published by Museum of Fine Arts, Boston, Massachusetts, 1983. Reprinted by permission.

Newsweek, Inc.: Essays by John Ashbery originally published in *Newsweek* magazine are reprinted by permission of Newsweek, Inc. Copyright © 1980, 1981, 1982, 1983, 1984, 1985 by Newsweek, Inc. All rights reserved by Newsweek, Inc.

Random House, Inc.: Excerpt from "A Bride in the 30s" in *W. H. Auden: Collected Poems,* edited by Edward Mendelson. Copyright 1937 and renewed 1965 by W. H. Auden; excerpt from "Crime" in *Selected Poems, 1923–1975* by Robert Penn Warren. Copyright 1942 by Robert Penn Warren. Reprinted by permission of Random House, Inc. *Taplinger Publishing Company:* Introduction ("Jane Freilicher") by John Ashbery to *Jane Freilicher Paintings,* published by Taplinger Publishing Company, New York. Copyright © 1986 by The Currier Gallery of Art. Reprinted by permission.

INTRODUCTION

by David Bergman

In 1960, when John Ashbery accepted a friend's offer to replace her as art critic for the Paris *Herald Tribune*, he was merely seeking employment in a city where Americans found it both difficult and necessary to earn money in order to live. Little did he know that the job would lead "as one thing followed another" into a career in which for the next twenty-five years almost without interruption he worked as a "sort of art critic" for such different journals as *ArtNews*, *Newsweek*, and *New York*.

But while the career may have been accidental, it has not been insignificant to his development as a poet. He has credited journalism for altering his writing methods. The weekly obligation to "grind out several pages," as he has put it, and "to produce an article . . . rain or shine, exhibition or no exhibition" broke down his resistance to poetic composition and led to the recognition that

he could "sit down the same way with a poem." Yet it seems to me that Ashbery's poetic debt to art writing is deeper and more interesting, and that his journalism is both compatible with and an extension of his other artistic work. The functions of the painter, the art critic and the poet—while not identical—are at least analogous as Ashbery conceives them. Among the artists who have most occupied his attention are ones like de Chirico, Fairfield Porter, Kitaj and Michaux, who have either written extensively themselves or are among the most literary of painters. The art writing has been a halfway point between the visual and the linguistic and often a place to explore ideas that make their way into the poems.

One of the rare times when Ashbery has tried to advise painters occurred in 1966, in a review discussing the "literary" sense of Romantic French artists.

Literary subject matter appealed strongly to some of the painters such as Delacroix (he had originally intended to be a writer) and Daumier . . . , while Géricault's "Raft of the Medusa" and Courbet's "The Studio" are not so much paintings as epic poems dealing with contemporary issues. But Romantic poetry influenced the style of Romantic painting as much as the subject matter. When Delacroix writes in his journal, "What I would need, then, in finding a subject is to open a book that can inspire me and let its mood guide me," he is describing a new way of creating . . . a reexamination and reworking of physical reality.

This new look at the Romantics might have interesting repercussions for artists today.

Ashbery's writing on art, especially the articles for *ArtNews* and in *Art in America*, attempted to bridge the painterly and the poetic communities—or, indeed, to reverse the flow of inspiration, since, as he wrote in "The Invisible Avant-Garde," many poets in the 1940s and 1950s relied for inspiration on the painters of that time. Cross-pollination might produce monsters, but it could also produce beautiful hybrids that defy conventional categories. As he says of Esteban Vicente, who carries on "a love-hate affair with edges" because they "limit meaningfulness of forms by defining them too well," Ashbery also longs for "a meaningful ambiguity that will give the work the widest range of associations."

Ashbery began to write about art in the late 1950s, a time of Harold Rosenberg's polemics, Clement Greenberg's advocacies, and Meyer Schapiro's remarkable scholarship—an age of schools, of argument, of partisanship. Against this background, his work is noteworthy for its "disinterestedness," to use his own word. The weekly pieces he wrote for the Paris *Herald Tribune* were

not motivated by a desire to champion a position, to refute an enemy or to promote a particular artist (although Ashbery has written often and generously about his friends). Rather, they were composed for no higher cause than to cover important events in the art world, to fulfill assignments, and to meet deadlines. Later, as editor of *ArtNews*, Ashbery wrote those articles others would not or could not complete satisfactorily. As a critic he has worked within the practical restrictions that newspapers and magazines impose.

Yet his work has not been strictly reportage. One can only guess that the same loose editorial control of the Paris *Herald Tribune* which allowed one critic to choose her successor from among her friends also gave Ashbery considerable latitude on subject matter, style and approach. His early articles have a wonderful freedom as they range over what could be seen in Paris. In his first year alone he wrote about Brazilian painting, Bulgarian art, Italian sculpture, Japanese photography, American abstractions, Flemish primitives, Barbizon landscapes, and the Gustave Moreau Museum. Like any good journalist, he wrote not as an expert but as an informed observer, and for a general audience interested in finding out what was worth seeing, and uninterested in esoteric squabbles over theory, practice and methodology. His role—as he conceived it—was to inform and explain rather than to propound and protest.

His journalism, which combines reportage, speculation and personal reaction, is marked by a contextual eruption of unusual and delightful asides, homey reminders of the amateur status he has paradoxically clung to throughout a long professional career. For example, commenting on the way brushwork is "made to substitute for genuine passion and inventiveness in painterly abstract painting," Ashbery recalls that "There was once a Mutt and Jeff strip in which Jeff had gone into business selling honey with a dead bee in each jar as proof of the genuineness, and frantic brushwork is often the dead bee in Abstract Expressionist painting." An exhibition of wallpaper occasions an auto-biographical response: "Many people's first aesthetic experience is triggered by wallpaper. . . . One of my earliest memories is of trying to peel off the wallpaper in my room, not out of animosity, but because it seemed there must be something fascinating beyond the surface pattern of galleons, globes and telescopes."

An early article on Pierre Bonnard, one of Ashbery's favorite painters, includes this not-so-homespun wisdom:

Bonnard once horrified the guards in the Grenoble museum by going up to one of his own canvases and calmly proceeding to paint on it. And in a sense, his paintings are unfinished, in the same way that nature is. They seem about to

change, just as light is always on the point of changing. That is perhaps the essence of his genius.

The breeziness of tone hides a discontinuity of ideas that is one of the hallmarks of Ashbery's style. The analogy is askew, yet the very spontaneity of the idea seems to preclude argument. And also, of course, the carefree style imitates the subject: the syntax of the second sentence, which starts with a conjunction and ends with an ellipsis, mirrors the ongoing process it seeks to assert, starting *in medias res* and fading to an "unfinished" conclusion. The "That" of the last sentence has a broad and ambiguous antecedent that embraces rather than specifies. Yet what is most typical of Ashbery is the way he equates the "unfinished" surface of the painting with the unending process of nature. But the transformation reverses itself: time is reconverted into space by being "always on the *point* of changing." Ashbery plays a variation on Einsteinian relativity, turning space into time and time into space through the agency of light and language. In making this transformation from spatial to temporal process, he moves from the pictorial to the poetic image.

Perhaps as part of his "love-hate affair with edges," Ashbery began his journalistic career in Paris, which in the 1960s was hardly the center of the art world, as he often noted in his articles of that time. But Ashbery seemed to enjoy his distance from the center. He is fascinated by artists like Michaux and Joseph Cornell who lived reclusive lives. His favorite artists, like Fairfield Porter and R. B. Kitaj, kept their distance from fashionable (or unfashionable) centers to work independently on their own. Ashbery maintains a particular sympathy for what he calls in "The Skaters," "professional exiles like me," artists such as Gertrude Stein, Patrick Henry Bruce, Ruth Franken and Esteban Vicente. Not that these artists necessarily swam cross-current, but they did not care to float with the crowds in midstream. Instead they spawned in the quiet waters in relative seclusion.

Ashbery's years in Paris, 1955–65, are especially important not only for what he saw but for what he failed to see. Unlike his friend Frank O'Hara, with whom he is frequently compared, Ashbery was not an integral part of the New York art scene during those heady years. Unlike O'Hara, he did not hobnob with Rivers, Kline or Guston or regularly engage in the discussions at the Cedar Bar, that historic meeting place of the Abstract Expressionists. If O'Hara's touchstones are Kline, Pollock and de Kooning, an exclusively—if naturalized— American circle, Ashbery's touchstones are de Chirico, Michaux and Duchamp, a continental orientation. When Ashbery discusses Abstract Expressionism, he frequently characterizes it as an outgrowth of Surrealism. He twice criticized the 1968 Museum of Modern Art exhibition "Dada, Surrealism and Their Heritage"

for not indicating how American action painters had "plowed under" Surrealism until "something new . . . sprang up in its place." Both his personal and his intellectual involvement in the New York School were substantially different from O'Hara's, as may be judged by his argument about the connection between Surrealism and Abstract Expressionism. According to Ashbery, the technique of Surrealism most borrowed by abstract painters was "automatism" (which "was not a viable possibility until later in the hands of Jackson Pollock"), the very aspect of Surrealism that he finds least interesting and useful.

Though Ashbery occasionally regretted his distance from the exciting New York art scene—and eventually joined it—he is usually proud of his decision to stay away. In the year he left Paris to become an editor for *ArtNews*, he wrote that "the secret attraction of Paris for Americans today" is that Paris, "unlike New York and most other capitals, provides a still neutral climate in which one can work pretty much as one chooses." Neutrality, independence, imaginative space—these are central concerns not only of Ashbery's critical beliefs but of his poetic process.

Repeatedly in his criticism Ashbery struggles with the American avant-garde responsibility to "make it new." The question he asks himself is how one can produce works of both aesthetic value and constant innovation. Isn't the price of artistic Maoism, the constant revolution of the arts, an empty fashionableness that produces artists such as "Bruce Nauman, a California 'Funk' artist whose work is determined not to look like anything"? "Is there nothing," he asked in a lecture at Yale, "between the extremes of Levittown and Haight-Ashbury, between an avant-garde which has become a tradition, and a tradition which is no longer one?" He ended on a very Eliotic note: "Has tradition finally managed to absorb the individual talent?"

His solution is to advocate that artists take up separate and individual spiritual pilgrimages to find their personal visions. Paris, in Ashbery's opinion, is a particularly good place to proceed on that pilgrimage, because the spiritual byways are less choked with fellow travelers and "one can work pretty much as one chooses." One must follow a path that "neither accepts nor rejects acceptance but is independent of it." The artists he most praises are those who eschew fashion to go it on their own. In "Working Toward the New," one of several articles he wrote for *The New Republic*, Ashbery took the opportunity to praise Jasper Johns, but in terms that raised questions about how well his public understood him:

Johns has been a dominant figure for a decade, but has anyone really thought about him lately? It is always hard to distinguish something new especially when its creator is a recognized artist. And Johns has never cared much about

pleasing or disconcerting his admirers. He has gone his rather leisurely way, sometimes turning out a bumper crop of flags, to the delight of those who collect them, sometimes . . . producing work whose calculated "no look" was bound to throw off those who were proud of having assimilated his flags.

The gustatory imagery is important. The public likes artists who produce a crop they think they can assimilate. But the artist must make himself indigestible, and Johns knew how to "throw off" the collectors.

The tone of the article is muted, ironic and distant, in part to reflect the " 'quiet' season" which is Ashbery's ostensible subject, but also out of respect for artists like Johns who take a "perverse" (a word of approbation in Ashbery's lexicon) delight in throwing off their admirers. Ashbery is at pains to show how one can admire Johns without claiming to have assimilated him, that appreciation need not be consumption. But Johns and Ashbery are linked in another way. Ashbery asserts that he is "one of the few people" who have "shared . . . enthusiasm" for Johns' latest work. The critic like the artist must go it alone, following a private aesthetic journey.

In his long poem "The New Spirit," Ashbery writes:

For the continual pilgrimage has not stopped. It is only that you are both moving at the same rate of speed and cannot apprehend the motion. Which carries you beyond, alarmingly fast out into the confusion where the river pours out into the sea. That place that seems even farther from shore . . .

The tonality that Ashbery adopts in describing Johns mirrors the surface of Johns' paintings. Both aspire to a style that, to use Yeats' phrase, is "cold and passionate," intense but aloof, cryptic and commonplace. Both wish to create an art that cannot be co-opted by the marketplace or the publicist, that falls within its own allusive rubric. Ashbery's praise of Jasper Johns is a carefully modulated discussion that does not presume to uncover its mystery or predict the future course of its development. He admires without domesticating; the housecat contains the atavistic strains of the tiger.

Liminality gives Ashbery room to experiment and to blur the categories of writing. The following two examples are a particularly vivid case in point. One passage is drawn from an article on Esteban Vicente, the other from "The System," one of the prose poems in *Three Poems,* itself a study in walking the boundaries between poetry and prose.

The window . . . is a source of light and, while hinting at those menacing outside forces, it remains a feature of interior architecture; what we see is

somehow always related to what we see inside, whether it be the figure, whose nature coalesces only within the four walls that Pascal advised us to stay within, or in unidentified phenomena which appear as functions of the carefully guarded and tended "intimacy and clarity of the interior life."

Not an atom but did not feel obscurely compelled to set out in search of a mate; not a living creature, no insect or rodent that didn't feel the obscure twitching of dormant love, that didn't ache to join in the universal turmoil . . . roiling the clear waters of the reflective intellect, getting into all kinds of messes that could be avoided if only, as Pascal says, we had the sense to stay in our rooms.

Both these passages are informed by what one might call Ashbery's spiritual agoraphobia, his fear of numinous crowds. Like George Herbert's pilgrim, Ashbery desires only "one good angel . . . tied / Close to my side." The allusion to Pascal functions in both passages as a spiritual and philosophical injunction that one should obey, and it reinforces an idea about which Ashbery is especially intent—the relationship between one's environment and one's capacity for self-analysis and self-definition, the dialectic between interior and exterior space. Stylistically, the two passages are quite similar. Each is cast in a long sentence which eventually moves into the subjunctive, with its rhetorical, elevated effect. Each employs abstraction in a discourse that is distant and impersonal despite—or perhaps because of—the use of the first person plural. But the poem is less formal and dips into the colloquial ("all kinds of messes") and makes larger leaps of imagery and subject matter.

The making of the impersonal self-portrait, which Ashbery learned from such masters as de Chirico and Tanguy, separates him from the Abstract Expressionists' automatism. "The automatic gestural painting of Pollock and Kline and their contemporaries looks different from the patient, minute, old-master technique of Tanguy," Ashbery writes. And it is the "patient, minute, old-master technique" to which Ashbery is drawn, those instances in which

the governing principle seems to be not so much automatism . . . but that of self-abnegation, one which will reflect the realities both of the spirit (rather than the individual consciousness) and of the world perceived by it: the state in which "*Je est un autre*," in Rimbaud's famous phrase.

Ashbery locates the "superior realism" not in the spontaneous outpourings of the diarist where we have traditionally located the discourse of the authentic and sincere, but in the highly formal, even overelaborated rococo framework of the self-conscious artist. Writing his brand of art criticism, with its carefully

constructed but self-abnegating persona, helped Ashbery to perfect the technique of becoming another.

How has he done this? How does Ashbery create a self as other? "Its method," according to Richard Howard, "has been to pluck from the world the constituted terms of being. . . . The curious selfhood of Ashbery's . . . gathered and gleaned its ready-mades in what seemed . . . a furthered capacity to *relate*." Howard's explanation sounds uncannily like Ashbery's own description of the procedures of the New Realists, "the European term for the art . . . which in one way or another makes use of the qualities of manufactured objects."

Ashbery himself locates the New Realism in both literary and pictorial traditions. "The[se] artists are at an advanced stage in the struggle to determine the real nature of reality which began at the time of Flaubert. One could point to other examples . . . the 'objective' novels of Robbe-Grillet and Sarraute."

The relationship between the self and its own otherness is never static. As the self changes, so must its otherness, and conversely the self is modulated by changes in the outside environment. The self-abnegation that Tanguy practices or the objectification that the New Realists engage in is not a single act, a one-time transformation; rather it constitutes "a continuing situation," a process of emission and absorption, a radar signal whose palindromic signifier can be read both ways with equal clarity. In his poem "Rural Objects," Ashbery addresses this alter and altered ego:

> And now you are this thing that is outside me
> And how I in token of it am like you is
> In place. In between are bits of information
> That circulate around you, all that ancient stuff,
>
> Brought here, reassembled, carted off again
> Into the back yard of your dreams.

At first, Ashbery leads us to believe that the relationship between the other and the observing self is static, a connection that is set "in place," like the painter's relationship to the model. But the bits of information continue to circulate, disappear and return, not finally as objects but as subjective experience, "the back yard of your dreams."

The critic Bonnie Costello has pointed out that in Ashbery's poem "Self-Portrait in a Convex Mirror" one is drawn to the analogy between poet and painter, reader and viewer: "Ashbery puts himself in the position of the beholder (analogously, the reader) even while he is also creating his own self-portrait in expectation of a beholder." This stance, calling for "both active and passive

responses," is one that Ashbery learned from painters (of whom Parmigianino is but one) and perfected in his art criticism. The art critic is both the beholder and the object the reader beholds, both invisible and the only thing to see. How can one make the most of this converging and diverging interaction of self with otherness? His review of Jasper Johns suggests the best rhetorical strategy: one must be appreciative, not possessive; one must not presume to know beyond the moment the shape of things; one must admit to one's limitations and desires and then transcend them with a certain passionate objectivity.

In an unpublished interview with Bill Berkson, Ashbery responded to an inquiry about the absence of polemic in his art criticism by commenting that "perhaps this is because I feel basically disinterested—not uninterested—in art." For Ashbery the art critic turned poet-painter, the work begins as translation and exegesis, two self-abnegating, disinterested acts that attempt to establish the world of objects as they move and are perceived. Then the coolly objective gives way to the passionately subjective. His poem "And *Ut Pictura Poesis* Is Her Name" can serve as a paradigm of this process. It begins matter-of-factly:

> Now,
> About what to put in your poem-painting:
> Flowers are always nice, particularly delphinium.
> Names of boys you once knew and their sleds,
> Skyrockets are good—do they still exist?
> There are a lot of other things of the same quality
> As those I've mentioned.

It continues in a tone of heightened drama and emotion as "she approached me / About buying her desk." Then

> Suddenly the street was
> Bananas and the clangor of Japanese instruments.
> Humdrum testaments were scattered around. His head
> Locked into mine. We were a seesaw.

The poem concludes as the matter-of-fact gives way to the epiphanous:

> The extreme austerity of an almost empty mind
> Colliding with the lush, Rousseau-like foliage of its desire to communicate
> Something between breaths, if only for the sake
> Of others and their desire to understand you . . .

The disinterestedness of the journalist is akin to the "extreme austerity of an almost empty mind" and the painter's "self-abnegation." In his art criticism Ashbery collides with the "lush, Rousseau-like foliage" that the artist desires to communicate to the viewer and the journalist to the reader. The journalistic requirement "to communicate/ . . . only for the sake / Of others and their desire to understand you" becomes a model for at least one of Ashbery's poetic strategies.

But the objective translation of experience and the inscription of oneself into the exterior world of objects is merely an opening gambit in a "yet-once-again-altered scheme of things" which "a simple decision on the part of the spectator" can turn into a "proposition of asceticism and conversion."

It no longer mattered very much whether prayers were answered with concrete events or the oracle gave a convincing reply, for there was no longer anyone to care in the old sense of caring. There were new people watching and waiting, conjugating in this way the distance and emptiness, transforming the scarcely noticeable blankness into something both intimate and noble.

On Ashbery's return to New York in 1966, a review of an exhibition of sixty masterworks of nineteenth-century French painting at the Wildenstein Gallery became an opportunity for him to celebrate Courbet as an artist who has much to offer contemporary sensibilities:

If there is a single common characteristic of current trends in the arts, it is probably impatience with existing forms of expression. This is a feeling one also gets from Courbet, for instance, who has influenced modern artists as diverse as de Chirico, Balthus and Larry Rivers, and whose "modernism" lies in the provocative unvisual qualities he incorporates into realistic land-scapes and portraits. In the beautiful "Roe-Deer in Snow," it is as though he continued to paint *after* he had obtained a satisfactorily realistic image. This "something else" is not essential to the picture . . . is in fact of great importance; it intrigues and excites us because we cannot tell why it seems right.

This passage needs to be placed beside his comments on Jasper Johns published two years later:

A painter said that Johns reminds him of Anthony Caro. Johns builds away from the edge of the canvas the way Caro builds up from the ground, from

something basic and primitive toward something illusory, and in doing so manages to pull through all kinds of being that can happen in painting or sculpture.

In both these passages Ashbery emphasizes the need for an objective starting point. In Courbet he calls it a "satisfactorily realistic image," in Caro it is something "basic and primitive." But the artist is not to stop there; he must go further, building up to "something illusory," something that "intrigues and excites us because we cannot tell why it is right." For Ashbery the method is not stripping away the realistic, but adding to it, "building away from the edge." Ashbery is concerned with building up from the surface, the layering of affect and medium. The surface of the paintings Ashbery admires is not a battlefield of competing expressionistic forces but an archaeological site, where the accreted objects of various civilizations lie in surprising juxtaposition.

In his art criticism, Ashbery himself practices this technique of building up from the "adequately realistic" depiction of a painting. For example, in an article on eighteenth-century French watercolor, he wrote of Maurice Quentin de la Tour's portrait of d'Alembert:

The famous La Tour smile, the *sourire universel*, which begins to cloy if one sees his work *in extenso* at the St. Quentin museum, is not overdone here. It is restrained and even a little defiant, and the absent gaze suggests that he is lost in thought or listening for a sound in the distance, perhaps the first rumble of the Revolution, for which, as one of the leading *Encyclopédistes*, he helped pave the way.

The *sourire universel*, with its combination of restraint and defiance, is an expression one can imagine Ashbery sometimes wearing as he writes. So, too, is Ashbery often lost in thought or listening to the rumble in the street. But he is not content to show us what is there or to turn the watercolor into a self-portrait. Like Keats, he goes beyond the painted surface to imagine what can't be seen. But while Keats imagines the Greek city vacated by its inhabitants to join the procession on the urn, Ashbery imagines the Parisian streets filled with soldiers and barricades. The "absent gaze" suggests a fullness elsewhere, a "something extra" that disturbs the "adequately realistic image."

The critic Leslie Wolf has argued that "in considering Ashbery's relationship to painting . . . we must resist the temptation to proceed by attending to those specific paintings on which some of his poems are based," and he rejects "Parmigianino, Ingres and de Chirico as artists whose work his own most closely parallels," attempting rather to situate Ashbery within the Abstract

Expressionist movement. He claims there is a "lack of 'finish'" in Ashbery's poetry and comments, "The surface [is] like that of the Abstract Expressionist painting" he had been discussing. It seems to me that the surfaces of Ashbery's poems have, on the contrary, been worked over and over again until, like the Courbet painting "The Roe-Deer in Snow," they achieve something excessive and right. His art journalism, which has been primarily concerned with artists like Ingres and especially de Chirico, is not only a good indication of his interests but also a proving ground for his technique.

Yet Ashbery has treated his art writing not only secondarily but dismissively, and only after thirty years has he permitted it to be collected in book form. Why? In his lecture titled "The Invisible Avant-Garde," Ashbery addresses his ambivalent feelings toward journalism:

> Thomas Hart Benton . . . was at his best a better painter than de Chirico is now, but is a worse artist because he accepted the acceptable. *Life* used to have an article on Benton almost every month, showing his murals for some new post office or library. The fact that *Life* switched its affections from Benton to Pollock does not make either of them worse, but it does illustrate that Benton's is the kind of art that cannot go on living without acceptance, while Pollock's is of the kind which cannot be destroyed by acceptance since it is basically unacceptable.

Art journalism is at best insignificant, at worst harmful when it bestows "acceptance" on inferior works of art. Ashbery as an artist is loath to wield this force of "acceptability," for the painter and poet must go on, independently, whether they are acceptable or not. For every artist the need for "acceptance" is a death wish. No wonder Ashbery is willing to let his criticism fade quietly. But if we read it not for what it approves, but for how he translates his perceptions and for its exegesis of others, we shall have gained something of value.

There is something more. In an article on Gertrude Stein, Ashbery asserts: "Poets when they write about other artists always tend to write about themselves." We must read his criticism not as an attempt to "approve" but as a means of self-portraiture. In these works written hurriedly, by a certain journalistic "automatism" as he rushed to meet deadlines and copy length, we may glimpse the poet himself. Here is "lack of 'finish,'" and the quick brushstrokes removed from his more canonical works. Here we may find the forces of time and circumstances embedded in the very texture of the work.

Here, too, it seems to me, one may find a chronicle that is witty, engaging and central to our understanding of American art and culture.

The selection here represents less than a third of Ashbery's total output,

and many of the pieces included here are the principal parts of longer articles. Typically in his dispatches for the *Herald Tribune* and *New York*, the lead story would be followed by several smaller, unrelated items. In those cases I have usually opted to reproduce only the lead story. Moreover, following the usual journalistic procedure, editors rarely allowed Ashbery to title his own articles. Here they appear with simple descriptive titles.

One way of organizing such a selection would have been the chronological one, a method that has the advantage of giving the reader a sense of Ashbery's development and suggesting the various editorial styles to which Ashbery had to accommodate himself. But it would also scatter pieces that developed similar themes or subjects though they were often written months or even years apart. Instead, I have opted for grouping works in rather large, loose categories. Certain figures become touchstones and repeated subjects for meditation, speculation and reevaluation.

This book, of course, could not have been assembled without the support and help of John Ashbery, who patiently answered my endless questions. I am grateful for his kindness, patience and trust. Gordon Lester-Massman first proposed the project to me and sent me into the archives from which I have only just reemerged. My father generously scoured Manhattan buying books and exhibition catalogues. James Hubbard, Regina Willingham and Eugene Richie, Mr. Ashbery's assistant, helped in assembling, organizing and typing the manuscript. Finally I want to thank John Lessner for his help and support throughout this long process.

I presented a portion of this introductory essay at the Conference of Twentieth Century Literature at the University of Louisville in 1986. Robert Miklitsch, one of the panelists, made valuable suggestions, and my presentation was in part funded by a grant from Towson State University, whose librarians have also been exceptionally helpful in locating material.

I

SURREALISM AND DADA

IN THE SURREALIST TRADITION

THE BIG SURREALIST show which has just opened at the Galerie Charpentier in Paris turns out to be one of the important events of this season. In true Surrealist tradition, it is also a subject of violent controversy.

Even before it opened, André Breton, the founder and theoretician of Surrealism from its beginnings, flew into print with an interview in *Le Monde* to denounce the show and dissociate himself and the movement from it. Why? Apparently because a large semiofficial manifestation of this kind makes Surrealism look like a thing of the past, a museum piece, and Breton contends that it is very much alive.

His chief objection is to the word *bilan* ("balance sheet"), which has been pronounced in connection with the show. "This word *bilan* belongs to the language of business," he complained. "Baudelaire disliked military meta-

phors and I dislike commercial metaphors. 'You draw up' a *bilan*, and I have no intention of drawing up that of Surrealism. Surrealism existed before me and I expect it to survive me."

If a Surrealist show without Breton seems a little like *Hamlet* without Hamlet, we can take comfort in the fact that his refusal is in the grand tradition of Surrealist manifestos and attacks. From the very beginning this artistic movement, whose sources are in dreams and the unconscious, has had a history of very down-to-earth quarreling, excommunications, anathematizations, political manifestations and internecine bickering of all kinds. One after the other, most of the original Surrealists have dropped out or been excommunicated by Breton, until today only he remains, surrounded by a hard core of young disciples. One of the last surviving members of the group, Max Ernst, was excluded several years ago because he had received a prize from the Venice Biennale and thus become an unhealthy example of success which might have a corrupting effect on Surrealist youth.

Breton is right in claiming that Surrealism is very much alive, but it remains so in spite of the politics and court etiquette which he has sought to impose on it. Max Ernst has always been a Surrealist and always will be: if he isn't, then who is? Breton is right also in pointing out that Surrealism existed before him and will survive him. What has in fact happened is that Surrealism has become a part of our daily lives: its effects can be seen everywhere, in the work of artists and writers who have no connection with the movement, in movies, interior decoration and popular speech. A degradation? Perhaps. But it is difficult to impose limitations on the unconscious, which has a habit of turning up in unlikely places.

Patrick Waldberg, the Franco-American art critic who arranged the show, has provided some fascinating predecessors such as the Italian masters of the fantastic Arcimboldo and Monsù Desiderio; the Fontainebleau mannerist Antoine Caron; Fuseli, Victor Hugo, Gustave Moreau and Redon. Among the immediate forerunners, de Chirico is represented by four important works, including "The Enigma of the Hour" and the famous "Tower" of 1912; Arp by a dozen works, including painted wood reliefs, sculptures and collages; Duchamp by a copy of his celebrated painting on glass "The Bride Stripped Bare by Her Bachelors, Even." Sometime Surrealists like Picasso and Giacometti are included, and, of course, Dali, Magritte, Tanguy, Miró and the other strictly Surrealist painters. The "successors" include Marie-Laure, Marc Janson, d'Orgeix, Assia, Léonor Fini, Calder and many others.

New York Herald Tribune (International Edition), April 21, 1964

THE HERITAGE OF DADA

AND SURREALISM

"DADA, SURREALISM AND THEIR HERITAGE" at the Museum of Modern Art in New York clarifies what the poet James Schuyler has called "one's love-hate relationship with Surrealism." Certainly Surrealism has influenced us in so many ways that we can hardly imagine what the world would be without it. Yet, like all revolutions, it substituted some new restrictions for old ones, limiting its direct effectiveness and eventually bringing about its own decay as a movement, though its effectiveness as a catalyst continues.

Liberté totale in Paris in the 1920s turned out to be something less than total, and if it was not total then it was something very much like the everyday liberty that pre-Surrealist generations had to cope with. In literature it meant automatic writing, but what is so free about that? Real freedom would be to use this method where it could be of service and to correct it with the conscious

mind where indicated. And in fact the finest writing of the Surrealists is the product of the conscious and the unconscious working hand in hand, as they have been wont to do in all ages. But if automatic writing is the prescribed ideal for literature, what about art? Dali's meticulous handling of infinitesimal brushes excludes any kind of automatism as far as the execution of his paintings goes, and perhaps even their conception was influenced by a desire to show off his dazzling technique to its best advantage. Breton called Miró the most surreal of the Surrealists, yet the deliberate wit and technical mastery of his work scarcely seem like tools to plumb the unconscious.

As the Surrealist movement pursued its stormy course, exclusions, anathemas and even suicide followed in the wake of Breton's rulings and pronouncements. Sexual liberty, he proclaimed, meant every conceivable kind of sexual act except for homosexuality — a notion that would have seemed odd to the Marquis de Sade, the Surrealists' unimpeachable authority on matters sexual. This exception may seem unimportant, since homosexuality affects a relatively small fraction of humanity, but to restrict something proclaimed as "total" is to turn it into its limited opposite. And in this case one of the most brilliant of the Surrealist writers, René Crevel, happened to be a homosexual. His suicide a few days after a notorious row between Breton and Ilya Ehrenburg (who with his customary finesse had qualified the Surrealist movement as "pederastic"), at the time of an international Communist cultural congress in Paris from which the Surrealists were excluded, was a blow to Surrealism and to literature. Though Maurice Nadeau in his *History of Surrealism* avoids linking Crevel's suicide to this incident and calls it an act of "attempted affirmation" (of the irrational, apparently), it seems obvious that Crevel must have felt like an exile in the promised land he helped discover. And what is one to think of a vanguard literary movement that found it necessary to excoriate Antonin Artaud?

The Communist adventure itself is one of Surrealism's unlikeliest non sequiturs. The idea that total liberty could somehow coexist with Stalinism is a truly Surrealist notion, but if one accepts it from this point of view one must go on to excuse the inconsequential behavior of munitions barons and concierges as part of the surreal demiurge. The Communists understood this very well and washed their hands of the whole disreputable bunch. So did Louis Aragon, who, faced with a choice between Surrealism and Communism, opted for the latter, thus committing a literary suicide as devastating for the movement as Crevel's real one. To read one of Aragon's Communist novels after reading his earlier ones like *Anicet* or *Le Paysan de Paris* is a truly depressing experience.

The point of mentioning all this is to show why Surrealism, in the narrow interpretation of its theologians, is so unsatisfactory and also why, from the broad point of view with which we all intuit it, it is indeed a renewing force. I

once interviewed the poet Henri Michaux, who said that, though he did not think of himself as a Surrealist, Surrealism had been the chief influence on him as a writer because it gave him the permission (*la grande permission* was his phrase) to do as he pleased. In this sense we are all indebted to Surrealism; the significant art of our time could not have been produced without it.

The show at the Museum of Modern Art chooses to treat the topic from an educational, art-historical standpoint which is fine as far as developments of the 1920s and 1930s are concerned but which in the final or "heritage" section gives us only a glimmer of what this heritage, by far the major contribution of Surrealism, has been. It presents early work by such painters as Pollock, Motherwell, Newman and Rothko in which the influence of Ernst, Masson and Miró can be seen, but it stops short of their later and major achievements, which are less obviously yet more truly Surreal. Similarly, the younger contemporaries exhibited are those who have in one way or another copied or paid homage to Surrealist modes of the past. Surrealism is, however, the connecting link among any number of current styles thought to be mutually exclusive, such as Abstract Expressionism, Minimalism and "color-field" painting. The art world is so divided into factions that the irrational, oneiric basis shared by these arts is, though obvious, scarcely perceived. It would then have been doubly interesting and pertinent to the present moment in art to use this occasion to illustrate it.

However, just as a true university is a collection of books, an art exhibition is an assortment of works of art, and the show does offer a chance to look at a good many of the notable works of this century, some of them rarely if ever shown in public. One of the high points is the Duchamp room, centered around a replica of the large glass panel "The Bride Stripped Bare by Her Bachelors, Even" in the Philadelphia Museum's Arensberg Collection, and also containing his magnificent painting-assemblage called "Tu m'em . . ." from Yale. It is considered proper to admire Duchamp less for what he once did than for what he has refused to do since. Yet much as one hesitates to question any act of the mind that produced this brilliant handful of masterpieces, one cannot escape the conclusion, on seeing them anew, that Duchamp's decision to give up art for chess was something less than a brainstorm.

Picabia, Arp and Schwitters are the most notable Dada artists after Duchamp, and, as with him, one finds it difficult to imagine how their work could ever have been construed as anything but a high form of art. It was a curious state of affairs: the Dadaists were really bent on shocking and destroying; the public that hissed and booed them was not bourgeois but cultivated, eager for new sensations; yet neither artist nor public could fathom what seems to us today like the timeless beauty of Schwitters' superbly ordered trash collages, Picabia's austere and funny mechanical drawings, and Arp's wood

reliefs, whose sweetness and purity suggest some unknown archaic art. Next to them the Berlin Dadaists, who took their antisocial position more seriously, look like pamphleteers.

Although de Chirico was not strictly speaking a Surrealist, he is in a sense the one great Surrealist painter, and the genius of his early work continued to be acknowledged by Breton and the others long after they had broken with him, disillusioned by his later evolution. (And it may well be also that his novel, *Hebdomeros*, written in 1929, well after the decline of his painting had set in, is the masterpiece of Surrealist literature.) With Dali and Magritte one is aware of a technique that coexists with their subjects; in de Chirico manner and matter form an inseparable whole. His dreamlike landscapes and still lifes and the paint that composes them form an irreducible, magic substance. Magritte's technique is invisible; he offers the enigmatic subject stripped of any connotations of "art," and not surprisingly he is being discovered today by a new generation of artists who believe that art should be pure concept. It is an interesting idea, but de Chirico's work exists in a sphere beyond the reach of interesting ideas. The museum is fortunate in being able to show, in addition to its own outstanding examples of his metaphysical period, such notable works from private collections as "The Song of Love," "The Jewish Angel," and "The Span of Black Ladders."

Miró, the other great Surrealist painter, resembles de Chirico; both men in their very different ways solved the question of dealing in plastic terms with material from the unconscious which in lesser hands remained "literature"— often moving, it is true, but always a little disappointing since it seems cast adrift in an alien medium. Miró retains his painterly genius even when he momentarily abandons painting for collage or assemblage. "The Spanish Dancer" collages and a "Poetic Object" in this show made from a stuffed parrot, a hat, a map and a wooden post have a truth for the eye that Ernst, for instance, never seems quite to achieve. A singularly beautiful canvas among the many Mirós on view is "The Birth of the World." It is on a heroic, almost "New York School" scale, measuring more than six by eight feet, and its wall of smoky, dripping pigment punctuated with a few pictographs will seem prophetic to amateurs of art history, though it needs no such extravisual justification.

Except for isolated phenomena like the early Giacometti, Surrealism during the 1930s, dutifully recorded here, is largely baubles and trouvailles. Pleasant enough, to be sure, and one covets some of the perversely decorative objects on view, but is this really *La Révolution Surréaliste*? It was not to erupt meaningfully again until after the war, in New York, but it is still what's happening.

The New Republic, June 1, 1968

"SPACE AND DREAM"

"SPACE AND DREAM" (at the Knoedler Gallery in New York) sounds at first like one of those procrustean titles that galleries use to dignify an otherwise amorphous group. We could all name, if we were asked, the artists whose space has the fluidity of dreams: de Chirico, Dali, Ernst, Miró and Gorky, who are in the present exhibition, as well as Rousseau, Picabia, Duchamp, Schwitters, Balthus and Pollock, who are not. And what about Moreau, Gauguin, Munch, Léger, Bacon and Morris Louis? Not to mention Rosso, Caravaggio, Ingres, Géricault and the Master of "Le Coeur d'Amour Epris."

It is true that Knoedler's meant to concentrate on the artists who succeeded Cubism and preceded Abstract Expressionism and who, dissimilar as they are, still constituted the one valid art tendency between the two wars, embracing artists as unlike as Miró and Mondrian, yet all of whom seem to us today, from

the security of our post-painterly hindsight, to have transcendental metaphysical content. It is precisely the heteroclite nature of the artists on view that makes one want to go on naming all the others who might have been included, until the definition collapses under its own weight. Still, once the kinship of these artists has been postulated it cannot be ignored, all the more because today we would like to eliminate from art everything that we consider "extravisual," forgetting that art, like the universe (the space of dreams?), continues on its creepy way after we have stopped imagining its limits.

Perhaps it is the fact that the so-called pendulum is now swinging back toward "science" as it has periodically done over the last eighty years, beginning with Seurat and continuing through Analytical Cubism, Suprematism, the Bauhaus and so on, that makes us view the assembled artists with a respect tinged with suspicion. Space is fine, but "dream"? There is something slightly icky about that word: we know we cannot stop dreaming, but we do not like to be thought of as people who dream. "Impractical" is the adjective that usually characterizes "dreamer," and that has an unfortunate ring, though we don't exactly want to be thought of as "practical" either. Must we be one or the other?

All this is part of our fatal habit of dividing things up into manageable units. The pendulum has not swung; the history of art proceeds in orderly fashion, in a straight line. Cézanne is not the Robert Oppenheimer of art, nor did the Cubists "analyze" anything. They may have thought they were boring deep into the invisible structure of matter, but their speculation, like Cézanne's, was fantasy. This is not to diminish their achievement (though "fantasy" sounds even worse to us than "dream"): on the contrary, they were great artists participating in the collective dream of art. One cannot entirely agree with Robert Goldwater when he says, in his introduction to the catalogue of this exhibition, that "space and dream were a double rejection of this [Cubist] approach: a rejection of bas-relief in favor of deep and often infinite recession with a compositional rhythm that penetrates the surface . . . and, just as significant, a rejection of reasoned analysis in favor of profounder irrational impulses whose associated directions are unhesitatingly accepted." For the space of dreams can be flat as well as deep, and the Cubists' fragmented mandolins and apéritif bottles reflect a *hantise* as compelling as de Chirico's penchant for arcades and perspectives. In fact de Chirico's later metaphysical pictures, as Goldwater reminds us, seal the perspectives with two-dimensional objects recalling Cubist planes. In his writings de Chirico dwells on constellations and other celestial phenomena, as Miró does in his paintings, and yet he is aware that we are what Gaston Bachelard calls "corner dwellers"; that we sometimes need a shallow space to dream in. Witness this remarkable passage from de Chirico's *Hebdomeros:* "At noon in those transitional seasons, autumn

and spring, the sky was as blue as a piece of taut paper; it was no whiter near the horizon; it was blue all over from top to bottom; a veritable ceiling stretching over the town. On those days of supreme happiness, the sense of north, south, east and west—all sense of direction, in fact—was lost . . ." Or again: "The sea of stars stretched into the distance, as if the sky no longer seemed to be a dome but a ceiling instead." De Chirico's earlier metaphysical paintings are not a phenomenon isolated from the mainstream of modern art, but an attempt like Cubism to enlarge the artist's sphere of action by changing the rules of space. For those "days of supreme happiness" to occur, one had to discover a medium no longer ruled by the compass, where potentialities could become facts merely through being evoked by the artist.

There had of course been similar attempts in the past. In Carpaccio, for instance, a detail in the foreground will often seem inextricably welded to something in the background, as in "St. Ursula and the Prince Taking Leave," where a stranded ship in the middle distance seems part and parcel of the distant mountain behind it; there is something strangely satisfying in this intimate joining of objects that would normally not cross each other's paths. The device has been used in our time, notably by Dali in his "double-image" paintings and by Balthus (for example in his "Portrait of the Vicomtesse de Noailles," where the lady's head seems inserted in the molding of the wall behind her). The Mannerists' telescoping of space is well known; one example is Primaticcio's "Ulysses and Penelope," where the two tiny figures in the background not only indicate exaggerated depth, but also seem to be attached to Penelope's gesturing hand which partly covers them. It is scarcely necessary to resume all the adjustments made on space down to the first decade of the twentieth century, where it suddenly explodes: the point is that they are part of the artist's traditional urge to recast the world in a shape suited to the mercurial nature of his inspiration, and the new dimensions and materials of present-day art are but one further sign of his continuing restlessness.

It comes down to a privileged area of communication between artist and spectator that is the equivalent of the freedom of the skies which poets have always enjoyed, where the mere mention of a place-name ("Aleppo once") is sufficient to transport us there, and a girdle may be put around the earth in something less than forty minutes. This hereditary province of poetry has been conquered by painting and sculpture only recently (the growing involvement of poets in the plastic arts, from Valéry and Apollinaire down to today's New York, Paris and San Francisco poets, is a sign of the times): matter had first to be pulverized before being rebuilt according to the whims of the artist. The artists in this show were among the first to begin this process of reconstruction, but it may be noted that the process is still continuing, even in the minimal, post-

painterly or "scientific" art of the present which at first seems so far from "dreams." The dream of escaping from dreams is a dream like the others. The closer artists come to reducing the temperature of their work to absolute zero, the hotter, by implication, is the climate that can result from such a resolution, and the conflict of the two is not less romantic for going unmentioned. Kandinsky, quoted by Goldwater, foresaw this situation: "It is no part of my program to paint with tears, or to make people cry, and I really don't care for sweets, but Romanticism goes far, far beyond tears. Today there is a *Neue Sachlichkeit* [New Objectivity]; why should there not be a (or the) New Romanticism. . . . The meaning, the content of art is Romanticism, and it is our fault if we mistake a temporal phenomenon for the whole notion."

So one ought to approach the Knoedler show not as a collection of lovely antiques from the 1920s, but as the declaration of independence on which our present democracy ("the Republic of Dreams," in Louis Aragon's phrase) is based. The space of dreams—deep, shallow, open, bent, a point which has no physical dimensions or a universal breadth—is the space in which we now live. All of the artists here, except for a few such as Calder or Gabo who do not really fit the category, helped conquer more territory for art; if their work now looks "classical," this is perhaps the price of innovation. On the other hand there is no real alternative to innovation, and the artist, if he is to survive, cannot leave art where he found it. Dreamers are insatiable expansionists, and the space of dreams rapidly becomes overcrowded.

ArtNews, December 1967

JOSEPH CORNELL

I loved stupid paintings, decorated transoms, stage sets, carnival booths,
signs, popular engravings; old-fashioned literature, church Latin, erotic books
with nonexistent spelling, the novels of our grandmothers, fairy tales,
children's books, old operas, silly refrains, naive rhythms.
 —*Rimbaud*, A Season in Hell

*. . . The painter lodged near the station in a modest apartment on the sixth
floor; he lived there in two rooms which he had papered from floor to ceiling
with very bizarre and disconcerting drawings which made certain highly
esteemed critics repeat for the thousandth time the celebrated refrain: It's*
literature. *At the end of a discussion whose subject was a recent vernissage,
these same critics had in fact laid down the law that* painting must be
painting and not literature, *but he seemed to attach very little importance to
all that, either because he understood nothing of it, or because he understood
it all too well and therefore pretended not to understand.*

—De Chirico, The Engineer's Son

THE GUGGENHEIM MUSEUM'S large show of eighty-nine constructions and
collages by Joseph Cornell will be remembered as a historic event: the first
satisfying measure of work by an artist who has become legendary in his
lifetime. There have been Cornell exhibitions in New York since 1932, when he
first appeared in a group show at the Julien Levy Gallery; three especially
copious and memorable ones were held at the Egan Gallery in 1949, 1950 and
1953. But the galleries which showed him had a disconcerting way of closing or
moving elsewhere, so one could never be sure when there would be another
Cornell show. Cornell's extremely retiring nature, his exemplary reluctance to
give out biographical data or make statements about his work, compounded the
aura of uncertainty that seemed to hang over that work like an electrically
charged cloud. Not uncertainty as to its merits, for these, though seldom
understood, have been almost universally recognized by artists and critics of
every persuasion—a unique event amid the turmoil and squabbles of the New
York art world. The uncertainty was rather an obscure wondering whether one
could go on *having* this work, whether the artist would not suddenly cause it all
to disappear as mysteriously as he gave it life. For Cornell's boxes embody the
substance of dreams so powerfully that it seems that these eminently palpable
bits of wood, cloth, glass and metal must vanish the next moment, as when the
atmosphere of a dream becomes so intensely realistic that you know you are
about to wake up. For the moment, however, the dream is on in the vast white
hutch of a museum whose softly falling white light and spiraling lines have taken
on strong Cornellian overtones; afterward the pieces will return to their niches
in public and private collections and to Cornell's famous garage, on a suburban
street called Utopia Parkway.

Our knowledge of Cornell's life is as sketchy as our knowledge of Carpac-
cio's or Vermeer's. He was born in 1903, lived as a child in Nyack, New York,
and moved in the late 1920s to the house in Flushing, Long Island, where he

still lives. As a young man he attended Phillips Academy at Andover, Massachusetts, and worked for a while in the family textile business. One imagines that his day-to-day existence in Queens must be as outwardly routine and as inwardly fabulous as Kant's in Koenigsberg. The latter once astounded an English visitor with a graphic description of St. Peter's in Rome; the visitor could not believe that Kant had never traveled beyond the borders of East Prussia. It is likewise hard to believe that Cornell has never been in France, so forcefully does his use of clippings from old French books and magazines re-create the atmosphere of that country. Looking at one of his "hotel" boxes, one can almost feel the chilly breeze off the Channel at Dieppe or some other outmoded, out-of-season French resort. But this is the secret of his eloquence: he does not re-create the country itself but the impression we have of it before going there, gleaned from Perrault's fairy tales or old copies of *L'Illustration,* or whatever people have told us about it. In fact, the genius of Cornell is that he sees and enables us to see with the eyes of childhood, before our vision got clouded by experience, when objects like a rubber ball or a pocket mirror seemed charged with meaning, and a marble rolling across a wooden floor could be as portentous as a passing comet.

Cornell has said that his first revelation of modern art came at the memorial show of paintings from the John Quinn collection, which was held at the Art Centre in New York in 1926 and included works of Picasso, Matisse, Braque and Brancusi, as well as Rousseau's "Sleeping Gypsy" and Seurat's "The Circus." His second revelation was the first New York exhibition of Surrealist art, at the Julien Levy Gallery in 1931, where he saw work by Ernst, Dali, Tchelitchew and Cartier-Bresson among others. Cornell was especially impressed by Max Ernst's collages of nineteenth-century engraved illustrations: a 1932 Cornell collage in a similar spirit is reproduced in Levy's *Surrealism,* while a 1942 number of *View* devoted to Max Ernst reproduces a series of sixteen marvelously delicate and witty Cornell collages called *Story Without a Name: For Max Ernst.*

The earliest of the works shown at the Guggenheim is an untitled collage of 1931, an engraving of a clipper ship with a giant cabbage rose nested in one of its sails: inside the rose is a spiderweb and at the center of the web lurks a spider. One might at first be tempted to dismiss this work as an overzealous homage to Ernst, but further inspection reveals fundamental dissimilarities which place it in quite another and in my opinion superior category to the collages in "Une Semaine de Bonté" or "La Femme Cent Têtes." For Cornell's collage, surreal as it is, also has extraordinary plastic qualities which compete for our attention with its "poetic" meaning. He wishes to present an enigma and at the same time is fascinated by the relationship between the parallel seams in

the ship's sails and the threads of the web, between the smoky-textured rose and the smudged look of the steel-engraved ocean. He establishes a delicately adjusted dialogue between the narrative and the visual qualities of the work in which neither is allowed to dominate. The result is a completely new kind of realism. This, I suspect, is why Cornell's work means so much to so many different kinds of artists, including some far removed from Surrealism. Each of his works is an autonomous visual experience, with its own natural laws and its climate: the thing in its thingness; revealed, not commented on; and with its ambience intact.

I don't wish to belabor Max Ernst's collages, but since they apparently started Cornell on the road to discovering his own art, it seems fair to examine further the differences between them and Cornell's own collages. In *Story Without a Name: For Max Ernst*, he appropriated, for the purposes of an homage, Ernst's collage-novel form; but in so doing he made it his own (a not unknown phenomenon—few would argue that the authorship of *Romeo and Juliet* is Arthur Brooke's because he wrote a poem called "Romeus and Juliet" which Shakespeare copied). Ernst's collage novels, clever and startling as they are, pall very quickly—after the first twenty or so pages one finds oneself skipping ahead. This may be because he tries to intervene too summarily in the spectator's attention, to capture him without a struggle. Surprises and shocks descend in an avalanche as in the tragedies of Seneca, so that one is very quickly immunized to this barrage of the erotic and the bizarre. To such an obvious desire to engage him, the reader reacts as instinctively as a wheedled child.

But the child—and ourselves—immediately becomes curious when the wheedling stops, or when an artist turns away from us into his own visions. Such is the case with *Story Without a Name*. One keeps returning to it to verify certain details, but remains tantalized: the spirit of the work flickers everywhere but stays as elusive as mercury. There is no attempt to shock the viewer (this is an idea that has probably never occurred to Cornell); on the contrary these fabulous landscapes somehow look natural, integrated, adjusted. Even at their most violent or fantastic they have, unlike Ernst's, a romantic tenderness which is all the more moving for its context: firemen are spraying a burning building out of which erupts a giant flower; the apparition of a little girl appears against a spectacular shipwreck. Violence is rare in Cornell's work (another example would be the 1956 "Sand Fountain"—a jagged goblet holding black sand, like a smashed hourglass). When it occurs it is like the violence of Mozart, whom Cornell resembles in so many ways—where a sudden shift into a minor key is as devastating as an entire Wagnerian battalion.

Much has been made of Cornell's transition from early, so-called picturesque works like the "Medici Slot Machine" to the bare, quasi-constructivist

"hotels" and "dovecotes" of the 1950s. In fact, Cornell seems to have continued to use "picturesque" materials throughout his period of presumed austerity: "Sun Box" (1956) and "Suite de la Longitude" (1957) are two examples. But it is important to note that the more complex works are far from picturesque, if by picturesqueness one means an anecdotal residue in a work of art. On the contrary, even when it seems frivolous on the surface, as in "Lobster Ballet," which is dedicated to Offenbach, or in "A Swan Lake for Tamara Toumanova," Cornell's work exists beyond questions of "literature" and "art" in a crystal world of its own making: archetypal and inexorable. Like de Chirico or the French poet and novelist Raymond Roussel, with whom he has much in common, Cornell has discovered how to neutralize romanesque content in such a way that it becomes the substance of his art rather than its embellishment: matter and manner fuse to form a new element. Thus we are allowed to keep all the stories that art seems to want to cut us off from, without giving up the inspiring asceticism of abstraction.

A glance at the work of Cornell's imitators, and there are quite a few, is enough to confirm that this higher order of his art is no mere figure of speech. This becomes even more evident when we look at artists who have been able to profit from his art, including some who may be unfamiliar with it but whose work would not exist in its present form without Cornell's example. Certainly Rauschenberg, one of the most significant influences on today's generation, looked long and deeply at Cornell's work before his show (also at the Egan Gallery) in 1954. It may seem a long way from the prim, whitewashed emptiness of Cornell's hotels to Rauschenberg's grubby urban palimpsests, but the lesson is the same in each case: the object and its nimbus of sensations, wrapped in one package, thrust at the viewer, here, now, inescapable. Largely through the medium of Rauschenberg's influence, one suspects, Cornell's work is having further repercussions today, not only on whole schools of assemblagists, but more recently in the radical simplicity of artists like Robert Morris, Donald Judd, Sol LeWitt or Ronald Bladen.

It would be idle to insist too much on the resemblance, say, between one of LeWitt's constructions and Cornell's "Multiple Cubes" (1946–48) or his "Crystal Palace" (1949)—there is physical resemblance, certainly, but it could easily be coincidental. What is not coincidental is the metaphysical similarity linking Cornell with these younger men. (The same holds true for the Abstract Expressionists: the night sky outside Cornell's hotel windows is sometimes spattered with white paint to indicate stars, but the key to the kinship between Cornell and an artist like Pollock lies elsewhere—in the understanding of a work of art as a phenomenon, a presence, of whatever sort.) Cornell's art assumes a romantic universe in which inexplicable events can and must occur. Minimal art,

notwithstanding the cartesian disclaimers of some of the artists, draws its being from this charged, romantic atmosphere, which permits an anonymous slab or cube to force us to believe in it as something inevitable. That this climate — marvelous or terrible, depending on how you react to the idea that anything can happen — can exist is largely due to Cornell. We all live in his enchanted forest.

ArtNews, Summer 1967

YVES TANGUY

"**I** BELIEVE THERE IS little to gain by exchanging opinions with other artists concerning either the ideology of art or technical methods. Very much alone in my work, I am almost jealous of it. Geography has no bearing on it, nor have the interests of the community in which I work." Thus Yves Tanguy, in a reply to a questionnaire on "the creative process" published in *Art Digest* in June 1954.

Faced with such a carefully worded caveat, one hesitates to discuss his work at all. Nor do the paintings themselves invite description or analysis. Self-created, totally autonomous, they exist in a world where time, space and light are functions of other natural laws than ours. Tanguy's landscapes, if they are landscapes, are not so much inhospitable as alien: neither vegetal nor mineral but an amalgam of both, absorbed in their own being, facing in another direction. "From the ends of the earth to the twilight of today/Nothing can

withstand my desolate images," wrote Tanguy's friend Paul Eluard in a poem titled "Yves Tanguy."

Hence one's reluctance to speak of these images, but also the necessity of doing so implied in the poet's accurate statement that they cannot be withstood. Nor is Tanguy the first artist to avoid discussions of his work, and thus by implication to seek to place it beyond the pale of language. Most artists would like to believe that their work renders criticism superfluous, since criticism is included in the act of creation. Some few, in Hazlitt's famous phrase, "defy calculation or comparison, and can be defined only by themselves. They are *sui generis*, and make the class to which they belong." Tanguy might be said to belong to this category of artists, and the remoteness of his work seems to make it even more impervious to "calculation or comparison"—even as it obliges one to pick up these tools.

Therefore one may begin by challenging Tanguy's statement that geography had no bearing on his work. It has often been pointed out that memories of childhood summers in Brittany emerged later in his paintings, just as the shoreline of the Costa Brava reappears obsessively in Dali's. In the vicinity of Locronan, where Tanguy's parents had a house, are fields strewn with prehistoric menhirs and dolmens (James Thrall Soby has pointed out their mutated presence in his catalogue essay for the Tanguy retrospective at the Museum of Modern Art in 1955), and Locronan is also near the site of the legendary sunken city of Ys, whose sea-changed architecture could have resembled the architecture in Tanguy's later paintings (such as the "steeples" in "From Pale Hands to Weary Skies" [1950]). The bizarre rock formations of the Breton coast are evoked in a little-known text called *On Silence* by de Chirico, whose work first determined Tanguy to become a painter:

O evening of Quiberon! In sublime poses of lassitude and sleep the warriors are stretched out now in final repose while over there behind the black cliffs, with their gothic apostles' profiles, a moon of boreal pallor is rising in the great silence; softly its rays light up the faces of the dead and waken reflections in the metal of their arms.

Finistère is the westernmost tip of France, the point closest to the setting sun. From a rocky promontory one looks out over the vast fields of the Atlantic with the tiny flat island of Sein a short distance offshore but separated from the mainland by notoriously treacherous currents, like the invisible flux one senses in Tanguy's spaces. (There is a 1930 photograph of Tanguy, looking happy and triumphant, aboard the small ferry that ran between Sein and the mainland.) Real geography also intruded briefly in his work after a trip to North Africa in

1930, where he was fascinated by some strange rock formations. Yet one must end by agreeing with Tanguy when he says that geography has no bearing on his work, insofar as geography implies any kind of local color. The geographical elements just noted are rather objects, extreme examples of the other-planetary look which our planet exhibits here and there—windows on a supravisible world rather than vignettes of this one.

The Duchesse de Guermantes advised Proust's narrator Marcel that the best way to view the paintings of Frans Hals in Haarlem was from the top of a moving streetcar. Tanguy's first climactic contact with painting came in 1923 in Paris while he was riding on the platform of a bus in the rue La Boëtie and glimpsed two early paintings by de Chirico in the window of Paul Guillaume's gallery. Soon after his discovery of de Chirico, Tanguy began painting, though the way had doubtless been prepared in advance; an early pencil drawing made some six years earlier when he was about seventeen has survived. One of his first paintings, "Rue de la Santé" (1925), suggests de Chirico in its exaggeratedly steep perspectives and oversize buildings. It is not incompetently done, but perhaps Tanguy's realization that he lacked the technical mastery of de Chirico drove him next into a deliberately naive style as well as toward a different kind of subject matter. One of the finest of these early pictures is "Fantômas" (1925–26), based on the series of detective novels that also intrigued the poets Apollinaire and Max Jacob. The stories recount the atrocious crimes of the archfiend Fantômas, master of a hundred disguises, always one jump ahead of his dogged police pursuers. The cover of one of the novels shows Fantômas masked and in elegant evening clothes, towering over a Lilliputian Paris at his feet. Tanguy's painting has a figure in the sky that could be that of Fantômas and next to it an outlined face that could be that of Lady Beltham, his mistress; the space below is occupied by at least one victim and perhaps some pursuers. But even in an atypical "literary" painting such as this, no very accurate reading is possible. Space and perspective are methodically distorted; it is impossible to gauge distances by the size of the figures, and there is some iconography (the cluster of eggs, the decorative panel on the left and the clownlike figure on the right) which seems not to relate to the story of Fantômas. The stage seems set for the radical transformations which will very shortly sweep it almost bare.

The paintings of 1927 still juggle recognizable objects along with purely imaginary ones in fantastic landscapes. "He Did What He Wanted" suspends in space a hexagonal pointed weight whose flat surface is ornamented with letters of the alphabet and some wavy lines; there is a figure of a man in the background and a less decipherable, rootlike shape in the foreground. As in Miró's paintings of the same period, abstraction and fanciful figuration coexist: on a background

which may be merely stippled brush-effects float objects which are sometimes real, sometimes abstract doodling, sometimes a combination of the two. Some of these are already major works, such as "A Large Painting Which Is a Landscape." Here the flat receding surface is striated with alternating light and dark bands, like the shadows of ripples on a sandy sea floor, a notion further suggested by the presence of a cloudlike school of "fish" in the sky, but contradicted by the strong lighting of the kind of pyramid on the left and by the horizon at the back. Subsequently Tanguy was to find even subtler ways of confusing the viewer's sense of perspective, of mingling earth and sky, the solid and the intangible.

A change in his work occurred in 1930 after the trip to North Africa. He produced a half-dozen pictures whose shapes suggest the fantastic rock formations in the paintings of Bosch or Patinir, and for the first and last time in his career he drew directly on the canvas before beginning to paint. (In the *Art Digest* questionnaire he stated: "The painting develops before my eyes, unfolding its surprises as it progresses. It is this which gives me the sense of complete liberty, and for this reason I am incapable of forming a plan or making a sketch beforehand.") With the abandonment of this method, so far removed from the theoretical automatism of Surrealism, Tanguy entered the final mature phase of his work, which was to develop slowly and meticulously until his death.

Henceforth, as Soby points out, Tanguy began to substitute mineral forms for the vegetal ones in his earlier paintings. Perhaps this was the result of his experience of the North African landscape, but Marcel Jean, in his *History of Surrealist Painting* (1960), suggests another, deeper reason. As the importance of the Surrealist movement in art began to be recognized, the Surrealists' work took on a new density, a new solidity. Jean says:

> The possibility of overcoming the limits usually assigned to man's aspirations became clear. . . . Thanks to an increasingly complete identification with inner reality, their work began to assume a more precise and in some ways more sculptural character (an evolution that is particularly noticeable with Tanguy), resulting from the harmony between the inner object and its representation. It could be said that the Surrealists' productions had originally been *presentative*, since they helped to create the reality they described—a still indeterminate reality shaped almost entirely from the future. Later they acquired more representative qualities, and hence specific and permanent traits, and characteristic, autonomous signs.

What had been sketched and "in the air" in the days of Dada and the early period of Surrealism began to assume, for Tanguy at any rate, the full contours,

the rich mineral colors, the strong light and cast shadows, the space that while still ambiguous is now emphatically so, as though the landscape were a real one in which the laws of perspective had been suspended. Objects of a type never encountered yet obviously *real* are strung out on an infinite plain. They have the brightness of pebbles viewed under water. They communicate with each other, exist in relation to one another, sometimes are even attached to one another by thread or other bonds, and their relationships are strangely explicit, though the protagonists themselves are of an unknown species. What is curious is that despite their disconcerting remoteness, these landscapes lack the metaphysical melancholy of de Chirico, the "paranoia" of Dali, the violence of Ernst. The feeling is one of calm exaltation. Perhaps because these objects seem to exist and to know they exist, their existence, bizarre and even macabre as it is, never threatens our idea of our own existence but seconds and supports it. Tanguy's world is hardly an inviting one, but its space seems to promise infinite possibilities. It has the limpidity of the poetry of Hölderlin or Novalis, where time has become a solid, transparent medium, no longer a vehicle of change and vicissitudes. Such is the universe of "The Geometer of Dreams" (1935), "The Great Nacre Butterfly" (1939), or "Satin Tuning-Fork" (1939): silent, luminous masterpieces produced in the 1930s as though to deny the outward darkness that deepened each year and to which Tanguy like most of his contemporaries was acutely sensitive. (As early as 1934 the rise of Fascism in Europe had caused him to try to emigrate to America with another Surrealist painter, Wolfgang Paalen, but he was unable to obtain the necessary papers.)

In 1939 Tanguy met the American painter Kay Sage in Paris; that November, having been exempted from military service due to disabilities from the last war, he joined her in New York. After a trip to the West, where Tanguy was struck by the resemblance of geological phenomena to his own paintings, they were married and shortly thereafter moved to Woodbury, Connecticut. In 1946 they bought a farmhouse there, where Tanguy lived until his death in 1955. (Sage died in 1963.)

In André Breton's *Le Surréalisme et la peinture* (1965) Tanguy is quoted as saying (in the 1940s) that he came to America to escape the war, but he speaks of the freedom he found here in plastic terms.

Here in the United States the only change I can distinguish in my work is possibly in my palette. What the cause of this intensification of color is I can't say. But I do recognize a considerable change. Perhaps it is due to the light. I also have a feeling of greater space here—more "room." But that was why I came here.

It was not only Tanguy's palette which intensified in America. Thanks no doubt to the peaceful mode of existence he enjoyed in Woodbury, the freedom from the material difficulties which had always plagued him and the distance from the war, he was able to embark on a series of paintings of ever-increasing complexity and strangeness. His colors now are "nasturtium, cock-of-the-rock, poplar leaf, rusty well-chain, cut sodium, slate, jellyfish and cinnamon," as Breton enumerated them. The forms and the substances have altered. The universe is no longer exclusively mineral; some of its tenants appear to be made of wood, paper or cloth. There are strange tissuelike folds, bones, creatures not only colored like jellyfish but of the same viscous, milky white or magenta pulp; weeping, burning to the touch like sodium, these forms have begun to prolife-rate, pullulate, assuming ever more complex, incestuous relationships. The inbred, interlocking shapes in such a painting as "My Life, White and Black" (1944) defy any attempt to describe them. It is almost as though the painter were aiming at a freedom of painting beyond the constricting qualifications of language, explicable only in its own terms. They remind one of the fantastically complicated "*machines célibataires*" described in the novels of Raymond Rou-ssel, one of the writers the Surrealists most admired (though he was not a member of their group). The title of one of Tanguy's early canvases, "Les Vues" (1929), may be an allusion to Roussel's long poem "La Vue," whose laborious cataloguing of minutiae prefigures Tanguy's spirit. Roussel's "demoiselle" in his novel *Locus Solus*—a kind of aerial pile driver capable of constructing a finely detailed mosaic of teeth—has the same almost insolent awareness of its own improbable being as the central colossus in Tanguy's "My Life, White and Black."

In the 1940s, Tanguy's forms, as they take on new bulk and density, also move closer to the spectator—too close for comfort at times, as in "Twice" (1944), which thrusts, almost into the viewer's face, a fleshy mass, draped in a sheet it has stained a deep pink. The poetry of distant horizons is often replaced by a drama, sometimes tinged with eroticism, which is taking place in the foreground; the spectator, instead of viewing the scene from a slight height as in many of the early paintings, may be placed slightly below the arena of action, as though in an orchestra pit, as, for example, in "Equivocal Colors" (1943), "Twice," and "The Provider" (1945). In these paintings the new massive biomorphic forms, daubed with traces of brilliant, chemical colors, predomi-nate. Sometimes the hallucinatory intensity of these colors seems imbued with its own specific gravity, as though it were heavier than the object of which it is a property, as in the strange "night" piece "Slowly Toward the North" (1942). On a black plain, before an ultramarine sky lit by white flares, a congress of strange object-creatures has convened. One is taller and wears as a miter of authority a

triangular shape wrapped in white paper. The smaller figure does not seem to have lost out to the taller despite being ensnared in a white wire construction that extends far into the background: it wears its rubbery dull green and red leather "head" defiantly. In the foreground is a small object consisting of an orange ball connected by a rod to a larger black-and-white-striped melon shape that recalls Kafka's Odradek, a living creature made of spools which the narrator occasionally meets in the stairway of his home and which saddens him with the thought that it will outlive him. And perhaps Tanguy was remembering here and in other paintings of the 1940s the colored fishing floats and wooden jigsaw shapes from de Chirico's metaphysical period. The swollen volumes and more fibrous, corruptible substances in some of the paintings from the 1940s are in turn questioned, dissected and parceled out in the work Tanguy did in the last five years of his life. This work culminates in his final masterpiece, the Museum of Modern Art's "Multiplication of Arcs" (1954), which Soby has called "a sort of boneyard of the world." Sometimes Tanguy's aim seems analytical, as though to break down large forms into their irregularly shaped components, as in "Fear" (1949). These irreducible elements can be pebble-shaped, notched, pierced; or they may become long and painfully attenuated thorns. At other times it looks as though the particles had drawn together to form a compact mass like a puzzle sphere. In the magnificent "From Pale Hands to Weary Skies," long splintered shapes are bound together to form a group of prickly spires like the strangely elongated ones of Coutances cathedral or (in the case of the spire on the right) like the organic architecture of Gaudí's Sagrada Familia. Equally magisterial is "The Hunted Sky" (1951), with two looming, parahuman beings made up of countless gray, osseous pebble shapes seemingly magnetized around a central core, in which papery white plaques like fragments of shells dropped by gulls are embedded. The swarming atoms of these late pictures are like the hordes of tiny soldiers in a battle painting by Altdorfer, here turned to stone or bone through some enchantment. The dusty grays from Tanguy's earlier paintings tend to veil the vibrant color of the 1940s pictures, although his rich palette and dramatic contrasts of light and dark reassert themselves in paintings like "Imaginary Numbers" and "The Saltimbanques," two major works from the last months of his life.

Sarane Alexandrian has written in *Surrealist Art* (1970) that Tanguy's titles were arbitrarily chosen and should not be looked to to explain the content of the pictures, and it is true that he often asked his friends to suggest titles; he and Breton found the title for one of his best-known early paintings, "Mama, Papa Is Wounded!", in a book of psychiatric case histories. Yet the fact that most of them are titled implies that a choice has been made, and that the purpose of this choice is to extend the range of the picture's meaning by slanting it in a certain direction:

as with Satie or Wallace Stevens, the title is a rudder. An engaging little piano piece by Satie becomes something else when it is called "Disagreeable Glimpses"; Stevens' poem "Mrs. Alfred Uruguay" changes when it is construed as a portrait. Tanguy's titles are like filters which project an oddly appropriate light on a scene that cannot be rationally deduced from them. It is the arbitrary but invincible logic of the *cadavre exquis*, the poetic game of chance which Tanguy used to participate in with his Surrealist friends in the 1920s.

This brings one to a further aspect of Tanguy's work: its surreality. It is usually a pointless exercise to discuss the work of a great artist in terms of "isms," but it may be excusable here on the grounds that the word "Surrealism," unlike "Cubism," "Expressionism" and the others that our century has produced, has been so thoroughly absorbed into our language and debased that we are no longer very sure, if we ever were, exactly what it means. Anything out of the ordinary is called "surreal." Surrealism when applied to art evokes images of drooping watches and fur-lined teacups, but what is the principle of which these are apparently manifestations? In the early days of Surrealism, great emphasis was placed by Breton and the others on automatism. Automatic writing was practiced for a while, though even the Surrealists soon tired of it, but automatism was not a viable possibility in art until much later, in the hands of artists like Jackson Pollock. In 1925 the writer Pierre Naville declared in *La Révolution Surréaliste* that Surrealist painting did not and could not exist: "Everyone knows now that there is no *Surrealist painting*. Neither pencil-marks recording chance gestures, nor images representing dream figures, nor imaginary fantasies can, of course, be so qualified."

Yet artists persisted in the attempt to produce Surrealist art. Since "automatic" art did seem to be out of the question, a trick, a procedure, had to be found to remove the artist, or at least his conscious mind, from the creative process so that the irrational could take over. Max Ernst accidentally discovered new ways of using the techniques of collage and frottage, which put the artist at one remove from the work. André Masson practiced a kind of automatic drawing and used sand as an arbitrary element in some of his paintings. Wolfgang Paalen invented the technique of fumage, in which smudges from a candle flame held close to the canvas dictated the shape of the image. And Tanguy sometimes painted his pictures upside down and reversed them for their effect. In all these instances the governing principle seems to be not so much automatism (even in the case of Masson's drawings, which look premeditated) as self-abnegation in the interests of a superior realism, one which will reflect the realities both of the spirit (rather than the individual consciousness) and of the world as perceived by it: the state in which *Je est un autre*, in Rimbaud's phrase.

This revolution is still continuing (although the term "Surrealism" has

fallen into disfavor), and "pencil marks recording chance gestures," as well as other forms of art condemned by Naville, are accepted today. And although Tanguy cannot be said to have had an important influence on the artists who succeeded him, he seems more than any other Surrealist painter to embody the spirit of Surrealism—not in the parochial 1920s sense of the term but in the second, open sense in which it can still be said to animate much of the most advanced art being done today. One reason for this is that the arbitrary distinction between abstract and figurative painting did not exist for Tanguy, who painted real if nonexistent objects, so that his work is in a sense a fusion of the two, always in the interests of a more integral realism. The automatic gestural painting of Pollock, Kline, and their contemporaries looks very different from the patient, minute, old-master technique of Tanguy, yet he was perhaps the Poussin of the same inner landscape of which Pollock was the Turner. Both pushed the concept of art a little further in their exclusive attention to what Eluard, reviewing a play by Raymond Roussel, defined as "all that has never been, which alone interests us."

Art in America, November–December 1974

II

ROMANTICS AND REALISTS

PARMIGIANINO

GIORGIO DE CHIRICO once wrote: "It must not be forgotten that a picture must always testify to a profound sensation, and that profound means strange, and that strange means little-known or completely unknown. For a work of art to be truly immortal, it must completely transcend human limitations. In this way it will approach dreams and the spirit of childhood."

If one accepts this definition of art, then one must consider Parmigianino, whose drawings are being shown with those of Correggio in the Cabinet des Dessins at the Louvre, as one of the greatest artists of all time. And even if one doesn't accept it, it is hard to remain unmoved by his craftsmanship at the service of a sense of the mystery behind physical appearances, which makes him a precursor of de Chirico himself.

Parmigianino's life was as curious as his work. Born Francesco Mazzola in

Parma, in 1503, he was brought up by two uncles who were painters and helped develop his precocious gift for painting. When he was twenty, they sent him to Rome, where he immediately won the favor of Pope Clement VII. One of the paintings he took with him was his famous self-portrait in a convex mirror, now in the Vienna Museum, of which Vasari says:

> One day he began to paint himself with the help of a convex barber's mirror. Noticing the curious distortions of the buildings and doors caused by the mirror, he conceived of the idea of reproducing it all. Accordingly he had a ball of wood made, and cutting it out to make it the same size and shape as the mirror, he set to work to copy everything that he saw there, including his own likeness, in the most natural manner imaginable.
>
> As things near the mirror appear large, while they diminish as they recede, he made a hand with wonderful realism, somewhat large as the mirror showed it. Being a handsome man, with the face of an angel rather than a man, his reflection in the ball appeared divine. He was most successful with the luster of his glass: the reflections, shadows and lights: in fact human ingenuity could go no further.

Parmigianino was forced to flee Rome when it was sacked in 1527; Vasari says that he was at work when the sack began, and continued even when German soldiers entered his house. The soldiers were so amazed at his sang-froid that they let him go on painting and finally let him escape after exacting a number of drawings and watercolors as a ransom. Eventually he returned to Parma after a long absence and was commissioned to paint a ceiling in Santa Maria della Steccata, but the work progressed so slowly that he was sued by his patrons and even imprisoned for a while. The reason for the slowness was that he had taken up alchemy, and was pouring all his strength and money into trying to find a way to solidify mercury.

He finally fled from Parma and spent his last few months in Casalmaggiore, where he died in 1540 at the age of thirty-seven. Here, according to Vasari, he remained under the spell of alchemy and

> allowed his beard to grow long and disordered, which made him look like a savage instead of a gentleman. He neglected himself and grew melancholy and eccentric. Being attacked by a malignant fever, he died after a few days' illness, thus concluding his troubles in a world which for him had always been full of worry and vexation. He desired to be laid in the church of the Servites, called La Fontana, a mile from Casalmaggiore, and was buried at his request naked, with a cypress cross on his breast.

In his paintings Parmigianino sometimes rose to heights of affectation and preciosity that are hard to take. His madonnas with their endlessly tapering necks and catlike faces make one feel slightly uncomfortable, and Vasari says that even Parmigianino did not care for one now in the Pitti Palace, which is called "Madonna with the Long Neck." But these Mannerist excesses are mostly absent from the drawings, and even when present, they are enhanced by his quicksilver technique as a draftsman.

The Louvre show includes fifty-six of his drawings from its reserves, most of them originally from French private collections. Parmigianino's drawings were highly prized by collectors in France in the seventeenth century, and in the eighteenth they had a definite influence on French art. Among the early works shown is a "Head of an Adolescent" thought to be a work related to the famous self-portrait and three beautiful sketches for decorations of a castle at Fontanellato, near Parma: a study of cherubs, another of a dog's head "with drooping ears" and another of a man seated in an armchair.

Most remarkable of all are several drawings of women, some carrying ornamental vases on their heads, which were studies for the frescoes at the Steccata church in Parma. The two numbered 86 and 87 in the catalogue are remarkable for the almost supernatural refinement of the drawing and for the bizarre distortions of the human form which look ahead to the twentieth century. When one remembers the important role distortion plays throughout his work, starting with the self-portrait in which the hand is larger than the head, it is possible to see in Parmigianino an ancestor of Picasso and other artists of today.

Twenty-eight drawings of Correggio are also shown. While one admires his equally great craftsmanship and occasional poetic eloquence, as in some of his studies for frescoes in the church of San Giovanni Evangelista in Parma, in this confrontation with Parmigianino one feels the lack of a demonic quality which often rescues the latter's work from the brink of sentimentality.

Minor artists of the Parmesan School are also represented: the extravagant Lelio Orsi by two wash drawings, one of them depicting "the Earth, watering the ground with her milk. She is surrounded by cherubs and tramples with her feet the face of a giant from which stalks of wheat spring up. Above her, the Winds. On the right, Apollo driving the chariot of the sun, accompanied by the signs of Taurus, Aries and Gemini, preceded by Flora." Other minor Parma artists shown include Michelangelo Anselmi, Bernardino Gatti, Camillo Boccaccino, Bartolommeo Schedoni, Schiavone, Bertoja, and Parmigianino's cousin Mazzol-Bedoni.

New York Herald Tribune (International Edition), October 20, 1964

FRENCH PAINTING

1820–1870

"ROMANTICS AND REALISTS: French Painting 1820–1870" at the Wildenstein Gallery in New York is the latest evidence of a reawakened interest in the artists who preceded the Impressionists. Other signs have been the large Courbet exhibition in Philadelphia a few years ago, a Géricault retrospective in Paris in 1964, and the traveling "Barbizon Revisited" show of 1962–63. Is this continuing reappraisal a consequence, as some think, of the fact that Impressionist paintings are now too costly for all but a handful of the world's museums and collectors? Or does it correspond to a deeper, more intellectual need—a yearning very much of our own time and similar to that which swept over Romantics and Realists alike in the first half of the nineteenth century? (In fact, from our present standpoint the distinctions between the two opposing factions are all but invisible: the "ugliness" which Courbet proclaimed for his subjects

and which so enraged his critics escapes us today. His embattled stags and Millet's archetypal peasants have become as Romantic as Delacroix's lions and giaours.) When one looks away from the Impressionists to their great precursors, the somber tonalities and emotional structures of the latter have a bracing effect. How curious that an art founded on theory like the Impressionists' produced works which delight the senses more than any other, while the presumably sensual Romantics painted pictures which attract the intellect as much as they do the eye. One thinks of the words of Constable, whose influence on Delacroix was so important:

> What are the most sublime productions of the pencil but selections of some of the forms of nature, and copies of a few of her evanescent effects; and this is the result, not of inspiration, but of long and patient study, under the direction of much good sense. . . . Painting is a science, and should be pursued as an inquiry into the laws of nature. Why, then, may not the landscape be considered as a branch of natural philosophy, of which pictures are but experiments?

Perhaps this "intellectual" substance was a result of a simultaneous literary and artistic revolution in France, which had run its course by the time the Impressionists appeared on the scene. Certainly literary subject matter appealed strongly to some of the painters, such as Delacroix (he had originally intended to be a writer) and Daumier (whose "Don Quixote and Sancho Panza Riding down a Hill" is in the Wildenstein show), while Géricault's "Raft of the Medusa" and Courbet's "The Studio" are not so much paintings as epic poems dealing with contemporary issues. But Romantic poetry influenced the style of Romantic painting as much as its subject matter. When Delacroix writes in his journal: "What I would need, then, in finding a subject is to open a book that can inspire me and let its mood guide me. There are those that are never ineffective. Just the same with engravings. Dante, Lamartine, Byron, Michelangelo," he is describing a new way of creating, and one which despite appearances may not be too far removed from Constable's "scientific" one. For both involve a reexamination and reworking of physical reality.

This new look at the Romantics might have interesting repercussions for artists today. If there is a single common characteristic of current trends in the arts, it is probably impatience with existing forms of expression. This is a feeling one also gets from Courbet, for instance, who has influenced modern artists as diverse as de Chirico, Balthus and Larry Rivers, and whose "modernism" lies in the provocative unvisual quality he incorporates into realistic landscapes and portraits. In the beautiful "Roe-Deer in Snow" it is as though he

continued to paint *after* he had obtained a satisfactorily realistic image. This "something else" not essential to the picture—whose signs are the crumbly, unrealistic surface of the snow, the clumsy arrangements of boulders and the insistence on the banal fork shape of the central tree—is in fact of great importance; it intrigues and excites us because we cannot tell why it seems right. One could extend the list of nonfunctional essentials to include Delacroix's extinguished colors, Daumier's impasto and the enigmatic relation Millet's figures have to space and to each other. In these details, the artists seem to be reaching toward something beyond the limits of the visual.

Among the many high points of the exhibition, which includes more than sixty paintings by Chassériau, Corot, Courbet, Daumier, Delacroix, Géricault, Millet and Rousseau, is Millet's celebrated "Man with a Hoe" (from the Collection of Mrs. Henry Potter Russell). Despite the sentimentality that may have rubbed off on it from Edwin Markham's poem, it is a masterpiece, not merely in humanistic but also in purely visual terms—for instance in the singular way the figure takes possession of the broad plains surrounding him. Another beautiful Millet, the "Starry Night" from the Toledo Museum, influenced van Gogh's much more famous version of the subject. The large choice of Delacroix includes two important historical pictures: the Toronto Museum's "Fanatics of Tangiers" and "The Capture of Weisslingen" from St. Louis—the latter never before exhibited in New York. Géricault's "The Madman" from the Springfield Museum is probably the finest of the comparatively few works by him in this country; also from Springfield is Courbet's magnificent portrait "M. Nodler the Younger." Outstanding among the Corots are "Diana and Actaeon" (Robert Lehman Collection); "Lake Como" (Mrs. Albert D. Lasker Collection) and the majestic, melancholy "Interrupted Reading" from the Chicago Art Institute. And Théodore Rousseau's "Valley of Tiffauges" from Cincinnati is, in its epic treatment of a modest landscape which would have attracted few of his contemporaries, possibly the masterpiece of this somewhat uneven painter.

ArtNews, April 1966

"THE REALIST TRADITION"

At a time of a major reevaluation of Realism by artists in this country, the Cleveland Museum of Art has mounted a revisionist show called "The Realist Tradition: French Painting and Drawing, 1830–1900." While it may not prove to be the last word on its subject, it is certainly the most complete ever put together anywhere, France included.

With it comes an encyclopedic catalogue by the show's organizer, Gabriel P. Weisberg, whose erudition seemingly has no limits. He knows that the boy in Jules Bastien-Lepage's show-stopping portrait called "The London Bootblack" probably belonged to the Shoe Black Brigade, whose original twenty-five members cleaned 101,000 pairs of shoes during the Great Exhibition of 1851. He also knows that the French horn being practiced on by a workman during a moment of leisure in Jean-Antoine Bail's 1880 painting "A Member of the Brass

Band" was an instrument that had become popular only since the 1870s, augmenting the traditional flute and bagpipe.

If all this sounds like pedantic icing on a cake of questionable freshness, be assured that it isn't. Weisberg's trivia function more like accumulations of detail in Proust, thrusting one forward on a voyage of discovery that has the breadth of an epic novel. Pictures and text together should change attitudes about "the stupid nineteenth century," as Balzac called it, even among skeptics inclined to lump all recent surveys of forgotten nineteenth-century art under the heading of kitsch.

One reason a large-scale survey of this complex and ill-understood field has never been attempted is that so much of the work has simply disappeared. Often it was bought by collectors of modest means, of whose collections no records exist; much of it remained in the painters' families and was handed down to descendants. Works bought by the state from the annual salons were distributed to provincial museums and government offices and wound up in limbo. The technical difficulties of doing research in France and the endemic xenophobia of French museum officials and bureaucrats make the sleuthing done by Weisberg and his wife, Yvonne, all the more impressive. In one instance, after tracking down a major work by Jean-François Raffaelli to the town hall of Le Quesnoy, where it had languished for decades, they had difficulty persuading village officials, who had never heard of Cleveland, to lend it.

The Realist movement arose gradually in the democratic climate following the July Revolution of 1830, formulated by artists and theoretical critics working together. One of the first of the latter was Gabriel Laviron, who called for an art dealing with everyday life, available to everybody, as an antidote to the historical and mythological dramas of Neoclassicism and the vapors of Romanticism. Artists should record their immediate environment, and not in a mechanical way but with concentrated feeling; moreover, it was their duty to help build a national art by attending to regional differences of landscape, dress, customs and so on. Later critics such as Théophile Thoré and Champfleury urged study of great Realists of the past in whom painterly and human concerns were intermingled: Rembrandt, Caravaggio, Velázquez, Goya and the rediscovered Le Nain brothers. The results can be seen in paintings by first-generation Realists like Théodule Ribot and François Bonvin, where figures and humble household objects loom out of interiors steeped in a rich seventeenth-century chiaroscuro.

As it progressed, Realism cut across schools to affect artists of very different persuasions. In Cleveland, paintings of the great Realists Courbet, Daumier and Millet hang next to works by dry academicians like Meissonier on

the one hand and by Impressionists like Pissarro on the other. For Realism is a state of mind, and an Impressionist boulevard scene evoking the vivid sights and sounds of a moment can be considered as Realist as the pious genre scenes of Alphonse Legros, or Pierre-Edouard Frère's anecdotes of playful children.

In the 1860s the term Naturalism, first applied to art by the critic Castagnary, began to supplant that of Realism, and Realist art began to change as well. Earlier, figures and still-life objects were frequently viewed from close up or isolated in a studio environment. By 1860, partly due to the influence of Impressionism and also of photography, there was a tendency to restore figures to their social or natural environment. Legros, perhaps feeling the need to integrate the kneeling figures in his "The Ex-Voto" with nature, painted out the background of a room with a deathbed and substituted a roadside shrine. Bastien-Lepage's bootblack, though pushed close to the viewer as if soliciting a shoeshine, is still situated in the tumult of a London street.

And the humanitarian concerns that had always been a part of Realism became more explicit. Earlier, they were often merely documentary: François Bonhomme was commissioned by industrialists to record the activity of mines and factories, and though he did so literally, there is no implied social criticism. Jules Breton's "Fire in a Haystack," on the other hand, registers sympathy with peasants trying to save their source of livelihood from encroaching flames. And later, the message becomes sharper, as in Jules Adler's "An Atelier for the Cutting of False Diamonds at Pré-Saint-Gervais," which, despite its light tonalities and quasi-Impressionist handling, powerfully projects the brutal monotony forced on women factory workers.

Again and again one is struck by the quality of the little-known or unknown artists whom Weisberg has resurrected. One new to me was Victor-Gabriel Gilbert, whose painting of meat haulers in a slaughterhouse has a Rubenslike monumentality and richness of tone that transform a scene of drudgery into high baroque drama. Another considerable artist whose name has been little more than a footnote is Norbert Goeneutte, a friend of Renoir and Degas. His starkly beautiful "Boulevard de Clichy Under Snow" indicates that he, like Degas, was attracted by the piquant asymmetry of Japanese *ukiyo-e* prints.

Perhaps the most precious of Weisberg's discoveries is Léon Bonvin, a little-known half-brother of François, who is given a separate exhibition of drawings and watercolors at the museum. His biography reads like a plot that Zola or the Goncourt brothers would have rejected as too grim to be plausible: he ended his impoverished and unhappy life at thirty-two by hanging himself from a tree the day after a Paris dealer refused to handle his work because it was "too dark, not gay enough."

Yet this handful of small works reveals him as one of the most remarkable

French artists of the pre-Impressionist period. Mostly kitchen still lifes of vegetables and utensils, or studies of shrubs and flowers seen through the mists of early morning or twilight, they have a finesse that few artists have ever achieved in watercolor.

Writing after Bonvin's death, the critic Philippe Burty noted that "those who have tried with sincerity to paint flowers in the open air have felt how difficult it is to combine accessories with them; either their brilliancy must be subordinated to the landscape, or the landscape must be sacrificed." Bonvin sacrificed neither, and the result is glimpses of a fabulous though ordinary world through the glass of an enchanted Easter egg: magic realism in the true sense of the term. These sparkling miniatures more than hold their own with the 250 others, many colossal in size, that constitute the main event in Cleveland's show.

Newsweek, November 17, 1980

DELACROIX'S DRAWINGS

THE DELACROIX EXHIBITION in honor of the centennial of his death in 1865 surpasses in its scale anything seen in Paris in recent years. The acres and acres of Delacroix canvases in the Grande Galerie of the Louvre are only a part of it. Even more remarkable in some ways, because it reveals a Delacroix few of us know, is the show of his drawings and watercolors at the Louvre's Cabinet des Dessins.

The Bibliothèque Nationale is showing his lithographs in an exhibition of graphic art of the Romantic period. The Bordeaux Museum has a Delacroix show. Delacroix's studio in the Place de Fürstenberg is open, and his ceilings in the Palais-Bourbon and the Palais du Luxembourg will again be visible in August. It is almost as though Malraux's Beaux-Arts Ministry had set out to apply General de Gaulle's *politique de la grandeur* to the arts.

Of course, Delacroix's work lends itself to this super-colossal treatment. He would certainly have approved vehemently the idea of grouping his *envois* to the annual salons in a single vast room, together with the smaller versions which preceded and sometimes succeeded them. And there is no doubt that he fills the seven-league boots Malraux has shined up for him.

Yet there are moments when one feels something like fatigue creeping over one at the sight of yet another of Delacroix's gigantic historical "machines" with a cast of thousands. It is a little like listening to a whole evening of Berlioz or reading all of *Childe Harold* at one sitting. You find yourself wondering what a show of Delacroix's great rival, Ingres, would be like, and even feeling a little impatient for 1967, when Ingres' centenary will no doubt be celebrated in similar style.

Fortunately, not all of Delacroix is in CinemaScope. Amid such spectaculars as "The Assassination of the Bishop of Liège" and "The Battle of Taillebourg won by Saint Louis," one comes upon quiet, intimate works of great beauty, such as the portraits of his friends Baron Schwiter and Frédéric Villot (from London's National Gallery and the Prague Museum, respectively), landscapes like the "Cliffs of Etretat," or his religious paintings (Baudelaire once called him "the one truly religious painter in our unbelieving century"). And of course among the large historical works there are some which convey a poignant sense of personal involvement, such as "The Massacre at Scio" and "The Death of Sardanapalus."

Best of all, perhaps, are the paintings inspired by Delacroix's trip to North Africa in 1832, like the "Women of Algiers" and the "Jewish Wedding in Morocco." This trip transformed Delacroix's life and his work. "The men and women of that race continue to haunt my imagination," he wrote. "In them and in their country I discovered the beauty of the ancients."

Henceforth a note of languorous melancholy can often be sensed in his work. Baudelaire said of the "Women of Algiers" that it "exhales an indefinable, pervasive perfume of a place of ill repute, which guides us rapidly to the unplumbed limbos of sorrow." Some of the sketches from the North African trip are included in the Cabinet des Dessins show. (After considerable difficulty he had managed to gain admittance to a harem, and the "Women of Algiers" is based on sketches he did there.) These are among the finest things Delacroix ever did, but the whole show of drawings sparkles with genius. It is interesting to note a drawing of a nude in the same pose as Ingres' "Grande Odalisque." Here Delacroix duplicates, intentionally perhaps, Ingres' virtuosity with the pencil, and at the same time gives the drawing a subtly romantic cast.

French graphic art of the romantic period is uncharted territory for most of us. Jean Adhémar, curator at the Bibliothèque Nationale, explains why in his

preface to the exhibition there. Engraving in early-nineteenth-century France was looked upon chiefly as a means of reproducing paintings. As for engravings as independent works of art, Dumas' opinion that "they blacken walls rather than adorn them" voiced the reaction of the general public. Engravings, on the rare occasions when they were shown in the annual salons, were usually hidden away in some dark corridor. As a result, few copies were made, and today they are impossible to find, although after Gustave Doré's rise to popularity some years later, some new prints were made from plates of the previous generation.

This show centers around Delacroix but includes many other artists as well. Of especial interest are Delacroix's weird and dramatic lithographs for Goethe's *Faust* which Goethe himself said surpassed his own mental image of the scenes he had described.

Delacroix also illustrated *Hamlet* and *Macbeth*, and Chassériau, whose devotion to Delacroix was balanced by admiration for Ingres' classic purity of line, is represented by some extraordinary illustrations for *Othello*. There are three pieces by the third great romantic painter, Géricault, including his "Boxers," the forerunner of all romantic engravings, according to Adhémar.

There are fascinating examples too from a host of minor artists, such as Nanteuil, the Johannot brothers, Paul Huet, Devéria and Louis Boulanger. The gothic spirit triumphs in these scenes of storm-swept heaths, midnight trysts, fantastic medieval cities and skeletons in armor galloping away with a beautiful young girl slung over the saddle. This is an unusual and attractive show, which gives the full flavor of the Romantic period.

New York Herald Tribune (International Edition), July 3, 1963

CONSTANTIN GUYS

In this Delacroix year the Galerie Motte in Paris is showing the work of Constantin Guys, a painter who, like Delacroix, had the advantage of being praised by Baudelaire. It is in fact difficult to think of Guys in any context but that of Baudelaire's essay "The Painter of Modern Life," one of the most famous pieces of art criticism ever written.

Guys lived at a time when the newly invented camera was beginning to make painters question the basic aims of painting—a process which was soon to result in Impressionism. Guys was intimately involved in this pictorial revolution, since he worked as a journalist for the *Illustrated London News* during the Crimean War, sending back sketches from the front which were used as illustrations.

Later on it was the spectacle of life in the streets of Paris that attracted his

candid-camera eye, just as it attracts Brassaï and Cartier-Bresson today. "The crowd," Baudelaire wrote, "is his element. . . . He admires the eternal beauty and the amazing harmony of life in the world's capitals, a life so providentially maintained in the tumult of human liberty." But Guys was more than a mere journalist of the arts, and Baudelaire defines it in a famous passage: "He is looking for something which we may call *modernity*, for there is no better word to express the idea. For him it is a question of isolating what fashion contains of poetry, history, of deducing the eternal from the transitory. In order for modernity to be worthy of becoming antiquity, the mysterious beauty which human life has involuntarily put there must be extracted."

The show at the Galerie Motte includes a typical selection of Guys' favorite street types—cavalry officers and *amazones*, carriages in the Bois de Boulogne, seminarians in Rome and especially *lorettes*, ladies of easy virtue so called because they favored the neighborhood near Notre-Dame-de-Lorette. One of his Crimean battle sketches, labeled in English "Myself at the Battle of Inkermann," is also shown. They are done in a deft but self-effacing style, with little color except gray, brown or blue, as though to focus all our interest on the fleeting contours of the subject. Little by little the eye is drawn by this style which is the absence of style. If it at first seems anonymous and neutral, it is perhaps because, as Baudelaire said of Guys, "the observer is a prince who enjoys traveling everywhere incognito."

New York Herald Tribune (International Edition), July 30, 1963

CHARDIN

Large-scale retrospective exhibitions of great artists of the past are a rarity in these days of soaring auction prices and insurance rates. So the Chardin exhibition at the Boston Museum of Fine Arts, which would be a notable event in any decade, takes on added prestige as a late survivor of a vanishing species. In fact this show is a considerably reduced version of one which opened earlier in 1979 at the Grand Palais in Paris, in commemoration of the two-hundredth anniversary of the painter's death. That one contained 142 works; the American one, which was seen earlier at the Cleveland Museum, has ninety. Nevertheless, this is one of those occasions *qui valent le déplacement*, as Michelin says, and unless you are some sort of curmudgeon you will probably enjoy displacing yourself to Boston before the show closes.

It would be hard to name an artist with more universal appeal than

Chardin, and this seems to have been the case almost from the start of his career. He was twenty-eight when he exhibited his painting "The Ray-Fish" at an outdoor fair and as a result was shortly thereafter admitted to the Royal Academy (albeit as a painter of still lifes—the humblest form of painting, according to the prevailing "hierarchy of genres"). Soon he was being collected by everybody, from crowned heads to his fellow artists (though he never reaped much in the way of financial rewards from his popularity). As early as 1748, an article in the *Mercure de France* complained that his works were being snapped up by foreigners and spirited out of the country.

What was his secret? Innumerable artists have tried to be timelessly simple without succeeding in becoming Chardin. The French poet Francis Ponge is close to it in his essay on the painter, quoted in the exhibition catalogue:

> I believe that more and more recognition will be given to those artists who, simply by their silence and by abstaining from the themes imposed by the ideology of their period, have kept in touch with the nonartists of their time, for at bottom, they lived in better agreement with the temper of their time. . . . If one takes the down-to-earth as point of departure and neither makes nor wastes any effort in trying to rise to an exalted or splendid level, every effort, every contribution of the artistic genius goes into transfiguring the manner of execution, changing the language, and helping the spirit to take a new step, thus constituting magnificent progress.

Closet yourself at home, painting the pots and pans you know from daily experience, and the world will come knocking at your door.

Since we know Chardin from chance encounters in the world's great museums, the opportunity to trace his evolution as an artist is a major pleasure of this exhibition. This is true of any retrospective, of course, but especially so with Chardin, whose work *seems* to develop so little and also presents unusual problems of dating. For one thing, he had the vexing (to art historians) habit of exhibiting both old and new works at the annual Salons. He also liked to work in pairs or series, repainting a work with only minor variations, sometimes at the behest of collectors but often for reasons that remain unclear.

Still, the curators (William S. Talbot of the Cleveland Museum, John Walsh, Jr., of the Boston Museum, and Pierre Rosenberg of the Louvre) have put together a convincing chronology, beginning with an atypical figure painting called "The Game of Billiards," which they believe must be attributed to Chardin; through some rather awkward and pompous still lifes of game and the

formal complications of the early "Ray-Fish"; to the exquisite still lifes of kitchen utensils which for many are the quintessence of his art.

In mid-career, still chafing under the label of "still-life painter" and apparently concerned lest the public weary of partridges and plums, Chardin embarked on the series of great genre scenes which are engraved in everyone's mind's eye: "The Governess," "Soap Bubbles," "Saying Grace," "The House of Cards." Although the attitudes and the handling of flesh are sometimes unconvincing, it is perhaps just for this reason that Chardin's figures—always motionless, caught in a moment of concentration or fatigue—have the air of existing outside of time, in some parallel bourgeois universe.

In his magical late still lifes, Chardin's almost pointillist technique of distributing tones in adjacent facets becomes fluid and vaporous. The glass of water in "Basket of Wild Strawberries" seems to have been breathed onto the canvas; the cone-shaped pile of strawberries is like a heap of embers. Such stunning alchemy leaves the critic with little to say; nevertheless, Diderot managed to sum up what there is to say in this critique of the Salon of 1765: "Welcome back, great magician, with your mute compositions! The light of the sun never has better redeemed the incongruity of the creatures on which it shines."

New York, November 12, 1979

FANTIN-LATOUR

Almost every provincial museum in the Western world seems to own a painting by the French artist Henri Fantin-Latour. Usually it's one of the still lifes of flowers that he churned out with amazing fecundity and, ironically, came to loathe doing. Sometimes it's a stiff society portrait, a genre he detested even more. So we feel we know him somewhat. Isn't he located somewhere on the fringes of Impressionism—far more conservative than his friend Manet yet somewhat to the left of reputable academic painters like Tissot and Carolus-Duran?

Well, yes. But he emerges in the large-scale retrospective at San Francisco's Palace of the Legion of Honor museum (the first major one since 1906) as a far more complicated figure—both as man and as artist—than anyone

suspected: by no means the footnote he had become in the decades since his death, though not quite an artist of the first rank either.

Fantin was born in Grenoble in 1836 to a Russian mother and a father who was a minor portrait painter; some critics have seen a hint of the son's Slavic heritage in his early, brooding self-portraits. There was also mental illness in the family; his sister Nathalie was confined to a mental hospital in 1859 soon after posing for a memorable double portrait with their sister Marie, and spent the rest of her long life there. In the portrait she stares vacantly away from her embroidery frame while Marie reads a book. The psychological isolation of the figures was to remain a curious constant in Fantin's group portraits; later on, a critic would chide him for failing to "envelop" his figures in "a common atmosphere."

Fantin probably was haunted by fears of being overtaken by his sister's illness. In any case his was a contradictory, tormented personality; shy but arrogant, infected with the then fashionable French mania for *la gloire*, but motivated even more by unswerving dedication to truth in art—*la vérité*. It was by design that he included a plaster statue of Minerva, symbolic of truth, in the portrait of Manet and other artists called "An Atelier in the Batignolles."

Still, exactly what Fantin meant by "truth" isn't clear. He considered himself a Realist, but the emotive Realism of Courbet displeased him, as did the mechanical Realism of the official salons. The truth sought by the Impressionists was not for him either. He deplored that phase in Renoir and Monet and disapproved of the broad handling in late Manet. He felt betrayed by Whistler's increasing modernism after an early friendship during which they formed a "Society of Three" with the painter Alphonse Legros, from whom Fantin was eventually estranged.

"The truth" seems to have been a question of paying the closest possible attention to physical appearances while endeavoring to express their "soul" as well, which amounts to "Realism adulterated with Romanticism" in the words of Charles Moffett, curator of paintings at the San Francisco museum. Yet his portraits are notably inexpressive. He indulged pale Romantic fancies in a large category of pictures known as his "imaginative works": veiled, intricately brushed vignettes often based on musical subjects, especially Wagner operas. (A passionate Wagnerian, Fantin postponed his wedding in order to attend performances of the *Ring* cycle at Bayreuth.)

These usually soppy works are by far the least rewarding in his *oeuvre* and almost end up compromising what is fine in the show. Fortunately, the third category in which he worked, still life, saves the day. Though he complained at having to turn out flower paintings for the English market, his art found its highest expression in them. In the best, his version of the truth shines through

resplendently: what he learned from the old masters in attempting to track it to its lair is at last evident. Fantin was an obsessive copier of certain paintings in the Louvre. He returned again and again to Veronese; one of five large copies he made of the "Wedding Feast at Cana" is in the show, and not only is it a faithful reproduction but it has an additional feathery chromaticism that demonstrates his own mastery of color as a tool of expressiveness. He learned also from Chardin and from Delacroix, whom he considered the greatest nineteenth-century painter and whose Romanticism, firmly grounded in Renaissance principles, coincided exactly with Fantin's ideals.

The tremulous, exhilarating atmosphere of Delacroix's rare studies of flowers recurs in Fantin's floral pieces. So does the richly saturated pigment of Chardin's still lifes, which were rediscovered while Fantin was a young man. "White Rockets and Fruit" and "The Betrothal Still Life" (an engagement present to his wife) in fact rival Chardin: a basket of apricots in the former picture appears to be made of the same magic substance that Proust found in a patch of yellow wall in Vermeer's "View of Delft."

Fantin produced potboiler still lifes as well, but the show mostly avoids them. The portraits are more of a problem. Those done on commission are frequently both elegant and wooden; his distaste for the work shows through. Of the four large group portraits intended partly as aesthetic manifestoes, only the Batignolles picture, whose cast of characters includes Monet, Renoir, Bazille, Zola and Manet, is in the retrospective at San Francisco. Its cool detachment and the seeming lack of communication among the figures are finally off-putting; one would think twice before mingling with these solemn young firebrands in their bourgeois frock coats.

There remain the self-portraits—the most spontaneous pictures he did— and the portraits of friends and family, in which his strikingly beautiful sister-in-law Charlotte Dubourg plays such a prominent role that the curators hint at possible hanky-panky. Given Fantin's austere, buttoned-up character this seems unlikely, however. The only love evident in his paintings is for ephemera like fruit and flowers, tantalizing emblems of a better life not to be found on earth. But in them, love truly sings.

Newsweek, July 18, 1983

VUILLARD

THE LARGE SHOW of paintings by Vuillard at the Galerie Durand-Ruel is probably the most important exhibition of this year in Paris.

The stuffy French bourgeois atmosphere of Paris in the early 1900s has been anathema to many writers and artists born around that time. Simone de Beauvoir in her *Memoirs of a Dutiful Daughter* mentions the sinking feeling she had as a child when the late-afternoon shadows began to deepen around the heavy furniture of the family apartment in the Boulevard Raspail. And Michel Leiris, writing of his childhood in Auteuil, suggests the strange feeling of nausea that the sight of ordinary middle-class furnishings and the sound of everyday conversation gave him as a very young child. The "antibourgeois" feeling in France is as deep-rooted as the traditions of the French bourgeoisie itself.

For others, such as Proust and Vuillard, the dull conventions and cere-monies of middle-class existence served as a springboard to a kind of universal vision. Proust, evoking his childhood through the taste of a madeleine dipped in a cup of tea, formed a philosophy of life. Because he loved to observe closely, even the hypocrisy and snobbery of Parisian society had a kind of exhilarating effect on him. A world that others found narrow and materialistic took on for him an Arabian Nights glamour because he was able to see beyond it into infinity. This is also true of Vuillard, who has dramatized the humdrum atmosphere of daily life in Paris in the 1900s in much the same way. The moments that he captured so well are precisely the moments that go to make up a lifetime, and it is for this reason that his paintings seem charged with profundity.

Like Proust, Vuillard adored his mother, and it is perhaps the wish to immortalize her that is behind his work. There are many portraits of Mme. Vuillard in the present show, and many works that suggest a kind of mother's world of darning, sewing, dishwashing, chats with callers, afternoons in the park.

The interest of this subject matter depends, of course, on the technique by which it is served, and it is here that Vuillard's real importance lies. Without straying beyond the comfortable frontiers of dining room or garden, Vuillard goes very far indeed in his handling of paint. Brilliant irregular dabs of color form a Persian carpet that rushes toward the viewer in one painting, while in the background two figures, barely visible, dissolve into mist. Another shows a vaporous interior in which, for some reason, only a black picture frame has any solidity.

By giving preeminence to a carpet or picture frame rather than to the people who inhabit the room, Vuillard seems to be trying to call into question our conventional notions of what is important or unimportant, in life and in painting. So he, too, like Proust, escapes beyond the patterned wallpaper of bourgeois life into a world of the ideal.

Though no details are given in the catalogue, the Durand-Ruel show is apparently one of the largest Vuillard has ever received, except for the retro-spective at the Museum of Modern Art in New York seven or eight years ago. The latter was an unforgettable experience, and probably opened the eyes of the American public to the true stature of Vuillard. But the present show includes seventy paintings, almost none of which were then shown in New York, and which still rank among his finest work. Many come from the collections of Vuillard's friends and have not been shown before.

New York Herald Tribune (International Edition), September 6, 1961

BONNARD

"DRAW YOUR PLEASURE—paint your pleasure—express your pleasure strongly," Pierre Bonnard counseled himself in one of the pocket diaries he used for jotting down thoughts on art, notes about the weather and fragmentary sketches. A later entry reads: "The minute one says one is happy, one isn't anymore."

These two remarks could be taken as the two poles between which stretches the gorgeous but difficult art of Bonnard, whose late paintings are being shown at the recently renovated and reopened Phillips Collection in Washington, D.C. They also help to explain the condescension with which his work has been received ever since the arrival of Cubism early in this century. Pleasure—undiluted essence of pleasure—is a suspect commodity in modern art. To be acceptable it must seem to be at the service of a rigorous set of

principles, as in the case of Matisse—though there are those who consider even Matisse too much of a hedonist. Further complicating the issue is the fact that Bonnard's pleasure is really something else: to name it would be to see it vanish. One must not be misled by the floods of orange, mauve and mango-colored light. The joy is there, certainly, but it remains potential, modulated by something dark and serious.

This is the first show to focus exclusively on Bonnard's late paintings, though in his case "late" is a broad term, covering the years from about 1900 to his death in 1947. The memorable Bonnard show at the Museum of Modern Art in 1948 undeniably inflected the course of American painting: one can see its traces in the work of artists such as Larry Rivers and Mark Rothko, while one critic finds a "Bonnard effect" in recent work by David Hockney and Avigdor Arikha. Duncan Phillips, who acquired sixteen Bonnards for the Phillips Collection, considered him "the link between Impressionism and Expressionism." If that is true, examining the nature of that link could help to mediate among the pluralistic tendencies of art at the moment, among which Expressionism and painterly Realism stand out.

Bonnard was born in 1867 to an eminent family in the Paris suburb of Fontenay-aux-Roses. At the insistence of his father, a government official, he prepared for a law career while at the same time attending art classes at the Académie Julien. In 1888 he banded together with painter friends Paul Sérusier, Maurice Denis and others in a group called Les Nabis (the Prophets) in order to spread the ideas of Sérusier's teacher Gauguin. The strong silhouettes and subjective colors of Gauguin, as well as the flat perspectives and unexpected croppings found in Japanese *ukiyo-e* prints, were reflected in the work of Bonnard's Nabi period. At that time he had his first commercial success, a striking poster for the vintners France-Champagne. For it Bonnard was paid the sum of 100 francs, so delighting his father that he broke into a dance in the garden—and presumably made no further objections to his son's vocation.

During the 1890s, Bonnard worked in the theater (he and Sérusier did sets for the first production of Alfred Jarry's *Ubu Roi*) and collaborated on the influential *Revue Blanche*; some of his lithographs of that period have gained icon status. None of the Nabi works appears in the present show, which is too bad since a bit of it would have added spice to the sweetness that was to come. A few pictures from as early as 1900 (the enigmatic, Munch-like "Man and Woman," depicting a nude couple separated by a screen that divides the canvas vertically) are included, but the show really begins with the magnificent "Dining Room in the Country" of 1913, a turning point in Bonnard's *oeuvre*. It announces much of what is to come: the strong rectilinear divisions of the door and

window frames pitted against the seething exuberance of nature inside and out; the blue-mauve, vermilion and yellow-green palette; the casual cameo appearances of the artist's wife, Marthe, and two small cats in peripheral positions.

It was a crucial time of life for Bonnard. He was forty-six, no longer a young hothead, but instead "the bearer of the taint of Post-Impressionism and degeneracy," as a contemporary writer put it. "The public was prepared to welcome Cubism and Surrealism before we had reached the goal we had set ourselves," Bonnard recalled later. "Thus we were, so to speak, left in the lurch." Perhaps the very absence of color and preeminence of structure in Cubism made him realize that "color had turned my head. . . . Clearly it's line I need to study."

The architectural grid that acts as a foil to ripe vagaries of landscape, foliage and flesh in "Dining Room in the Country" is one of several devices that Bonnard used continuously from then on. Similarly, in "Le Jardin Sauvage" of 1918, the diagonals of a porch railing, the checked pattern of a tablecloth and the oblong cylindrical shapes of a window box and flowerpots are marshaled in the foreground against a sumptuous tangle of trees and—almost incidentally—the figures of a man and a woman who seem to be tending the garden. The sharp modeling of the railing against the blur of trees fails to keep them at bay and in effect brings them closer, almost up to the surface of the picture.

Another perspective-fracturing device is the mirror, which occurs naturally in the bathrooms and boudoirs where the hygienically obsessed Mme. Bonnard seems to have spent a good part of her days. The bathroom offered still further opportunities for flattened space and improvisational color in the form of tiles, whose angles melt into humid iridescence; in the refracting surface of the water; in the emphatic outline of the tub; and finally in the flesh of the nude, streaked and mottled like a sunset, whose eroticism is all the more powerful for being sublimated. These strange and beautiful paintings form in Bonnard's work a series as obsessive as Monet's haystacks or cathedral facades, and as rich in implications for art that was to come.

Throughout the 1920s and 1930s, Bonnard would remain, in the words of the French critic André Fermigier, the "best behaved and most innocently Epicurean of Impressionism's successors, last poet of bourgeois sensibility." This may have been just as well, since it provided him with a "cover" for ever more daring experimentation. He is close to Abstract Expressionism in a picture like "The Garden" (1936), inspired by the garden at his house in Le Cannet on the French Riviera. The perspective lines of a path and a hedge are now all but vertical and wobbling violently, resulting in a mass of sopping color that comes and goes like a mirage—what would now be described as "all-over" painting. In "The Studio and Mimosa, Le Cannet" the flaming wall of mimosa

advances on the fragile window mullions like Birnam Wood marching on Dunsinane; barely visible in the lower left-hand corner is the ectoplasmic face of a woman, a negligible presence next to the cataract of light from outside.

It was customary for Bonnard to push his figures into the margins of the picture, to leave a vacancy at the center. He was trying, he said, "to show what one sees when one enters a room all of a sudden," and the eye has an annoying way of zeroing in on unimportant details and ignoring the business of the day. So, too, does the mind, and in fact Bonnard was attempting to get beyond the Impressionists' fidelity to mere appearances (*la petite sensation*) and to replicate the way phenomena appear to the mind's eye as well. The paintings do not so much reflect reality as the way reality appears to the memory—an enterprise which has often been likened to that of Proust.

Jean Clair's remarkable catalogue essay enumerates, perhaps a bit too scientifically for an artist who consistently denied the presence of any theory in his work, such self-effacing technical innovations as Bonnard's habit of frustrating visual expectations by placing blue and violet in the foreground and zones of bright yellow and red in what should logically be the hazy distance. In this already disorienting context, shapes dissolve and outlines swoon. "A way had to be found of capturing [the subject's] dying flame and, as it were, of painting its slow burning up," says Clair. "In other words, of taking the elimination of the subject and using it as the subject of his own art and as the source of a new bewilderment"—a process which continues today.

"Many little lies to create a great truth," Bonnard wrote in another journal entry. And indeed it will be necessary for the artist to lie, cheat and steal at every moment in order to keep a firm grasp on the life of the picture, because life itself is protean and slippery. Only after the struggle has ended in a draw can he step back from the canvas and watch the lies fall into place and the emergence of a truth that is more lifelike for having been wrestled so ignobly onto its surface. Paradoxically, this apparent dishonesty is the only honesty that matters in art, and Bonnard's confrontation of it still looks exemplary.

JEAN HÉLION PAINTS A PICTURE

JEAN HÉLION LIVES and paints in a large, irregularly shaped penthouse apartment near the Jardin du Luxembourg in Paris. You take a somewhat rusty elevator to the fifth floor and walk up two more flights and then up some blue wooden steps, where you press what seems to be a doorbell but which actually operates a mechanism that pops the door open in front of you. It serves the purpose of a doorbell, though, since Hélion, who is invariably at work behind the enormous studio window, looks up to see the visitor emerging onto the roof and comes out to greet him and watch him look at the view, which is superb. It includes St. Sulpice and Sacré-Coeur sandwiched together in the distance, and in the foreground the backs of the buildings on the Boulevard St. Michel—a welter of curving metal roofs, skylights and walls of that sandy-colored stone used in France in places where it is not supposed to be seen. "It's like the sea,"

Hélion says of the ensemble, which is one of the things he likes most to paint. "Roofs" are a category of painting for him, like landscapes or portraits. "They're the most difficult thing of all, because they've already been designed by the architects," he says. "I'd like to be able to look at them as though they were mountains and craters."

At fifty-five, Hélion is a stocky, energetic man with a small, set mouth, light blue eyes and a shock of gray hair. Born in Normandy, he began painting abstractly in Paris in the late 1920s and in the 1930s emigrated to America, where he is perhaps best known for the kind of painting he did then—abstractions employing clear, monumental, rounded forms and quiet metallic tones, which give an impression of tranquillity and unclamorous strength. He served with the French army during the war and was taken prisoner by the Germans. Since 1946 he has lived in France, and it is hard to imagine him working anywhere else—the cold, spare Paris studio light is as important in the paintings he does today as it is in those of Chardin or David. After the war he turned from abstraction to a style no doubt influenced in part by Léger and by Surrealism, in which the same objects and situations kept recurring: newspapers, cigars, hats, tailor's dummies eyeing wooden-looking men; the strong, cheerful colors (usually blue and orange) contrasted with the ominous mood of the scene. His last show in New York dates from this period: one of the most striking of the pictures in it showed three seated nude women staring glumly at a fully clothed man lying on the floor in front of them.

Hélion began to dispense with storytelling and abstract color as he moved toward a kind of figurative painting new to him, which culminated around 1953 in a series of large, fanatically realistic still lifes that disconcerted quite a few of his old admirers, but have strength and a kind of awe-inspiring quality that stems from their tightness. In the last five years he has developed this style in the way one might have hoped—toward a freedom new in his work. He has kept the objectivity of his abstract period and some of the "magic" of his realism and uses both in a new and looser realistic style, painting over and over again the things he loves: friends, roofs, landscapes, the sea around Belle-Isle-en-Mer off the Brittany coast where he spends every summer. In spite of his austerely limited palette—mostly blues and browns, sometimes replaced by a cool green-yellow-brown gamut in the landscapes—color in his paintings is rich and rings true, suggesting the work of some of the painters of the past whom he considers to have been great colorists: Hals, Velázquez, Poussin, Chardin, Manet, Cézanne.

His "conversion" from abstract to figurative painting has perhaps resulted in his being better known in France than he had been previously. Critics who dislike modern art were delighted to welcome him from behind the iron curtain

of abstraction. Unaware perhaps of the peaceful coexistence between abstraction and realism practiced in New York, many were thunderstruck by the change, seeing in it a sort of medieval struggle between opposing forces of light and darkness. Thus one critic recently wrote that Hélion in "liberating" himself from abstraction had "made the gesture of freedom, flung a torch into the abyss." And of course modernist critics disapproved, though some of them made the discovery that, in spite of the presence of a subject, the paint was handled with a freedom that suggests Abstract Expressionism.

All this fuss has obscured the fact that Hélion has always been a fine painter, that his work has developed steadily, that the switch from abstraction to realism has been incidental in this development. Hélion himself does not seem to attach much importance to the two categories. He wrote in the journal he kept while this article was being written: "I wonder if the gulf which separates my painting from what is generally considered contemporary won't soon appear to have been an illusion. And whether all the valid painting being done today doesn't bear certain resemblances which escape us at the present time."

When Hélion was approached about this article he was about to start a portrait of his friend Jean-Pierre Burgart, a young poet with the healthy, happy look that many French intellectuals paradoxically have. He decided to go ahead with this project, making a larger, more elaborate portrait than he had been planning. Hélion paints portraits only of his friends ("We're not necessarily a happy family—but they're what I have to interpret the world with"). Like Jean-Pierre, many of Hélion's friends—René Char, Francis Ponge, André du Bouchet, Yves Bonnefoy—are poets, and his work has always had a special attraction for writers. He is a poet's painter, as Ponge (who has written on Hélion) is a painter's writer. Both have invented a new kind of description, poetic without being rhapsodic, which treats the outside of things as though it were their soul, and in which the avoidance of all metaphysical temptations becomes itself a kind of religion.

The first sitting took place in late February 1959. Hélion posed Jean-Pierre in a straight metal chair on a wooden model's stand and began quickly setting out the colors—black, umber, burnt sienna, ocher, cobalt blue, white and mauve. "I'm constructing the palette that is going to join us together," he said. "The palette is my piano. When I hear the 'air'—when it begins to be set up—I can begin. The painting is a dream but it must have the palette to lean on."

The canvas he had chosen was sized light blue, and was about three feet high by two feet wide. After a few blue-chalk strokes, he began to block in the darks in fluid dark brown, using a two-inch-wide housepainter's brush. He indicated the light areas of the figure summarily with a light gray wash, and the

olive sweater the model was wearing under his jacket became a swath of gray-green. Hélion used a slat to guide the brush when he sketched the legs of the chair.

During the first break he brought out some of his recent paintings and placed them about the room. Quite a number of them were similar to the one he was doing now: small studies of men seated in neutral gray surroundings—a subject which is peculiarly haunting in his hands. "I have been painting seated men. There's something about a seated man—he could be God or a judge. . . . The meaning of gesture, if you like. . . ." Pointing to a rear-view portrait, he added: "Merely turning one's back is something."

He rarely paints a single picture of a given subject; rather the paintings come in clusters, with perhaps a single large version surrounded by a group of smaller ones done in a variety of ways and mediums, as this one was to be done. Thus he never really finishes with the subject he is working on: perhaps because he is reluctant to leave a subject which has come to mean more to him through his having painted it. Once when a French interviewer asked him the inevitable question of why he stopped painting abstractly, he answered simply and truthfully, "I was nostalgic for the things and people I had loved." Some themes—one is tempted to call them symbols, but in fact they seem to symbolize only themselves—have been with him ever since he took up figurative painting. Among these are the man seated on a park bench reading a newspaper ("All men carry newspapers," Hélion says, and this is true, in France at least); a somber young couple walking under an umbrella; a dead chestnut-tree branch on a table; pumpkins ("They're simple, dumb, at the same time they have a kind of mystery; in Normandy we have jack-o'-lanterns like those you have in the States").

After blocking in the background of the portrait with large squarish blue and gray areas, he decided to stop work for the day. He had been painting about two hours. Glancing critically at the free, flowing oil sketch, he said to Jean-Pierre: "Tomorrow I'll paint your portrait on it." He said he would finish this picture the next day and would then paint a more detailed portrait of the model's face, using the seated portrait as a study.

Before the next day's sitting Hélion worked on the portrait. He brushed the gray of the suit over the brown of the shadows and lightened the latter by scrubbing them, starting from the inside and working out. "Highlights" of the art school variety were added, with a fairly large brush. Those scattered sparingly over the face were like angular petals, terra-cotta with a thread of white at the edge. The larger ones, brushed down so as to blur the gradations of tone, recalled his abstract period; their shapes suggested colored metal tubes. The darks of the suit were now very thin, and brown like a rusty brown suit, with

the canvas showing through. The grays of the suit and background and the shadows on the flesh were smooth and supple. The highlights were small but thick and their impasto, grooved by the bristles of the brush, gave the impression of a field of messy snow in spring melting into the earth, but the whole was marvelously luminous, moist and elegant.

For the portrait of the head he took a medium-sized horizontal canvas sized dull pink and ruled off one end of it for the present picture—a common practice of his. He often uses the leftover parts for smaller versions of the subject, which gives these canvases at first glance the alluring look of a comic strip. No doubt the effect is due more to practical necessity than to conscious planning, but that is part of the curious charm of his work, in which the practical and the mysterious exist side by side without infringing on each other.

He made a rough, angular sketch of the head in brown chalk, then filled in the area around it with a thin coat of pale blue-gray, rendered more chilly by the pink sizing underneath. He began painting the face, indicating the planes with wide brush-marked strokes, sketching the features and also the lapels with dark brown bands. Already the portrait had a more forceful look than the rather delicate and noncommittal seated figure had ever had. He accented Burgart's pointed chin and gave him a frown.

From the beginning Hélion had been uncomfortable about painting before an audience, which at times—what with the photographer, the interviewer, Hélion's housekeeper, various friends and all the portraits on easels—had seemed to fill the studio. "It's curious to be watched over like this. One really ought to work in the Place de la Concorde—or perhaps in the Gare de l'Est." However, at first he had been inclined to tolerate it as a kind of test, and had cited a friend of his, a well-known violinist who is hired to play the violin for Hollywood movie sound tracks, not as it should be played but as people expect it to be played. "It's an imitation of serious art by a serious artist. He feels that it's an ordeal that's been proposed to him, and does it to prove that truth can survive truth. . . . Still one is conscious nevertheless of a certain temptation to ham acting. . . ." Now he felt that the painting had reached a crucial stage ("There is a moment when the painting stops being a project and becomes what is happening") and asked to work on it in privacy for a few days.

Less than a week later the head had been roughly completed. It was somber and vigorous. The hair and jacket were heavily, almost sloppily painted; the face seemed to have been done quickly—there was a contrast between the thoughtful expression and the nervous, sometimes violent handling of the paint which gave the sideways-looking head a beleaguered look. He had also done two small watercolor sketches on gray paper—one detailed, with red, blue and orange accents scattered over white wastes, which showed Jean-Pierre looking

at a paper. The other was vague, white and gray, occasionally bracketed by a fragment of outline. In this one Hélion had draped a coat over the back of the chair "to make a citadel, protect him against the exterior."

In addition he had painted two small oil sketches of the model in a new pose—seated in profile with one foot resting on a low wooden stand. One sketch was rapid, light, with no features; the other was in purplish and brown tones, like stamps, with strong juicy accents, the figures and objects outlined in sienna. The face, turned toward the viewer, was barely indicated, though everything else in the picture prompted one to look to it for some important declaration. Its blankness was the center of the picture. In a sketch he had repeated this pose in a figure as yet merely outlined in brown on white canvas, in which the background (door, baseboard, etc.) was clear and unequivocal for the first time. It seemed that he had progressed from the gentle, expert but not too profound or "like" first seated portrait, to the strong but rough and general head, to these small paintings full of delicacy and cleverness and a final sketch in which he could now allow himself to look at details.

The next week Hélion had finished the painting he had begun in this final sketch. In it, the prelude to the final version, Jean-Pierre was seated and writing, looking a bit hostilely at the viewer. Behind him the door and alcove were detailed. This picture was painted entirely in grays and browns, lit here and there by patches of white untouched canvas. Next Hélion had taken a large canvas about seven feet long by four feet high and sketched in charcoal what was to be the final version of the portrait of Jean-Pierre. Once again Hélion begged for privacy (in the last stages of the portrait even the model was dismissed), and promised to keep a journal of his progress.

Here are some of the entries in the journal.

March 12. I spent the entire day dreaming of this portrait of J.P., enlarged now, and painted in such a way that it can be completed without its losing the freshness of the sketch.

Get everything that is naturally big out of the way at once: the big shadows, the big flat spaces. The big "round" ones too, like the cylinder of the forehead. If only one could set this all up forcefully but calmly and at the last moment bring into play the look of the eyes, the smile, and, on the cheek and shoulder, the splashing of the light.

March 18. Build up a crescendo from the wide toward the compact, from the constructive toward the expressive, from the general toward the individual and from the individual toward the person.

March 19. Jean-Pierre arrives in time for coffee. He likes to have "his cup" every now and then. He places a blue package of Gauloise cigarettes at

his feet. I had thought of putting it into the composition, but the cup on the window sill is so right that one more object would throw things off. Of the package of cigarettes, only the blue remains—it circulates throughout the model's stand on which J.P. is resting his foot. It will appear also in the metal legs of the chair.

I'm very fond of the relationship of the color of the raincoat over the back of the chair with that of the stretcher leaning against the wall and that of the floor.

All this dialectic because this is a work done over a long period, as distinguished from a work dashed off quickly, in which the passion of a brush stroke or the burst of a light often takes the place of the object.

April 8. At the Louvre looking at Courbet. Power of a black area to be either light or shadow (superbly utilized in the "Enterrement"). Try to paint a portrait in black in a light space. In a stairway?

April 17. My portrait of J.P.B. as of today is too well staged, too much of a *"pièce de résistance."* Not unforeseen enough.

April 21. The picture has suddenly begun to rise, to stand independent of its scaffolding. It has begun to live, to speak louder than me and my stupid projects.

May 5. I've shortened the raised leg, and suddenly the figure works like a mechanism. And now a sketch suddenly comes to fasten itself to the canvas turned to the wall, in which the blue of the sky and the olive green of the sweater reappear. Which sketch? Why, naturally one of the landscapes I did at Easter when I was "on vacation" from this portrait. Note that this landscape introduced on an oblique plane has two plastic functions: 1) to create depth; 2) to fix the motif of the portrait in the large landscape of the room.

May 7. In real life the folds in the pants demonstrate the effect of the laws of gravity on a body. But in the picture their purpose is to define and honor the person incarnated in that body. To be right in real life all the folds must be there. To be right in the picture they must appear only insofar as they don't attract attention to the pants at the expense of the head. . . .

The portrait is slowly ending. After having resisted for a long time, it now seems to have reached the top of a hill and to be coasting down the other side, toward the plain of repose. It calls for whatever it needs. And so a light expands, a shadow affirms itself, a warmth radiates outward, a superfluous tone disappears, leaving only a speck behind.

The final portrait did not have the tempestuousness of most of the previous versions: what agitation there was had left the décor to settle on the figure. The canvas was just high enough for the seated figure and much too long. Jean-Pierre

now seemed to be in an attic. One foot was up on a gray box which also supported a canvas turned to the wall, and a landscape, placed perpendicular to the surface of the picture, swooped back into it in an exaggerated perspective so that there was here on the left a complicated geometrical *jeu* which included also the gray wooden stand, the framework of the stretcher leaning against the wall and even the triangular wedges at the corners of the stretcher. This arrangement seemed to have little to do with the rest of the picture and was pleasing just because of this autonomy. It was one of several independent islands in the long frieze of the portrait.

In the center, Jean-Pierre sat writing. The coat was still draped over his chair, as protection from the alcove behind. His suit was thickly and in places muddily painted in a technique different from that used in the rest of the picture. The back wall was divided up arbitrarily into light-tinted, maplike areas, and one came rather abruptly on the model's head, caught between the light wall and the dark alcove and hatched with swiftly scudding strokes from among which the eye looked out. The hands were terra-cotta-colored, violently lit. Jean-Pierre seemed to be writing furiously; a leaf of paper had fallen to the floor. His whole figure was aggressively daubed with brown, blue, mauve, as though he were under attack, like a besieged castle in a calm landscape. One couldn't help feeling that there might be a literary romantic meaning in all of this; but the head also had a fierce independence from suggestiveness, as if to say that the painter could not be held responsible for any opinions expressed about his painting. One looked next into the alcove, in which hung a *camaïeu* copy of the earliest portrait, as though to remind one of how the sitter once had been. The outside door, window curtain, cup and cloth were quietly, richly painted, forming another group which seemed to stand intentionally apart from the rest of the composition. But the picture as a whole had the unity of a day which is very warm in the sun and very cool in the shade.

Hélion had finished the portrait in the privacy of his journal. Before going on vacation he made yet another small study, which seemed to please him—just horizontal dabs of brown, Prussian blue, ocher lit by white as after a storm, the head a swiftly seen ball. It seemed influenced by the approaching summer, as the first study had been by the wet February light. And he hopes soon to do another large portrait of Jean-Pierre. It is hard for him to leave his subjects: he is always "saying goodbye but coming back," in Auden's words. And though it is difficult to forecast future developments in his work, it is safe to predict that he will remain in this intimate involvement with the mysteries of subject matter. As he once said: "I realize today that it is the abstract which is reasonable and possible. And that it is the pursuit of reality which is madness, the ideal, the impossible!"

ArtNews, February 1960

THE PARIS SEASON draws to its climax. Dilettantes, if such things still exist, must be finding it all rather a strain. With an average of ten vernissages a day, not to mention all the theatrical and sports events, the professional spectator has his work cut out for him. Dilettantism is now more exhausting than creativity.

Last week the Giacometti show opened, and this week it is the turn of Jean Hélion to present figurative work that seems more "avant-garde" in the real sense than any of the pots of paint that have been flung at our heads all winter long. Hélion is not just one of the great figurative painters; he is one of the greatest painters of any kind today, in my opinion.

Curiously enough, Hélion is today better known for the abstract paintings he did in the 1930s than for the ultrarealistic ones he does now. The experience of the war, especially a German prison camp, produced a state of spiritual shock in him. At the end, he found it impossible to return to the world of the idealized, abstract form, and began for the first time to paint what he saw around him. (He believes that an analogous shock took place in America, where painters were shocked into abstraction.) Indifferent to fashions or financial success, he has gone on developing his favorite themes: people strolling in a park, portraits of his friends, studio still lifes, the roofs outside his window.

It is difficult at first glance to say precisely what is so fascinating about his work, what sets it off from that of other painters. Everything is painted with complete objectivity, without mannerism, "style" or editorializing. The painter's personality is invisible in the paintings, and yet one senses it everywhere, far more than if Hélion had added stylistic trademarks, as so many painters today feel compelled to do. This lucid objectivity is precisely what distinguishes Hélion's work. It is what we look for, and so seldom find, in abstract painting. His new work is painted with the same quiet brilliance, the controlled lyricism that has always characterized him, even in his abstract period. The high point of this show is a large painting of the Jardin du Luxembourg, which groups figures and trees in a complex counterpoint.

Portraits, landscapes and still lifes are included. They suggest the work of a modern-day Courbet or Corot who has lived through the experience of abstraction.

New York Herald Tribune (International Edition), June 14, 1961

"VICTORIAN HIGH RENAISSANCE"

M<small>Y FIRST ENCOUNTER</small> with the work of Frederic, Lord Leighton (he was ennobled less than a month before his death, in 1896), was in my high school Latin book. Many of the illustrations showed his idealized figures from mythology—Atalanta, Perseus, Persephone—with draperies billowing high above their heads like spinnakers, on an apparently windless day. In the background was a landscape which, if not exactly down-home, made the ancient world seem imaginable and the fourth declension less forbidding.

I had lost sight of him until now, when he turns up as one of the four protagonists of an exhibition called "Victorian High Renaissance" at the Brooklyn Museum, where it winds up a tour that began last fall in England at the City of Manchester Art Galleries in Manchester and then proceeded to the Minneapolis Institute of Arts. It was organized by several scholars under the direction of

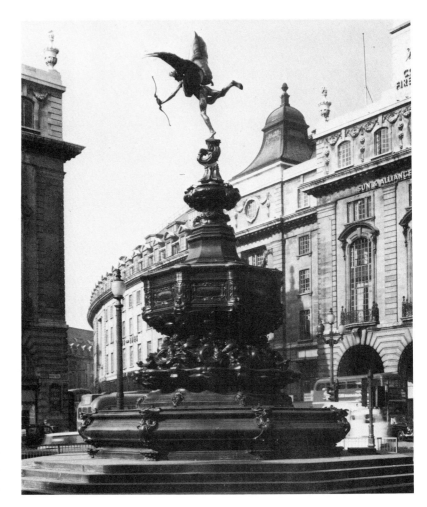

ALFRED GILBERT

Eros

(1886–93)

the young American art historian Allen Staley, who has done much to stimulate exploration of the *terra incognita* of late Victorian art.

Another of the artists included is George Frederick Watts, whose allegorical picture "Hope," showing a blindfold maiden with a broken lyre seated atop the terrestrial globe, once rivaled "The Angelus" in chromo reproduction as an indispensable ornament of the Anglo-Saxon parlor. (Apparently considered a national treasure, this painting was not allowed to participate in the American part of the tour.) The other two are Albert Moore, whose specialty was narcoleptic nymphs in classical drapery, and the sculptor Alfred Gilbert, author of the Eros statue in Piccadilly Circus.

Although the place of the pre-Raphaelites in art history has been grudgingly granted in recent times, it is only within the last decade that artists

such as these four have been considered legitimate subjects for reevaluation.
And, although they certainly do deserve to be seen again if only because of the
colossal reputations they once enjoyed, one wonders just how far reevaluation
can go. For this long-overdue look at them reveals more weaknesses than
strengths.

Leighton and Watts, the two superstars of their day, suffer particularly,
for, with a few exceptions, it turns out that their work looks better in black-and-
white reproduction. Most of the aesthetic pleasure and surprise is provided by
the lesser-known Moore and by Gilbert, whose flamboyant life-style and self-
destructive nature nipped a promising career in the bud.

The title "Victorian High Renaissance" refers to the Italianate classicizing
tendencies of these artists, which followed the "early Renaissance" phase of the
pre-Raphaelites. The latter had attempted to reintroduce the sharp focus, the
pure color and crystalline light, and the heightened naturalistic detail of early
Italian masters such as Botticelli and Mantegna. The generation of Leighton and
his followers aspired to the more attenuated palette and the noble idealizations of
the High Renaissance as seen in Raphael, Michelangelo, Correggio, and the
Venetians.

Italy played a formative role in the careers of all four artists. Watts and
Leighton probably produced their best work during their apprenticeship there.
Leighton's "Portrait of May Sartoris," though painted just after he moved back to
England in 1859, has as its subject a close friend he had met in Rome. Her
striking and forthright stance, the dramatic slash of a crimson scarf across her
black velvet jacket and the quasi-Impressionist landscape behind her are in
sharp contrast to the posed mythological subjects and insipid halftones which
would prevail later on.

Similarly, the light of the sun (albeit a sinking one) brings out patches of
vibrant color in Watts' "Peasants of the Roman Campagna" (1845) which would
fade after his return to the land of brown Windsor soup. Henceforth his
paintings would match Huysmans' description of them:

> Looking as if they had been sketched by an ailing Gustave Moreau, painted in
> by an anemic Michelangelo, and retouched by a romantic Raphael. . . . The
> strange and mysterious amalgam of these three masters was informed by the
> personality, at once coarse and refined, of a dreamy, scholarly Englishman
> afflicted with a predilection for hideous hues.

Still, there is something affecting in the drama of Watts' conceptions, if not in
their realization. The paintings are best appreciated, if at all, from a distance
rather than close up.

Of the three painters, only Moore, a sort of Victorian Matisse, shows much sensitivity to the niceties of color and pigment, and that is about all he does show. His draped, full-length female figures are, as with his friend Whistler, pretexts for dissertations on color: each has its pastel key signature. "Shuttlecock," a Grecian damsel anachronistically contemplating a game of badminton, is an exquisite set of variations on the theme of cobalt blue. Still, it is refreshing to turn from these Victorians to paintings by their French contemporaries from the Brooklyn Museum's collection, which have been newly hung close by. Even a minor French academic such as Jules Breton or Benjamin Constant has an intuitive sense of how to put light into paint which seems at best artificial or contrived with the English painters.

That is perhaps why Alfred Gilbert's sculpture steals the show. Leighton and Watts had a strong grasp of sculptural masses (and frequently worked in that medium) which translates uncomfortably onto canvas. Gilbert, for his part, was sometimes beguiled into encrusting his bronzes with marble, ivory, mother-of-pearl and semiprecious stones. Yet his magnificent way with angular but fluid passages of flesh, its cascading broken off abruptly by articulations of bone and muscle, triumphs over the sometimes outlandish materials. Best of all are the early, smallish bronzes, among them an Eros related to the Piccadilly one, in which his admiration for Donatello is somehow linked to an awareness of burgeoning Art Nouveau.

New York, February 26, 1979

BLAKE AND THE FUSELI CIRCLE

An EXHIBITION AT New Haven's Yale Center for British Art called "The Fuseli Circle in Rome" is the very model of what a university-museum show ought to be. It makes its scholarly points succinctly as it reveals a constellation of little-known artists in the orbit of one or two major ones, neatly placing the whole thing in a larger historical context, in this case the period of developing Romanticism as it was emerging from Neoclassicism in eighteenth-century Rome. Meanwhile, the Morgan Library in New York is documenting a further chapter in that history with a hanging of William Blake's circa-1810 watercolor illustrations for the Book of Job and for Milton's "L'Allegro" and "Il Penseroso."

Henry Fuseli was born Johann Heinrich Füssli in Zurich in 1741; as a young man he emigrated to England and attracted the notice of Reynolds, who encouraged him to study in Rome. During his years there (1770–78) he

immersed himself in the study of Michelangelo and Roman antiquities, but his own brand of classicism was far from the frigid history painting that flourished there under the guidance of the theoretician Winckelmann. Though Fuseli had for some reason translated Winckelmann's *Reflections on the Painting and Sculpture of the Greeks*, his own penchant from the beginning was not for a sedate sublime but for the horrific kind—that of Michelangelo's "Last Judgment" and Shakespeare's *Macbeth*. Edmund Burke had decreed that terror was the most exalted emotion, and it became so popular that a certain Aikin produced a book called *On the Pleasures Derived from Objects of Terror and an Enquiry into the Kinds of Distress Which Excite Agreeable Sensations*, thus anticipating by two centuries such phenomena as Twisted Sister and *The Rocky Horror Picture Show*.

Fuseli was an accomplished draftsman before he left England. "The Cave of Despair," an illustration for an episode in Spenser's *Faerie Queene*, suggests his later work in its fluency, its dramatic thrust, and its morbid subject drawn from English poetry. It doesn't yet have the schematic figure drawing which was to come later, under the influence of the Mannerists Parmigianino, Bandinelli, and especially Cambiaso, whose drawings of cigar-box figures Fuseli collected. Macbeth in "The Witches Show Macbeth Banquo's Descendants" has a similar mechanical build which enforces the nightmare ambience. This modeling appears in the "Half-Length Figure of a Courtesan"—an erect, menacing version of the prostrate sleeper in his famous painting "The Nightmare," who is so much more frightening than the nightmare apparition itself. (The same female type shows up in the Scottish artist John Brown's vignettes of Roman street life.)

What strikes one most in the work of these artists, viewed as a group, is the atmosphere of sinister fantasy which they were able to project with just a few incisive jabs of the pen and a splash of ink—"dramatic chiaroscuro wash," as it is termed in the catalogue. The sunny climate revived memories of Odin and Ossian among these gloomy Danes and Englishmen. Their adoptive land was the nocturnal one of Piranesi and Salvator Rosa, though it may have been closer to the real thing than the idealizations of Goethe and Mendelssohn's "Italian Symphony."

Next to Fuseli the most commanding figure here is that of Johan Tobias Sergel, whose beautifully modeled sculptures of Greek heroes have an up-to-date nervous dynamism that caused a friend to dub him "the Swedish Phidias." His drawings reveal his darker side: they are roughly laid down and steeped in a violent eroticism that is distinct from Fuseli's more studied and cerebral orgies. Other notables are the Dane Nicolai Abildgaard, the short-lived James Jefferys, Romney, Flaxman and Blake.

Nancy Pressly, who put together this intriguing show, has stretched the

term "circle": Flaxman was not in Rome at the time Fuseli was, and Blake was never there at all; other artists "presumably" knew Fuseli. But one can hardly complain, since the results of her meticulous scholarship are so consistently entertaining and revealing.

Blake's admiration for Fuseli is known from his characteristically crusty "epigram": "The only man that e'er I knew/Who did not make me almost spew. . . ." It is less obvious from his drawing—those "boneless" figures (the adjective is Mrs. Pressly's) are a far cry from Fuseli's razor-backed nudes. But, as she astutely remarks, "the style evolved by Fuseli in Rome and interpreted by Romney in the late 1770s had, by the early 1780s, become something of a common language."

Though the majesty of Blake's concepts in the Job illustrations is apparent to the unschooled eye, the complexity of his symbolism (he warns us that "not a line is drawn without intention") is such that it is best to approach the pictures with a guide—S. Foster Damon's *Blake's Job* is the definitive one. Even the casual viewer will note that Job and God are identical twins—hence, Job's God, in Blake's reading, was a creature of his mind. But less apparent is the symbolism of the books held by some figures and the scrolls carried by others: Books, being "the letter," are bad ("The Letter killeth, the Spirit giveth Life"), and scrolls are of the spirit. And there is the iconography of left and right: Beware of figures who arrive left foot first.

Blake's painting is one of the glories of English literature; its hybrid nature leaves me fascinated but never entirely convinced. *Job* is an extraordinary monument, but I am more at home in the dulcet never-never land of the "L'Allegro" and "Il Penseroso" designs, where Blake achieves in purely visual terms the rainbow-hued perfection of the *Songs of Innocence.*

New York, October 8, 1979

THE CAMDEN TOWN PAINTERS

Something rather like a revival—awakening might be a better word—is currently taking place in the field of twentieth-century English art. I'm speaking not of international stars like Hockney and Bacon, both of whom happen to be showing here presently, but of earlier figures who have hitherto had no following outside England, and sometimes very little even there.

Since the Yale Center for British Art opened in 1977, we have had new opportunities to appreciate the richness of English art of the past and present, while in New York several galleries—Marlborough, Bernard Jacobson, and Davis and Long among them—have a definite British bias. At the moment, a show at Yale and another at Davis and Long illuminate two little-known aspects of twentieth-century painting. Yale's show, "The Camden Town Group," takes a look at the work of seven of the artists who made up that group, which has been

likened to the contemporaneous Ashcan School in America. And Davis and Long has the first American show of Vanessa Bell's paintings, textile designs and prints. The current vogue for Virginia Woolf, Vanessa's younger sister, no doubt has something to do with this. In any case, it's pleasant to have her work here and to realize that Virginia by no means usurped all the genius in the family.

Of the Camden Town painters, only Sickert is known at all well in this country, and even he isn't exactly a household word here. The others shown are Malcolm Drummond, Spencer Frederick Gore, Charles Ginner, William Ratcliffe, Harold Gilman and Robert Polhill Bevan. (Some artists who were associated with the group, among them Vanessa's close friend Duncan Grant, haven't been included because their aims diverged widely from those of these seven key figures.) Although, not surprisingly, Sickert emerges as the strongest of the lot, he is at times matched or even surpassed by some of the others, especially Gilman and Gore.

Influenced by Impressionism (partly through the presence in London of Lucien Pissarro, Camille's son and himself a painter and member of the group) and by Post-Impressionism (which had not yet begun to be shown in London but which Sickert had encountered during a long stay in France), the group set about forging its own peculiar sort of modernism. Disgruntled with the staleness of the Royal Academy and also of the New London Arts Club, which had been founded to oppose it, they rented what would today be called an "alternative space" in London's seedy Camden Town district. Here the artists could store their paintings and invite visitors in to inspect and perhaps buy them. (Malcolm Drummond's painting "19 Fitzroy Street" documents the look and ambience of the place.) Typically, their works were small in size, probably so they would sell; they have been called "little pictures for little patrons."

The Camden Town artists were variously tempted by the work of Gauguin, Cézanne, van Gogh and Seurat. At the same time, under Sickert's aegis, they felt a commitment to record the frequently seamy urban scene around them. All this could result in very curious hybrids, such as Ginner's "Victoria Embankment Gardens"—the painter apparently thought he was in van Gogh's Arles rather than a stone's throw from Charing Cross Station. (Elsewhere he can be more cohesive, as in "The Angel, Islington." The title alludes to a famous pub, and the mood is that of T. S. Eliot's "Preludes"—one can almost whiff the "smell of steaks in passageways.")

By and large, this is a rather bookish sort of modernism. The artists weren't firebrands like van Gogh: they first made careful drawings on squared paper and then copied them on canvas, finally adding impasto or pointillist spots in a kind of calculated spontaneity. At times it was enough just to make the

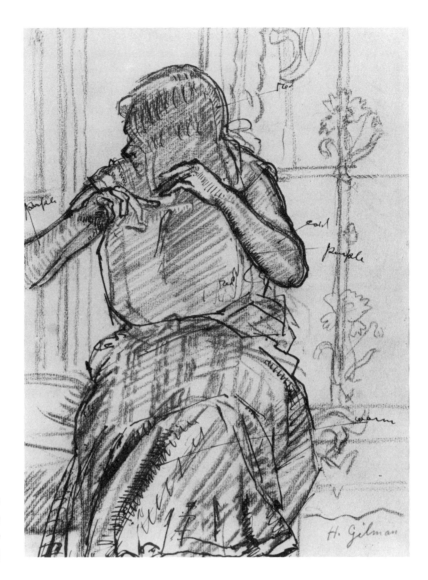

HAROLD GILMAN
Woman Combing
Her Hair
(1911)

grass pink and the shadows purple. Yet the effect is sometimes very moving, as in Gilman's "Girl Combing Her Hair," a picture I would class above any of the Sickerts in the show. The rough, scumbled impasto and jarring, dirty colors have, for once, an awkward but compelling majesty.

Vanessa Bell's art is an altogether different story. From the earliest painting in the show, "Iceland Poppies" (1908), it is obvious that we are in the presence of someone for whom painting was an affair of the heart rather than the head. Though it is still conservative in style, its liquid, opalescent grays and

curious format, with three poppies laid out in the foreground like elegant corpses, are immediately engaging. Soon after, she began to evolve *her* variety of English Post-Impressionism, more convincing than most of what came out of Camden Town—without the latter's violent and arbitrary contrasts of color, yet revolutionary and reductive in its handling of forms. In later life, deeply affected by various tragedies, including the death of her son Julian and the destruction of her studio during the Blitz, she returned to a sedate realism that consolidates the experiments of her youth and, in its well-reasoned rejection of them, is an experiment of another kind.

One would have to have more of an experience of the work of Duncan Grant than it is now possible to get in this country, and maybe in England as well, in order fully to gauge her originality—a 1917 portrait of her by Grant included in this show is similar in style to her paintings of that time. Still, this is a tantalizing look at an artist who, it turns out, is not just another droppable Bloomsbury name but an artist of singular gifts as well.

New York, May 5, 1980

JOHN F. PETO

B<small>ARELY KNOWN DURING</small> his lifetime, the American still-life painter John F. Peto sank into almost total obscurity after his death in 1907. Many of his works survived only because they were mistaken for those of the much more famous William Harnett; some even wound up with Harnett's forged signature affixed to them. A modest revival in the early 1950s, which included a show at the Brooklyn Museum, failed to resurrect Peto. Now an exhibition of his paintings at the National Gallery in Washington, D.C., is again focusing attention on this strange artist's singular achievement.

Peto has long been lumped with Harnett and the other trompe-l'oeil painters who prospered in this country during the latter half of the nineteenth century. It's a dubious distinction. If still life has traditionally been considered the humblest branch of painting by the academies, trompe-l'oeil still life is

much farther down the aesthetic scale. Even during its heyday, critics who admired its technical virtuosity found something faintly immoral in its crowd-pleasing "deception"—a feeling that persists today when one is confronted with "hyperrealism," trompe l'oeil's newest avatar.

Still, it's hard to suppress a gasp of admiration in front of one of Harnett's pieces of fabulous illusionism, such as his still life of game called "After the Hunt." But Peto's case is more complicated. Though he was a friend of Harnett's and seems to have admired him more than any other artist, he stops short of Harnett's bravura fool-the-eye flourishes. Whether he did so by intention or from lack of ability isn't quite clear. What is certain is that he emerges in this show (thoughtfully assembled by the National Gallery's John Wilmerding, whose catalogue contains much new scholarly information) as a far more complex and finally more considerable talent than Harnett.

Peto was born in Philadelphia in 1854; at the time, his father was a dealer in picture frames. He enrolled at the Pennsylvania Academy of the Fine Arts in 1877 and for several years contributed works to its annual art exhibitions. In 1889 he and his wife moved to the house he built in the New Jersey resort community of Island Heights. There, far from the nation's art centers, he began to lead a semireclusive, work-filled existence. His final years were troubled by ill health, an exhausting lawsuit and the presence in the house of a senile aunt who rattled the locked door of her room for hours on end while Peto tried to paint downstairs.

Only gradually did Peto's paintings begin to distance themselves from the run-of-the-mill still lifes of the time. An early "Fruit, Vase and Statuette" is conventional and dull. Its luxury goods are far removed from the battered detritus that Peto would paint almost exclusively later on. The pipe-and-mug still lifes that followed, with their overtones of solitary pleasures (which Wilmerding situates in the "Philadelphia tabletop tradition"), signal the beginning of the shift. These arrangements become more monumental and more disheveled, as in the chaotic jumble of books in "Job Lot Cheap" (circa 1900)—Books, usually damaged and decrepit, were one of Peto's favorite subjects. They take on an almost tragic life in his hands: one thinks of Ezra Pound's equation of our "botched civilization" with "a few thousand battered books."

The most fascinating and disturbing of Peto's works are his "rack pictures" and "door pictures"—extremely realistic renderings in which assorted old papers and prints appear to be attached to a letter rack made of strips of tape or nailed to a dark-hued wooden door. The effect, as critic Alfred Frankenstein described it, is of "a symphony of tatters, scuffs, frayings, and tears, fabulous in its precarious, asymmetrical design and highly mysterious, but generally quite somber in its emotional tone." It is hard not to see the torments of Peto's

later years reflected in these bizarre concatenations of trivia, where what is missing is insistently underscored. (A business card, for example, is ripped away, with only a corner or two still tacked down to the door.) The surface of the painting, which simulates exactly a door or an office wall, is maddening in its impassability. In one of the few reviews Peto received in his lifetime, the writer noted: "The hand itches to play with that string, which seems to move and flutter. . . . One is seized with the notion of extracting those stumpy nails, or denuding the picture of its objects." Yet Peto's illusionism, unlike Harnett's, has a painterliness that should win him new admirers today. His pigment, which has been likened to Vermeer's, looks porous, saturated with light or steeped in shadow. In more "advanced" works like "Teacup and a Slice of Cake," it seems to embark on adventures of its own, attending only absentmindedly to its task of precise delineation.

Peto is a haunting, at times even depressing, artist. The ambiguity of the humdrum artifacts he deploys can be agonizing: is there hope for us in their survival or is all his work an extended *vanitas?* Wilmerding has given his show the title "Important Information Inside," from a message on an envelope that appears in several of the rack pictures. And important the information is, though buried so deep inside that one glimpses it only intermittently. But those glimpses are thrilling.

Newsweek, March 14, 1983

THE NEW REALISTS

T HE "NEW REALISM" is the European term for the art of today which in one way or another makes use of the qualities of manufactured objects. As the name indicates, it is (like Surrealism) another kind of Realism—that movement which began in the nineteenth century at the same time that machines and machine-made objects began to play such an important part in daily life.

The artists in this exhibition are at an advanced stage of the struggle to determine the real nature of reality which began at the time of Flaubert. One could point to other examples in the arts today (elsewhere for instance the "objective" novels of Robbe-Grillet and Sarraute, or the importance of objects, especially artifacts, in the recent films of Resnais or Antonioni) of this continuing effort to come to grips with the emptiness of industrialized modern life. The most successful way of doing this seems to be to accord it its due. That

is, to recognize that the phenomena evoked by the artists in this show are not phenomena, but part of our experience, our lives—created by us and creating us.

New Realism is not new. Even before Duchamp produced the first ready-made, Apollinaire had written that the true poetry of our age is to be found in the window of a barber shop. Picasso had constructed his absinthe glass, Gaudí his gigantic mosaic of broken dishes in the Parque Guell; Gris had used the severely elegant Quaker Oats package in one of his collages; and the posters at Trouville were a favorite subject of the Fauves.

The explosion of Dada cleared the air by bringing these new materials violently to the attention of the public. Today's New Realists are not neo-Dadaists in the sense that they copy the Dadaists; they are using a language which existed before Dada and has always existed. The way back to this language is what Dada forcibly laid bare. Today it is possible not to speak in metaphors, whereas in the 1920s a poet such as Eliot couldn't evoke a gasworks without feeling obliged to call the whole history of human thought into play. In today's violent reaction to threadbare intellectualism the artist has brought the gasworks into the home.

But why *the* object? Why are objects any more or less important than anything else? The answer is that they are not, and that, I think, is the secret of their popularity with these artists. They are a common ground, a neutral language understood by everybody, and therefore the ideal material with which to create experiences which transcend the objects (and which transcend them all the more effectively when they seem least to, as in the work of several artists in this group whose policy is simply to leave the objects alone).

What these artists are doing is calling attention with singular effectiveness to the ambiguity of the artistic experience; to the crucial confusion about the nature of art, which, let us remember, has never been properly defined. The sight of a fire hydrant may give me an aesthetic pleasure keener than the sight of the "Mona Lisa"; both in fact are objects, things external to myself which accumulate the electrodes of my feelings on a number of subjects. As the French critic Françoise Choay points out, speaking of Duchamp: "On one side the product of industry is denounced in its anonymity, its banality, its essential poverty which deprives it of human and poetic qualifications. On the other hand it still remains an object which a simple decision on the part of the spectator can tear out from its context to give it mystery and opacity. . . . The ready-made is satire, but at the same time it is also a proposition of asceticism and conversion."

The unmanageable vastness of our experience, the regrettable unpredictability of our aims and tastes, have been seized on by the New Realists as the

core of a continuing situation; that of man on the one side and a colorful indifferent universe on the other. There is no moral to be drawn from this, and in any case the artist's work on this as on other occasions is not preaching or even mediation, but translation and exegesis, in order to show us where the balance of power lies in the yet-once-again altered scheme of things. Today it seems to repose in the objects that surround us; that is in our perceptions of them or, simply and once again, in ourselves.

From "The New Realists" exhibition catalogue, 1962

III

AMERICANS ABROAD

AMERICAN SANCTUARY IN PARIS

Up until the last war it was expected of American artists who could afford it to spend a year or more studying in Paris and looking at the museums of Europe. Today the situation has changed. American artists no longer come to Europe to study; maybe they don't study at all? For spiritual and commercial reasons, New York is the capital of the contemporary art world, and it is French artists who are now beginning their *Wanderjahre* in New York or Los Angeles.

The purpose of this article is not to rehash the too-much-discussed reasons for this state of affairs, but to look at the Americans who still continue to live and work in France, in spite of everything. They differ from their predecessors in not being a lost generation, though they frequently prefer France for reasons of privacy and isolation, which are, according to them, more easily attainable there. The emergence of American art has put them in a stronger position; they

can show in Paris and with luck an American collector may see the show and buy something. It is difficult for anybody to remain undiscovered any more, and with today's communications and transportation, nobody is an expatriate. Tragic, but typical, cases like Patrick Henry Bruce or John Storrs, who emigrated to France and evolved an art which remained largely unknown, are now unlikely.

But the advantages of isolation, of keeping one's distance from both worlds and discovering oneself, are perhaps also less than they used to be. One danger for an artist is that, feeling himself far from the center of things, he may produce only provincial, watered-down versions of whatever is currently being explored elsewhere. This fear, even when they won't admit to it, seems to go with the hope of achieving fruitful independence for most of the American artists living in Paris.

Yet even this can have its advantages, as it undoubtedly did for the Firbank lady who said, "I always follow the fashions, dear, at a distance!"

The Americans in Paris are permanently out of fashion, first ahead of it and now behind it, without ever having gone through an intervening period of acceptance. This may account for a look that many of them have in common, even when they are working in entirely different ways. It is not so much a look perhaps as a quality. It is as though they had given up all efforts at trying to please a public, whether French or American, and had gone back to pleasing themselves. For once, you don't have the feeling that the artist is breathing down your neck in his work, or that you are catching the work in a split-second of its trajectory from easel to gallery to museum. So, though there can be no question of a new American "school" in Paris—the Americans are in fact independent, if not downright suspicious, of one another—there is a subtler kind of unity in their work. It is the result of American restlessness, energy and visual know-how being released in a non-American space of great physical charm, of subtly different human relationships, whose real nature is elegiac and conservative rather than forward-looking and constructive. When what is most attractive in both these positions is united in the work of a single artist, the result can be powerfully engaging and slightly mysterious. Such was the case in the work of Bruce, for instance, whose nearness to Villon-inspired Cubism was only a coincidence, or a consequence rather of this artist's extreme originality—it was essentially a memo from the painter to himself not to express strange new truths in a language too remote from that of his contemporaries, lest these truths go unperceived. It is the case today for painters like Shirley Jaffe and Beryl Barr-Sharrar, who paint in a straightforward Abstract Expressionist style revitalized by their having no axe to grind, nothing to "express" beyond the pleasure of how paint can sometimes look on canvas at certain right moments. Or again, in the work of James Bishop, who has never had to decide whether he was "Hard Edge"

or not because no one has ever asked him, and whose work gains in freshness from having never been questioned, worried, vexed or even much looked at by professional pulse-takers.

For the purposes of this article, questionnaires were sent to a number of American painters and sculptors living in Paris, asking them their reasons for living there, whether they believed Paris or New York is the hub of the universe of art, whether this mattered to them, and whether they planned to go back to America or on to some other place. Some didn't know; others refused to answer; others tried to, and a cross section of their answers will be found elsewhere in the article. But one of them, the sculptor Caroline Lee, used it as a pretext to probe her own ambiguous feelings about living away from home, and her answer deserves to be quoted at length since it sums up the thought of many others and gives an acute analysis of this problem, which is broader than it seems and concerns not only artists abroad but those at home who for various reasons must absent themselves from "the center" at various times. She writes:

No, I do not feel that artistic life in Paris is more interesting than that in the United States. I feel that the reverse is true. Frankly, I thought so before I came to France, and have never felt any serious doubts about it, with the exception of France's best sculptors, who hold my attention absolutely equally with American sculptors. . . .

Despite my previous attraction to the work of certain European sculptors, I did not come to Paris because of them, but more simply ("materially" might be a better word) because a Fulbright grant gave me the opportunity for the peace and total anonymity I wanted. I don't mean anonymity in the sense of being myself unknown; but anonymous in the sense that my habits, reactions, impulses would neither expect nor find comprehending or knowing reactions. I wanted to begin work (I say "begin" because I got the Fulbright in painting despite the inner knowledge that I was headed for sculpture) with the possibility of the same kind of innocent failure of a leaf still green falling from a tree. I would have taken a grant to work in the outskirts of Oakland, California (although I admit preferring a foreign atmosphere where I cannot read other people any better than they can read me; where observation is the principal activity on both sides). . . .

The suite of events has led me to stay in Paris. Sculpture has demanded enormous concessions in my way of life and the expectations I started out with. The giving up of different possibilities in myself, the transformation of basic aspects of my identity, has absorbed a great deal of my energy. I have no idea if this is so difficult for other sculptors, but for me it has been a long

operation, a personal one, requiring the indifference which is such an important ingredient in the French atmosphere. . . .

All this has nothing to do with artistic life anywhere, and it is indeed why I have not been much interested in what's going on. Perhaps some day I will be able to perceive what's going on around me as well as myself, and use myself to go toward that which is surely building outside of myself. I suspect that it is at this point that I will go back to the United States, when all the wheels are in place in my machine, and I shall be free to operate in interreaction, unafraid of being destroyed and confident of being able to take in everything that falls in my line of sight. . . .

But to be brutally frank about myself in France as an American, I am here to get strong enough to go back. I confess that the American atmosphere seemed scorching to me seven years ago when I left. It suggested to me that excessive self-protection was necessary; I wasn't prepared to take in the tensions. . . . But even should I live most of my life here I don't think I shall ever identify with French art, or imagine myself very closely related to it. I can't measure yet what it means, but I work out of my past life—Chicago—out of a nut (noyau, nucleus—whatever you want to call it) that was formed so long ago that no particular place could distract it very much. . . .

One of the questions that intrigues me is to see eventually where on the American horizon my work will sit, as I cannot identify anywhere else, despite my chosen exile.

Miss Lee's analysis of her "chosen exile" suggests a passage on the same subject by Hawthorne:

The years, after all, have a kind of emptiness when we spend too many of them on a foreign shore. We defer the reality of life, in such cases, until a future moment when we shall again breathe our native air; but, by and by there are no future moments; or, if we do return, we find that the native air has lost its invigorating quality, and that life has shifted its reality to the spot where we have deemed ourselves only temporary residents. Thus, between two countries, we have none at all, or only that little space of either in which we finally lay down our discontented bones.

The redeeming feature of this pessimistic tableau is, for an artist, precisely the inability of identifying anywhere. The feeling of being a stranger even in moments of greatest rapport with one's adopted home is the opposite of the American "acceptance world" which so often ends up by stifling an artist's

originality through the efficacious means of over-encouragement. If indifference and even hostility are not exactly beneficial for an artist, too much success is usually worse, for it corrupts subtly. What is especially moving in the work of the Americans abroad is a general resolution in the face of apathy and apartheid to determine their individuality, to create something independent of fashion.

Most of the better-known American painters living in Paris are in one way or another Abstract Expressionists. Perhaps because they fell under the spell of this art at a time when few Europeans knew of it and, not being closely linked to galleries and out of touch with the periodic paroxysms of taste in America, saw no reason to abandon what had become for them a complete form of expression. Only a few of them paint figuratively, perhaps because most contemporary French figurative art is bad and the American neo-figurative painters are rarely seen abroad. Pop Art, though admired by some French intellectuals, has never really caught on with the painters. Since most of the Americans who live in Paris do so because for one reason or another they prefer its climate to that of America, it would be surprising if they found it necessary to satirize this climate or call attention to the soullessness of its décor. Even French Pop artists (like Jacquet, Raysse, Smerck or Rancillac) find it difficult not to be charmed by what they see around them.

No, there is not much "protest" in the work of Americans in Paris, simply because they probably feel they have already sufficiently expressed whatever protest they feel by expatriating themselves. So that even Abstract Expressionism, in the hands of Shirley Goldfarb, Shirley Jaffe and Beryl Barr-Sharrar, tends to be limpid, meditative, delicate in color. Even a painter like Richard Luboski, who admires the gritty wastes and nihilism of Tàpies, suffuses his own work with afterthoughts in passages of tender color.

Miss Jaffe, who has lived in Paris since the late 1940s, is one of the most gifted of the Americans in Paris. With little local encouragement (she has not had a Paris show in years, although she occasionally exhibits in Switzerland) she has developed a personal and touching style of her own, based on quiet antagonisms between a few major forms in a thoughtful context supplied by patient brushwork (she works over the same painting for months at a time so that the word "Expressionist" seems a little too headlong to apply to her) and dull, mottled glazes of color that wind up being singularly attractive. A trip back to New York in 1960 and a recent year spent in Berlin on a Ford Foundation grant have shaken her strong attachment to Paris.

"I just came here to see the world," she says, "and stayed on as one does anyplace. I feel now a great desire to have a more active contact with the society

I live in—hence my desire to get back to America again. One can't here. Living here is no longer, I think, an expression of anything—revolt, with-ness or nonengagement. Even if one thought that way the French wouldn't *let* you."

Miss Goldfarb has also worked chiefly in solitude, though she has a few staunch French admirers, among them the novelist Michel Butor, who recently commissioned "a large purple painting." Her paintings, most of them very large, are concerned with unanchored stretches of pastel light held in a kind of Monet flux; recently she has been moving toward pointillistic abstraction; and the "purple painting," which is one of her best, is a vast area smoothed over with dabs of white and mauve. Raw white used straight to suggest both light and opacity is a characteristic of her painting; it both invigorates and sets the teeth on edge. She says that she lives in Paris because she wants to be alone and finds it easier here. "I have *no* painter friends. I am not nurtured by looking at other painters' work. I like even less to talk about my painting. I would like all my paintings to enter American collections. I feel intensely American, perhaps more so here than when I'm in America."

Her husband, Gregory Masurovsky, is closer to France because he is close to Surrealism; he draws exclusively and his drawings are built up out of endless tiny hair-thin strokes that collect into magnetic fields, contours of the body or weird vegetation. Although his work is widely admired in France (one reason could be that it looks so "un-American") and he has won prizes in the Salons, he does not feel strongly involved with Paris. "I still don't feel part of the French art world, and I'm obviously not part of the American art world either. I'm sort of out in orbit. For matters of identity, I'm an American Abroad. Reduced to the bone, I'm a human being who passes the larger part of his waking hours trying to fix an image on a blank space."

Richard Luboski is twenty-eight and has lived in Paris for the last six years. Recently he returned to America for six months and "looked closely" since he had thought of returning, but although "still split" has decided to "stay on."

When I visited the New York galleries in March, Paul Jenkins was showing at Martha Jackson, Mike Todd at Pace, Jacquet at Iolas, Sugai at Kootz, Ferro at Gertrude Stein, Saura at Matisse, Wotruba at Marlborough, etc., etc. The Paris School didn't look dead. I don't think that because New York invented Pop and not Paris one must locate the umbilical cord of the art world as inevitably coming from Madison Avenue. A lot, it seems, that is happening in New York now *still* finds origins on this side. To know that such American artists as Ellsworth Kelly, Youngerman and Jim Bishop did their apprentice-ship here; that two of the greats—Tobey and Sam Francis—chose Paris, as

well as Joan Mitchell and quantities of others—all these things seem to indicate that the cultural milieu is not as dead as it seems. There seem to be too many waves of this and that in New York and if perhaps this is good for business, it's not always too good for art and even less recommendable for the artist.

Luboski's work is in the "scorched earth" vein of Tàpies, with accretions of *matière* and sanded surfaces, delicate nuances of no-color and sometimes outlines of figures seemingly burnt into the picture.

Since coming to Paris in 1955, Beauford Delaney has moved from Expressionist figuration to weblike surfaces whose only function is to show off light, to reveal it in as many of its manifestations as possible. He writes: "Life in Paris offers me the anonymity and objectivity to release long-stored memories of sorrow, and the beauty of the difficult effort to release and orchestrate in form and color a personal design. Being in France gives time for reflection. One never leaves home if one was never there."

In Paris since the end of the war, Oscar Chelimsky is an example of the kind of painter who has a strong allegiance to the School of Paris (he shows at the Galerie Jeanne Bucher, the gallery of Vieira da Silva, Bissière, and Dubuffet), but who expresses it in American terms. The transparent washes and quiet introspection of Paris are there, but so is a direct lyricism in his way of setting down an image. The introspection is not, as with so many Frenchmen, an *arrière-pensée*.

For him, "art is the pursuit of a crystallization, whose meaning will only be clear at the end of the road to be achieved across, with or against the art currents of the time," and he "happened" to choose Paris because it is for him the place where "daily rapport with society is easiest and . . . people are willing to look at my work."

This is the feeling expressed by Joe Downing, another painter whose work is even closer to the School of Paris—low-keyed in color and using rough but still composed abstract shapes which can become Surrealist figures in a Klee twilight. He finds in Paris "an explicable quiet nourishment which makes it a rewarding place to work. One can take a stand of participation in quasi-isolation without feeling aggressive about it."

Kimber Smith has lived in Paris since 1954. His first Paris show was a three-man one with Shirley Jaffe and Sam Francis at the U. S. Cultural Center in 1958; more recently he has shown at the Galerie Lawrence (which is run by the American Lawrence Rubin). With James Bishop he is one of the most original of Americans now in Paris; both painters seem to have moved out of Rothko-Francis territory to a more rarefied climate which has affinities with Morris

Louis. Most recently Smith has been painting in black with X's or lozenges roughly sketched in white or silver as a terse communication, like a Basic English palimpsest. Significantly, both painters are more or less disenchanted with Paris. Smith believes that "Paris can only work for artists who can self-generate ideas — there is no or very little stimulation from the outside." He is in fact spending the 1965–66 school year teaching at the Dayton Art Institute in Ohio.

James Bishop's work has gone largely unnoticed in spite of a show in 1963 at the Galerie Lucien Durand and one in 1964 at the Galerie Lawrence, though he has a few influential admirers, among them the novelist Philippe Sollers, who devoted a brilliant essay to him in a recent number of the avant-garde magazine *Tel Quel*. Born in 1927 in Neosho, Missouri, Bishop studied at Black Mountain and in 1957 drifted to Paris, where he lives for reasons that are "personal, as they say, though I can't say they don't have to do with my painting." However, he "detests" Paris and is frequently in Italy, whose art and climate he prefers.

Several years ago his painting was strongly influenced by Rothko; sheets of dark color contained things like acts or ambiences dissolved deep within, almost invisible. These emerged as simple, curiously related shapes reminiscent of Kline or Motherwell, whom he admires, and now they have become almost static — a vertical canvas will be framed with a red border and divided horizontally by a green bar, but they are light-years away from Op; intensely "painted" and with their stillness as a prelude to motion or growth. It is a shame that Bishop's painting, partly owing to his own personal aloofness, seems destined for neglect in both New York and Paris, for he is one of the most original American painters of his generation.

A similar case is Hugh Weiss, a Philadelphian whose spectacularly unsuccessful Paris career began in 1948 and has been limited to a recent group show at the Galerie Jacques Massol and a show in Philadelphia in 1964. He says that "if one wants to be let alone to work, one can be let alone in Paris better than any place I know of." The consequences of this fertile neglect have only recently become apparent in his work, which was for a long time tyrannized by Dubuffet. His paintings of the last two years are quasi-figurative, but the figures are usually 1925 biplanes, whole or in segments, and a caricature of two tonsiled mouths talking at each other, the whole happily smeared with hot Expressionist oranges and lemons. It has the force of a story which must be true because no one could have made it up. It is obviously painting that was done with no intention to please, and for this reason it pleases. Weiss is one of the Americans more violently committed to Paris, in whose artistic life he rarely shares: "The fact that New York may have, for a year or two, three or four more exciting new painters than Paris doesn't mean anything. Their influence is felt here almost as rapidly as in New York itself.

One can talk about them in twenty-five different cafés until any hour of the morning that one chooses. And outside on a terrace, too."

With the exception of Biala and Daniel Brustlein, the more important American figurative painters in Paris have been completely cut off from the tradition of neo-figurative painting that has flourished in New York in recent years, and though this sometimes shows painfully in their work, it also sometimes results in painting that is startlingly different, and that could only have been achieved by a painter struggling alone without a tradition to cushion him. One such painter is Anne Harvey, whose curious metaphysical still lifes and interiors are admired by Giacometti and Hélion, among others. She has spent almost all her life in Paris, though her parents were American. Yet neither climate affects her work. Her still lifes of copper pots, flowers, chimney corners, etc., look conventional during the first few seconds of glimpsing, but this effect is quickly replaced by a perception of the probing anguish of an almost Jamesian dissecting eye. Despite appearances, her paintings are unrealistic: leaves and stems twist unnaturally away, shadows are wrongly placed; everything directs the eye into the inner reaches of the being of the objects painted. A curious anxiety, tempered by the exhilaration of her novel optics, is the result.

Daniel Brustlein and his wife, Biala, are European-born Americans who have lived off and on in Paris since before the war. Unlike many of their less fortunate colleagues, they show regularly in New York, and the influence of New York is visible in their work. Biala's suavely formulated pictures use drip and overpainting techniques from Abstract Expressionism; more important, their calm holds echoes of the restlessness behind the "objective" look of New York neo-figuration. Brustlein's portraits, in which figures often seem to result from the colliding edges of large planes, are also New York–oriented, though they retain the mood if not the procedures of Giacometti. Some of the intense but impersonal drama in his work can be accounted for by the reason he gives for preferring Paris as a place to live:

What is important is not so much the scenery as such, but to feel another community, to see how—historically and in daily living—it is confronting the big questions of life and death and what kinds of art and architecture are needed to sum up its identity. The people everywhere are the same figures of chess, but the chessboard is arranged differently, and it's exciting to see how the game works out.

Charles Marks came to France on the GI bill and has remained there ever since, until this year, when he returned for a time to New York. Like Anne Harvey, his work has no American look yet it could not possibly have been done

by a Frenchman or a person of any nationality other than American, and this despite a frank admiration of Giacometti (which has been taken for uncritical adulation). In fact, though he uses Giacometti's hesitant graphism, the message of his painting is impressionistic rather than metaphysical, even though the impressions can be mental ones. Where Giacometti abnegates almost all plastic qualities in favor of intensity of expression, Marks is seeking to reinstall sensation at the heart of this airless kingdom. Filtered through the critical retina of countless linear revisions are small but inviolable planes of color, harmony and even a sensual fullness. It is a tantalizing synthesis, and again one which could probably not have been possible except in a state of exile.

Zuka's portraits are the current outcome of a recent questioning of Abstract Expressionism. They bear many similarities to the kind of work New York artists such as Jane Freilicher and Leland Bell were doing in the mid-1950s, that is, figuration utilizing the free techniques and feelings of Abstract Expressionism. And, as was the case then, the synthesis is not always a stable one—in fact it cannot be, since it has purposely chosen a climate of risk. In addition, Zuka's work lacks the context of Abstract Expressionism which gave sonority to the first neo-figuratives. Yet at its best, as in some portraits, the churning pigment with its acid blond tonalities bears up, as on the crest of a wave, an original and startling perception of a physical presence. She finds in Paris "the liberty of being a privileged foreigner; as a foreigner you don't have to conform, fit or keep up with the society around you."

Beryl Barr-Sharrar has lived in Paris since 1957; with her sculptor husband, Roger Barr, she runs an art school for American students at the American Center in the Boulevard Raspail. Although she has never had a one-man show, she was in 1964 the first American ever to win the annual Prix Lefranc. Her work is untormentedly Abstract Expressionist, generous in its constellations of colors that plummet from one end to the other of surging planes like opening flags or flowers. She says:

> I came to Europe originally because I needed to isolate myself from what I believed to be the danger of a growing national academy of Abstract Expressionism. It is my own tradition and I would be the last to deny my roots within it; it has been the first American force in world art. But because it was my own, American, and a heady background out of which to find my own singular voice, the exploration of other cultures became vital for me. I wanted to know everything about Europe.

This perhaps is the real reason why younger American painters take to Europe: a feeling of wanting to keep their American-ness whole, in the sur-

roundings in which it is most likely to flourish and take root. The calm and the isolation of exile work together to accomplish this perilous experiment which, when it succeeds, can result in an exciting art that is independent of environment, as art must be in order to survive when the environment has been removed.

ArtNews Annual, 1966

JOAN MITCHELL

Joan Mitchell is one of the American artists who live in Paris for extra-artistic reasons and who are different in that way from the Americans who went to live there before the last war. They are not expatriates but *apatrides*. Finding Europe only slightly more congenial than America, they have stayed on for various reasons, some of them "personal"—but do artists ever have any other kind of reason? A personal reason can mean being in love or liking the food or the look of the roofs across the courtyard—or in some cases the art. The *apatrides* of today are usually affected by one or more of these reasons melting together and producing a rather negative feeling of being at home. Far from dreading the day when their money runs out and they have to go back to America, many of them look forward disgruntledly to it. They feel they should have gone back long ago to become successes instead of staying on in this city

famous for its angry inhabitants, high living costs and lack of any sustained excitement in the contemporary arts.

Joan Mitchell is a radical example of this kind of American. Her reasons for living here are strictly personal. That is, she likes her friends, her three dogs, her studio in the plebeian 15th Arrondissement, her frequent trips to the Riviera from where she goes boating to Corsica, Italy and Greece. And that's about it. She rarely goes to the theater, movies or exhibitions (except to friends' openings) and never to parties. Her social life is limited to having friends over to lunch, and sometimes going at night to one of the Montparnasse bars frequented by American painters. She has French friends but few of them are painters. In a word, she does not participate in the cultural life of Paris, and although she can be said to live and work there, the city is little more than a backdrop for these activities. And that is perhaps the secret attraction of Paris for Americans today. Unlike New York and most other capitals, it provides a still neutral climate in which one can work pretty much as one chooses.

And it is precisely this lack of interference, even when it takes the saddening form of dealers and collectors losing sight of one, that is a force in much of the painting being done today by Americans abroad. This is perhaps less true of Joan Mitchell than of the majority of American painters in Paris, since she was established in America before coming to live here, and has continued to show regularly in New York and to return there for visits. Still, one feels that the calm of Paris and the fact that it is far from where the money is being made have affected her work (as well as that of Shirley Jaffe, Kimber Smith, Norman Bluhm, James Bishop, Beryl Barr-Sharrar and others). The exalting and the deadening effects of an abundance of cash and action are alike absent from her work. It looks strong and relaxed, classical and refreshing at the same time; it has both the time and the will to be itself. To the strength, the capacity for immediately sizing up a situation, the instinctive knowledge of what painting is all about which characterize the best postwar art in America, the sojourn in Paris has contributed intelligence and introspection which heighten rather than attenuate these gifts. It seems that such an artist has ripened more slowly and more naturally in the Parisian climate of indifference than she might have in the intensive-care wards of New York.

Joan Mitchell's new paintings continue an unhurried meditation on bits of landscape and air. There are new forms, new images in this new work, but no more than were needed at any given moment. For instance, one long horizontal painting uses almost unscathed planes of chalky color, their borders meandering but determined, like the lines of a watershed. A lesser painter might have been tempted to turn this discovery into a whole new vocabulary, "change his image." But these unelaborated planes happened to suit Joan Mitchell only once

or twice, after which she discarded them, for the time being at least. Again, "Calvi," one of a group of "new black" pictures ("although there's no black in any of them"), floats a dense, dark shape like an almost-square pentagon into the top center of the canvas. (The black in this case turns out to be dark blues and reds). But the abrupt materialization of this shape strikes few echoes in the other paintings, where calligraphy, sometimes flowing, sometimes congealing, continues patiently, as though in a long letter to someone, to analyze the apearances that hold her attention the longest. (She said recently, "I'm trying to remember what I felt about a certain cypress tree and I feel if I remember it, it will last me quite a long time.")

The relation of her painting and that of other Abstract Expressionists to nature has never really been clarified. On the one hand there are painters who threaten you if you dare to let their abstract landscapes suggest a landscape. On the other hand there are painters like Joan Mitchell who are indifferent to these deductions when they are not actively encouraging them. Is one of these things better or worse than the other, and ought abstract painting to stay abstract? Things are not clarified by artists' statements that their work depicts a "feeling" about a landscape, because in most cases such feelings closely resemble the sight which gave rise to them. What then is the difference between, say, Joan Mitchell's kind of painting and a very loose kind of landscape painting?

There is, first, the obvious fact that the elements don't really very often add up to a legible landscape (the black pentagon in "Calvi" looks no more like a cave than the squares in Mondrian look like skyscraper windows—that is, a confusion might be possible because of the limited number of shapes available, but everything in the intention of the painting is there to steer one away from it). But there are cases when they do. "Girolata" (named after a creek in Corsica, but after the picture was painted), one of the most beautiful of Joan Mitchell's recent paintings, is a large triptych which does look very much like a fairly literal impression of the face of a cliff pocked with crevices and littered here and there with vines and messy vegetation. Even the colors—grayish mauve, light green, black—are not too far from what they would be in an explicit representation of such a scene. Is this then figurative painting, and if so, what is the meaning of the term Abstract Expressionism?

The answer seems to be that one's feelings about nature are at different removes from it. There will be elements of things seen even in the most abstracted impression; otherwise the feeling is likely to disappear and leave an object in its place. At other times feelings remain close to the subject, which is nothing against them; in fact, feelings that leave the subject intact may be freer to develop, in and around the theme and independent of it as well. This seems to be the case in "Girolata"—for once the feelings were a reflection of the precise

look of the creek, or cliff, or whatever; nevertheless it is this reflection rather than the memory it suggests that remains the dominant force in the painting.

The proof of this is that the other, less realistic paintings in the show continue to impress us with their fidelity to what, in these cases, we can only imagine are the painter's feelings, since she does not provide us with the coordinates of a landscape to attach them to. A persistent shape, like a helmet or a horse's skull, doesn't give any clue to what the painter intended, except in one painting where it suggests dark masses of trees at the edge of a river. Elsewhere there are antagonisms and sparrings between shapes whose true nature is left unstated, and sudden lashings of caked or viscous pigment whose inspiration is again no longer in nature but in something in the nature of paint, or of the feeling that takes hold of a painter when he attacks it. Yet there is never any sense of transition; we move in and out of these episodes, coherent or enigmatic ones, always with a sense of feeling at home with the painter's language, of understanding what she is saying even when we could not translate it.

Joan Mitchell calls herself a "visual" painter. She does not talk much about her own work, perhaps not out of reticence, but because the paintings *are* meaning and therefore do not have a residue of meaning which can be talked about. The recent upsurge of conceptual art and the resultant downgrading of Abstract Expressionism do not particularly surprise or alarm her. Working in Paris, she has always been fairly independent of her fellow artists, American or French, and intends to go on as before.

There'll always be painters around. It'll take more than Pop or Op to discourage them—they've never been encouraged anyway. So we're back where we started from. There have always been very few people who really like painting—like poetry.

I don't think you can stop visual painters and all the rest is an intellectual problem. Did you see that article on Duchamp in *Time?* He's thankful that intelligence has come back to art and says he can't see any gray matter in Abstract Expressionism. That's why I use a little color.

She likes ideas when they're visual, as in Jasper Johns for instance, but "that particular thing I want can't be verbalized. . . . I like to look out of a window or at photos or pictures or at that awful thing called nature. I'm trying for something more specific than movies of my everyday life: to define a feeling."

ArtNews, April 1965

JAMES BISHOP

J AMES BISHOP, who has his first American show this month at the age of thirty-nine, is the Enoch Arden of younger American painters. In 1957 he left New York on what was supposed to be a brief trip to Europe and did not return until 1966. When he left, the Abstract Expressionist dynasty was firmly installed in contradictory peaceableness; he returns to something like the period of Chinese history known as "The Warring States" — a difficult, romantic time which the historian Frederick Hirth characterized as being full of "examples of heroism, cowardice, diplomatic skill and philosophical equanimity." The bumptious decade from the mid-1950s to the mid-1960s, a period of reversals and surprises, palace revolutions, deathbed conversions, posthumous knightings, anathemas, miraculous presages, eclipses, earthquakes and floods, was spent in the (for Bishop) detestable isolation of Paris. For

he is not one of those artists who advertise themselves as having worked for years in complete isolation. His reasons for living in Paris are personal and unconnected with art, and he has followed American developments with the zeal of an exile banished to some insalubrious colony, even though he was forced to rely largely on art magazines and the accounts of returning travelers, both of which frequently get things garbled. I insist on Bishop's long absence from the scene not merely to explain why his name is unfamiliar in New York, but also because I think it helps to explain the impressive originality of his painting. Uninhibited by the obligations of the success he would certainly have had in New York, he has been free to develop in a way artists seldom are today.

Bishop was born in Missouri in 1927; he studied at Black Mountain (with Vicente) and at Columbia, and lived in New York and Cambridge, Massachusetts, before going to France. Paris was slow to appreciate his work, perhaps because Bishop (with the combination of modesty and aloofness which characterizes him) made absolutely no attempt to promote it. Finally some of his friends succeeded in persuading the dealer Lucien Durand to make the trip out to Bishop's studio in suburban Sceaux to look at his work. Impressed, Durand immediately offered him a show, which opened in December 1963.

At that time Bishop had been six years away from America and, to his way of thinking, cut off from modern art. Not completely, however, for there had been rare exhibitions of major postwar American artists, and their very infrequency and the emphasis they gained from being seen outside an American context made these occasions even more momentous for the painter than they might have been in New York. Running into Bishop after the opening of a Rothko show in Paris, I was reminded of Henry James' account of how Hawthorne, receiving some Flaxman engravings from England, invited his New England neighbors over to see them and made quite an evening out of this rare cultural treat. (I should add that this view of Paris as a wilderness is exclusively Bishop's.)

In 1959 the Museum of Modern Art's show of Pollock and other Americans visited Paris, and Bishop was able to take in some recent work by Rothko, Still, Newman and Motherwell which probably influenced him a good deal: the "heroic period" of the New York School has been crucial in his development, but the artists just mentioned, his favorites, are not typical of the movement as a whole. In their work the romantic premise of Abstract Expressionism has largely become a question of scale, romanticism having turned into a more inclusive kind of classicism. At this time Bishop was painting in a style strongly influenced by Rothko in particular. Almost-opaque veils of color prevented one from seeing, but not from feeling, an intensely charged atmosphere, with or without accompanying structures and events, that reigned deep within the

canvas, appearing on its surface in the form of faint seismic displacements. The paintings of this period have a powerful, magnetic eloquence; they seem almost to speak. Except for Rothko, it is hard to think of a modern painter who has used color with so intuitive a knowledge of what it can and cannot do.

Despite the originality of this work and despite the reluctance of the Paris public to contemplate anything new, especially of American origin, his first show was a financial if not a critical success (the critics simply neglected to come). Its proceeds allowed Bishop to spend two months in Italy looking at art and filling in the gaps in his already extensive scholarly knowledge of Italian painting. He was especially impressed by the Ferrara painters Tura and Cossa (one of his paintings from around this time is called "News from Ferrara"); by the Sienese primitives; and by Piero della Francesca, Pollaiuolo, Sassetta, Crivelli. His rediscovery of the Italians coincided with the showing in Paris of important new work by Frank Stella, Kenneth Noland and Ellsworth Kelly, and these two apparently irreconcilable influences, the Quattrocento and the post-painterly, produced a new direction in Bishop's work. The ambiguous structures were fished up from beneath the surface of his paintings and fused with the surface into an elementary shape, such as a square archway or two perpendicular bars. He restricted his palette to three, two or sometimes one color, with strong, acid reds, greens and blues predominating. Often a band of color would frame an empty canvas, left untouched except for an occasional splash of paint from the brush, which was neither solicited as evidence of white-hot emotion, nor expunged for compromising the purity of the whole. The pictures suggested portals or prosceniums, but there was no tension, no feeling that something was about to happen on a bare stage, but rather a feeling that something had happened and might one day happen again; that possibilities are better than probabilities. The new work apparently disappointed his Paris admirers: no paintings at all were sold from his December 1964 show at Galerie Lawrence, though his first show had been a sellout.

Since then Bishop has tended toward ever simpler, stronger, calmer statements. In this he resembles dozens of young painters on both sides of the Atlantic, and yet his aesthetic is his own. "Reductive" as his work is, it is not preconceived but develops according to the usual laws of growth. He obviously has a pretty good idea of how the painting will look when finished, and he is also prepared to let it take a divergent course if it thinks best. He is doing what Maurice Denis said that Cézanne did: "preserving sensibility's essential role while substituting conscious reflection for empiricism."

Nor, despite Bishop's obvious enthusiasm for the "post-painterly," can his work be put in this category. Even in so elemental a picture as "Folded" or "Two Reds," where the image consists merely of two or three bars of color laid across

the top of an empty canvas, painting is always his chief concern. One senses here the importance that the early Italian masters have for him: his monochrome planes have the intense saturation, the deep flatness of an expanse of masonry or fabric in a Sassetta or a Duccio. The bands of color are like slits in a thick wall. One seems to be looking into a distant past; centuries of painting have been pulverized to produce this mediating, glowing, incantatory space. When painters once again begin to examine the nature of painting, Bishop may emerge as the major figure that he is: an artist in whom the perennial concerns of painting find dramatic expression in a language that is just being born.

ArtNews, December 1966

J AMES BISHOP has lived mostly in France since 1957, but in the North Atlantic tradition he keeps a studio in New York which he occupies for a small part of each year. Widely known in France and Italy, he has shown very rarely. His present exhibition of tiny oil sketches on paper—undated but spanning the last decade or so—and two recent large paintings is a delight.

Bishop has always been a Minimalist, but a sensitive one; the stripping down is obviously a decision of the heart, not the head. His new work is austere even by comparison with that which preceded it. The paintings are white, or no-color—the color of off-white window shades pulled against the sun. Only a few wraithlike rectilinear lines organize them; mostly the color, or absence of it, is left alone to pulse and breathe and surprise you with how full emptiness really is. The gouaches are more deliberately laid out, but the color is again severely limited to a scale in which burnt sienna is made to flash like scarlet and putty color operates as blue. They have an agreeably astringent taste—one always wants a little more, and one obviously isn't going to get it. The artist's unspecified motive in this is a seeming "Grab it while it's here" or "This hurts me more than it does you."

New York, May 21, 1979

GERTRUDE STEIN

This one always had something coming out of this one. This one was working. This one always had been working. This one was always having something that was coming out of this one that was a solid thing, a charming thing, a lovely thing, a perplexing thing, a disconcerting thing, a simple thing, a clear thing, a complicated thing, an interesting thing, a disturbing thing, a repellent thing, a very pretty thing. This one was certainly being one having something coming out of him. This one was one whom some were following. This one was one who was working.

Poets when they write about other artists always tend to write about themselves, and none more so than Gertrude Stein in the "Cubist" passage above from her *Portrait of Picasso*, which is reprinted along with her *Portrait of*

Matisse in the catalogue to the Museum of Modern Art's magnificent show of the Stein collections, "Four Americans in Paris." And never before, perhaps, has Picasso seemed as moving as he does now, appearing under the watchful aegis of the eccentric American lady who was his earliest apologist and whose brilliant gifts do so much to explain his own. Again we are reminded that the twentieth century, whatever else it may be, is the century of *Matisse, Picasso and Gertrude Stein*, the title of a Gertrude Stein work whose alternate title, *G.M.P.*, puts Gertrude's initial before the other two, which perhaps is as it should be. For, at least during this exhibition, the others begin to look like facets of her solid, charming, lovely, perplexing imagination.

A great gaiety and a certain melancholy pervade the show. In the years before Cubism we see Picasso trying out and discarding a number of approaches before settling down to form the alphabet of Cubism, and seeing these works, many of them rare examples of styles that didn't last long, is like receiving a succession of electric shocks. There are blue pictures (Picasso, Gertrude tells us in her book on him, brought back blue from a trip to Spain, blue being the color of that country in her opinion), including the superb "Blue House" now in André Meyer's collection. There are strong examples from his underestimated Rose Period, including the Cleveland Museum's magnificent "Head of a Boy" and a portrait of young Allan Stein, son of Gertrude's brother Michael and his wife, Sarah. There are "green" pictures — landscapes and still lifes from the period of *art nègre*, and cubic landscapes done on another trip to Spain, Spain also being the country of the cube, according to Gertrude. There is the Cézanne-like apple that Picasso painted for her to console her for the loss of a Cézanne painting of apples that Leo took with him when they divided up their collections (the Cézanne is in the show, too). There are nudes of the "Demoiselles d'Avignon" variety which are among the most profound and most disturbing expressions of modern art, and sheets of caricatures (including the famous one of Apollinaire as a nude muscle-man) which aren't funny at all and remind one how the total absence of humor in Picasso's paintings is a source of their strength.

Perhaps the knowledge that all this is leading inexorably up to the War is one reason for the melancholy, but there are others. In her book on Picasso, Gertrude Stein tells us that the early years of Cubism were years of gaiety, and that the gaiety ended when Picasso left Montmartre in 1912. The move itself can't have been the cause; in fact Picasso moved to Montparnasse, nearer to where Gertrude lived, which must have pleased her. Perhaps it has something to do with the fact that Cubism was now in full flower, and there was nothing much to look forward to except endless chains of masterpieces. Gertrude Stein said that Picasso achieved "perfection" and "total mastery" in the paintings of 1914–17, and in fact the last period of Cubism has never looked so gorgeous

and provocative as in this show. But ripeness and amplitude imply decline, even if it is a great distance off (in Picasso's case it would hold off for a couple of decades at least). A friend of mine experiences an annual depression some time before the summer solstice, at the thought that the days will eventually begin to get shorter; and in *The Autobiography of Alice B. Toklas* Gertrude Stein wrote: "She says she likes what she has and she likes the adventure of a new one. That is what she always says about young painters, about anything, once everybody knows they are good the adventure is over."

And it did end eventually. All the Steins' collecting activities diminished greatly after the war. Possibly they were less affluent than before; in any case their favorite artists, partly no doubt due to their own championing of them, were now too expensive to collect in the wholesale manner of former years. Gertrude made no major discoveries after Juan Gris, and perhaps none were to be made: the drama of modern art in France was all but played out.

Given the sureness of Gertrude's taste as a collector in the days of Cubism, it is puzzling to find her waxing enthusiastic over the likes of Bérard and Tchelitchev, good as they are in their limited way. And there are even more unlikely enthusiasms, such as Sir Francis Rose, of whom Gertrude acquired some 130 works. But—and this would explain the absence of Braque from her collection—perhaps she found the near-great peculiarly antipathetic. Better a nonentity like Rose, who in his total eclecticism could not really be said to be imitating anyone, than an inspired follower like Braque.

At any rate, while the "adventure" lasted it was a prodigious one, not only for the paintings but for their reflection in Gertrude Stein's writing. The period of *art nègre* and proto-Cubism coincides with the composition of her monolithic masterpiece *The Making of Americans*, a novel of which she remarks modestly in *The Autobiography of Alice B. Toklas* that the sentences get longer as the book progresses; and the growth of this peculiarly organic, irregular and repetitive work echoes Picasso's own feverish testing at the time. The passage about him quoted at the beginning of this article is typical of Gertrude Stein's early style, which was characterized by repeated statements with slight variations in them that jarringly fit together to give an impression of completeness as do the planes in a Cubist painting. Later, the analogy is less neat: Gertrude switched from writing "portraits" to "still lifes" as Picasso was doing the reverse in his Cubist period, but the unfathomable solidity of works like *Tender Buttons* has no obvious counterpart in art or in literature either. What it does is enunciate the triumphant *it is* of Picasso's pictures. In the very act of starting to ask, Why this one and not another? one is cut short by the undeniable thereness of the work. Something was certainly "coming out" of both Picasso and Stein; it could be anything but it was most definitely something.

Why Gertrude Stein, after a rather peripatetic early life which took her across the Atlantic and the American continent several times, chose to anchor herself in Paris (she did not return to America between 1903 and 1934) is not entirely clear. Certainly Paris is, or was, a very agreeable city to live in, but we tend to discount mere hedonism as a motive when dealing with an artist or an intellectual. We know her feeling that America was her country and Paris her home town; that good Americans go to France when they die*; but these are typical Steinian statements rather than explanations. One feels there must be a connection between her decision to install herself in Paris at the age of twenty-nine and the beginning of a period that saw the birth of *Three Lives* and *The Making of Americans*, her first masterpieces of narrative prose.

The distance from America afforded the proper focus and even the occasion for a monumental study of the making of Americans; the foreign language that surrounded her was probably also a necessary insulation for the immense effort of concentration that this book required. But there was frustration, no doubt, in the fact that few if any members of her entourage in the early days of the rue de Fleurus salon could have or would have appreciated her work: even her admired older brother Leo, who had a keen intelligence and was unhampered by a language barrier, rejected it. No doubt Picasso and the rest of her circle took the fact of her genius on faith and let it go at that. The first Frenchman to really understand and champion her work seems to have been Bernard Faÿ, whom she did not meet until the 1920s.

Surrounded as she was by brilliant minds in her chosen place of exile, Gertrude Stein was peculiarly alone. It would have been difficult to find an audience anywhere in the world at that time for such highly experimental writing, but especially in the traditionally conservative esthetic climate of official Paris from which she was in any case separated even further by her language. Thus she was both free to go her own way, inspired by the example of Picasso with whom she was in constant contact, and also alone, which accounts for the anguish one feels behind the screen of verbiage in this early work, and which ultimately lifts it into greatness. *The Making of Americans*, a serious attempt to catalogue every sort of person who existed on the face of the earth, was a Tower of Babel, doomed from the start. It could have been a monumental bore, if the author had not managed to keep us convinced that she understood both the hopelessness of the task and the absolute necessity of undertaking it. The neutral atmosphere of Paris—stilted and *arrière-garde* on the one hand, teeming with unrecognized artistic ferment on the other; offering a comfortable,

* This remark, often attributed to Gertrude Stein, actually occurs in Oscar Wilde's play *A Woman of No Importance*.

neutral, cosmopolitan working space to a writer who did not wish to be disturbed—no doubt helped considerably.

Both Picasso and Gertrude Stein manage to escape critical judgment by working in a climate where it simply could not exist. Picasso sets up new forms whose newness protects them from criticism: there are no standards by which to judge them except the painter's own as gleaned from other works by him. He has continued to occupy this safe, fertile universe. Similarly, Gertrude Stein's method of composition is to make statements which cannot be disproved even when they may be ignored. Who could argue with this statement from *Tender Buttons:* "Light curls very light curls have no more curliness than soup. This is not a subject"? Even in her "normal" writing like *The Autobiography of Alice B. Toklas* her way is to proceed from one unshakable (though not necessarily correct) affirmation to the next. She begins her book *Paris France* by informing us: "There are two things that french animals do not do, cats do not fight much and do not howl much and chickens do not get flustered running across the road, if they start to cross the road they keep on going which is what french people do too." It is impossible to refute a statement made in a poem; poetry is by nature true and affords blanket protection to anything one wishes to say in it. Gertrude Stein is a poet in this sense. Like Picasso, she is *building.* Her structures may be demolished; what remains is a sense of someone's having built.

Whatever one's position in the Picasso-versus-Matisse controversy, one has to admit the superiority of Picasso in the framework of the present show. Like the Steins who collected him, Matisse remains somewhat in the background. Not that there aren't some important examples of his work: the study for "Music" and the "Blue Nude" which caused so much fuss at the Armory Show are included, and two marvelously bold and austere portraits of Michael and Sarah Stein. But somehow his interpretive approach, Apollonian though it is, cannot quite stand up to the ferocious creativeness of the early Picassos. Matisse seems to be saying, This is the way it is; Picasso merely thrusts up chunks of a new and unknown reality like strata in a telluric upheaval.

There is a public for whom the uncontrolled making of new things will always remain beyond the pale. Leo Stein ceased to be interested in Picasso as the latter approached Cubism, and he could not take his sister's writings seriously. In a new and doubtless definitive study called *Gertrude Stein in Pieces,* Richard Bridgman quotes Leo on the subject of the errant pair: "Both he and Gertrude are using their intellects, which they ain't got, to do what would need the finest critical tact, which they ain't got neither . . ." and again, speaking of the triangular noses in Picasso's *art nègre* figure paintings, "When once you know that a nose is not a nose is not a nose you can go on to discover what all the other things are not. . . ." History may seem to have had the laugh

on Leo, and yet, despite the fact that Picasso's name is now a household word, who has really understood or explained away those triangular noses? *Tender Buttons* has made it into a Modern Library selection of Gertrude Stein's writing, but how many people have actually read it and of these how many can claim to have gotten anything at all from it? Despite lip service, her achievement, though present, is somehow endangered, and it will be a long time before a true evaluation of it will be possible. Matisse's work is secure; Gertrude's and Picasso's, ubiquitous as it is, remains excitingly in doubt and thus alive. This is why the show of the Steins' collections turns out to be not only very beautiful but at times almost painfully exciting to witness.

ArtNews, May 1971

PATRICK HENRY BRUCE

T HE NAME PATRICK HENRY BRUCE is not unknown in the annals of modern art. An American who spent most of his life in France, Bruce showed his work in the annual Paris salons and in the Armory Show. Six of his paintings were acquired by the enlightened patroness of the arts Katherine Dreier for her Société Anonyme collection, which she gave to Yale in 1941. His work is in other public collections, including those of the Metropolitan and the Whitney, the Museum of Modern Art, and the Centre Georges Pompidou in Paris, and it has occasionally been included in exhibitions. The first Bruce retrospective, organized by William C. Agee and Barbara Rose, opened earlier this year in Houston and has now come to the Museum of Modern Art in New York, reversing the usual direction of these cultural exchanges.

Yet despite such evidence of an enduring reputation, Bruce has remained virtually unknown. His standing as an artist should now be secure, and Mr. Agee's and Ms. Rose's claim for him as a major twentieth-century artist who would be recognized as such had the circumstances of his life been different is, on the basis of this show, to be taken seriously. But the man himself is still a wraith and probably always will be.

Thanks to the catalogue, which incorporates a *catalogue raisonné* of all of Bruce's surviving work and is an important part of the show, we now know the basic facts of his biography (even the year of his death had been disputed until quite recently). We know now from photographs what he looked like, what his wife and son looked like, and what his Paris apartment looked like (an important discovery, since the furnishings provide clues for unraveling his late abstract still lifes). Yet, while the detective work of the organizers has illuminated many mysteries, it points to the existence of still others, which I'll come back to.

It turns out that Bruce was born in Virginia in 1881 (the exact place and date are uncertain) to aristocratic but far from affluent parents; he was the great-great-great-grandson of Patrick Henry. Left an orphan at sixteen, he worked briefly at a real-estate job in Richmond before going to New York to study with William Merritt Chase and Robert Henri at the New York School of Art. He soon moved on to Paris, where he eventually discovered modernism in the work of Cézanne and Matisse. He frequented Gertrude Stein's salon in the rue de Fleurus and was even friendlier with her brothers Leo and Michael. His work was admired by Matisse, Apollinaire and the Delaunays; for a time he was the only American painter whom the French avant-garde took seriously. He showed at galleries in Berlin and New York as well as in Paris, and seemed at the threshold of a brilliant career.

After World War I things took a different turn. His marriage fell apart, and his wife returned to New York with their son. Arthur B. Frost, a young American painter who was his closest friend, died before the age of thirty. Bruce's style changed in ways that his Paris supporters couldn't condone, and he became increasingly withdrawn and embittered, periodically destroying his work, refusing to show it except to one or two friends and after 1933 to anyone at all.

The Depression ruined his antiques trading business, and his health declined. Forced by circumstances to return to New York for the first time in more than thirty years, he committed suicide with Veronal in November 1936, having destroyed as many of his works as he could get his hands on— determined, as Agee says, to leave no trace of himself behind. Only recently has the surviving work managed to pierce this self-imposed interdiction and find a

response among younger artists who, like Bruce, practice an abstract art dominated by color. It is the classic story of the artist out of sync with his time, painful to read but redeemed by the eerie beauty of the late pictures.

Early works illustrated in the *catalogue raisonné* show that Bruce was a gifted if conventional portraitist even before he went to study with Chase and Henri. He didn't readily renounce his academic formation in France, but once he had come under the spell of Matisse and other "freaks," as Henri called them, the change was irreversible. The prewar landscapes, still lifes, and studies of foliage show him working with great originality in a style not yet his own. Increasingly he discards drawing and modeling to let color sculpt and situate his subjects in space. And his preferred colors—cool but intense pastel reds, mauves, and apple greens—are highly idiosyncratic ones that will return later on to invest the late abstractions.

A period of probing and uncertainty must have produced the hectic "Compositions" of 1916, whose interweaving, stridently colored planes show the influence of Delaunay's Orphic abstraction and perhaps of the Synchromists; as did Delaunay, he takes the confusion and multiplicity of modern urban life as a point of departure. One painting is named after the Bal Bullier, a popular dance hall which Bruce frequented for a time. Then, from the early twenties onward, he began formulating the language of his ultimate, quasi-abstract still lifes, which Barbara Rose compares to the solitary bead game of Hermann Hesse's *Magister Ludi:* twenty-three of these are included in the show, and they are Bruce's real achievement.

Still-life objects such as an orange, a glass with a straw, a plant, a boater hat, and other less decipherable geometric forms are blocked out with unmodulated planes of glacial pastel hues separated by black and white and areas of unpainted canvas. Their relationship to one another is "metaphysical" in the de Chirico sense, with none of the latter's enigmatic poetry to deflect attention from their supreme object-ness. Analyzing their subtle skewings of perspective and lighting, Barbara Rose says: "Bruce has depicted, in the most lucid, seemingly rational terms possible, a madhouse of contradictions in which no two objects are seen from the same point of view or lit from the same source." Even more than his sophisticated manipulation of color theories, the high intractability of this parallel universe—"a completely new set of objects," in Wallace Stevens' words—makes it exciting and relevant to today's color painters and to us.

The artist remains as enigmatic as his art. The catalogue skirts a number of issues: I cannot learn from it, for instance, whether Bruce's widow and son are still living, and though interviews with them and with his friends are cited, none is quoted from extensively. Who is the "Madame X" with whom Bruce shared

the last years of his life and to whom he wrote just before committing suicide? Who was responsible for the damaging alterations to some of the paintings after William Agee had photographed them in Paris in 1964, and why were they made? There are still enormous gaps in the novel of Bruce's career; meanwhile the multicolored spars from its wreckage are altering the scenery of modern art.

New York, September 10, 1979

MARSDEN HARTLEY

In 1979 THE MUSEUM OF MODERN ART brought us a retrospective by Patrick Henry Bruce, a painter who had previously been only a footnote, though a frequently encountered one, in histories of twentieth-century American art. The show was a revelation and immediately placed Bruce in the front rank of early vanguard American painters. Now the Whitney Museum is performing a similar service, on an even more ambitious scale, for another neglected pioneer, Marsden Hartley; once again, it is an important act of restitution.

The two cases aren't quite the same, since Hartley's work, unlike Bruce's, has not been an unknown quantity — in fact, one is struck by how many pictures of the more than a hundred at the Whitney are familiar, from either museum collections or reproduction. Still, this is the first time a large show has been

attempted. As Barbara Haskell, who organized it and wrote the catalogue, points out, Hartley "occupies a singular position in the history of American art. Considered one of the leading practitioners of an abstract style in the first half of the twentieth century, he is treated as a key figure. . . . Yet no major monograph—no full-scale and scholarly study of his life and work—has ever been published." Ms. Haskell, who had access to papers and other biographical materials unavailable to other researchers, has succeeded in bridging the gap. Her monograph on Hartley, while not quite a full-fledged critical biography or a *catalogue raisonné,* is nevertheless invaluable for understanding this strange artist.

It is always a surprise to realize how recently avant-garde art gained credibility in the United States. Hartley died in 1943, a scant decade before the Abstract Expressionists began to win tremendous critical acclaim and monetary success. Yet up until the last year of his life, he had known mostly extreme poverty: For a long period he managed to live on the sum of $4 a week, and even that wasn't always forthcoming. Like Bruce, he fled to Europe at the first opportunity, frequented Gertrude Stein's salon and achieved a certain *succès d'estime;* also like Bruce, he was finally compelled to return to an America he despised. And both were punished for their expatriate wanderings by neglect after their return, though the neglect was far more acute in the case of Bruce, who committed suicide in New York a few months after arriving. Hartley, who often considered suicide and once practiced composing suicide notes, lived on and finally came to terms with his homeland, which, at the end, grudgingly accepted him.

Edmund Hartley (Marsden, his stepmother's maiden name, was added later) was born in 1877 to poor working-class English parents who had emigrated to Maine. His mother died when he was eight, and he was shunted from relative to relative before joining his father and stepmother in Cleveland, where he had his first art lessons. A perpetual wanderer who never during his adult life spent more than ten months in the same lodgings, Hartley eventually made his way to New York, met Alfred Stieglitz and had his first one-man show at the latter's 291 gallery. Three years later, with Stieglitz's help, he was able to visit Europe for the first time, and began to absorb just about every prevailing tendency, from the Fauvism of Matisse and the Analytical Cubism of Picasso to Kandinsky's lyrical abstraction and the Expressionism of other painters of the Blaue Reiter group in Germany.

Until then, Hartley's most notable works had been proto-Expressionist landscapes of Maine—tremendous dark mountains beetling over tiny, helpless-looking farmhouses. Now he began to branch out in all directions, particularly

after arriving in Berlin, whose energy and street life were more attractive than those of Paris and where he could indulge his lifelong passion for solitude in the midst of a crowd. The endless military parades in Berlin were a special delight to him and resulted in his well-known series of "military" abstractions—at that time among the most advanced paintings ever done by an American.

The outbreak of World War I eventually forced him to return to New York, where these seeming homages to Prussian militarism found few admirers in a city that had banned the music of Beethoven and Mozart and renamed sauerkraut "liberty cabbage." And indeed, what was one to make of them? For, unlike the anonymous printed fragments in a Cubist collage, Hartley's signs were private allusions, referring to a young German lieutenant, Karl von Freyburg, whom he had met in Paris and fallen in love with. It is not known whether this relationship was ever consummated (though elsewhere Ms. Haskell provides for the first time details concerning Hartley's long-hushed-up homosexuality), but in any case, Freyburg's vital statistics enter into paintings such as the 1914 abstraction "Portrait of a German Officer," which utilizes his initials (K. v. F.), his regiment number (4), and his age (twenty-four) when he was killed during the first months of the war; the composition is dominated by an Iron Cross. Even if one were to ignore the overtones of propaganda, it would be impossible for any spectator who didn't know the circumstances of Hartley's life to interpret this iconography correctly, and in America Hartley found himself estranged from the progressive public who might otherwise have been receptive to his experiments.

This indifference persisted during the remainder of his career. Constantly needy, often in poor health, morbidly sensitive to the point of arrogance, Hartley had a knack of alienating those who might have helped him. During the 1920s and much of the 1930s he drifted from style to style and from country to country without ever putting down roots. It wasn't until his definitive reluctant return from Europe in 1934 (bringing with him landscapes of the Bavarian Alps which, due to Hitler's rise to power, were once more anathema to Americans) that he began finally to assimilate the jumble of modernist influences he had embraced one after another ever since his first trip to Europe, and became what he was at the beginning: an Expressionist and visionary determined to focus the power and tragic potential of the American scene, particularly as it appeared in the rugged landscape of northern Maine, where he frequently sojourned.

This late period culminates in the amazing series of "portraits" of Mount Katahdin, which Hartley climbed in a sort of pilgrimage when he was old and ailing. And there are other great paintings from this period: symbolic, iconlike portraits of a family of fisher-folk with whom he lived in Nova Scotia; earthshak-

ing confrontations of surf and rock, as in the "Lighthouse" (1940); still lifes of fishes, flowers and dead seagulls that are emblems of a fierce religious conviction akin to Rouault's. Here, Hartley's work finally comes of age, and the resulting body of work constitutes one of the finest, and until now least understood, chapters in the history of modern American painting.

New York, March 31, 1980

ANDY WARHOL IN PARIS

"LE POP ART" became a respectable *franglais* term in record time. Re-
porters are always asking Brigitte Bardot and Jeanne Moreau what they think of
it; it is the theme of a striptease at the Crazy Horse Saloon; and there is even a
Pop Art dress shop in the rue du Bac called Popard, decorated with photomurals
of Blondie comic strips.

Perhaps this explains why Andy Warhol, in Paris for the first time for his
show here, is causing the biggest transatlantic fuss since Oscar Wilde brought
culture to Buffalo in the nineties. He has been photographed at Chez Castel by
Paris-Match and *Vogue,* and his opening broke all attendance records at the
Galerie Ileana Sonnabend.

A shy, pleasant fellow with dark glasses and a mop of prematurely gray
hair, Warhol seems both surprised and slightly bored by his success. He claims

not to believe in art, although he collects paintings by fellow artists who have little in common with him, such as Joan Mitchell, Willem de Kooning and Fairfield Porter.

His own show consists of dozens of reproductions of photographs of flowers taken from a Kodak ad, in a variety of color schemes but with only two or three basic designs. They are produced by a lithographic process, and Warhol, who hates physical effort, doesn't have very much to do with their actual creation. "Friends come over to my studio and do the work for me," he yawned. "Sometimes there'll be as many as fifteen people in the afternoon, filling in the colors and stretching the canvases."

The flowers are a change from the Campbell's soup cans which first made him famous. "I thought the French would probably like flowers because of Renoir and so on. Anyway, my last show in New York was flowers and it didn't seem worthwhile trying to think up something new."

Asked how he liked Paris, he became momentarily more animated. "I love it. I never came here before because I didn't believe in it. I traveled all around the world, even to Katmandu, but I never wanted to see Paris. Now I hate to leave. Everything is beautiful and the food is yummy and the French themselves are terrific. They don't care about anything. They're completely indifferent."

Indifference is a quality that rates very high in Warhol's books. His opinion of Pop Art would probably surprise many of his fans, starting with his dealer. He thinks it's finished. Does this mean he's going to stop producing it? "I don't know. Maybe I will. My real interest right now is movies. I make a movie every day."

This is possible because Warhol lets the camera do all the work for him. One of his movies, called *Sleep*, is an eight-hour documentary of a man sleeping. Another is a half-hour short of the critic Henry Geldzahler smoking a cigar.

Though art may be finished, Warhol believes that artists will go on. "Only they'll change. They'll become more like impresarios. They'll organize things rather than do them." He notes that such a trend has already begun in New York. "Everybody's branching out. Claes Oldenburg has bought a movie camera. Jim Dine and Rosenquist have bought movie cameras. Rauschenberg has bought a movie camera and founded his own ballet company."

But Warhol is so far the only artist in his set to have his own fan clubs. "I have five of them. Three in New York, one in Massachusetts, one in South Carolina. They're called 'Fannies.' It's nice to have fans. Maybe I won't give up painting after all. Why should I give up something that's so easy?"

The far-out fringe has been very in this week. Another member is Arman, one of the rare French artists to find favor in New York at the moment. Andy Warhol considers him one of the most indifferent of Frenchmen.

Arman's new work is impersonal and beautiful. As usual, he offers "accumulations"—numberless copies of the same object arranged together in a frame or eternalized in a block of transparent plastic. The pleasantly noncommittal colors of metal dominate in this show. One work is thousands of metal washers behind a sheet of acrylic. Curiously, it has a vivacity that Kandinsky would have admired. Another work, "Prison of Aeolus," assembles several dozen electric fans into a sleek bas-relief.

It is getting harder for artists to come up with something original in the way of invitations, but those designed by Arman for his show deserve an award of some kind. He has spelled out his name and the pertinent data in tiny metallic letters and imprisoned them in a plastic ice cube. Real cool.

New York Herald Tribune (International Edition), May 17, 1965

IV

PORTRAITS

MAX KLINGER

F EW PEOPLE TODAY have heard of Max Klinger (born 1857 in Leipzig; died 1920 at Grossjena, near Naumburg), and these few would be even fewer if Giorgio de Chirico had not admired him to the point of writing an admiring article on his work, published in the review *Il Convegno* in 1920. Klinger thus joined Raphael, Courbet and Böcklin in the bizarre cenacle of artists to whom de Chirico has paid written homage. Metaphysics makes strange bedfellows.

Reading de Chirico on Klinger is like listening to a brilliant defense attorney who is fully aware of his power of moving the most hard-hearted jury to tears:

> What is this romanticism of modern life? It is the breath of yearning that flows over the capitals of cities, over the geometry of suburban factories, over the

apartment houses that rise like cement or stone cubes, over the sea of houses and buildings, compressing within their hard flanks the sorrows and hopes of insipid daily life. It is the pretentious private residence in the breathless torpor of a springtime morning or the moonlit calm of a summer night, with all the shutters closed behind the garden trees and the wrought-iron gates. It is the nostalgia of railroad stations, of arrivals and departures, the anxiety of seaports where ships, their hawsers loosened, sail into the black waters of the night, their lights aglitter as in cities on a holiday. *

Elsewhere in the essay he says, "The pictorial question did not matter, because his entire creation was based on the enormous possibilities of his exceptional mind—the mind of a poet, philosopher, observer, dreamer and psychologist." Which reminds one of de Chirico's definition of art in an early essay, "Meditations of a Painter":

A truly immortal work of art can only be born through revelation. Schopenhauer has, perhaps, best defined and also (why not) explained such a moment when in *Parerga and Paralipomena* he says, "To have original, extraordinary, and perhaps even immortal ideas, one has but to isolate oneself from the world for a few moments so completely that the most commonplace happenings appear to be new and unfamiliar, and in this way reveal their true essence." If, instead of the birth of *original, extraordinary, immortal* ideas, you imagine the birth of a work of art (painting or sculpture) in an artist's mind, you will have the principle of revelation in painting.

"The pictorial question did not matter . . ." Despite the nineteenth-century sound of "principle of revelation," Klinger is one of those artists who transcend the restrictions of the pictorial question and therefore of criticism. Appearances to the contrary, he is a colleague of such artists as Duchamp, Mondrian or de Chirico himself. In each of these cases, the "meaning" of art is offstage—either (as with de Chirico and Klinger) buried so deep inside the work that no one can find it; or (as with Mondrian) somehow adjacent to the work but out of sight; or (as with Duchamp) just absent. Thus, if we accept Klinger at all as an artist (and probably, in the absence of any case for the prosecution, we shall have to admit de Chirico's virtuoso defense), we must forget about "the pictorial question" and accept both the academic virtues for which he was admired in his day, and also the "faults" of drawing and composition for which

* This and other quotations from de Chirico are from James Thrall Soby's *Giorgio de Chirico* (1955).

he was sometimes scolded by his contemporaries. (For example, the stern Elizabeth Luther Carey of the *New York Times,* who was perhaps not so far wrong in her estimate of Klinger: "We may say that his drawing is sometimes poor, his imagination clumsy, his treatment of a subject coarse, but . . . out of his figures looks the spirit of life, more often defiant than noble, more often capricious than beautiful, but not to be mistaken.")

Although Klinger was a painter and a sculptor (his realistic, polychrome statues of nudes approach the ultimate in creepiness), what little reputation he has today rests on his engravings, especially the series called *A Glove* (so titled in its first and third editions; the second edition was entitled *Paraphrase on the Finding of a Glove*). While individual engravings and another sequence called *Fantasy on Brahms* are also notable, *A Glove* is the most prodigal of what de Chirico, in the title of one of his paintings, calls "the joys and enigmas of a strange hour."

Although *A Glove*'s scenario was given its due Germanic explication by contemporary critics, it defies rational analysis. The last picture, which was seen as a kind of happy ending to the glove's peregrinations, is particularly ambiguous and leaves the whole meaning of the series in doubt. The story is a parable of loss about a trivial lost article, like the lost keys in *Bluebeard* and in *Alice,* like Desdemona's missing handkerchief, or like the philosopher's spectacles in Klinger's own *Fantasy on Brahms,* which have slid out of their proprietor's reach just as he was nearing the summit of a kind of Matterhorn. There are overtones of erotic symbolism and fetishism in the glove and in the phalloid monster who abducts it, heightened for a modern viewer by the Krafft-Ebing-period costumes and decors (the engravings appeared in 1881, and the drawings were apparently finished in 1878).

Scene, the first plate in the series, seems at first to be a perfectly straightforward vignette of a group of people standing around in a Berlin roller-skating rink; the two at extreme left have been identified as portraits of Klinger (in striped trousers) and his friend Prell. But as one continues to look at the picture it becomes curiouser and curiouser. Several of the figures are looking out toward the viewer at a new arrival whom we cannot see, no doubt the owner of the glove whom we shall glimpse in the next plate. Her invisible presence already sets up a current of uneasiness. In addition, to quote the critic Paul Kuhn, "the figures standing around and greeting each other are lifeless, as in a fashion plate." All, that is, except the little girl who has just taken a spill. Her arrested motion makes us realize that what we are looking at is actually a kind of high-speed snapshot, in spite of the relaxed, lounging poses of the other figures.

Plate II, *Action,* presents the crucial, irrevocable moment of the drama. Everything contributes to give the scene that strangely immortal look that our

surroundings take on during a moment of crisis: the arbitrary framing of the hero in the outline of the distant terrace (a device also used by such masters of the bizarre as Carpaccio and Balthus); the strange, phallic dome of the pergola; the stiffly swaying postures of the background figures including the mysterious lady herself: in this, our only close look at her, we see only her back. (Some critics call her "the Brazilian," and Kuhn identifies her with an actual Brazilian girl whose graceful roller-skating was for a time the talk of Berlin.)

With the fatal purloining of the glove begin the hero's dream misadventures. In each of the succeeding plates the glove appears as in a puzzle; sometimes it is tiny and almost invisible; sometimes it swells to monstrous proportions as though to call attention to the protagonist's complex sin: at once a theft, a transgression of sexual taboos, and the always fatal worship of an image rather than the reality it symbolizes—literally, in this case, the container instead of the thing contained. In "Dreams (III)," the hero is safe in bed with his trophy before him on the coverlet, but he seems to be lost in anguished dreams. There are other signs that already all is not well: a young woman, the Brazilian no doubt, is watching him from a distance; and nature (the slender trees, the forest on the hillside) has begun to take on disquieting resemblances to the object of his monomania. (Furniture in a landscape, such as we see here, is a theme that frequently occurs in de Chirico's paintings of the 1920s, such as the circa 1927 "Furniture in the Valley"; and in his prose.)

The hero is next seen (in "Rescue") in a small boat, trying to fish the glove out of a billowy sea. It is worth noting that he is now wearing his hat, which he dropped the moment he picked up the glove, although it seems hardly appropriate to his present nautical role. In "Triumph" the glove is riding a conch-shell chariot drawn by two coursers through a tide of flowers; it grips the reins with a force that is in utter contrast to its helpless state in "Rescue." This plate marks the first appearance of one of the crocodilelike creatures who seem to be the glove's custodians. In "Homage" we find that the glove lies on a kind of altar at the edge of the sea and seems to be accepting offerings from the waves, which are strewn with roses.

Next, in "Anguish," the most spectacular plate of the series, the sea invades the hero's bedroom in a Freudian nightmare awash with sexual symbols, such as the candle, the moon, the dugs of the witches, and the white, feminine hands that are reaching out for the glove, which has become monstrous and dominates the other objects in the room. One recalls Auden's lines, "The mouse you banished yesterday / Is an enraged rhinoceros today."

Somehow the hero again retrieves his quarry, for in the next plate, "Peace," he has placed it on a table in a little sanctuary closed off by a curtain of gloves, perhaps so that it will feel at home. But such subterfuges, as we know

from Proust's *The Captive*, never succeed. The crocodile is already parting the curtain with its snout, and in "Abduction," the penultimate picture, it flies off with it into the night, as the hero's arms grasp futilely through the panes of a broken window. (How the crocodile managed to get through one of the holes in the window is one of the many enigmas of the series.)

In the last plate, "Amor," the glove is once more in a sanctuary, watched over by a smirking cupid. But it is impossible to know whether this sanctuary is the hero's night table, as some writers (including de Chirico) have supposed. It is more likely something in the nature of Pandora's box, a repository for archetypal erotic trifles, where the glove will remain until it is next needed to trouble the sleep of mortals. But one cannot say for sure. One of the properties of the metaphysical, of "art by revelation," is to elude the very definitions it proposes. The secret of such art is, like the glove, something inviolable, despite the hazards which surround it and are its natural element.

ArtNews Annual, October 1966

TOULOUSE-LAUTREC

T<small>HE CROWD WAITING</small> in the rain outside the Petit Palais museum in Paris rivaled the one queueing up for the latest Alain Delon movie on the Champs-Elysées. The reason was that the long-awaited Toulouse-Lautrec centenary exhibition had just opened and already seems set to break all box-office records, even that of the Delacroix show two years ago.

I suppose I should be disqualified from writing about it, since I am one of a very small minority who do not fully appreciate Lautrec's work. Trying to analyze my reasons for this as I went through the exhibition, I concluded that, brilliantly executed as they are, these works depend far too much on their subject matter for their effect, and that one's response to them is sharply conditioned by how worked up one can get about Montmartre night life at the turn of the century. I personally believe that *la belle époque* as it has come down

to us was a boring and occasionally tragic period, that the floor show at the Moulin Rouge was pretty tacky, and that drinking champagne out of Cléo de Mérode's slipper at Maxim's at three in the morning was not the ultimate sensual experience.

Still, a great painter can make any subject interesting, and it is conceivable that another might have been able successfully to amplify this thin thematic material—in fact, Renoir did so in "Le Moulin de la Galette," and so did Bonnard in some of his Nabi pictures.

It may be Lautrec's own uncertainties as to what he felt about his subjects that produce the vaguely restless and unsatisfied feeling that we, or at least I, experience in front of a Lautrec painting. We interrogate his models: are we to feel sorry for the ladies in the rue des Moulins, for instance, or shocked, or amused, or angry with society for bringing them to this pass? They cannot supply the answer, and meanwhile we become uncomfortably aware of a kind of stuffiness in the painting, a lack of air and space around the objects, in fact of the absence of an unconscious nobility we do find in Renoir and Bonnard.

Would Lautrec have been a different, and greater, painter if the accident which caused his physical deformity had not forced him away from the cultivated aristocratic society into which he was born and into the bars and brothels of Montmartre, where people at least made fun of him openly? This is one of the questions raised by this large and definitive exhibition, which is made up of works from the Lautrec museum at Albi and also from public and private collections in France and seven other countries, including the United States.

Lautrec's pre-Montmartre work, which is especially well represented in the show, is in quite another vein. We see him in his youth trying a number of styles, often with success. Two tiny views of vineyards on his family's estate at Célyran, done when he was sixteen, are in a limpid Corot-like manner. A vignette of horses in the Bois de Boulogne done the following year is dashed off in a sketchy style that suggests Monticelli. One can feel Manet's presence behind the cool and sober portrait of van Gogh, painted in 1887; while the "Artilleryman and Girl" of 1886 is in an amazingly advanced technique that, as the catalogue says, anticipates Rouault.

These, and other occasional pieces—sketches of animals (Lautrec's first teacher was Princeteau, an animal painter who was also a family friend) and here and there a quiet portrait, especially those of his mother—have a profounder ring than the recognized masterpieces that make up the bulk of the exhibition: La Goulue, Jane Avril, Yvette Guilbert, May Belfort, and all the anonymous denizens of Montmartre whom he immortalized. These works are certainly close to the borderline between talent and genius, but on this side of it in my opinion.

An exception is his "Moulin de la Galette" from the Chicago Art Institute, a picture whose colors and ambitious composition suggest the later "Salon de la rue des Moulins." Here, for once, he succeeded in ennobling the commonplace, in giving a timeless generality to a moment in time, in attaining, as Proust said of Vermeer, "a world of kindness." It is this kindness, not to be confused with affectionate semicaricaturing, that is critically absent in most of the other major works.

New York Herald Tribune (International Edition), October 13, 1964

ODILON REDON AND

MAURICE DENIS

A SPRINKLING OF shows of modern French masters in the galleries is adding luster to this season, which has so far been more remarkable for art of the past than that of the present.

The Galerie Bernheim's show of Odilon Redon is mostly from French private collections. Though a contemporary of the Impressionists, Redon found their "ceiling" too low and worked in another, more imaginative vein. Modest and retiring, he did not become known until he was well past forty, when the Symbolists discovered him, though his real fame dates from the Surrealists, who placed him in their pantheon of ancestors.

There are two sides to Redon's character: the romantic but straightforward painter of landscapes, flowers and portraits, and the creator of the tortured nocturnal lithographs and allegorical paintings. Strict copying of nature was a

kind of exercise which liberated his imagination. He once wrote: "It is only after an effort to represent in detail a blade of grass, a stone, a branch or a bit of old wall that I am seized by a torment to create the imaginary. . . . I owe my major works to the moments which have followed such exercises."

I have always found Redon's realistic paintings more fantastic than the imaginary ones, and the flower pieces stranger and more disturbing than the monsters who lurk in his graphic work. In paintings like the "Still Life with Two Peppers" in this show, or the "Still Life with a Blue Jug," he emerges as a kind of Cézanne of the unconscious. That is, he discovered new laws of inner vision, as striking and as valid as Cézanne's revolutionary optics. The deep cerulean shadow on the brown jar in the latter picture is a color no one has ever seen in nature, yet it is both romantic and right.

There are other beautiful samples of Redon's "imaginary realism" in the show, such as the early "Médoc Heathland" with its *merveilleux nuages*, the "Horse in a Pasture," the "Cliffs of Valières," a scene of Venice, and a number of flower pieces in oil and pastel. There is also a pastel of "Mme. Sabouraud," a remarkable example of Redon's meticulously realistic but fantastic portraits. A large selection of original lithographs completes the show.

We do not often get to see much of the work of Maurice Denis. This is perhaps just as well. Though isolated samples of his painting have a mellifluous charm, an exposition as large as that at the Galerie Beaux-Arts can be cloying.

A founder of the Nabi movement with Vuillard and Bonnard, Denis seems much closer to some of the artists of Gauguin's Pont-Aven group, with which he was also associated. He defined a painting as "essentially a plane surface covered with colors assembled in a certain order." This resulted in pretty *cloisonné* effects which often work well in the landscapes—some, like the ones called "Meadow with Horses" and "The Rise to the City," are modest masterpieces. But as soon as figures enter the scene, sentiment takes over. Denis painted babies galore, with or without their pretty young mothers, and though he obviously meant well, the result is suggestive of a 1900 ad for Mother's Oats. Still, mostly because of the landscapes, this is a show which can be seen for pleasure as well as for historical reasons.

New York Herald Tribune (International Edition), May 22, 1963

JEAN FAUTRIER

PARIS IS FINALLY getting a long look at the work of Jean Fautrier, an abstractionist who has been billed by André Malraux and others as France's answer to Jackson Pollock and the New York School. Though he won the International Grand Prize at the 1960 Venice Biennale, there has been no important show of Fautrier here since 1957. Now the Musée d'Art Moderne de la Ville de Paris comes forward with a retrospective covering his work from 1921 to the present.

Born in Paris in 1898, Fautrier spent his early adolescence in London, where he studied with Sickert, a painter who seems several eons away from him in time as well as aesthetics. After World War I, in which he fought and was gassed, he began showing in groups and in 1927 had his first one-man show,

organized by the famous collector Paul Guillaume. His second show, in 1933, was presented by Malraux.

In a 1959 interview, Malraux casually remarked that Pollock, Kline and their New York colleagues were just copying the French, notably Fautrier, Wols and Masson. This was also, apparently, the view of Fautrier, whose much-publicized dispute with the late Franz Kline enlivened the opening of the Venice Biennale the following year. To Fautrier's "U.S. Go Home!" or words to that effect, Kline is said to have retorted, "French cook!"

In these days when art "movements" follow each other with ever-increasing rapidity, the question of who did what first is often a vexed one. An Italian avant-gardist whose specialty is lacerating posters once told me: "Other artists tear up posters but I am the first to tear up movie posters." And it has become common practice for artists to alter the dates on their early work to prove they were slinging housepaint around when Pollock was a pup.

Even if some of Fautrier's Abstract Expressionist paintings preceded those of Pollock & Co., it is extremely doubtful that anyone in New York was aware of them, let alone influenced by them. Anyway, it is doing no service to either Fautrier or the New Yorkers to rewrite art history so as to relate them. They are worlds apart. Fautrier's work is private, even secretive; it has little appeal: the colors are dull, the surfaces disquietingly gooey, the composition nil, so that Americans may be excused for wondering what all the fuss is about.

On the other hand, I can understand how a Frenchman, nationalism apart, might prefer him. The swashbuckling energy, wide-open spaces and "O Pioneers!" stance of much American Abstract Expressionism often ring a trifle hollow. Even the best of us tire of heroics, and at these times one could profitably rest one's eyes on the dun-colored, introspective world of Fautrier.

His early work is figurative, and the first picture in the exhibition comes as a shock. Called "The Sunday Promenade," it is a group portrait of ten dour-faced women and children in peasant dress. Although it has the dull, brackish colors he has always favored, it is minutely realistic. After that he began taking liberties, barely suggesting the outlines of nudes or trees in a landscape, which just emerge out of a sweep of livid light.

In the late 1920s he began to reduce the picture to a blur of sickly color in the center of the canvas, sometimes scribbled over with meaningless calligraphy. His work has changed little since then. An apathetic square of thick impasto in the center of the canvas, a scrawl of faded gray or mauve, some powdered pigment dusted over it—that is all. Those accustomed to the exciting architecture of Kline and the others are puzzled: for them it looks like a bird's-eye view of a heavily frosted cake, and a rather stale one at that.

I must admit that I myself have hitherto not been able to muster much

enthusiasm for Fautrier, but in the course of this retrospective I began to appreciate him. He emerges as a lonely figure, indifferent to the attractiveness of his work, at grips with an intellectual vision of light which is all that matters to him. If he is not the precursor some critics would like to see in him, he at any rate is something better: a poet.

New York Herald Tribune (International Edition), April 14, 1964

YVES KLEIN

A RETROSPECTIVE SHOW OF work by the late Yves Klein is on now at the Galerie Alexandre Iolas in Paris. From the mid-1950s until his death at the age of thirty-four in 1962, Klein became famous as one of the most original and disconcerting of Paris avant-garde artists.

Klein considered the traditional means of artistic expression so passé that, in his own words, he was able to remain "completely detached from all physical labor during the time of creation." The chief impression his work gives us is one of emptiness, and this is intentional. "The void has always been my principal preoccupation," he wrote. "I am convinced that, in the heart of the void as in the heart of man, there are fires which burn."

Klein set about his exploration of nothingness in various ways. Once, possibly inspired by "The Emperor's New Clothes," he put on an exhibition

which was merely an empty gallery. It is reported that he was able to find collectors willing to pay for a portion of the "sensitized space" he offered them. During his Blue Period, Klein stained canvases and sponges a uniform shade of indigo. In his Gold Period he applied gold leaf to the canvas. One of the works in the show is a sculpture of his friend Arman—actually a cast of Arman in the nude, painted blue and fastened to a gold panel. At other times Klein "painted" with an acetylene torch on a fireproof canvas. He also experimented with the effects of weather on canvas. Once he attached a freshly painted canvas to the roof of his car and drove from Paris to Nice; the canvas was "prematurely aged" by the effects of heat, cold, sunlight, wind and rain. Another time he exposed a canvas to lightning during a storm but confessed that this experiment resulted in a "catastrophe."

An experiment which proved very popular when Klein performed it in public consisted of smearing a nude model with blue paint and pressing her against a white canvas. The model thus produced her own portrait with no help from the artist, who was once again able to avoid physical labor.

In his art and in his life, Klein was a perfect example of a poker face, or, as the French say, a *pince-sans-rire*. Needless to say, he was dismissed by conservative critics as a practical joker. Yet others took him seriously. In Germany, where he was highly esteemed, the town of Gelsenkirchen commissioned him to decorate their new opera house with a mural of blue sponges. And the Krefeld Museum had him construct "flame fountains" in its park.

The current exhibition includes a number of the blue works as well as some "monopink" and "monogold" ones. Several of the scorched canvases and the "anthropometric" ones formed by the impression of the model on canvas are also included. Now that their comic aura has subsided, they make a disturbing and haunting impression. Perhaps the fact of Klein's death gives them a new seriousness. In any case, one is now tempted to agree with him that there are indeed fires at the heart of the void.

New York Herald Tribune (International Edition), April 20, 1965

RAOUL DUFY

About one hundred works of Raoul Dufy are being shown in the Galerie Mollien in the Louvre in Paris. They are part of the collection left to the museums of Paris, Nice and Le Havre by the painter's widow, who died a few months ago.

There was a large retrospective of Dufy only last summer in Paris, but this one is even bigger and better. Or is it that as time goes by, Dufy's art looks stronger and more universal? We are still in the habit of considering him a charming but superficial *petit-maître*, but I shall not be surprised if he is eventually classed with Picasso, Matisse and Bonnard as one of the great innovators of our century. His cause will be helped by the gift of these major paintings to the museums of France.

Dufy's early years were difficult—he began working full-time for a coffee

importer at Le Havre when he was fourteen, and studying at a local art school in the evening. After Impressionist beginnings, he fell under the spell of Matisse, especially the latter's "Luxe, Calme et Volupté," and this influence is reflected in some of the early works in this show, like the "Rue Pavoisée" (1906). There is surprisingly a somber, almost expressionist side to this work which gives little hint of what is to come.

Little by little his technique changes. Drawing becomes a kind of short-hand, a way of alluding to something without describing it; color becomes more and more arbitrary, the shading antinatural. Finally the picture begins to resemble a series of hasty but brilliant notes on a subject; without representing it, Dufy gives the essence of what is there. Often he deliberately chooses antipictorial subjects, like the "explorers" for a mural at the Vincennes Zoo, or the gigantic mural illustrating the history of electricity for the 1937 exposition.

At the end of his life he was evolving a theory of color based on colors which the eye feels do not belong together, in opposition to the law of complementary colors. All this is far from the popular notion of Dufy as a frivolous master-of-revels — an idea probably suggested by his preference for subjects like regattas, concerts, racetracks and so on. In any case this prejudice seems to be disappearing. It will be further dispelled by the magnificent paintings, drawings, tapestries and ceramics in this show, which give the full range of Dufy's almost Mozartian genius.

New York Herald Tribune (International Edition), March 6, 1963

GEORGES MATHIEU

THE NEW PAINTINGS of Georges Mathieu on view at the Galerie Internationale in Paris are among the finest work he has done so far and probably establish him as France's foremost abstract painter. From now on it will be difficult for colleagues jealous of Mathieu's very efficient publicity methods and the high prices his paintings command to dismiss him as a kind of P. T. Barnum of painting.

The new work has a richness, a completeness, a truth which cannot be ignored, and for the first time, perhaps, it has the kind of unquestionable authority that Jackson Pollock's best work has. It should convince all but the most stubborn foes of abstract painting.

Mathieu has always given his paintings bizarre historical titles, usually allusions to battles or little-known eighth-century bishops. His fondness for

obscure historical figures has led him to organize manifestations such as his "Ceremonies for the Condemnation of Siger of Brabant" several years ago, at which guests were invited to walk across portraits of Descartes and Pasteur.

This sort of fun is the kind of thing we have come to expect from the Paris avant-garde since the days of the Dadaists. But the historical titles of Mathieu's new paintings seem for the first time to have a real bearing on the subject, or rather the spirit, of the works themselves. One of the new works is entitled "The Drawing and Quartering of François Ravaillac, Assassin of Henri IV, King of France, May 27, 1610, on the Place de Grève." On a gray canvas Mathieu builds up his well-known calligraphic "signs" and squiggles into a composition of incredible density; at the center, all is confusion, but the confusion results from the calculated placing of innumerable single thrusts. White squares on the outer reaches of the canvas seem the product of the boiling mass at the center, just as the forces of nature produce geometrical shapes such as crystals. Two thick zigzags of red and green could be the assassin's dying scream. Everywhere, the lurid colors, contrasting with the coldly organized structure, somehow suggest both the horror of physical torment and the abstract importance of a historical event.

The largest picture on display, and runner-up in the title marathon, is "The Entry of Louis XIII and Queen Anne of Austria into Paris on Their Return from Bordeaux; May 14th, 1616." It suggests that Mathieu may be the first abstract historical painter.

It is strange that some of the world's greatest paintings have been of historical subjects, since a battle or a triumphant cortège offers the painter relatively little opportunity for identification with his subject. But when the result is successful, as with Velázquez, Rubens, El Greco or Uccello, we feel the absorbing contrast between the moment of history and eternity, between the individual and the mass of humanity. And in "Louis XIII" we feel the splendor of a forgotten festival, momentous when it occurred but long since displaced by others. Here Mathieu employs colors far removed from the severe red-black-white gamut that is so characteristic of him; there are greens and yellows suggestive of van Gogh (one of his favorite painters). The pigment, usually used raw from the tube, is here mixed, or mashed, directly on the canvas.

Upstairs is his "Magnificences on the Occasion of the Fortunate Birth of Thierry of Alsace, Count of Flanders, April 7th, 1100." The bluish-mauve background, suggesting Monet, is spiced with tiny strokes of red-orange, which become a fireworks-like cluster of red, blue and green signs at the far left of the long canvas. The general impression is one of luxury and gaiety, but the gaiety is serious—that of a public ceremony of rejoicing.

Mathieu is, in fact, a public painter. His work commemorates historical

events, and he frequently paints in public, preferably in some historic site and surrounded by reporters and television cameras. The presence of the public, he says, stimulates him. He cannot afford to ruin a painting when there is an audience, hence he rises to the occasion. Yet he nonetheless believes in a kind of aesthetic aristocracy. His favorite form of government, he said in a recent interview with Alain Bosquet in the magazine *Ring des Arts*, would be an absolute monarchy—"and I mean absolute." (One presumes that Mathieu would occupy the post of court painter, if not that of king.)

In the same interview he announced that at the time of his first one-man show in America in 1952, "the critics were quick to recognize my contribution to modern painting, but I must in all humility say that they weren't telling me anything I didn't already know." Such an affirmation would be annoying coming from a lesser artist, but it seems normal in the mouth of this Charlemagne of painters. When he strikes out at his fellow artists, he seems rather like d'Artagnan thrashing a churl. And when he praises them he does so with the same noble elegance.

The show also includes work by Compard, Degottex and the brothers Pomodoro. They are all gifted artists, and it is perhaps a high compliment to say that they manage to hold their own among Mathieu's new work.

New York Herald Tribune (International Edition), September 21, 1960

NIKI DE SAINT-PHALLE

THE PARIS ART season is ending not with a whimper but with a series of repeated bangs. Or so it seemed at the Left Bank vernissage of American Dadaist Niki de Saint-Phalle, who has invented a new kind of painting that must be finished by the spectator with the aid of rifle bullets fired at the canvas.

Niki, a stunning blonde ex-model (she has appeared on the covers of *Life* and *Elle*), is a niece of the French banker Count Alexandre de Saint-Phalle, who reportedly takes a dim view of her artistic activities. Her parents moved from Paris to New York when she was only two, and she was brought up in conservative finishing schools. Bored, she returned to Paris eight years ago and has been painting ever since.

It was only recently that the idea of shotgun painting occurred to her. Her method is to embed plastic bags containing paint or ink in a shallow box which

is then filled with plaster. Sometimes she puts in some eggs or tomatoes for good measure. Niki then either paints the surface of the plaster, decorates it with discarded objects, or leaves it plain. The painting is now ready to be destroyed or created, depending on your viewpoint.

The spectator stands at a convenient distance from the painting and fires the rifle. The plaster chips away, the objects disintegrate, and the bullet-pierced bags of color inundate the whole thing, creating bizarre and often beautiful effects. The painting is finished when the spectator decides it is.

Niki's main problem is finding a locale. For a while she used a vacant lot in the Impasse Ronsin, borrowing the services of an obliging shooting-gallery proprietor, since unsurveyed shooting is of course illegal.

She has managed to transplant her art successfully to the new Galerie "J," where marksmen and aesthetes can admire it. The quarters are, however, slightly cramped: at the vernissage, plaster kept falling into champagne glasses and one woman's Chanel suit emerged with some unintentional Jackson Pollock–type decoration.

For Niki, who is married to the American writer Harry Mathews, painting is a communal affair. She feels that she is close to the spirit of the French Surrealist poet Lautréamont, who said that "poetry should be made by all, not by one."

First of all, it is up to her husband to lug home the heavy bags of plaster. Their two young children, Philip and Laura, help fill the bags with paint and grudgingly contribute an occasional toy or piece of clothing for the picture. Finally, of course, it is the spectator who actually "does" the painting. In doing so he fulfills at least two basic urges: the urge to "do it yourself" and the urge to destroy a work of art. Perhaps that is why the show seems to be going over with such a bang.

New York Herald Tribune (International Edition), July 2, 1961

CHRISTIAN BÉRARD

T HE CASE OF Christian Bérard is a curious one. His nickname of Bébé, his talents as a chic portrait painter and set designer, and the loving admiration of the small group known as *le tout Paris* conspired to give him the wrong kind of reputation. Small wonder that even this reputation seems almost to have melted away less than ten years after his death. The law of the jungle prevails more and more in the art world of Paris and New York: only the fittest of the *monstres sacrés* can survive for long.

In the retrospective of Bérard at the Galerie Pont des Arts in Paris, one notices first of all that his reputation for chic is well founded. But it is classic French chic, a close relative of the exalted good taste that produced the ordered masterpieces of Racine and Rameau.

The note of Bérard's art is *dépouillement* — the stripping down to essentials

so important to the French, in whom the instincts of both conformity and individuality are developed to a high degree. If French art is not boring, it is because of individual differences of opinion as to what "the essentials" are. But in France the creative act seems typically to begin by a process of elimination. Many people would concur that "enough is as good as a feast," but only a Frenchman would hold that enough is actually better than a feast.

Bérard paints in dull colors on cardboard so that the pigment soaks into the neutral gray of the background. Often he paints merely the features of a portrait, leaving the rest undefined. Even in more finished works he rarely strays beyond the cool gamut of gray, pale blue and ocher—the colors of birds' eggs or of the much-vaunted skies of the Ile de France. This asceticism also dictates the choice of beggars or scenes of picturesque poverty as subjects. Typical is a gouache entitled "Les Forains"—a design for the Sauguet ballet of that name. Four rumpled figures stand in a vague pearl-gray space. Their clothes are summarily indicated, but their faces are complicated with unrepresentational spots of green, red and white.

It is almost a *tachiste* technique that one encounters also in "Les Amoureux" and "La jeune Veuve," where he scrapes the surface of the cardboard before applying pastel to it. The intentional fussiness contrasts with the simplicity of the rest of the portrait, and gives the face a strangely eloquent expression.

Color is employed discreetly in the airy, theatrical gouaches of London and more boldly in "Bois de Vincennes." But the bright tints of the latter only heighten the prevailing bittersweet mood. Fortunately, though, the sadness and even the morbidity never get out of hand. Everything is held exquisitely in check. Those who admire the novels of Marivaux, the music of Marin Marais, the poetry of Millevoye, the films of Bresson or the clothes of Chanel will relish the discreet but authoritative mastery of Bérard.

New York Herald Tribune (International Edition), March 1, 1961

GEORGES BRAQUE

Of the Picasso-Braque-Matisse triumvirate, it is probably Braque whose personality remains least known to the majority of the people who are familiar with his name. Lacking (or so it seems) the universality of Picasso and the attractiveness of Matisse, Braque has not created a strong artistic "personality" for himself, and has influenced the course of contemporary painting less than his two contemporaries.

Of Picasso and Matisse, one might say that each has explored his own genius thoroughly, has realized his potentialities and given us the best of what he had to offer. But Braque seems never to have embarked on a systematic voyage of self-discovery, preferring to wander aimlessly but happily in the landscape of his mind. In fact, part of his charm lies in the fact that he is still able to surprise himself, and can therefore surprise us.

This is something he does consistently in the current exposition of his graphic works at the Bibliothèque Nationale in Paris. The very first picture shown, a nude of 1908, has the characteristic casualness, the reduction to essentials, the feeling of mystery not pushed too far and thus remaining mysterious. The figure was sketched with just a few lines and the artist then spent a great deal of time covering an area on the right with abundant tiny cross-hatched strokes, like a child who had begun a drawing and whose attention had been absorbed by something outside the window. Whatever the reasons that dictated this treatment (and Braque's reasons are always inscrutable), the result is somehow deeply satisfying.

He experimented with engraving during the Cubist period and then, typically, did little with it until he was almost fifty, preferring to be led by his talent rather than to lead it by the nose. Since 1930 his interest in graphic art has intensified. He has illustrated a number of books, including Hesiod's *Theogony*, the poems of the Tibetan monk Milarepa, and the works of such modern poets as René Char, Francis Ponge, and the late Pierre Reverdy. His illustrations seem to depend very little on the text, and yet they illuminate it. The summarily outlined vine leaves and tendrils he drew for Reverdy's *Liberty of the Seas*, for instance, cast an oblique light on the poetry.

This oblique directness may stem from his interest in Oriental philosophy, including Taoism and Zen Buddhism. His work has the bareness and simplicity we associate with the Tao, and the abrupt insights of Zen. One has the impression of the form's being suddenly *there*, of its having arrived with the swift inevitability of an event. Its ambiguity is that of reality.

Braque is, among other things, the poet of dim French interiors. (He began life, in fact, as a housepainter, and dutifully learned how to paint wood to imitate marble, and so on.) His colors remind one of tea, wallpaper, lemons, ivy, pewter, and autumn light seeping through curtains. In short, of cool, dry, reflective things.

At the same time, there is a primitive strength deriving from early Greek art. He will borrow a smiling, staring profile from a Greek vase, or scratch a white outline drawing of a mythical subject in black plaster. The solemn joy we find in archaic Greek sculpture echoes throughout his work.

The late studies of birds are in a way symbolic of Braque the artist. Their simply outlined forms seem to fly straight above the arrows at some unspecified but definite goal, and yet a kind of vague poetic enchantment hovers over them. They prove that at seventy-eight this rather secret painter still has a great deal to say and that there is still a great deal to be said about him.

New York Herald Tribune (International Edition), July 13, 1960

ANDRÉ DERAIN

T HE CASE OF André Derain is one of the strangest and saddest in the annals of
twentieth-century art. Born in 1880, he found himself at the forefront of the
avant-garde in 1904–5, when he and his friend Matisse were developing the
freewheeling, violently chromatic painting that caused an unfriendly critic to
dub them *fauves* (wild beasts). At that time their work looked more innovative
than anybody's, including Picasso's. But Derain gradually adopted a more
conservative stance, participated only halfheartedly in Cubism, and by the
1920s had evolved a Neoclassic style strongly influenced by Corot and Renoir
and such old masters as Poussin and Velázquez.

Even so, Derain was regarded by some critics in the 1920s as the greatest
living French painter—*le régulateur*, or one by whose standard other artists

were judged. But during the 1930s he gradually dropped out of sight. An ill-starred official trip to Germany during the Nazi occupation, along with five other artists including his onetime comrade Vlaminck, left his reputation permanently tarnished. (Derain had been persuaded to go by the Nazis' promise that some French prisoners of war would be released. The Nazis did, in fact, live up to their end of the bargain, but they also extracted maximum propaganda value from the tour.) By the time Derain died in 1954, after being hit by a car, he had ceased to be reckoned a force in French art.

That is pretty much where things stand today, though occasional intensive-care resuscitations have been attempted. The latest of these is a small (sixty-two works), beautifully selected show now at the University Art Museum in Berkeley, California. Originally organized by a Derain zealot, Michael Parke-Taylor of the University of Regina, Saskatchewan, for the Norman Mackenzie Art Gallery there, it was put together on a shoestring budget, and this is apparent. Still, as the only major Derain exhibition in this country since 1944, when the Pierre Matisse Gallery in New York mounted one, it is definitely worth the while of anybody interested in modern French painting.

Unfortunately, even within the show's limited scope—"André Derain in North American Collections"—many key works are lacking, notably the 1910 "Bagpiper" and the "Self-Portrait" (1911) at the Minneapolis Institute of Arts. An important late still life in a California private collection and the "Still Life with Dead Game" at Pittsburgh's Carnegie Institute (which won the institute's International Prize in 1928) are also absent. Nevertheless, Parke-Taylor has succeeded in bringing together a number of first-rate works—as well as a few second-rate ones. (Even Derain's most fervent fans admit that he sometimes churned out potboilers to satisfy his passion for high living and expensive sports cars.)

Several important pictures from his Fauve period, including a mesmerizing "Self-Portrait with a Soft Hat" and the "River Seine at Chatou" (1905), as well as a vermilion-faced "Portrait of Matisse" from the same year, make it clear why this period in Derain's oeuvre has remained beyond critical dispute. But even here the restraint and reserve that characterized his later work are hinted at, notably in the muted pinks and lilacs of "Landscape by the Sea: The Côte d'Azur near Agay." Unlike his fellow "wild beasts," Derain seems to have reflected before laying on his vibrant colors—which, in the end, do not clash but coexist reasonably with one another.

As early as 1907, in "Landscape at Cassis," the color, though still bold, is at the service of a Cézanne-like play of volumes; what Derain called the "weight" of colors rather than their sensory overtones is the ordering principle.

By 1913, in "Portrait of a Young Man," he had adopted an austere Cubist palette as well as something of Cubism's flattened prismatic shapes and its mood of melancholy reticence—though even here he kept his distance from the prevailing mode of the day. ("Cubism is dead magic," he once wrote.) Two other masterpieces, one a Giottoesque "Italian Woman," now in the collection of the Museum of Modern Art in New York, and a "Still Life in Front of a Window" (1914), close Derain's pre–World War I period. After that his art, like that of most of his contemporaries, would never be the same.

A classically calm drawing of a young girl (from the Detroit Institute of Arts), circa 1919, announces the change. Enough of arty experimentation, Derain seems to be saying here: the trauma of his years in the trenches had turned him toward what is timeless. A compulsive museum-goer and collector of Cézanne, Corot and Renoir as well as of African and Romanesque sculpture, he henceforth gave his eclectic erudition free rein. References to such motley sources as Roman and Faiyum portraits, Pompeian frescoes, Poussin and Zurbarán, Courbet and Delacroix all abound in his later work, held together by what the English painter Patrick Heron has called "that smoothness, that modeling, that sinuous outline, that superb mastery of recession and control of perspectival volumes." But unlike de Chirico, whose career as first an iconoclast and later a reactionary bears a superficial resemblance to that of Derain, the latter never imitated the art of the past. It is a question of allusions, from a man who felt the relevance of the art of all time pressing on what he attempted in the present.

Derain's palette from the 1920s on settled into a spectrum of browns, grays, ochers and greens, as well as a rich, limpid lampblack. That black became his signature, as in works like the 1939 "Still Life," with its white tracer-bullet highlights that suggest Pompeian frescoes. Yet for all its reserve, the color is endlessly evocative: of distances, volumes, atmosphere and above all of some secret relation among the intrinsic natures of things, whether of nude figures or of trees in a landscape.

When all of the results are in, it may turn out that it was Derain who had the most fecund influence of any of the painters of his generation, Picasso included. The two major artists of postwar France, Balthus and Giacometti, have acknowledged their debt to him. One sees how Balthus learned from paintings like the "Portrait of a Boy with a Hat" (1922) and the later, breathtaking "Young Girl Peeling Fruit." As for Giacometti, "Derain excites me more, has given me more and taught me more, than any painter since Cézanne," he wrote. "To me he is the most audacious of them all." In this country, Derain's influence has been tirelessly disseminated by the painter Leland Bell, who

helped organize the current show. What one sees at Berkeley, then, is merely the prismatic tip of an iceberg so vast that few critics, given the present disordered state of Derain scholarship, can even guess at the rest. With luck, Derain will one day get the retrospective he deserves. Meanwhile this show is an unexpected and tantalizing foretaste.

Newsweek, April 20, 1981

LÉON SPILLIAERT

I CONFESS TO ALMOST total ignorance of the career of the Belgian artist Léon Spilliaert, whose work is being shown at the Metropolitan Museum in New York. I say "almost" only because a few of Spilliaert's works were included in the recent show "Belgian Art: 1880 to 1914" at the Brooklyn Museum. One picture, a deserted restaurant interior at night, was a remarkable one, but it didn't prepare me for the excitement of the Met's show, which is a revelation. One reason it didn't is that Spilliaert's works, though obviously produced by the same mind, tend not to resemble one another very much.

Like the Brooklyn show, the Spilliaert show is one of the series of "Belgium Today" cultural events that have been sprouting around the country in celebration of the 150th anniversary of Belgian independence. It is an abbreviated version of the one that opened in the spring at the Phillips Collection, in

Washington. With all that's going on right now at the Met, one imagines that the powers there were reluctant to give up excessive houseroom to an artist whose name means so little in America. Nor can I blame them, since, I remember, I was in Washington when the show was on there and managed to find an excuse not to visit it, which I now regret. Anyway, thirty works on paper (mostly watercolors, with additions of pastel and pencil drawing—Spilliaert rarely used oils) out of the fifty-one shown at the Phillips are on view, and the exhibit is one of the highlights of this summer.

Spilliaert was born in 1881 at Ostend, then one of the most fashionable seaside resorts in Europe. He grew up a few blocks from the studio of James Ensor, whose macabre humor he sometimes echoes—though the gloom of a Belgian sea resort off-season would be of itself conducive to weird fantasies, and Spilliaert's, though less aggressive than Ensor's, are finally even more unsettling. Nevertheless, it was the place he felt closest to, and both the vast littoral spaces of the town and its ghostly Art Nouveau interiors were his preferred subjects.

Judging from the works shown, Spilliaert's technique and tone varied widely from picture to picture. His self-portraits have an almost academic finish, although their startling compositions and bizarre ambience are anything but academic. In one of these, the "Self-Portrait with Mirror" (1908), the young artist portrays himself as a wraith with sunken cheeks, gasping mouth, and an ominous blue lozenge shape framing one glittery eye, in a bourgeois interior that could be a setting for Strindberg's *Ghost Sonata*. If this were his only side, Spilliaert would still be an important artist. Yet elsewhere this savage proto-Expressionism is leavened with playful humor, as in "Woman in a Pink Hat" (1904), a gaunt dowager whose electric-blue eyes are the only touches of color in a sea of monochrome—the hat, a sort of pancake firmly pressed down on her upswept coiffure, contains no trace of pink.

And sometimes the two strains are intermingled, as in "The Bather" (1910). In this powerful painting a woman in a black bathing suit is seated on the ramp of a stone stairway, turning away from the viewer to contemplate the arabesque patterns on the surface of the water, rendered in heavy swirls of yellow and black. Next to her a little black dog also gazes seaward. The woman's figure is compressed into an almost painful arc, yet one waits in vain for the message of cosmic horror that this pose would have announced in a work by Munch, to whom Spilliaert has been compared. Indeed, a work like Munch's "The Cry" seems like overkill in comparison. Obviously, all is not normal in this world of overbearing shadows and contorted drawing, yet it's impossible to say what precisely is amiss: the mood of the picture could be the result as easily

of a Matisse-like joy in forms for their own sake as of morbid introspection, and thus it remains infinitely suggestive.

In fact, Spilliaert's work resists labels as assiduously as it invokes them. He has been lumped under the Symbolist heading, but except for some early, reputedly Beardsley-esque pictures, the wit that is never entirely absent from his work is inhospitable to Symbolist veils. Some paintings, such as "Woman on the Dike," prefigure the agoraphobia of de Chirico and Dali, yet even this singularly beautiful, quasi-abstract composition — a woman wrapped in a shawl caught in a grid of dramatically receding planes — is as much a formal *jeu* as it is an evocation of melancholy and foreboding.

Most of the works in the show are from the period just before World War I. Later, after Spilliaert had married and settled down to an apparently felicitous domestic life, his moods and palette are lighter: the "Mauve and Yellow Seascape" (1923) is an unqualifiedly sensual exercise that, as Patricia Farmer points out in her catalogue essay, anticipates the Abstract Expressionists, particularly Clyfford Still. (She also likens Spilliaert to Ryder, Dove, Hartley, Hopper and Milton Avery. And although there is no reason to think that any of these artists knew of Spilliaert, the list does suggest the curious multiplicity of his talent.) The late pictures of trees, more conventionally drawn and more modeled than the early work, have a delicate mystery of their own.

One is grateful to the Belgians for sending Spilliaert this way. As far as I can tell, his only other showing in America was a 1974 group exhibition called "Painters of the Mind's Eye" at the now defunct New York Cultural Center. It would be good to see more of him and to be able to fill in the gaps left by the present selection.

New York, August 4, 1980

MICHELANGELO PISTOLETTO

THIS IS AN exceptionally desolate week for art in Paris, but an Italian named Pistoletto (I am told that his first name is Michelangelo) compensates for it with one of the brightest and most original shows of the season. He is showing at the Ileana Sonnabend Gallery, which launched Pop Art here and whose motto rather than "Excelsior!" seems to be "Farther out!"

Pistoletto's method is the following: onto a large metal mirror he glues life-size cutouts of figures which are actually photographs on silver-gray paper "improved" by the artist with a little pencil drawing and some paint. Period.

Simpleminded as it sounds, Pistoletto's art is fascinating and even haunting. For one thing, the mirror surfaces automatically pick up the rest of the room including you, who suddenly find yourself, like it or not, the subject of a Pop picture. Not the main subject, either, but somewhere in the background—the

foreground being taken up by your anonymous two-dimensional companions.

These figures have a peculiarly oppressive quality. Well dressed in a white-collarish way, they remind you of the languid countesses and business executives in Antonioni's movies (Pistoletto is from Turin, where *Le Amiche* was filmed). They either turn away from you gazing listlessly into the mirrored depths of the picture, or slump in modern chairs, fixing an unexpectedly pale and unsettling gaze on the viewer.

Two of his pictures contain no people, only objects. One is a modern glass cocktail table supporting four empty highball glasses and a pair of horn-rimmed spectacles. The other—possibly his most daring conceit—is merely a bottle placed in the lower left corner of an unrelieved expanse of mirror. It reminded me of Wallace Stevens' poem "Anecdote of the Jar," which begins:

> I placed a jar in Tennessee
> And round it was, upon a hill.
> It made the slovenly wilderness
> Surround that hill.

and which ends:

> It took dominion everywhere.
> The jar was gray and bare.
> It did not give of bird or bush,
> Like nothing else in Tennessee.

Pistoletto's work gives nothing either, and is like nothing in Tennessee or in Paris for that matter. But it organizes its "slovenly" environment, including you the viewer, emptying it of meaning and at the same time hinting at another kind of meaning, beyond appearances. It is an exciting experiment, which, if only for its strangeness, merits your attention.

New York Herald Tribune (International Edition), March 3, 1964

FRANCIS BACON

THE ZURICH KUNSTHAUS is showing the large exhibition of Francis Bacon's work which opened last summer at the Tate Gallery and will later be seen at the Museum of Modern Art in New York.

Bacon is today one of the few British painters with an international reputation. His fame has not suffered with the rise of New York School abstraction: on the contrary, he is about the only figurative painter who is respected in advanced New York circles, though he himself is said to be virulent on the subject of American abstraction, which he dismisses as "decoration." Yet his statement on painting published in the catalogue suggests that his aesthetic ideas are not so far removed from those of Pollock, de Kooning or Kline:

Real painting is a mysterious and continuous struggle with chance—mysterious because the very substance of the paint, when used in this way, can make such a direct assault on the nervous system: continuous because the medium is so fluid and subtle that every change that is made loses what is already there in the hope of making a fresh gain. I think that painting today is pure intuition and luck and taking advantage of what happens when you splash the bits down.

It is interesting to see Bacon's work in the Zurich museum, which has a large collection of paintings by Fuseli, the Swiss-born painter who is inseparably linked with the English Romantic movement. I can think of no painting which makes me uneasier than Fuseli's scenes from Shakespeare, unless it is Bacon's portraits of van Gogh. The work of both painters suggests high-speed snapshots of a nightmare. Out of vague and terrifying spaces, figures suddenly congeal with the incontrovertible reality of characters in a dream.

Although Bacon disowns all of his work done before 1944 (he was born in 1909), the show includes a few examples dating as far back as 1930. The first important works are the 1944–45 studies for a "Cruciform"—three deformed, howling shapes on a cheerful orange background which give us a premonition of what is to come. During the following years he developed the peculiar iconography of his world, in which seemingly innocuous objects suddenly take on portentous significance. For instance, the tweed overcoat draped over the bawling figure of "Magdalen" of 1945–46 is at once recognized by the spectator as an oppressive symbol of *la condition humaine*.

During the 1950s Bacon did his famous studies of popes and cardinals, their faces bloated with laughter or twisted into a scream, sitting all alone in an ambiguous space hemmed in by straight lines that suggest railings. Also from this period are the sinister studies of men in business suits, some of them inspired by candid photographs in *Time*. Bacon is endlessly fascinated by photographs, especially early studies of figures in motion: the "Diver" in this show was inspired by one of these.

In the van Gogh portraits of around 1957 Bacon's palette takes on brilliant and lurid new tones, and at the same time the pigment becomes juicier and more "accident"-prone. In his latest pictures the colors are again somber—oppressive reds, greens that suggest billiard tables and worn tuxedos, bluish flesh tones. And he has a new fondness for boldly outlined areas of flat color that suggest Gauguin at times.

His subject matter is still man in the horror of his isolation—naked and

obscene on a studio couch, or grinning baboonlike from behind a desk. Yet, strangely enough, Bacon's work is neither horrible nor depressing. His tremendous gifts crowd out all feelings but admiration, and after the initial shock one begins to feel almost on friendly terms with the creatures in his zoo. It may be an ugly, obscene and terrifying world, but it is also a deeply human one.

New York Herald Tribune (International Edition), November 7, 1963

RODRIGO MOYNIHAN

ONE OF ENGLAND'S most respected and least exported contemporary painters is Rodrigo Moynihan, who turned seventy this month and will have a show of recent pictures at the Robert Miller Gallery in New York. His career has been a curious one. From his beginnings as a proto–Abstract Expressionist in the early 1930s (a fellow artist dubbed one of his early paintings "Explosion in a Jam Factory"), he has continually vacillated between realism and abstraction of one kind or another. And his reputation in England has fluctuated wildly as a result. As the critic John Russell puts it, "There have been moments when he has been known to everyone and moments when he has been known to no one."

Moynihan's biography is as errant as the course of his painting. Born in the Canary Islands of a Spanish mother and English father, he moved with his parents to London and then to Madison, New Jersey, where he attended high

school. Back in Europe he studied painting in Rome and then at London's Slade School. In 1934 he and the painters Geoffrey Tibble and Graham Bell banded together to form a new movement, Objective Abstractionism, which strangely anticipates American Abstract Expressionism.

Moynihan's pictures from that period are built up out of touches of pale, crusted pigment. They are almost monochrome, yet luminous—"an abstraction built purely from color and light," as the young poet David Gascoyne said in a review of the one and only Objective Abstractionist exhibition at the Zwemmer Gallery in London. There was a brief *succès de scandale*. Moynihan and his friends were even interviewed for a newsreel but discovered, when they saw it, that the background music was the familiar theme from the movies of Laurel and Hardy.

Total lack of success and the darkening climate in Europe helped to steer Moynihan toward realism. At that time abstraction came to seem like a denial of humanity for many artists, and Moynihan speaks in a journal entry of "this terrible urge to hide one's light beneath great lumps of negative paint." Eventually he was being commissioned to do official portraits, including ones of the future Queen and Prime Minister Clement Attlee. A large group portrait of the painting faculty at the Royal College, where Moynihan taught, is, for all the establishment aura of its subjects, among the most startling and moving large figure paintings of this century. But even here, he never abandons his fascination with paint for paint's sake.

In the late 1950s Moynihan suddenly gave up his post at the Royal College and his membership in the Royal Academy and moved to France with his second wife, the painter Anne Dunn, to begin another period when he was "known to no one." Encouraged by developments in American painting, he returned to the emotional abstract style of his youth, this time using a somber palette and awkward, mutilated-looking shapes somewhat suggestive of the late "black paintings" of Goya. A few years later the palette brightened and the forms stretched into quasi-geometric bands of force—a direction that could have been suggested by the work of Ellsworth Kelly and Barnett Newman, both of whom Moynihan admires.

In the early 1970s he again veered toward realism in a series of still lifes he calls "shelf paintings," which he is still doing today and which make up most of the Miller Gallery's show. Not surprisingly, perhaps, this return to the fold of realism again brought official recognition: in 1978 the Royal Academy pardoned its onetime dissident and gave him a large retrospective show where the many conflicting facets of his career were first pulled together.

Though the work in the new show looks traditional, one immediately perceives something rich and strange behind the fluid modeling and sober

tonalities. The still lifes are straightforward in handling, yet frequently viewed from bizarre angles. Their air of remoteness makes them seem as though glimpsed through the wrong end of a telescope, as Robert Rosenblum says in his catalogue text. The dull subject matter—plastic sponges and bottles, rolls of paper towels and cotton batting, or a lone bar of soap in one magnificent picture called "Soap"—takes on a vehement though static life of its own. The result is almost a new genre of still life, in which the objects seem aching to transcend their objectness. Although this is denied them, there is a feeling of transcendence in the soft gray studio light that envelops them with the solitude of creativity and of death.

The portraits that have occupied him most recently share these qualities, but the compositions are less arbitrary, the painterliness almost lush again. A group of small full-length self-portraits are painted with a loaded brush that results in occasional drips and splatters—could Moynihan be planning a new foray into Abstract Expressionism? Another large self-portrait has a liquid, pearly finish that Sargent would have envied.

Yet the tacit melancholy that has always haunted his work persists. The portrait of Francis Bacon, for instance, seems to sum up both that painter's work and Moynihan's. It is a profound meditation on life and its decay. Bacon's British overstatement is nowhere to be found; yet the message comes through loud and clear, though hushed. Moynihan's show—his fourth in America—isn't a large one (there are only about twenty paintings), but it crystallizes the late achievement of a singular, elusive artist.

Newsweek, October 27, 1980

ANNE DUNN

ANNE DUNN shows large India ink and colored ink drawings, mostly land-scapes done in Canada and the south of France, at the Fischbach Gallery in New York. Her technique in these is remarkable and very original, playing off areas of sparse outline drawing partially filled in with accretions of pointillist dots against explosions of color whose splashiness and painterliness are nevertheless kept in check by the austerity of the colored ink medium. By treating the latter as though it were gouache, which it very much isn't, she is able to project an atmosphere both sensuous and ascetic—sensuous for its chromaticism and loose handling; ascetic in the ink's reluctance to submit to that handling, which "rubs it the wrong way," and in the intense but rather chilly and "commercial" colors: cold reds, oranges, aquamarines, and fuchsias. Ink is after all a

utilitarian substance, and Dunn seems to be quietly making this point even in the most lyric passages.

Most of the drawings pit blocky architecture against exuberant foliage—man-made rectilinear spaces encroach on or retire behind seething fronds and vines. The straight lines against the unforeseeable, indescribable natural tangle both absorb a measure of dignity from it and seem to restore a sense of its own vigor to the natural confusion.

Several drawings approach the point of imposing even more of an order on what was seen. "Cabin, New Brunswick" materializes behind (in front of?) an arbitrary grid of line drawing "shaded" with areas of dots. The cabin itself is drawn in much the same way, so that it is difficult to say where representation ends and graphic fantasy takes over, if indeed it does. Elsewhere, as in "La Cournière" (the name of a house), spatial ambiguity manifests itself in patches of pointillist sky which seem to belong in the same plane as the flowers in the foreground, so that the house in the background is, as it were, trapped in a dream of conflicting spatial prerogatives. These games of contrasts—line drawing against color, right angles squaring off against *informel* profusion, distance versus nearness—are worked up to an almost Mannerist tenseness in a drawing called "Camp, New Brunswick, No. 2," where the steep perspective of a porch roof raked by the receding angles of wooden supports (which echo the cabin's log walls and the angular scrollwork of an elaborate TV antenna) clashes with the straggling but emphatic irregularities of branches and foliage. As usual the contest is a draw, but it is here fought with enormous *panache*.

Other drawings dwell on the baroque inventiveness rather than the untidiness of vegetation, notably a drawing of "Black-Eyed Susans" from which the architectural scansion is absent (except for a marked-off square in which more of the same flowers were "framed"), and two called "New Brunswick 1" and "2," where the flowers are splashed over the foreground, finely picked out as though with embroidery, while the landscape in which they occur remains vague and scarcely delineated. "New Brunswick 1" is in fact the outstanding drawing in the show. Dunn's flowers are both beautiful and a little morbid in their minuteness of drawing, their glowing, corrosive colors, rather like those in Rimbaud's poem "Fleurs": "From a golden step—among silk cords, gray gauze, green velvet and crystal discs that blacken in the sun—I see the foxglove open on a ground of silver filigree, of eyes and tresses."

One is continually struck by how much these drawings, with their restricted range of themes and their frugality of means, seem to be saying. The limited but appropriate colors, the self-effacing yet pointed drawing, and especially the random pointillist areas, which concentrate detail only at certain

important junctures, leaving much of the sheet bare, speak of the importance of attentiveness, and of the importance of abandoning it at certain times in the larger interests of the work. The drawings appear to be constantly coming into or going out of focus, and to be intending this movement as the only truthful way of capturing, in a fixed medium, this way of happening. To quote Wallace Stevens: "A mountainous music always seemed / To be falling and to be passing away."

Arts Magazine, March 1977

TREVOR WINKFIELD

TREVOR WINKFIELD IS an English painter who has lived in New York since 1969. He has exhibited rarely: once at the Fischbach Gallery in New York in 1977 and again at the Blue Mountain Gallery in New York in 1980. (He had a show at the Coracle Gallery in London in 1978.) However, almost from day one, his crisply painted concatenations of unlikely objects, which make Lautréamont's famous dissecting table with its umbrella and sewing machine look decidedly underpopulated, have attracted a small but fanatical group of admirers, including myself. For them (and, one hopes, for a larger audience as well), the recent phenomenon of two Winkfield shows is an event of major importance, even though the show at the Edward Thorp Gallery in New York was a small one and that at Boston's Institute of Contemporary Art (in that museum's "Currents" series—installations of work by new artists which in Winkfield's

case amounted to nine acrylic-on-paper pictures) was even smaller. Unfortunately, this will probably be true of future Winkfield exhibitions as well, since his method of work is so time-consuming that he describes himself as a "seasonal" painter—one painting per season.

Winkfield was born in 1944 in Leeds, "a grim satanic mill town which also doubled as a cultural desert," as he described it in an interview with David Shapiro in *Arts Magazine* (May 1986). The only art he encountered during his childhood was reproductions: "either in books or on postcards, or neatly framed behind glass on neighbors' walls. So I grew up believing that all paintings were small, glossy and flatly painted." While still in kindergarten he made friends with a fellow pupil, Glen Baxter, whose surreal sendups of old boys'-book illustrations have lately become cultural icons; the two lost sight of each other but met again at the Leeds College of Art, where Winkfield studied from 1960 to 1964. Although the visual results are different in each case, Baxter and Winkfield certainly share a highly eccentric "outsider" position toward contemporary art, which must have seemed like high treason at a provincial English art school in the 1960s. Winkfield obtained an intermediate certificate at Leeds and in 1967 an MFA at the Royal College of Art in London (the former he derides as "a bigoted art college whose motto might well have been 'Some Say God, We Say Ben Nicholson'"). He also produced several issues of a mimeographed little magazine called *Juillard* (named after a character in Raymond Roussel's proto-Surrealist 1910 novel *Impressions d'Afrique*) which attracted the attention of poets in New York, who began to appear in its pages. Not long after that he moved to New York.

It is important to note the literary connection, since Winkfield's painting is, among other things, "literary," which may be one reason why his previous New York shows attracted so little attention: the last one was in 1980, before the emergence of Neo-Expressionism legitimized literature and other taboos. Another reason is that it's impossible to put a label on his work. In recent years, the notion that it's OK to like any kind of art as long as it's good of its kind has gradually gained credence, while the equally heretical one that art may, under certain circumstances, be pleasurable and still not flunk out now looms in the sky above the art world like a giant cartoon light bulb, signifying "Idea!" The writing of Raymond Roussel is especially pertinent. Winkfield is known to Roussel scholars as the translator into English of Roussel's essay *Comment j'ai écrit certains de mes Livres* (*How I Wrote Certain of My Books*, 1977) which detailed some of the French writer's curious methods of literary composition. These are too complicated to summarize here, but basically they depend on puns: in Roussel's case, the transformation of common phrases, book titles, lines of verse or whatever into phonetic equivalents with different meanings

which would serve as the elements for the plot of a story. For example, he took the phrase "*demoiselle à prétendant*" (maiden with a suitor) and transformed the first word by substituting an unusual alternate meaning of the word *demoiselle:* "pile driver." As for *prétendant*, he dismembered this word into a phrase: *reître en dents*, or "Reiter [a German cavalry soldier in the service of the Huguenots] made of teeth." The phrase thus becomes the nucleus of an episode in the novel *Locus Solus* in which the inventor Canterel shows a group of invited guests one of his stranger creations: an airborne pile driver constructing a mosaic of teeth whose subject is a German cavalryman.

Winkfield has never been too specific about his working methods (perhaps following the example of Roussel, whose essay just cited in fact raises more questions than it answers), but it is obvious that some similar punning mechanism is at work in his paintings. Puns are a childish form of humor (and imagery from childhood, albeit transformed and distressed, peoples Winkfield's tableaux); they also catapult us into an adjacent world of the unconscious where aerial pile drivers are a not uncommon sight. In the case of both Roussel and Winkfield, we can see the results of the puns but can rarely trace the images back to their raw material. (One which I was able to detect was in an early Winkfield painting of an academician wearing his robe and a mortarboard, atop which was a trowel stuck in a blob of mortar.)

Another example of Winkfield's literariness is the extreme attention he obviously pays to titles. (This is rare among artists, who often don't title their works at all, to the despair of critics who are then forced to discuss "the red horizontal oblong one with the green lozenge on the right," when a simple "Number 3" would have made things so much easier.) Many of them would make poets envious, for example "In April or in May" and "Depraved Bumpkins and Lesser Worries" from the Boston show. Books sometimes have illustrations, and these too are very important to Winkfield, not least because they are bright, clear, reveal no brushstrokes and fit easily behind glass in a frame. One of his keenest enthusiasms is the work of the *fin-de-siècle* French cartoonist Christophe, creator of "La Famille Fenouillard," a kind of forerunner of America's "Bringing Up Father." Winkfield mentions Christophe in the same breath as Gauguin, and he in fact has his own ideas on who the great artists are. Another is the fourteenth-century Burgundian painter Jean Malouel, whose "Last Communion and Martyrdom of Saint Denis" in the Louvre is, he says, the only painting he ever really gave himself over to. Among the moderns he admires Jasper Johns, which is not unusual, but it is perhaps so coming from one who also admires Maurice Denis and de Chirico's 1918 still lifes, and considers Gerald Murphy a major twentieth-century artist. Not surprisingly, such a jarringly exotic bouquet of sources has resulted in an extremely complex

and individual art, difficult to read and even more difficult to interpret and describe. At times it is as though Bosch and Beatrix Potter had collaborated on a Book of Hours, with assists from all the artists mentioned above.

I fear that what I have written so far may give the impression that Winkfield is a special case, to be safely classified with "endearing" oddballs like Edward Lear or Winsor McCay in the Eccentrics drawer. But this would be misleading. For starters, Winkfield's work isn't endearing, though it draws on nostalgic popular imagery, from illustrated *Chatterbox* annuals to Bonzo dog postcards. But the aura of coziness that the beguiling colors and cartoonish figures create dissipates as one looks at the work, giving way first to spatial and iconographic ambiguities and then to tensions of mood that are even harder to circumscribe. The atmosphere can turn suddenly tragic, as in "Rice Bomb," in which a peppermint-striped puppet figure is being subjected to tortures that suggest the work of Hans Bellmer; or "Very Strong and Very Weak," whose skeleton dressed like an organ grinder's monkey is but one of many *mementi mori* that occur throughout Winkfield's work. Bones, skulls and instruments of torment are sometimes placed in the foreground, but more often are peeking out from the sidelines while conventionally idyllic images—clowns, moonfaces out of a Méliès film, children in Dutch costumes—occupy center stage. Cocteau's description of Roussel's writing (in *Opium*) captures Winkfield's work perfectly: "a suspended world of elegance, fantasy and fear."

Winkfield says that even as a small child he "realized that there are those who accept *the* world and those who create *a* world—I always felt I belonged in the second category." It was then that he discovered heraldry, "which has very rigid, hieratical rules. The simplified flat colors influenced me a great deal, even more so when these percolated down to the vernacular as with country inn signs." Such firm, even rigid materials were useful for carpentering "a" world, and he has not varied his methods much over the years, except that the later work has a greater range and complexity, and makes more demands on the viewer. He remarked recently that in the later (1984) of the two pictures in the Thorp Gallery show called *Circus*, in which color is more subdued, he felt he had succeeded in "controlling" color for the first time, which surprised me since he has always struck me as being very much in command of his palette, even when the chromaticism reaches a feverish pitch (as it does in *Circus I*). But his attitudes toward color are obviously those of someone who has spent many years pondering the issues.

You see I utilize childish imagery as a subterfuge, as an enticement in a far more menacing world [he told David Shapiro]. When you first glance at the paintings the colors look so seductive, so inviting, as though they'd been

hatched in a nursery or taken from the "happy" tints of birthday cards. But the more you look the more you realize the nasty aspects of the coloration. I actually made a study of the neutral colors you find decorating dentists' waiting rooms, airport lounges and hotel foyers—baby blues, eau-de-nils, pinks, tepid grays, creams, light browns, and you know the longer you linger in those kinds of spaces the less lulling they become. The browns and creams take on the look of discolored dentures, even excrement, while the pastel hues bring to mind medicinal dyes, mucus, vomit and the artificial coloring found in cheap pastries and wedding cake icings. They set your teeth on edge and your stomach churning! So the color and the imagery in my paintings likewise end up by being quite bilious and ferocious. And likewise the initially non-threatening characters are soon seen to be couched in tense, confrontational juxtapositions.

Juan Gris, another painter Winkfield admires, said, "One must be inexact but precise." It almost seems as though Winkfield had founded his work on this dictum, translating the uncertainty that we inhabit with the precision of a mathematician. What is confusing in what we are given to see remains so. But at least its terms have been defined, its battle lines established. Winkfield offers us a trompe-l'oeil rendering of things as yet unseen.

Art in America, June 1986

GUSTAVE MOREAU AND

HIS MUSEUM

THERE IS STILL little artistic activity in Paris, though we are promised some good things for the near future: in mid-October the Musée d'Art Moderne will unwrap a mystery package, "Sources of Modern Art," which may well contain those French "antecedents" of Pollock about whom we heard rumors from André Malraux last spring. The Petit Palais show "The Eighteenth Century in Italy," which opens on November 4, promises to be an opulent affair; and in December the Galerie Charpentier will present a large exhibition of the Douanier Rousseau, which will no doubt be one of the main events of the season. While waiting for these shows, the frustrated gallery-goer would do well to visit one of the least-known and most curious museums of Paris, the Musée Gustave Moreau. It is advisable, in fact, to visit it before the cold weather starts, since the museum is not heated in winter. And it would be best to choose a sunny day, since the

afternoon sunlight, streaming in through the vast skylights over the crimson and gold of Moreau's colossal canvases, is an unforgettable spectacle.

We know relatively little of Moreau's life, save that he was born into a well-to-do family in 1826 and died in 1898 after a long and controversial artistic career. He is best remembered today as the teacher of Rouault (whose work certainly bears his stamp), Matisse and Marquet. He was also a friend of Mallarmé and of Degas, whose portrait of Moreau is on view here. He seems to have been eccentric and secretive, with a tendency to shut himself off from the world.

After the death of his parents, he decided to enlarge the family home into what it is today—a kind of mausoleum built to contain his work. Moreau willed the house to the state along with its collection—more than twelve hundred paintings and watercolors and more than four thousand drawings, the bulk of his artistic production.

He remained aloof from the main currents of the painting of his time, preferring to shut himself up in his mansion, painting the fantastic visions that haunted him. He is best known for large-scale mythological and religious paintings such as "Jupiter and Semele," or "The Daughters of Thespius and Salomé." These are labyrinthine compositions of figures, architecture and drapery, painted in exotic colors and encrusted with gold and silver. At their worst, they can be melodramatic or just vulgar. But more often than not they are touched with genius. "The Magi" is a superb painting, with its three heavy-lidded, somewhat androgynous kings advancing slowly through garlanded figures and an improbable rocky landscape. Here his technique of juxtaposing meticulously drawn details with summarily indicated blurred areas is seen at its best. He employs it also in "The Unicorns" and "The Chimeras," whose quiet, mysterious pathos makes one realize why he is one of the Surrealists' favorite painters. And indeed, according to the museum guardian, André Breton and Salvador Dali are frequent visitors to the museum.

In his smaller oils, Moreau often used a violent, frantic kind of brushwork that looks surprisingly like the Abstract Expressionism of today. In fact, the critic Julien Alvard included him as a predecessor in the show of avant-garde work last spring at the Musée des Arts Décoratifs entitled "Antagonismes." Alvard feels that Moreau, after first trying to reproduce a photographic likeness of the dreams that obsessed him, pushed on toward a kind of abstraction, realizing that his Nirvana could not be translated into ordinary pictorial terms. And Alvard quotes a remark of Moreau's that could have been made by one of today's abstract painters: "I believe neither in what I see nor in what I touch: I believe only in what I do not see and in what I feel."

Perhaps the gem of the museum is the collection of more than two hundred

watercolors housed in a revolving cabinet which Moreau had specially constructed to contain them. Each is different from the others and all are beautiful. There are studies of fashionable ladies like those of Guys, but painted with a crisp, crackling elegance; bizarre illustrations for La Fontaine; surreal landscapes and mythological scenes done in colors of an unearthly brilliance. Especially fascinating are the wash drawings of Italy, which have an Oriental simplicity: four or five strokes of the pen and a wash of pale beige suffice to render the scene.

The visitor is likely to have the museum, which is open from 2:00 to 5:00 p.m. and closed on Sundays and Tuesdays, all to himself. The guard, a friendly man with a deep appreciation and knowledge of Moreau's work, sometimes passes whole days without seeing a single visitor. He says that those who do come are generally foreigners — Britons and Americans especially. Its lack of visitors no doubt explains why the museum is not heated in winter (or is it the other way round?). Unfortunately, the resulting dampness is beginning to have a disastrous effect on some of the paintings. Many of them are badly warped, and most need to be cleaned. It would really be a shame if, for lack of necessary funds, this fascinating collection were left to deteriorate until it was beyond repair.

New York Herald Tribune (International Edition), October 5, 1960

V

AMERICAN ARTISTS

GRANDMA MOSES

W<small>HAT BETTER WAY</small> could there be of getting ready for Christmas than going to see Grandma Moses' paintings? The Musée d'Art Moderne de la Ville de Paris, where an important show by the Abstract Expressionist Mark Rothko opens this week, is also playing host to the work of a very different kind of American painter.

Just as Giotto and Fra Angelico are regarded with almost filial affection by the Italians because of something uniquely Italian in their work, Grandma Moses strikes a special chord in Americans. Even city-dwellers whose experience of American scenery is limited to the Merritt Parkway and who have replaced maple syrup with Metrecal grow nostalgic before Grandma's evocations of halcyon days in upstate New York.

Though naïve in the best sense of the word, she was by no means a

primitive. What strikes one is the sophistication with which she achieves certain effects. Her landscapes have depth, and the farawayness of distant blue mountaintops is beautifully conveyed. In "Shenandoah Valley," the landscape is composed of varied tones, while the river is rendered as a flat sheet of blue-gray which Whistler might have envied.

In "The Death of President Lincoln," the event is offstage just as in Breughel's "Fall of Icarus." What we have is a landscape whose distant red barns are delicately evoked; in the foreground only a few black decorations indicate that anything untoward has happened. The effect is startling.

Grandma Moses describes it in her autobiography. She had driven in to town with her mother on the day of Lincoln's assassination. "The pillars on the store were all wrapped in black bunting. And this man told her that President Lincoln was shot the night before. And I remember her coming back to the buggy and she said to Aunt Lib: 'Oh, what will become of us now?'"

The forty paintings in this show tell the story of Grandma's life. "Childhood Home," "The Night Before Christmas," and "Catching the Turkey for Thanksgiving" (or *La Fête d'Action de Grâces*, as the French titles have it) are followed by scenes of her marriage and subsequent move to Virginia, her return to Eagle Bridge and the big day in 1940 when she went to New York, to be present at her first exhibition. After twenty years as a successful painter (Governor Nelson A. Rockefeller decreed a state Grandma Moses Day in 1960), she died exactly a year ago, at 101.

She looked back on her life, "like a good day's work. It was done and I feel satisfied with it. I was happy and contented, I knew nothing better and made the best out of what life offered." These are feelings which, alas, are rarely expressed in modern painting, and Grandma Moses puts them across with conviction.

New York Herald Tribune (International Edition), December 5, 1962

WILLEM DE KOONING

IN THE FALL of 1970 Willem de Kooning began a series of twenty black-and-white lithographs, his first work in this form except for two inconclusive stabs at it in 1960 and 1967 whose results apparently didn't satisfy him. The reasons for his taking up a medium seemingly so foreign to his temperament at the age of sixty-six are not entirely clear; or rather, one can point to some possible ones but they seem no more nor less relevant to the work itself than his immediate sources of inspiration generally are: they are curiously independent of it and as it were co-existing with it.

One impulse, nevertheless, for the series may have come as the result of a trip in 1969 to Japan which happened, like his other rare journeys out of this country since he arrived here from Holland in 1926, almost by chance, at the suggestion of his friend and dealer Xavier Fourcade, who was going there on

business. Though he probably had never intended to visit Japan, once he got there de Kooning looked closely at Japanese art, particularly *sumi* ink drawings. Some aspects of the lithographs that were to come later suggest a parody of the parody of nature that *sumi* drawings, in a sense, already are.

Another impetus might be the friendly insistence of Irving Hollander, who with his partner Fred Genis runs Hollanders Workshop on New York's Lower East Side. For years de Kooning had rejected similar proposals from graphics studios and, knowing him as an artist for whom the notion of "finishing" a work is somehow irrelevant, one can understand his refusal. For the lithography stone or plate has to be considered finished by somebody before the printing process can take place and the work come into existence, however tentatively it may wish to do so. And the idea of a series of prints being pulled menaces even further this tentativeness, this openness to further suggestion, that is at the center of de Kooning's art. Furthermore the mystique of craftsmanship and the almost guildlike reverence for fine printing that prevail in the better studios are also alien to de Kooning's rugged spontaneity, although, having begun life as an artisan (sign painting and window display, founded on solid practical training at the Rotterdam Academy), he might have felt an obscure impulse to return briefly to the closed, comfortable certainties that the exercise of a manual skill can give. No doubt too the informal atmosphere of the two-man Hollanders Workshop (Fred Genis is also Dutch and speaks English with an accent almost like de Kooning's all-but-inimitable one) made the suggestion more attractive: the pieties of craft are totally alien to the workshop, whose casual ambience is more like that of a garage, though the level of craftsmanship is high.

Still another cause may be the restless desire for change and expansion that has always characterized de Kooning. After the "Women" of the 1950s he moved into the "Landscape" and "Parkway" pictures which were simultaneously topography and woman looked at too closely to be legible as such. These in turn precipitated the "Women in the Country" paintings of the late 1960s, in which the landscape seems to have given birth to its women before retreating once again to the sidelines, leaving behind only the barest reference to itself. The exuberant, often strident chromaticism and the luxuriant paint in these late, great pictures may have caused him to look for an antidote which the restrictions of the lithography process and the more or less mandatory black-on-white provided. (De Kooning had tried experimenting with color lithography but gave it up for the time being as too complicated; it requires that each color be drawn separately on a single plate or stone; these are then superimposed in the printing process. Having learned a great deal about technique while doing the black-and-white lithographs, he intends to try color lithography again.)

In a way, the lithographs have an oblique relation to the paintings that

preceded them, similar to that which his black-and-white paintings of the late 1940s have to their predecessors. In the latter case, the tautly organized, hot-colored figure paintings of the middle 1940s were gradually supplanted by paintings like "Attic" and "Mailbox." Here, drained of color, the shapes turn abstract, welling up meanwhile and pushing toward the front of the canvas' shallow space to produce an almost claustrophobic feeling that somehow soothes after the sustained euphoria of, for example, the "Woman" (circa 1944) or of "Pink Angels." Color and the human form have been purged and rendered ideal and remote; but in the process new pressures have built up which will in turn require puncturing when the time is ripe. In the same way, the vehement physicality of the "Women in the Country" leads to an equally vehement renunciation of physicality in the earlier lithographs such as "Love to Wakako" or "Weekend at Mr. and Mrs. Krisher." Subsequently there is an almost nostalgic return to the look of the Women, followed by a later period in which this dualism disappears and the artist begins again coining new words with the alphabet he has just learned, and where references to landscape, body and undecipherable abstract notations combine, proliferate, disappear or collide, sometimes all at once, to explode finally in the four lithographs done after the series was completed. Here de Kooning at last took to drawing directly on the stone slab, a process that had somewhat intimidated him before. He had at first used transfer paper, which he liked because he could throw away the sheets or cut them up and combine them. He also drew on zinc plates, but there is something about the sheer monumentality of a lithography stone that makes the most impetuous artist think twice before attacking it directly. At any rate, in the four post-series lithographs, the surface of the stone erupts into a dazzling over-all field of activity, as though "Attic" had exploded in a joyful apotheosis into the night sky. The effect is something like a sudden orchestral *tutti* coming after a solo passage.

The earlier lithographs with their Zen austerity and kineticism ("Love to Wakako" could be the visual equivalent of the Zen novice's getting hit over the head with a stick when he least expects it during meditation) are, however, worlds apart from de Kooning's previous black-and-white pictures and, in several cases, from the main tendencies in his work as a whole. The *sumi* "influence," if such it can be called, seems fairly apparent in the lithographs just mentioned and in a beautiful, somewhat denser one called "Reflections to Kermit for Our Trip to Japan," in which the "rivers and mountains without end" of a Japanese scroll are turned inside out to produce a perverse effect of calm. But these fairly explicit references do not intrude on the "meaning" of a particular picture—they remain contiguous to it, just as his early Ingres-like drawing of Elaine de Kooning isn't an homage to Ingres or an *exercice du style*

but a completely original work occupying the manner of another artist in order to remake it new. Allusions to other styles in de Kooning's work take place almost by chance, like a reference in a conversation that touched on a number of disparate topics without attempting to emphasize any one in particular. He is saying that anything that can be formulated in visual terms has a value for this reason and only for this reason—it is a part and a part only of the totality of the work which surrounds the viewer in a continuum where parts cease to matter.

"Love to Wakako" and "Weekend at Mr. and Mrs. Krisher," with their scudding stabs of painterly black line (set down so quickly that the spatters and bubbles in the ink are preserved like fossils), look like nonfunctional versions of the attempt to establish salient points in a new space that we get in Kline's black-and-white paintings. We know by now that de Kooning doesn't feel impelled to joust with space, to make exploratory forays into it. It is all around him; he knows it "like his pocket" as the French say, and its seething jungle of forms is here merely invisible, offstage rather than absent. Nor does the allegorical "richness" of black on white (as in Kline or in Pollock's black paintings of the early 1950s) really interest him. Though he is at times throughout the series happy to conjugate the nuances of black—crisp or velvety, thin or gooey—with a virtuoso's relish, more often than not it is the poverty of black that he is calling attention to. Many of the blacks look almost grizzled, and sometimes all nuances are lost in murky passages where no attempt is made to distinguish one kind of black from another. Some of the lithographs are printed on a dull beige stock suggesting cheap wrapping paper or newsprint, further muffling any monochrome elegance and making them seem humble and awkward, two qualities he seems to like in the things he loves.

"Weekend" marks the first appearance in the series of the curious mushroomlike shape that suggests a little house, here floating on a band of black cloud perhaps; he takes it up later in the strange "Table and Chair," a comparatively straightforward, Expressionistic rendering of some bits of organic furniture. This same shape reappears as an explicitly phallic mountain in "Japanese Village" (there are nineteenth-century erotic Japanese prints which similarly shows a mountain in the shape of a phallus, towering over a peaceful village). There is nothing to be said about this new shape, however, nor about the peculiar mantislike one at the bottom of "Weekend," which has become a swarm in "Wah Kee Spareribs." They are merely examples of how de Kooning can, when he feels like it, invent what Wallace Stevens called "a completely new set of objects." There are other times when this doesn't interest him at all, and indeed one of his important unstated assumptions is that it is good not to do the same thing all the time, even at the risk of doing nothing: this too will eventually take its place in the scheme of things.

After this promising and novel beginning, de Kooning seems to be turning to thoughts of how the themes that have recently preoccupied him will fit the exigencies of the new medium. "Mother and Child," "Woman in Amagansett," "Figure at Gerard Beach" are lush, horizontal variations on the theme of the landscape-woman; here, perhaps because he feels himself in familiar territory, de Kooning allows himself the leisure for elegance: the blacks of "Mother and Child" have that crisp, freshly crayoned look that is so exhilarating in Bonnard's lithographs, for instance. Another figure, "Clam Digger," is a revised version of an earlier lithograph; its elegance is the coarse elegance of a squat, bawdy Japanese figurine. (Clam diggers are common on eastern Long Island where de Kooning lives; the name is also used for a vodka, tomato and clam-juice cocktail served in the bar cars of the Long Island Rail Road. The *gaudeamus igitur* air of de Kooning's toiler of the sea suggests that the title might be an allusion to both.)

In works such as "Beach Scene," "Woman with Corset and Long Hair," "Table and Chair," "Japanese Village," "Marshes" and "Big," de Kooning gives the impression of advancing boldly into the medium and creating new forms uniquely suited and sometimes purposely inappropriate to it. "Marshes" and "Big" are two which he at first thought of publishing separately — according to Fred Genis he considered them "too good," a comment which, to one familiar with de Kooning's wit, need not be taken as an adverse judgment on the rest of the series. Perhaps he meant that they are too full, too "realized"; that their teeming richness is out of keeping with the skimming allusiveness of many of the others. Certainly they are remarkable, particularly "Marshes," whose congested field of black strokes reads both like a "mad" Zen monk's version of an iris garden and like a Chinese ideogram where the meaning and its figuration seem to move along parallel tracks, illuminating each other but destined never to meet. "Figure" and "Beach Scene" suggest the epigrammatic, enigmatic simplicity of early paintings like the untitled one of 1934 in John Becker's collection, yet here loosened enough to allow free play to the oozing ink with its moist and erotic overtones of beaches; and the "villages" are the odd bonuses that arrive seemingly out of nowhere when an artist has fought his way into familiarity with a new medium. The rage for reordering reaches a paroxysm in "Sting Ray," with its two halves apparently cut from separate sheets of tracing paper and juxtaposed. Both halves are clogged with swarming, blotted shapes from which issue smeared trajectories that are in turn absorbed back into them. The title suggests that the globular forms are swollen with venom, and the two halves could refer to a predator and its victim, but as usual there is no sense of tragedy, only an astringent reality that isn't grim because it's real.

In what at this writing were his most recent lithographs, the four done directly on the stone, de Kooning has "gone after" the work with an energy and

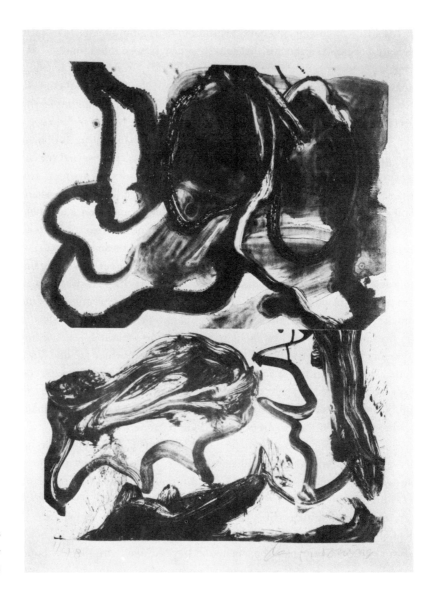

WILLEM DE KOONING
Sting Ray
(1970)

euphoria unusual even for him. It is as though the tense shorthand comments of a work like "Weekend" on the one hand and, on the other, the almost virulent, bulging masses of "Sting Ray" had erupted simultaneously, showering the surface of the picture with multiple allusions and proliferating forms. "The Preacher" is an outwardly-fanning field of repeated, interlocking gestures that suggests Boccioni (whom de Kooning admires while dismissing the concept of "Futurism" and of schools in general). The all-over *horror vacui* is unusual in de Kooning's work, for it is kinetic and fleeing rather than an unstable emulsion

like the highly charged juxtapositions of works like "Attic." "Landscape at Stanton Street" is kinetic, but here the strata seem to be collapsing inward into what Andrew Forge, writing on de Kooning, has called "reconcilable extremes of fragmentation and wholeness, violence and repose." A third recasts these galactic phenomena into a recognizable human shape: that of "Minnie Mouse," if we are to believe de Kooning's joking title, and sure enough, there are the oversize pumps, the hair ribbon, the ferocious *moue*. But these are, again, a metaphor for Woman, for woman as watershed, collecting evasive feelings and anomalies of execution under a single heading and thus letting them live.

This is where things stand at the moment. To the ecstatic, ecdysiastic world of "Women in the Country" — a sort of Eden situated, like Dante's, on top of the mountain of purgatory — the lithograph series as a whole seems to be opposing not only the austerity of monochrome but also a kind of discipline which still has room for moments of storytelling and sensuality. That there is no foretelling the future as far as de Kooning's work is concerned is of course obvious. All that we know is that it will change, and in art, in a sense, all change has to be for the better, since it shows that the artist hasn't yet given in to the ever-present temptation to stand still and that his constantly menaced vitality is emitting signals.

ArtNews Annual, October 1971

MARK TOBEY

A RETROSPECTIVE SHOW of the work of Mark Tobey has opened in Paris at the Musée des Arts Décoratifs. With more than three hundred paintings and drawings from 1917 to the present, it is the largest show ever held of the work of the American painter. This is another sign — perhaps one of the most significant to date — of the present dominance of American painting in Europe. To appreciate its importance, one should remember that France has long suffered from acute xenophobia, especially as far as the visual arts are concerned. Until recently there was a feeling here that modern art began and ended in Paris, and that to look for it elsewhere — especially in America — would be as pointless as to import California burgundy.

Then there is the fact that the Musée des Arts Décoratifs is, physically and spiritually, a part of the Louvre. In the past few years it has had memorable

exhibitions of great modern French painters—Picasso, Léger, Matisse, Chagall. Last fall it went a step further and shocked traditionalists with a retrospective of the caustic avant-garde painter Jean Dubuffet. This year it goes all-out by consecrating a painter who is not only essentially abstract but American, and it is a gesture which should touch and please Americans who are interested in their country's culture.

In order for the French fully to accept an American artist it helps if they can convince themselves that he is neglected in America. You occasionally meet a Frenchmen who tells you that Poe, Faulkner, Steinbeck and Dos Passos are unknown in their own country, or were until they had been discovered by France. There is a similar impression here that Tobey is a prophet without honor in the United States. This is, of course, quite untrue, as a glance at the list of his exhibitions there proves. On the other hand, it is true that Tobey's reputation in his own country has got misplaced, if not actually lost, in the shuffle of the last few years. His work is quiet as a whisper next to the stentorian voices of Kline and Pollock. He is closer perhaps to more introspective painters like Rothko and Clyfford Still, yet he eschews the large formats and dramatic solid-color areas they favor.

Most typical of Tobey are the "white writing" pictures—tiny gouaches whose gray or blue background disappears under a labyrinthine tangle of fine white lines. So it is perhaps not surprising that Tobey's subtle, self-effacing work should have gone relatively unnoticed. However, the current Paris show is proof that Tobey is the equal, at least, of the revolutionary painters mentioned above. From the very first picture shown, a meticulously realistic portrait from 1917, it is evident that we are in the presence of a painter of great originality and power. And each successive work confirms the monumental, heroic quality which Tobey paradoxically manages to capture in these fragile-seeming, weblike compositions. It is trite perhaps to quote Blake's line "To see the world in a grain of sand" in connection with Tobey, but this is exactly what the painter has done in his work.

Tobey has never been exclusively an abstract painter. For many years he made a living by painting portraits, and recently his bold "Sumi ink" portraits prove that he considers the distinction between the visual world and the world of the artist's vision an artificial one. Few would deny, however, that the abstractions constitute his most original achievement. Even in figurative scenes of Broadway, he pays less attention to the strollers than to the tangle of neon signs in the sky above them.

These lines somehow give an impression of the trajectories traced by the millions of lives in a great metropolis. One thinks of Kafka's story "The Great Wall of China," which describes the plight of a messenger who is entrusted by

the emperor with a message which he must carry to a distant part of China. He never succeeds even in getting out of the palace because of its incredibly unexpected vastness and the density of its population.

This feeling of an infinity of people, atoms and worlds, of endless spaces and incalculable lengths of time is what gives Tobey's work its strange poignancy. In a time when everything is measured by the inhuman figures of megaton and billion, Tobey's work strikes a note of hope. For it implies that no matter how vast and foreign are the spaces that surround us, there is nothing so unlike man that it cannot be comprehended and translated into human terms by the artist.

The exhibition has been brilliantly installed. The large rooms have been broken up into little chapel-like areas whose gray walls set off perfectly these intimate, meditative paintings. An unusual feature is a kind of conveyor belt of paintings which passes slowly before the spectator, and whose movement seems to echo the purposeful meandering of Tobey's drawing.

New York Herald Tribune (International Edition), October 25, 1961

BRADLEY WALKER TOMLIN

"REFINED SENSIBILITY" and "aesthetic preoccupation" are two of the clichés that are almost bound to crop up in any discussion of Bradley Walker Tomlin's work. His retrospective at the Whitney Museum in New York clearly shows that if his taste was not always as sure as is generally assumed, neither do his paintings lack a kind of virile profundity which transcends questions of refinement. It also gives the viewer familiar only with the canvases of Tomlin's final years as a "gentleman" Abstract Expressionist an opportunity to trace the complicated ways by which he approached this final realization of his gifts.

The earliest works shown, "The Red Box" (1930) and the rather woolly "Self-Portrait" (1932), seem the work of a beginner, neither promising nor unpromising, and one is surprised to note that Tomlin was respectively thirty-one and thirty-three when he painted them. Though they are "realistic," they

show no concern for the reality of the subject: surfaces are undelineated; shadows gouge irrational holes here and there wherever Tomlin felt they belonged. The color is muddy and "abstract." "The Red Box" with its composition of upended planes (suggesting a geological upheaval) and its preoccupation with bands and scrolls might prefigure the later Tomlin, if only the famous taste were more in evidence.

The next pictures, "Two Figures and an Easel" and "Collage" (both 1937), have a freshness and vivacity, even a whimsicality, that are completely lacking in the earlier ones. In spite of their lightness they indicate how seriously Tomlin took his painting: a traditionalist, he was ready to revolutionize his art at a moment's notice if he felt that the change was going to be justified. One is surprised to discover that the torn newspaper and the postage stamp in the collage are American, so European is its general look. "Two Figures and an Easel" is in the tradition of romantic, aesthetic Cubism and strongly suggests La Fresnaye (as do many of the later Cubist pictures). Opposing forces clash pleasantly: the easel, a Tomlinesque grid out of his penultimate geometric phase, is slapped down in the center in defiance to the jumbled mass of the two figures, who circulate freely around the outer edges. The whole has a cockiness, a *décousu* casualness in which order is nonetheless present, that makes it perhaps the most successful of the early paintings shown. Though they look French, both these pictures have an American exquisiteness like Demuth's. And though one feels that they are possibly overaesthetic in their approach, one should remember that it took real guts to be considered aesthetic in Socialist Realist America of the 1930s.

Around 1939 Tomlin began a period which was to last until the middle 1940s and which was, to this reviewer, a less happy one. Perhaps it is no accident that it coincided exactly with the war. "Outward Preoccupation" is an ectoplasmic still life dominated by an unsmiling Cheshire cat; other more or less symbolic objects in the picture include another cat, a vase with a pattern of numbers and letters, a mandolin, a Cubistic Greek head, and a bust (probably of Tomlin himself) with real hair and whiskers! The title apparently comes from the fact that the two cats and the two heads are each gazing in a different direction, away from the center of the canvas. The objects are bunched in the center, while the outer space has been rather listlessly filled in with geometrical shapes and suggestions of sky. The drabness of the colors is deliberate but uninteresting nevertheless; they bleed over the outlines of the objects, creating a blurred effect. His outward preoccupation seems to have distracted Tomlin: he is looking in too many directions, trying too many things at once. This blend of Cubism, realism and Surrealism is disturbing and unsatisfying.

Similarly, the well-known "To the Sea" (1942) presents an uneasy blend of

realism and abstraction. The real objects in this painting are pale and transparent and have an allegorical meaning: the wreath, the carved figurehead, the gray wing of a seagull or a graveyard angel. The shapes, on the other hand, are mostly real objects whose form happens to be geometric: the pier buildings, the railing. The same is true of "The Burial" (1943), with its apparent influence from Edwin Dickinson. In these pictures there is a poetic remainder: one feels Tomlin trying to convey a deep and complicated message. But the surface is not interesting enough to persuade one to probe among these gray mists, dull-colored squares and funereal statuary.

Very different seem the almost Gorkyesque still lifes of the middle forties, such as "The Armor Must Change" and "The Arrangement" (1944) (reproduced in the catalogue but not figuring in the show). It's too bad, as a matter of fact, that the crucial periods of Tomlin's development, such as the middle 1930s and the middle to late 1940s, are not better documented here. Luckily several works are included from 1948, perhaps the most important year of all. "Tensions by Moonlight" reveals a daring new side to Tomlin. It consists merely of a few white strokes on a black ground. These suggest many things: the tresses and curves of a young girl, a Cocteauesque minotaur, a Pierrot's buttoned costume. Yet, as was not the case with the canvases of the war period, the literary content has been dissolved into forms which exist only for themselves. It is an exciting picture. So is its companion, "Death Cry," painted the same year. Here the strokes are more elaborated, forecasting the pictographs of 1949. Other interesting phenomena of this period include "Number 3, 1948," which is halfway between a still life and a pictograph, and the science-fiction-like "Maneuver for Position." The variety of the work indicates that Tomlin found release in pictures like "Tension by Moonlight" and that more changes are in store.

These, not surprisingly, tend back toward gentleness and refinement. In "Number 8, 1949" the nervous energy of a pattern which seems to be made up of scythes and swear-words in Chinese is tempered by the sweet blue background. This contrast between form and color was to be the central idea in all the pictures Tomlin painted until his death in 1953. What a difference between a black-and-white reproduction of one like "Number 10, 1952–53," and the actual painting! In the reproduction it is frightening: a buildup of tiny interlocking bands whose mere number causes a swift apprehension, like the anxious feeling that the sight of the hundreds of windows in a skyscraper can cause in the heart of a New York resident. But in real life the almost luscious colors (olive, black, pale blue, spiked here and there with pink, purple or lime green) annihilate this impression: the picture is pretty, and could almost be a fabric design. And we remember that Tomlin's hobby was interior decoration.

If this ultimate attitude toward color is at times the weakness of the later

paintings, it is more often their strength. Until now, his deployment of color has lacked certitude: the drabness of most of the Cubist paintings never had the tone of a forceful utterance. Now on the other hand each picture has a new color "scheme" that is both bright and soothing: Tomlin's almost childlike happiness over his discovery of color is infectious. And he seems to be saying something profound about color, about why we like it, as well as about its relation to the more sordid aspects of life. In such a painting as the chic and powerful "Number 20, 1949" the colors are drab but they are crisp and inviting. They are in harmony with the shapes, which are at times like fragments of an alphabet for our instruction and at other times like weapons or like arrows directing our look off the canvas. Perhaps the simplest expression of the message of this picture and others of the late period is that both pleasure and pain exist in life and sometimes resemble each other.

The final canvases are the purest expression of Tomlin's personality: vast fields vibrating with falling petals or pink snowflakes. Falling suggests sadness but here the fall has been arrested and there is no sadness. One comes back to bathe in the light and glamour of these paintings as one continues to pick up a paperweight filled with snow to shake it and see the falling start again. Amid these soft clashings and feathery excitement Tomlin at last succeeded in creating an order out of disorder, and the result is one of the most convincing expressions of joy in contemporary painting.

ArtNews, October 1957

LELAND BELL

Lᴇᴇ Bᴇʟʟ ɪs ᴀ painter and a polemicist. Seeing him in his studio, vigorously at work on a number of canvases and meanwhile sounding off on his various pet peeves and enthusiasms, one has the feeling of coming upon an almost extinct variety of whooping crane, alive and well in its environment, happily honking around the pond and causing quite a commotion. For polemics, and by extension commitment — to art, that is — are all but extinct in the art world. Where polemics seems to flourish, it often turns out to be the wishful thinking of artists dedicated to the hopeless task of doing away with the art of the past, and must therefore be construed as a romantic metaphor rather than a practical exercise in persuasion.

Bell's commitment to the past is almost violent. Unlike other New York School diehards, his acrimony is not reserved for such suspect recent American

phenomena as earthworks and "Minimal," but extends right back through "heroic" Abstract Expressionism to the nineteenth and even the eighteenth centuries. Though he painted abstractly for a while, in the late 1940s, he broke with abstraction—violently, one feels—and has never made a separate peace with it despite the present old-master standing of such artists as Kline, Rothko, Newman and de Kooning. He grudgingly grants points to the last, but is much more severe about Pollock ("one Pollock in a hundred *really* succeeds—there's this phenomenal dryness to them"), and is even more negative, not to say irascible, about the others. Yet this is not the sour-grapes irascibility of an artist who has refused to conform to contemporary taste and has thus renounced the more gratifying forms of New York art-world success. Listening to him fume one day about the wishy-washiness of an Eakins he had seen in Washington hanging near a Bonnard, I realized that his hard line is the reflection of a coherent and completely honest aesthetic attitude. Most important, he does not spare himself: in Bell's opinion, there has never been a major American painter, himself included. However, a few almost measure up. One is Eilshemius, probably his favorite American painter. And he likes a few Ryders, and an occasional Inness. He detests Homer and Eakins. Beyond them there is nothing much except for an occasional Copley, West or Ralph Earle. Among twentieth-century Americans he admires Knaths, as well as his own contemporaries Robert de Niro, Nell Blaine and Al Kresch. One is bemused: obviously he knows what he likes, and probably he is right, but for a nonpainter, and probably even for most painters, an act of faith is necessary to follow his line of argument and to really see the qualities that link such diverse and marginal artists as Earle, Eilshemius and Knaths. Fortunately this act of faith is not inconceivable, thanks not only to his own vigorous powers of persuasion but, more important, to the evident integrity and beauty of his own work.

The art that matters for Bell is French, and his almost running defense of it would give aid and comfort to the French chauvinists who accuse American artists of chauvinism. For his is by no means the customary *idée reçue* that French art was great until 1914, when it ended except for rare anomalies like Picasso's "Bone" period and an occasional mutant like Dubuffet or Giacometti. In fact, it is the "other" tradition in modern French art that Bell values. He does not mention Picasso very much, and though he is quick to defend himself against the charge of neglecting both Matisse and Braque, it is the painters most of us tend to think of, when we think of them, as the secondary ones whom he considers the masters of the twentieth century. First and foremost there is Derain, the mere utterance of whose name puts a catch in Bell's voice. For him Derain is *the* painter, and listening to his impassioned proselytizing one wonders how one could ever have thought otherwise. But there are also Rouault,

Dufy, La Fresnaye, Marquet, van Dongen ("he painted the people of their day in their clothes and it worked")—in short, the painters of what we usually think of as the Silver Age of modern art. Nor does he share the prevailing low opinion of present-day French art: Balthus, Hélion and Giacometti are for him painters whose likes are to be found nowhere else, and who, despite their few disciples, are important enough to compensate for the current lack of a French tradition, and far superior to the masters of the New York School.

Why these painters, or, to simplify, why Derain, since he occupies the summit of the hierarchy that is modern painting as far as Bell is concerned? Although he can and does wax eloquent on the subject, his eloquence, though it persuades, never quite succeeds in explaining Derain's mastery. And this is as it should be, since the greatness of art can only be discussed, not explained—a fact that would seem too obvious to mention in any but today's pragmatic context. Bell says that no painting really satisfies him and that Derain's comes the closest. It has something to do with "color, with classic form, even though he doesn't always seize the human, pathetic moment. Derain holds more mystery, more unexpectedness. He takes enormous chances." I suggested that Derain's seeming "superficiality" throws many people off, and Bell said that he considers those dense, closed, glassy surfaces part of the chances. Also, Derain is for Bell "the biggest odd man out." He likes underdogs, and, one supposes, rather relishes being one himself—defense sometimes being the best form of offense.

In a 1960 article called "The Case for Derain as an Immortal," Bell began by describing a 1953 Derain self-portrait which he considers the most fascinating one of modern times:

> It exists in a state of buoyancy. Nothing is forced or exaggerated. A cheekbone, an earlobe, the smallest element of wrinkle—Derain sustains an unflagging love for each part. There is virtuosity without self-interest—virtuosity conquered. . . . I found it impossible to grasp its unpretentious and restrained style. There are the points, proof of the security of the work's angles, asserting the sharpness of locations in space (in the sense of Giacometti's sharpness) and the rotundities whose curves are caressed and released in surprising sequences. The mysterious play between point and roundness seems to exalt the volumes of the head. Drawing it was like trying to draw my own head. It completely eluded me.

"Virtuosity without self-interest"—such a program, as demanding as it is difficult to spell out in terms of regulations and restrictions, is one Bell has set himself, and his remark about drawing his own head takes on meaning when one realizes that he has been doing just that for more than a decade. His works

cluster around a few central themes, one of which is the self-portrait: these in particular give a tantalizing sense of incompleteness pursued almost up to the vanishing point. Each one seems to be saying, "Well, maybe *next* time . . ." Yet there is of course no next time, in Bell's sense that the perfectly satisfying painting has not yet been painted. The most each picture can do is to fulfill a little more of its potentiality than the previous one did, calling attention meanwhile to the results that still have to be achieved. In this, Bell's work suggests Giacometti's. But where the latter artist seems sometimes to have embarked on a hopeless mission, a sort of Penelope's web created only to be rubbed out and rebegun, Bell is not afraid to contemplate completeness, and his pictures are really finished works of art with built-in room for expansion on some hypothetical future occasion. In other words, he is not constructing a metaphor about the impossibility of art's ever becoming, but taking this impossibility into account while continuing to build an art that lives and breathes, that is complete in the sense that a life can be looked on as complete.

Most, but by no means all, of the paintings in Bell's current show at the Schoelkopf Gallery in New York are new variants of themes which have preoccupied him for a number of years. Some of these are traditional studio subjects: nudes, still lifes, self-portraits. But there are other, odder ones: for instance, the recurring theme of a group of three or more figures, half-figures usually, in an interior, sometimes gesturing at a butterfly that has entered the room, or playing cards and drinking wine; or another series about a nude woman recoiling in surprise from a dead bird that her cat has just discovered also. In view of Bell's insistence on absolute painting, the almost anecdotal, genre character of these pictures (remember Greuze's tear-jerker "The Dead Bird"?) can seem surprising. There is the additional fact that in these last two instances, the subject of the painting is something wild from outside that has intruded on the classic calm of the studio. Could Bell be trying to tell us something in addition to the living but unspecific truth of the painting? Not, I think, if one remembers his comment about Derain's not always seizing "the human, pathetic moment," and other remarks about the psychology of painting. The pathetic moment and the look of psychological truth are inseparable from the picture's plastic qualities, not in the Greuze certainly, but in the painters of the past whom Bell worships: Titian, Louis Le Nain, especially Giotto, whose figures he feels as a great influence on his own. And then of course in Balthus, whose smooth ambiguities are echoed somewhat roughly in Bell's work. Balthus' children playing cards or reading on the floor are to some degree a metaphor of boredom and, by extension, of man's fate, condemned to putter about the universe, halfheartedly trying to make some sense of it; but this idea fuses with the substance of the picture in a way that it does not in, say, a work by Hopper, of whom Bell has

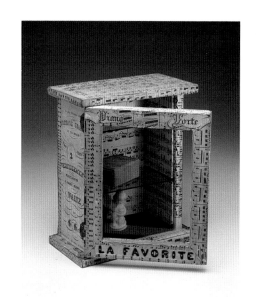

JOSEPH CORNELL

Untitled (La Favorite)

(1948)

YVES TANGUY

Multiplication of the Arcs

(1954)

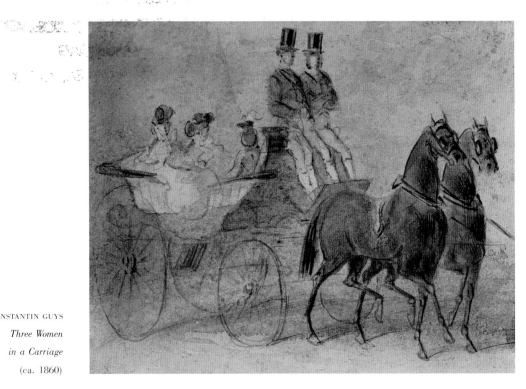

CONSTANTIN GUYS

Three Women

in a Carriage

(ca. 1860)

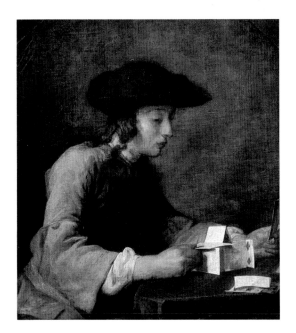

JEAN BAPTISTE CHARDIN

The House of Cards

(1737)

JOAN MITCHELL
Girolata
(1964)

JAMES BISHOP
News from Ferrara
(1964)

ANDRÉ DERAIN

The Artist

(ca. 1930)

GEORGES MATHIEU

*The Drawing and
Quartering of François
Ravaillac, Assassin
of Henry IV, King of
France, May 27, 1610*

(1960)

ANNE DUNN
Studio Interior I
(1980)

EDWIN W. DICKINSON
Villa La Mouette
(1938)

BRICE MARDEN
Blue Painting
(1972)

ALEX KATZ
Frank O'Hara
(1959)

JANE FREILICHER
Circle of Fish
(1981)

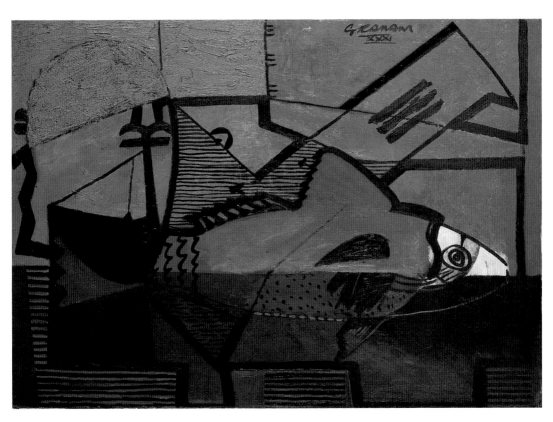

JOHN D. GRAHAM

Blue Abstraction

(1931)

SANDRA FISHER
Reading Baudelaire
(1983)

LUIS MARSANS
Varia
(1983)

SAUL STEINBERG
Millet (detail)
(1969)

JOSEPH SHANNON

Pete's Beer

(1970)

JESS

The Bridal Spell

(1979)

FAIRFIELD PORTER

Interior with a

Dress Pattern

(1969)

ALDO ROSSI
Teatro del Mondo
with Objects
(1980)

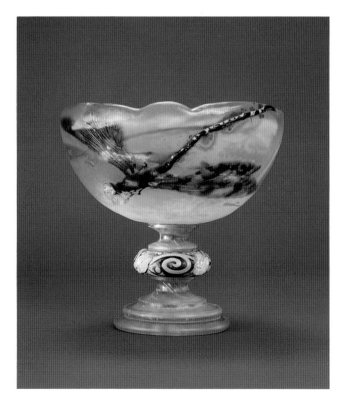

EMILE GALLÉ
Dragonfly Coupe
(1903)

GIORGIO DE CHIRICO

The Song of Love

(1914)

remarked that he likes his moods but not the painting. The greatest artists, for Bell at any rate, are those who manage to put in everything—light, drawing, color, story, psychology, the human condition—without any one element's remaining identifiable in the emulsion.

Bell did not mention it (in fact, for one so articulate about the painting of others, he is relatively uncommunicative about his own work and acts almost surprised when questioned about it; one feels he is so close to it that he doesn't need to see it), but these various themes seem to call forth different methods of handling from him. The still lifes, for instance, are done almost lightly in comparison with the figures. They are often large pictures (while the groups of figures can be tiny), and one is conscious of the air between the objects, their casual interplay, the space beyond them. One of his finest pictures is a still life done several years ago when he was teaching in Kansas City, which shows some bluish objects including a broken vase on a table, with a window behind and a car parked outside, without any facile suggestions of a worldview—these objects just conjugate each other nicely, at some distance from each other and as though indifferently. Another still life, with a toy horse, mixing bowl, dish towel and basket, is a similarly good example of Bell's almost carefree manner. The colors are light and noncommittal—white, tan, light green and blue—and one is very conscious of the drawing and the resulting contrapuntal verve.

Somewhat "heavier," to use the convenient rock term, is a large interior with a nude seated on a couch; this is apparently an isolated work not belonging to any series. Again, the architectonic drawing, heightened by the neutral, gray-green washes of color brushed in casually, more like indications to the viewer than a realistic assessment, is the driving force behind the picture, though the lean, sinewy nude with her jutting breasts and thighs has elicited a more detailed, more rounded account than the still-life objects just mentioned. This "deeper" treatment is also observable in portraits of his wife, the fine painter Louisa Matthiasdottir, and their daughter Temma, herself a gifted figurative painter. One portrait of Temma in a magenta skirt, with washes of ocher and cobalt blue in the surrounding room, has a lushness of color and an almost elegiac wistfulness more characteristic of his idol Balthus than of Bell. The blues and ochers also made me think of Cézanne, a painter whom Bell, after elaborately paying his respects to him, is apt to juxtapose with Corot, who for him is the greater master, and all the more so because modern art has tended to deify Cézanne and neglect Corot. In Corot, he says, "It's not the tint that is important, but the weight of the tint." And this would seem to hold true for Bell as well, particularly in works like the portrait of Temma, where the shifting and settling of these weights is allowed an almost fugal treatment.

The groups of figures in an interior occupy an important and special place

in Bell's oeuvre. One feels he will have never exhausted the possibilities of these moments of quiet domestic drama, nor have precisely isolated what it is that keeps bringing him back to them. Sometimes the figures—two women and a man, usually—are related in a sedate, sociable way, like figures in a Longhi, without one's being able to tell precisely what has brought them together. Occasionally there seems to be something like a marriage proposal in the offing—one of Bell's favorite pictures is an Eilshemius called "The Jealous Suitor," and nineteenth-century American genre painting is certainly, if distantly, being alluded to here. And then there are the butterfly pictures, with their gesturing figures whose mood, lilting at times, at others verges on something almost violent. Bell has apparently pushed these variations further than any of the others, judging from the amount of them in his studio, some large, some done on tiny bits of composition board ("I really almost had it down in that one," he said, gesturing toward one of the smallest ones which to the uninitiated eye did not differ greatly from the others). Color here becomes somber, even harsh and gritty: usually a dark red for the dress of the central figure, dark blue and green for the clothes of the other figures and the wall of the room. Also, there seems something almost accidental about it, as though in his haste to "get down" whatever it is, Bell were taking the first colors to hand since, as elements, they are of secondary importance. And here the drawing is modeled out of existence: anatomical forms are summarily indicated, forced into the swirling composition, outlined with heavy bands which the painter says are there merely to help him "keep it all straight" rather than as elements in a preconceived design. These pictures give off something hypnotic: except for Giacometti, one cannot think of an artist who so accurately puts across the idea of a man in the grip of his urge to create, to squeeze the essence out of what is around him, a hopeless task supplied with an inexhaustible stock of hope.

The nudes with a cat and bird, a more recent theme, are also treated in this manner. What is seen seems to matter less than what is being done. These are kinetic pictures, on their way to something else, and this is the source of their fascination. The culmination of what I think of as Bell's "darker" style is the suite of self-portraits he has been working on for years—at least since 1958, when James Schuyler chronicled the growth of one self-portrait, on which occasion the painter said of his sketches for the work: "One could say it's like the failure of a self-portrait. You never make it." These seething, monumental and tragic works are among his strongest. Looking at them one realizes the truth of his observation about Rouault, that he is a classicist, like Corot, not an Expressionist. They are also a link with the little-known abstract paintings he showed at the now-legendary Jane Street Gallery in the 1940s. Although his renunciation of abstraction was total and more vehement than most, there

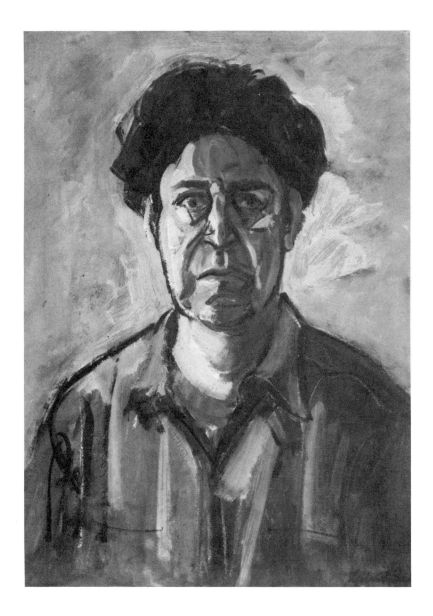

LELAND BELL
Self-Portrait
(1959)

remains an element of ambiguity to it. He said that at the time he had been "putting down big abstract forms before they had meaning for him." And, in the few abstractions he had around the studio, some very impressive indeed, one did feel that these complicated yet monolithic forms were about to break up into recognizable ones. The meaningful particularities of his own face have, worn away from repetition; one remains conscious of "the sharpness of locations in space," "the mysterious play between point and roundness" that he noted in the

Derain self-portrait. And yet the face remains human, beleaguered, awesome, like the self-portraits of Rembrandt which, more than any other paintings, leave one speechless by saying everything there is to say.

Glancing around the studio at the uncompleted series of paintings, Bell remarked recently that they were his "prisons." What he would like to do, he said, would be to take his easel outdoors, despite the arctic cold New York was experiencing at the time, and do some landscapes, to clear his head. Perhaps. But prisons, the kind one carries around with one, are not so easily broken out of. It seems likely that in his conflict with imprisoning reality Bell will continue to explore the general character of the struggle.

ArtNews, February 1970

ESTEBAN VICENTE

Although Esteban Vicente is well established as one of the leading painters of the New York School, he is presently having his first show of paintings in New York in seven years. (There was a show of his collages in 1969.) In addition to the fact that the painter is not one of those who feels compelled to exhibit every season, there might be two reasons why we have had to wait so long. One is the prevalent notion, which has only recently begun to be disputed, that only one type of art can be exhibited and taken in during a given period. In 1966—remember?—Minimal Art had suddenly expanded to fill all the available gallery space and the space in people's heads. Three years later everyone was having trenches dug in Utah. And now, it seems, anyone is free to do whatever he wants—a new and radical idea. In addition, Abstract Expressionism, after a long sojourn in oblivion, has suddenly returned, no longer as a

camp revival but as a living force. It began with "lyric abstraction," a sort of cold parody of Abstract Expressionism which almost immediately began to lose its aspects of a put-on and become more serious and more sensual. And suddenly Vicente is "rediscovered"; in the current ambience he reemerges as a master, but a master who has never stopped examining and developing his pictures, rebuilding and destroying and then rebuilding again. The above may be an oversimplification, but there is no denying that Vicente's paintings have probably never looked better than in the current show at the downtown Emmerich Gallery, not just because of the space and the acreage of gleaming white walls, but because downtown is where it's happening and where the young are, and Vicente occupies this seminal location quite naturally; it is indeed where he belongs. Not only is he widely known and admired as one of the best teachers of painting in America (formerly at Black Mountain and Yale; now at Princeton and the New York Studio School), but his own work is constantly undergoing changes which take new aesthetic developments into account, without necessarily conforming to them. Thus, in line with the temper of the times, his recent paintings have become simpler and more monumental, with fewer traces of their making, less brushwork, less of the vehemence and fragmentation of some of his earlier work. He has, he says, been trying to get rid of brushstrokes, which had begun to seem to him as something false, a kind of posturing; and often, in fact, they are made to substitute for genuine passion and inventiveness in painterly abstract painting: "I sweated over this and you'd better respect it" is the message. There was once a Mutt and Jeff strip in which Jeff went into business selling honey with a dead bee in each jar as a proof of genuineness, and frantic brushwork is often the dead bee in Abstract Expressionist painting. Vicente's paint seems to have somehow got itself on the canvas, thanks to a number of subtle "camouflaging" effects of which spraying the paint is only one. The forms in his paintings have always been gifted with a mysterious autonomy, as though they could be no other way; and the new absence of *facture* in his work allows them an even greater share of self-determination: shapes loom, condense, accumulate, dissolve, recur; color is a solid, a liquid or a gas, floating, emerging, returning into itself, sometimes far back in the canvas, sometimes out in the room behind the spectator. How the paintings got made is a mystery: as with the statues of Easter Island, it seems impossible that they *could* have been made and yet they are there. This is merely to point out that Vicente, a man who keeps up with and meditates on what is happening around him and who is in a mutually fruitful relationship of many years' standing with emerging young artists, has probably been affected by one current tendency—the reductive, depersonalizing one—but in his own way, forming his own conclusions and proceeding on toward a newly heightened and acute formulation of the problems

that have always preoccupied him—problems of edge, of "true" shape (in the sense of "true" color), of naturalness, of clearing away enough visual debris so that the authentic nature of the forms can become manifest, returning them to life from the limbo of concepts in which they had been asleep. This continuing process is well described in a statement by Juan Gris quoted by Vicente in an article he wrote on this painter: "I hope I shall come to express with great precision a reality imagined in terms of pure intellectual elements: this really means painting which is inaccurate but precise, that is to say, the reverse of bad painting which is accurate but imprecise."

Vicente was born in the Castilian city of Segovia in 1904. He left military school at the age of sixteen to enroll in the Academy of Fine Arts in Madrid, where he studied sculpture for three years before taking up painting. He had his first show at twenty-two in Madrid and then left for Paris, where he eked out a living as a photographer's assistant and scene painter, working on his own painting at night. He came to this country in 1936 and has lived here since.

A few months after his arrival in New York Vicente had his first show, at the Kleemann Galleries. It was reviewed favorably and at some length in *ArtNews*, and a black-and-white reproduction of a painting called "Catalina and Her Grandmother" was published. For one familiar with Vicente's later work, the picture comes as a surprise, for it seems to be in the conservative romantic vein of certain 1930s American painters like Benton, Bohrod or Leon Kroll. Two dark-clad figures, a young girl standing next to her grandmother, who is seated, stand out against an only slightly less somber background. But even here one can note concerns which have persisted: the loving delineation of similar dark tones, the massive shapes and their thoughtfully worked out relation to each other. The reviewer, Martha Davidson, noted: "The colors of Vicente's palette are low-keyed browns and reds, earth colors. His figures carefully composed within the frame of the picture have a sculptural volume"—words which might apply to some of the very different paintings in the current exhibition.

In a later review (of November 1951; by this time Vicente had been painting abstractly for a number of years), Lawrence Campbell pointed out that "while Vicente does not use any figurative content, one senses that emotionally his work exists indoors, and that the initial urge came not from landscape but from the figure." And in his article on Gris, Vicente himself says: "It is important to understand that all through the history of Spanish art, landscape painting as such is nonexistent. This, I think, explains in part the Spanish mind in relation to art as well as to life and religion. Nature as nature is not understood. It is an alien and cruel force that disturbs the intimacy and clarity of the interior life. This quality is passionately expressed by the great Spanish mystics."

And indeed, even where reference to the "interior" is not overtly given in the titles of the paintings (the words "room" and "interior" often occur, as does "window"—but the window does not give on a vista: it is a source of light and, while hinting at those menacing outside forces, it remains a feature of interior architecture), what we see is somehow always related to what we see inside, whether it be the figure, whose nature coalesces only within the four walls that Pascal advised us to stay within, or unidentified phenomena which appear as functions of the carefully guarded and tended "intimacy and clarity of the interior life." The paintings, and never more so than now, are the visible precipitations of the moment-to-moment awareness that is life—testing, questioning but persisting. A generalized idea of "nature," the one that everybody has, is all that is necessary for it to be shut out so that the business of discovering the real nature of nature, the one we arrive at only after repeated successful attempts, can be undertaken.

Vicente says that he is very concerned with edges, which are important because they ultimately define a figure, just as words make up a poem. One senses in his work a love-hate affair with edges, an urge to ignore them and get beyond them at the very moment of coming to grips with them. Edges limit the meaningfulness of forms by defining them too well, and Vicente is after a meaningful ambiguity that will give the work the widest possible range of associations. For a long time his solution was to work in collage, which he began doing in 1950. The edge of a torn piece of colored paper is less emphatic, less definitive, less of a statement than a drawn line; when it is torn in a certain way there will be a soft, fuzzy edge which is almost like no edge. The finished collages often gave the clue for a painting, though they were not exactly studies: he pursued both collage and painting side by side, with a collage influencing a painting which might then determine another collage. The earlier paintings were organized around the ghost of a linear framework, the painterly equivalent of the ambiguous boundary lines of the torn paper shapes in the collages. The lines caused a subtle shuttling movement, juggling depths and distances so that the viewer is always aware of them and yet unable to gauge them precisely. Elaine de Kooning wrote in 1953: "One segment of Vicente's composition will seem at one moment to belong to the vague and mysterious solid in the foreground; at the next, to the panorama behind. Positions are consistently ambiguous." And since they are *consistently* ambiguous they mean something, on a level which a mere bald statement of the facts could never attain.

Along with his concern not to leave traces of the artist's passage through his painting in the form of brushwork, has come a new and triumphant solution to the problem of the edge. One imagines Vicente as having always been slightly frustrated by those ghosts of edges in the collages and the paintings they

suggested. Accordingly the linear grid, subtle though it was, has been dropped, and the forms liberated from the restricting definitions supplied by the lines; they are free at last to be themselves as a cloud is (clouds don't have edges, they just seem to). Just how he does this is something of a mystery in the case of each canvas. Sometimes he manages it through subtle variations on a single tone, as in "Room 113 Red," which might be subtitled "Adventures of a Red": under blue, into vermilion, and through many other phases difficult to trace. Its subtleties baffle the eye so that it retreats, abandoning its simplistic desire to trace the exact outlines of the mysterious hieratic shapes that loom out of and into the canvas. Or a mist of one color will be floated over an area of closely related yet clashing color, as with the two blues in "Afternoon": the resulting "short circuit" attracts one's eye away from the edge, so that it registers before one is aware of it. The horizontal green streak in that painting is another such device: suggestive of a wisp of cloud trailing in front of the face of a mountain, it supplies notions—misleading ones—of depth and distance, and in so doing draws attention away from its hard-to-define shape. "Blues," one of my favorite paintings in the show despite its atypical festive colors (pink, gold, cobalt blue), dissolves edges in a number of ways: by blurring the margin between a pink zone and a gold one into a pinkish-gold buffer area; by burying a blue oblong so deep inside an area of slightly lighter blue that its contours merge with the surround; or, between the gold and the blue zones, by defining the edges rather straightforwardly, so that in the ambiguous context one is suspicious of the abrupt directness, until even this edge begins to waver.

The foregoing suggests that the paintings resemble Rothko's, and it is true that both painters share a concern for eliminating edges while retaining the forms that they define, and that occasionally their techniques for doing so coincide (as in the "buffer" of two superimposed colors referred to above). But Vicente's preoccupation with space and its ever-changing ambiguities is the dominant force in his work. Rothko, on the other hand, seems to negate the possibility of these ambiguities in an attempt to liberate color, even color with "spatial" implications, from the demands of illusionary space. Rothko might be at the end of a tradition of slowly squeezing and flattening space so as to celebrate color. Vicente, on the other hand, seems at the beginning of a new attempt to rehabilitate illusionism through color, without relying on its traditional range of references.

Yet in looking at these paintings one is not conscious of these subtleties as devices, and that is Vicente's triumph. Certainly he is a master of techniques for masking his thought so as to project it more efficiently at the viewer. His aim throughout his career seems to have been to find exact technical means for achieving just the right degree of ambiguity, that razor edge where the world and

preconceived notions of it meet and fuse. So it is not surprising that the techniques themselves are invisible, in view of his long concerted effort to make them so. The result in the paintings is wonder that confronts one's own wonder. One is aware of a shape such as a mock rectangle really for the first time; a trace of acid deep red will seep slowly into the recesses of the canvas in such a way as to remind one that one hadn't seen that color in some time and had missed it. One senses a coming to the world, a being born. A painting such as "Fallen Light"—all harsh chilly grays and grayed whites—makes one long for the colors of the dismal late-afternoon winter sky it suggests, because one now sees there was a truth to them.

Painters when they write on other painters often involuntarily describe their own work, and some of Vicente's remarks on Gris are extraordinarily applicable to his new paintings. Of Gris' last period, he wrote:

> The still lifes are monumental; simpler, richer. The integration of all the elements is completed. There is a fluidity, a complexity of both ideas and materials that he did not have before. He discards the volume from the form, he no longer uses the trompe-l'oeil introduction of space into flat surface. From the plastic point of view the work of this period has fullness and is superior.

And elsewhere: "You go into the work. It is strange and arresting. One feels a mixed sensation: there is painting and at the same time a world beyond painting full of a particular drama that is difficult to explain. Perhaps it is the drama of a man, the painter himself with his anxieties and the intensity of his search."

ArtNews, May 1974

EDWIN DICKINSON

BACK IN THE 1950S, when Abstract Expressionism exerted a monolithic hold over art in America, there were always a few artists with little or no relation to the movement who were looked upon as good guys and even allies by the Abstract Expressionists. Joseph Cornell, Ad Reinhardt, Fairfield Porter, and John Graham were among them, and so to a lesser extent was Edwin Dickinson, who is currently the subject of a small but superb retrospective show at the Hirshhorn Museum in Washington.

It would be interesting to know just why these artists were tolerated at a time when the prevailing taste in art amounted almost to a dictatorship. Dickinson's case is a little easier to understand, for in his swiftly executed oil sketches (or "premier coups," as he called them) smeared and throttled pigment coexists with passages of virtuoso realism, as in some of de Kooning's early

figure paintings. But it is even more a question of mood, I think. There is an otherworldliness in Dickinson that also appears in Rothko and Pollock, even though the physical resemblances are slight and fortuitous.

The Hirshhorn show, organized by the museum's curator, Joe Shannon, himself a brilliant painter and an articulate critic, consists of about sixty smallish landscapes, most of them premier coups—though one or two, such as "Hoyt House," are more developed and closer to Dickinson's other side: the large, ambitious and somewhat nightmarish paintings he would work on for years before finally "abandoning" them (among these are the Whitney Museum's "Fossil Hunters" and the Metropolitan's "Ruins at Daphne," which occupied him from 1943 to 1953). Coming on this show fresh from the Whitney's Hopper retrospective made me wonder once again if we really know who our greatest artists are. I would be the last to deny Hopper's importance, but in even the smallest and most slapdash of these oil sketches, Dickinson seems to me a greater and more elevated painter, and all notions of his "cerebralism" and "decadence"—two words critics throw around when they can't find anything bad to say about an artist—are swept away by the freshness of these pictures, in which eeriness and vivacity seem to go hand in hand, as they do in our social life.

The son of a Presbyterian minister, Dickinson was born in Seneca Falls, New York, and moved to Buffalo at an early age with his family. The landscape of western New York State—undramatic, slightly melancholy: your basic landscape—occurs throughout his work. So does Provincetown, where he first summered in 1912, studying at the Cape Cod School of Art under Charles Hawthorne. He also made occasional trips to Europe, painting views of summer cottages seen in an unearthly glare that is certainly not the light of Provence but rather the light of the mind.

Although the large pictures of figures and objects in ambiguous and disturbing proximity to one another are his masterpieces, the oil sketches at the Hirshhorn embody the essence of his painting. After scouting the "ideal" subject, he would draw it in a couple of minutes and then spend from two to five hours painting it. If the finished work was unsatisfactory, it was wiped out.

What was it about his subjects that appealed to him? Unlike Hopper, he seems often to have chosen them for their lack of suggestiveness. One such is "School Building, Bandol"—a drab pile of masonry that becomes charged with drama in his hands. Another French landscape from the 1930s is "Orchard," done at Lancieux, Brittany. The right half of the picture is a smear of crystalline murk that might be foliage; on the left are a few summarily sketched-in fruit trees. Few other painters would have seen any possibilities in this dour patch of landscape, but he transforms it into something unforgettable.

He is also unlike Hopper and other regionalists in his seeming indifference to specific moods of time and place. Rather it is a kind of universal specificness, applicable to any subject, that he is after. "Backyard, 770 West Ferry Street," painted in Buffalo in the 1930s, is at the opposite pole from Charles Burchfield's contemporaneous celebrations of the picturesque splendors and miseries of that city. Although we feel that an impression has been accurately seized, Dickinson's impressionism is a one-size-fits-all kind that can touch down anywhere like a tornado, fixing particulars that are part of an underlying essence that never changes.

<div align="right">New York, October 13, 1980</div>

BRICE MARDEN

ON THE MANTELPIECE in Brice Marden's studio in lower Manhattan are two photographs of Anna Karina (in the films *Alphaville* and *Justine*); photographs of Bob Dylan, Kafka and Falconetti (the actress in Dreyer's *Passion of Joan of Arc*); and postcard reproductions of Manet's "Olympia," Zurbarán's "St. Serapion," Goya's "Marquise de la Solana," two Cézanne paintings of bathers and his "Blue Vase" in the Jeu de Paume: a mixed bag of icons whose common denominator is their evocation of high moments in "Western" consciousness, which is often identified with decadence but which here, a few steps from the Bowery, is kept intact and pure, thanks to the multiple allusions that these juxtaposed images propose. The otherworldly glitter in Kafka's eye, Karina's withdrawn gaze, the tear snaking down Falconetti's cheek, and the paintings — each an example of an artist arduously and brilliantly storming the canvas, covering it with something

new because there was no other way of doing—are all aspects of the same experience, which is nothing more than the one of daily living, with knowledge, on our tired but still exciting planet. All of the pictures seem to be keeping a weather eye on Doomsday while asserting in various ways that there are important things still to be done. When art is produced, all kinds of disparate things get boiled down and distilled into something that is again new. In the case of Brice Marden this process is particularly striking, for it seems that the urgent articulations of Kafka, Dylan or Cézanne are being reduced to a primal matter that contains them all invisibly, at the level of essences, in vast reaches of uninflected paint which is simultaneously no-color and many colors at once.

Marden canvases are monochrome, but the resemblance to reductive art ends there. For, rather than reducing the complexities of art to zero, he is performing the infinitely more valuable and interesting operation of showing the complexities hidden in what was thought to be elemental. Looking back over events in art of the past ten or fifteen years, one realizes that the reductive phase (including Minimal Art, Conceptual Art and the other negations) was inevitable, given the tendency of each new wave of artists to tie art into ideological knots that their successors will find it increasingly difficult to unravel. And each time it becomes more important to do so, since double negatives immediately take on the secondary characteristics of the same tired old affirmative. The Gordian Knot technique never seems to work either: drastic solutions are usually temporary ones. Marden's solution has been to untie the knot, a long and painstaking but particularly rewarding process. Appearances to the contrary, his art is not negative minimal but positive phenomenal; it is not an abstraction but an object made by and for the senses. It is just as well, no doubt, that it does have the fashionable empty look. First of all it shows that Marden is aware of the problem posed by the Reductivists and is working within the limits imposed by it so as to get past it—the only way of doing so. And it certainly doesn't hurt for the paintings to look correct to the casual observer—and there are plenty of these around—even though Marden's stated unfashionable opinions ought to be enough to give his dealer ulcers. ("I work with no specific theories or ideas. . . . Painting for me is nonintelligent blundering through and making a painting. . . . It looks right or it doesn't. . . . I'm not nihilistic, I'm trying to make something complicated. . . . Sensibility rather than intellect. . . . Painting says pain in it. . . .")

I first saw Marden's work in 1966 at his first one-man show; I went because it had been recommended to me by Fairfield Porter, who might seem an unlikely champion of Marden's kind of painting until one remembers the areas of flat but resonant waxy pigment in Porter's landscapes, the precise distinctions among values, the recurring plums, grays and olives with their atmosphere of sober

festivity. "He paints panels that are all one color, but they're such *beautiful* colors." Porter didn't mean they were lovely colors (Marden: "I try to avoid interior-decorating color combinations"); probably "meaningful" would be a better word. And part of their meaning is that it can't be said in any other way. Robert Frost defined poetry as what gets lost when a poem is translated into another language; in this sense, poetry would be the sole content of a Marden canvas. Some of his colors can't even be described, let alone paraphrased, for instance those of the two horizontal panels of "Hydra I" in his recent show, two extremely close yet vigorously opposed "grays"—yet to call them grays is like calling *Remembrance of Things Past* a novel. Each seems to be the product of every color on Marden's palette except one; and although these colors have left no visible traces of themselves, they nevertheless burn insidiously in the non-color that has replaced them. To create a work of art that the critic cannot even begin to talk about ought to be the artist's chief concern; Marden has achieved it.

It was not quite correct to say as I did above that Marden works from some sort of attitude to other reductive art: actually he has been painting monochrome pictures since he was a student at the Yale Art School in the early 1960s, and with reference to no one. Still, the Minimalist riddle existed long before it was actually formulated—negation is always just around the corner—and Marden's reply is no less appropriate for having preceded this formulation in time. From the very first it was apparent that his art would be both austere, for its limitations, and sensual, for its allusiveness. He still has two paintings from his Yale days: one is divided into four squares: black, mahogany and two grays, with a churning Abstract Expressionist pulsion under the relatively calm surfaces. The other is divided vertically into two panels, one gray, one black. Though they are definitely student works lacking the finesses of light and texture that concern him today, they establish once and for all the narrow limits of his painting, which will be transcended only inwardly while outwardly remaining much the same.

Brice Marden was born in Bronxville, New York, in 1938. From 1957 to 1961 he attended Boston University, where he studied drawing and painting with Reed Kay, a teacher whose strict academic disciplines helped him enormously, he feels. The first year the students weren't allowed to paint, only to draw from the model. Later, when they took up painting, abstraction was forbidden. "If you did an abstract painting at home and brought it into class, your grades were likely to go down," Marden recalls. But he is happy to have had this early training; it gave him an added incentive toward an abstraction based, however secretively, in nature. His color is referential and not arbitrary; it must fit and hold the shape of the canvas exactly as it does in Cézanne, Manet or

Velázquez, three of the painters he admires most. After Boston he went to Yale, where his teachers included Alex Katz, Jon Schueler, Jack Tworkov, Esteban Vicente and Reginald Pollack, from all of whom he feels he learned something, but most particularly from Schueler and Katz, the former for his "romanticism," the latter for his brilliant verbalizations of problems. At that time Marden was influenced by de Kooning and Kline; it was Katz who persuaded him to stop imitating them and go off on his own: "With your sideburns and motorcycle boots, why are you trying to paint like a sixty-year-old Dutch master?" It was at this time that he painted his first monochrome paintings, still influenced by Abstract Expressionism.

One difference between the early paintings and those of today is in the quality of their surfaces. The two student paintings have hard, shiny ones ("a very physical kind of surface") scored with tiny scratches and lesions as though to emphasize their brittle tactility. So does another painting done after a fruitful four-month stay in Paris in 1964, and which he says was inspired by the quality of the walls in Paris—a gray diptych the color of a ceiling which he calls a "homage to Giacometti." This canvas looks as though it had been buffed to a high polish; today, Marden uses a wax-and-oil medium precisely to avoid any shininess, but both techniques seem related in their search for a certain physicality—in the recent matte paintings a less obvious but even more deeply abiding *Dasein*, too obvious for proofs of its existence to matter.

After leaving Yale in 1963 Marden lived on the Lower East Side, with relatively few contacts with fellow artists, and held various part-time jobs which allowed him to paint at night, which he still does. One of the jobs was as a guard at the Jewish Museum at the time of Jasper Johns' retrospective there. This gave him ample time to study Johns' work, which he feels has been very influential, although it obviously confirmed him in a direction he had already taken. "There was the whole idea of what's real—like the flags were real but they were paintings. And the grays, of course." These had preoccupied him for some time, but now they seemed to become the forms of his thought about his work. He has never, he says, considered himself as a colorist—at least until recently when color began more or less to seep into his work. He had taken the Albers color course at Boston and says he didn't understand it at all. The grays, however, were colors that allowed him to be *specific* (a word he frequently uses in talking about his work; also, one of his paintings is titled "Three Deliberate Grays for Jasper Johns") without facing the (for him) superfluous problems that prismatic color would bring in. Yet it is obvious that Marden has always been a colorist, by any definition but his own. The grays, though muted, are infinitely suggestive because of the precision with which they are differentiated; little by little, as the eye gets attuned to this pianissimo world, intervals that were at first

unnoticeable begin to seem tremendous. His current discreet excursions into hitherto uncharted territory such as blue, gold or orange were carefully prepared long ago. A certain French concert pianist is said to practice with gloves on in order to perfect his technique. In a sense this is what Marden has been doing, though the gray paintings are of course finished works and not preparatory studies.

Previously, in the one-panel, one-color paintings, he "wanted a complicated color experience from one color — yellow-gray one day, red-gray the next." The new two- and three-panel color paintings (in which, it should be mentioned, color scarcely runs riot) are the amplifications of this aim, undertaken after long premeditation. He has gained a new freedom. Suddenly, for instance, he found himself using blue after having always avoided it ("Blue Painting"). Why had he? Painters' statements about their mysterious aversions or attractions to a certain color are always fascinating to a nonpainter. In this case the answer was about as illuminating as it ever gets: "Because blue became either cold gray or too blue." The blues in "Blue Painting," however, fall into neither of these pitfalls; they are "just right" in the particularly satisfying way of Baby Bear's porridge, which one can judge only at the moment of experiencing it, as the painter did.

Brice Marden says that the three-panel paintings have "put him through a lot of changes." They made him ask himself: "What have I been doing all this time? What do I want to do in these?" And the beauty of these paintings is that the question is never answered, only stated ever more precisely and more urgently, so that the work goes on developing. One awaits these developments with impatience, as book reviewers say. He will probably not end up painting like Velázquez, although he has probably already achieved a quality he admires in another of his favorite painters, Zurbarán: "He looked at things so hard he went off into a mystical state. When he paints silk it's like iron but it's still like silk." This also evokes Marden's surfaces, which he has described as "not reflecting light but looking like they are absorbing light and giving off light at the same time." Which is to say that they aren't, like so much of today's art, allusions or comments, however oblique, on ideas that are elsewhere: they are themselves what is happening.

ArtNews, March 1972

LARRY RIVERS

W HY DOES LARRY RIVERS keep painting those cigar-box labels over and over?

Last year he showed a group of paintings in New York called "Golden Oldies" that were sort of a salute to his early work, with familiar themes such as playing cards and the Dutch Masters cigar label thrown together, as in a Victorian découpage screen. This year he's at it again: his new show at the Marlborough Gallery is called "Recent Works—Golden Oldies." Isn't it time, I asked him recently, that he stopped repeating himself?

Always delighted to explicate his work, he came up with a two-part answer, more or less to the effect that (a) he isn't repeating himself and (b) he is, but with a difference. "First of all, I've just been doing Oldies for a year and a half. And second, everybody does them and doesn't call them that. Look at Johns,

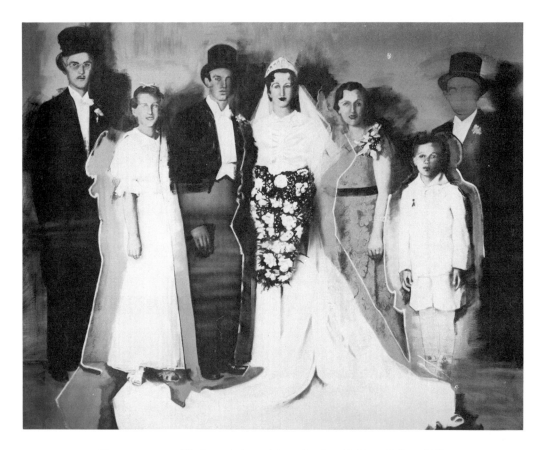

LARRY RIVERS
Wedding Photo
(Social Patterns)
(1979)

Newman. . . . Their work is nothing else *but* Golden Oldies." These assertions had a slightly familiar ring, which became more familiar when he added, "Take the Camel cigarette package. I'm pretty sure I was doing them before Andy started on the soup cans. I can't prove it, but . . ." And I suddenly remembered a certain artist who staggered out of a Niki de Saint-Phalle vernissage in the 1960s, moaning, "She's stolen my *burnt dolls*."

"What I'm doing," Rivers resumed as he showed me around the gallery, "is taking subjects that became popular and identified me and looking at them in the light of how I'm painting today."

It's true that there is a change in the way these new homages to his past are executed. Their painterliness has been reachieved after a period of his working almost exclusively with airbrush. One result of this was a 1974 show of paintings copied from Japanese erotic prints. And of course the mechanical means of airbrush and stencils helped Rivers reproduce the look of woodblock printing. Besides, he enjoys forcing one medium to do the work of another, as in several new paintings done from faded black-and-white photographs and as in

"French Vocabulary Lesson," where he uses colored pencil to simulate dripping pigment.

His new fluency with paint adds a dimension to the Oldies. One begins to notice it in a series of portraits of Daniel Webster surrounded by the usual cigar-label imagery, stylized flowers in particular. (Terry Southern told Rivers that flowers are reproduced so often on cigar boxes in order to combat the notion that cigars stink.) Something has changed since the "Webster Babies" series of the 1960s. "Well, I'd always been attracted to the sweetness of those labels — flowers, thrones, chariots, goddesses — somehow all the absurdity of the nineteenth century. But I got tired of doing the face the same way — the mouth, so cute and doll-like — and then I found a photograph made from a daguerreotype of Daniel Webster, and he looked so forbidding and . . . sexually repressed, and I started painting his real face on the label."

In fact, Webster's dour face is startling now as it peers out through stylized garlands, especially in one opalescent gray-and-pink version which reminds Rivers (never one to underestimate his own gifts) of Tiepolo, because "I think of Tiepolo as somebody who puts everything in the sky and makes you look up." It becomes even more startling in Mannerist parodies like "Wide-Angled Webster" and "Narrow-Angled Webster," where a distorting lens has turned the statesman into a bogeyman from some eminent Victorian's acid trip.

The biggest and most ambitious painting in the show is called "Wedding Photo (Social Patterns)." It is accompanied by a number of smaller satellite works, which is Rivers' usual method. First came a large and unusually detailed pencil drawing whose main purpose was to enable him to make stencils, using tracing paper. The stencils were then employed here and there throughout the paintings that followed, making little explosions of precision that help bring into focus a tangled skein of charcoal drawing or a wash of spray paint.

One of the larger wedding paintings, "Wedding Photo (On Approval)," even bears the "stamp" of the photographer, La Ruth Studios in the Bronx, warning that all proofs must be returned, at which time "blemishes, wrinkles, etc. will be removed." This photograph comes from a different wedding, circa 1940 (the one used in "Social Patterns" dates from a few years earlier), and includes a self-portrait of the seventeen-year-old Rivers looking like a young Tony Curtis. Rivers has played all kinds of tricks on the wedding guests in their rented finery — tricks which hint at the ironies and outrages of fate and time. As usual, he has "forgotten" to include a lot of the facial features, but here the effect on these faces striving to look composed and gracious for the camera is especially devastating. Vertical segments of bodies that weren't visible in the photo because the figures were crowded together are added as negative space, which looks like Peter Pan's chiffon shadow. "I got a charge out of trimming that

body," Rivers remarked, adding, "Now what that has to do with art, I don't know."

The painting at first appears to be all black and white, but this neutrality is undercut by "trace" colors—pink and grayish blue—which become apparent only gradually. Finally, the grab bag of techniques—airbrush, fine drawing, painterly realism (as in the bride's puckered white satin dress) adjacent to sputters of "action painting"—somehow fuse into a kinetic instant that says what there is to say about the realism and unreality of photography.

It's a great picture—along with several others in this show, which seems to have been put together to prove the truth of Kierkegaard's assertion that "repetition is reality, and it is the seriousness of life."

New York, October 29, 1979

JOHN CAGE AND JULES OLITSKI

AT AN AGE when most composers are either resting on their laurels or fluffing them in preparation for doing so, John Cage at sixty-five is not only hard at work on his music, but has also just ventured into a new branch of the arts—etching. The results are being shown at the Carl Solway Gallery on Spring Street.

Why etching? "Because, years ago, Gira Sarabhai invited me on a walking tour in the Himalayas, and I thought I was too busy to go." Wiser from this experience, he said yes when the Crown Point Press in Oakland invited him out to spend a week making etchings, a process he knew nothing about.

Out of this came a gorgeous large etching in color called "Seventeen Drawings by Thoreau," which uses tiny sketches Thoreau made in his journals of bugs, leaves, feathers, cracks in the ice, and other natural trivia. But no less impressive is a portfolio of seven prints called *Seven Day Diary*, the record of a

crash program in learning all the techniques of etching, or at least in using them—"an activity," he says, "that would be characterized by the fact of my not knowing what I was doing."

As usual, Cage let the I Ching take over. "Toward the end of the first day, I Ching chance operations were used with respect to two techniques—hard ground and drypoint—determining the tool to be used and the number of marks on a copperplate to be made with it. . . . All marks were made without looking at the plate on which I was working. Lilah Toland kept count, since I sometimes missed the plate."

"What," I asked Cage, "is the advantage of not knowing what you are doing?" "It cheers up the knowing," he explained. "Otherwise, knowing will be very self-conscious and frequently guilty." He added that his friend the late Mark Tobey used to have students draw a still life by first looking at the model, then placing their toes and noses flat against a wall and drawing on a sheet of paper placed above their heads. With the student practically immobilized, the work took over and did itself.

Cage's etchings seem likewise to have given birth to themselves. The meandering lines, sometimes trapped in the impression of a found object (grass or a piece of netting), have a life of their own that is closer to life than to art. The randomness isn't tentative. Cage's etchings have a physical presence so strong that it would be almost frightening if it weren't also so good-humored.

Cage also exhibits some early and recent musical scores which are close to graphic art. One is a 1940 "percussion and speech quartet" called "Living-Room Music," scored for the percussion instruments available in any living room: furniture, books, papers, windows, walls, doors. Some of the recent "Etudes Australes," which translate maps of the stars into musical notation, are included, as is the 1959 "Sounds of Venice," which contains such memorable instructions to the performers as "Pour water into dishpan. Uncover birds. Give birds water" and "Get cigarette. Put in mouth."

The show is like a marvelous overdose of spring tonic. After you come out of it, everything and everybody you see looks like a new percussion instrument.

IT'S TOO bad that Jules Olitski's painting (and that of his colleagues Kenneth Noland, Helen Frankenthaler and Morris Louis) has been pressed into the service of a critic-heavy industry which always threatens to smother it under a blanket of turgid and fustian prose that is far removed from the lucidity and cool immediacy of the work itself. (The latest example of this is Neil Marshall's tedious scholastic exercise in the catalogue of Olitski's show at the André Emmerich Gallery.) Difficult as it is for an artist to perform in a critical vacuum,

the overreaction to Olitski's work is something no artist needs. An Olitski bibliography accompanying the show runs to 141 entries, suggesting that the uninitiated ought at least to dip into some of it before raising their eyes to the work.

In fact, the work needs and demands to be looked at with fresh eyes. I don't think it's even necessary to know what Clement Greenberg means by "quality" (might it just be possible that he means what we all mean?) to recognize it staring at one from these seething but impressively mute canvases.

A student in Paris from 1949 to 1951, Olitski was one of the few American painters of his generation to have learned something from postwar European painting, including the much maligned School of Paris. Fautrier and Degottex, as well as the Spanish *matière* painters Tàpies and Cuixart, probably influenced him. Admirable (and underrated in America) as they are, one has only to glance at Olitski's new paintings to realize that they are also, by comparison, minor. Fautrier's gooey surfaces sprayed with chemical magenta or electric blue were a stimulating antidote to the prettiness of Paris abstraction in the fifties. But they also looked fatally intellectual, a pictorial demonstration of existentialism; and this temptation to ideology continues to undermine avant-garde art in Europe today.

Americans, including Olitski, have no difficulty absorbing the fact that art isn't about ideas but *is* ideas. There are pitfalls here too, of course: the Abstract Expressionist movement helped to spawn a horde of now forgotten geniuses whose work was based on the premise "I scrawl, therefore I am." At times Olitski has skirted similar abysses, notably in his sculptures of the sixties, which for me were too uneasily close to his spray paintings of that time to justify translation into another medium. But by now any doubt as to his position as one of our leading abstract painters should be swept away by the sheer weight and authority of these new paintings.

A small group from various series whose titles hint at eroticism or at least sensuality (*Cythera, Passion Flight, Esprit de Baron Ochs*) are grouped together in a small room of the gallery. They are delightful, particularly "Cythera 10," whose sculpted butterscotch surface suggests a detail from a Watteau painting magnified hundreds of times. But the major works in the show are the seemingly monochrome pictures in which Olitski has not only invented new colors but transcended the category of "color." "Profane Sleeper I," a swarming of gray particles in whitish space, seems carved out of the substance of sleep itself. "Tiresias View 2" is, precisely, the "view" of blind, androgynous prophecy: a shirred, puckered column of wind that scarcely stands out from its surroundings. "Line Passage 2," like others in that series, records the progress of a troubled, spidery line along the chaotic surface of the canvas. In "Line Passage

7" the "passage" works its way with the utmost difficulty down a grayish surface spattered with white, like a chain of mountain climbers making a forced descent along a cliff face.

One isn't supposed to "see things" like that in color-field painting, but one sign of Olitski's genius, I think, is that he makes it almost impossible to describe his work in words. Colors, shapes, textures demand a vocabulary that doesn't exist yet, and perhaps never will—a sure sign that the life of this work is in the work itself and not in danger of being drained out of it by critics. His new paintings, especially, stake out a claim to a territory that is beyond criticism, a place that looks like outer space but is also as near and as lively as dreams. Like Cage, Olitski shows us a not-knowing that cheers up our knowing.

New York, April 10, 1978

RED GROOMS

FEW MODERN ARTISTS have succeeded at being truly modern and pleasing
the general public as well. One vanguard artist who succeeds in entertaining
just about everybody from critics to kindergarten kids is a shy, gulping,
amiable, carrot-topped forty-three-year-old teenager from Nashville named
Red Grooms. A fixture of the New York art scene almost since he moved there at
nineteen, and now an international star, Grooms is known best for his zany 1975
environmental piece "Ruckus Manhattan," a vast scale model of much of his
adopted city. Installed in the austere splendor of the Marlborough Gallery, it was
for a while New York's answer to Disneyland.

Grooms now returns to Marlborough with a show of recent work that is both
effervescent and a tad more serious than usual. Once again, his humor cannot
be extricated from what comes across as a relaxed, humane attitude toward life.

His caricatures are sharply satirical but never mean (and Grooms often caricatures himself—in this show he is a frazzled soda jerk in a takeoff on Edward Hopper's "Nighthawks," while Hopper himself sits at the counter, glowering). He takes on urban garbage and graffiti without suggesting that a different state of things might be preferable, and does so not out of aesthetic laissez-faire but out of a deeper involvement with his material than most social satirists achieve. He celebrates the way things are, not the way they are supposed to be. Everybody is funny-looking, he seems to be saying, so nobody need be ashamed of it, and this enlightened attitude is an important reason why so many people respond to his humor.

This time around there are more signs than before of Grooms' awareness of Renaissance and classic modern art. Italian Mannerism, for example: Grooms discovered it in 1960 during a long trip he made through Italy with his wife, Mimi, in a rented horse-drawn gypsy cart. They put on puppet shows at night and toured museums and monasteries during the day. It comes as a surprise to hear that one of his favorite artists is Pontormo, though not after looking closely at "Danny's Hero Sandwich," an almost life-size replica of a takeout stand across the street from Grooms' loft in lower Manhattan. "Mannerism is fun and sexy to do," he says. "All those necks in the wrong places and muscles bigger than they should be." In fact, Danny and his sandwich men come almost alive through the exaggerations of limbs and features and the steeply shelving perspective of the stand—"because that's the way the eye takes in things."

Among Grooms' other not-so-obvious concerns are the work of the Abstract Expressionists and that of the late realist painter Fairfield Porter, whom he considers the most important influence of all. Porter noticed and admired Grooms when the latter was still staging happenings like "The Burning Building" (cost of production: $15) at funky downtown galleries in the late 1950s. Thanks to Porter's support, Grooms was able to make the leap from his own Lower East Side establishment, the Delancey Street Museum, to East Seventy-second Street, where he had his first "uptown" show with Porter's dealers Tibor de Nagy and John Bernard Myers—at which point his career was off and running.

What does Grooms see in Porter's work?

He made modern pictures with a clear eye, like a photographer's. If he saw someone sitting in a chair he could make a big modern picture of it. I'm trying to do that by analyzing the look of things and hoping that formality will come. Porter had both: form and the look of modern life. He was a very modern artist, like a Pop artist in a way. Once he painted this portrait of a kid in a Cub Scout suit, and I thought, how can he do that—*a Cub Scout suit!*

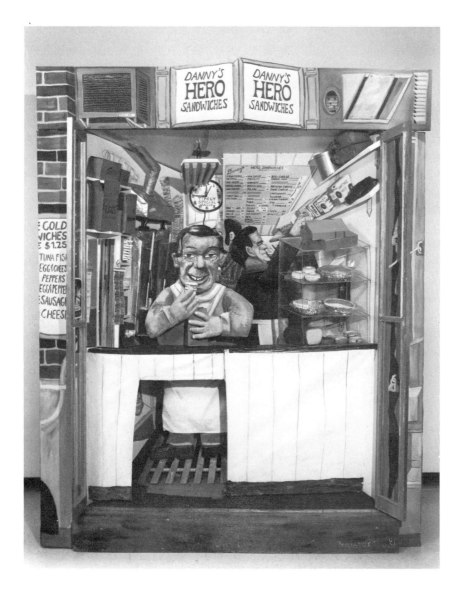

RED GROOMS
Danny's
Hero Sandwich
(1981)

Last summer Grooms rented a house in a small Breton village near Quimper, and the pictures he did there reveal his consciousness of Porter's impact and that of other modernist work considered to be more "serious" than his own. "I was intending to do a 'Ruckus' type piece about Brittany but it didn't work out," he says. "I'm always subdued in Europe."

What he did instead were scenes of Breton beaches, islands, farmhouses, churches and domestic interiors, which are surprisingly straightforward and sober. Though the exuberant, ricocheting drawing is familiar, the palette is not:

he has purposely limited it to "four or five" cool colors—pale yellow, green, gray-blue, light red. With a minimum of anecdote he has really captured the taciturn look of the land under the severe but soft Breton light.

These pictures are not going to alienate his fans, but just in case, Grooms has supplied plenty of new crowd-pleasers. Some, like "Goal Posts," are in a new medium, painted bronze, which he admits looks "just like my other stuff— but bronze is for the ages." For "Ruckus Manhattan" fans, the Canal Street Canaletto has provided "Looking Along Broadway Towards Grace Church": a sharply receding 3-D panorama bordered with garish skyscrapers tilted like playing cards and populated by the usual freaks and freaky vehicles, including one of New York's jinxed Grumman "Flxible" buses. Spoofs of modern art abound: besides the Hopper lunchroom there is "Walking the Dogs," whose tartan-clad Scotties have the multiple legs of Giacomo Balla's 1912 futurist "Dynamism of a Dog on a Leash," and a portrait of Jasper Johns looking plutocratic and backed by American flags; it was painted soon after the Whitney Museum acquired Johns' "Three Flags" for $1 million.

"Sometimes you want to be clear, sometimes private," he says. "I started out humorous, but I keep feeling more rational." Not too much so, though. Grooms is still a superbly wacky artist with a long way to go before sobriety sets in, and the latest stops along the way are as exotic as ever.

Newsweek, April 20, 1981

CARL ANDRE

"It is very hard to be simple enough to be good," wrote Emerson, and this lesson has been a bitter one for the Minimalist artists of a decade ago to swallow. Although it will probably be revived someday, along with everything else, Minimalism now seems as quaint as a Shaker rocker in contrast to the teeming heterodoxy of today's art. It survives, as schools do, in the work of a handful of artists brilliant enough to have transcended it: Stella, Judd, Marden, Flavin, and a few more, including Carl Andre, who is now showing at the Paula Cooper Gallery in New York.

Andre has made the transition from *enfant terrible* to *monstre sacré* very smoothly. His work, which gave offense at its first showing, in 1965, continues to offend, though it now does so on an international scale. Andre's "pile of bricks" called "Equivalent VIII" caused a flap of epic proportions in England when the press revealed that the Tate Gallery had paid $12,000 for it. And in

Hartford, where Andre's city-commissioned boulder-strewn lot downtown ("Stone Field Sculpture") continues to stir up political rancor, one Republican hopeful called it "a slap in the face of the poor and the elderly."

Nevertheless, on most of this side of the Atlantic it is hard to see what all the fuss is about. Andre's work seems no more shocking than that of many accepted avant-garde artists. Why are his "floor" sculptures more intimidating than, say, a Robert Morris felt piece or a Flavin fluorescent tube? In Andre's rough-cut timbers and their ritualistic deployment there are even vestiges of a sensuality that his colleagues have rigorously purged from their work. Maybe that's why he still infuriates some people—they are angry not because his work has some sensory appeal but because there isn't more (or less) of it. For in America we learn early that it is okay to be all one way, no matter what that way is, provided we "don't mess with Mr. In-Between."

For whatever reason, Andre's work continues to hold up remarkably well, though it has changed very little in the last fifteen years. His new show consists of four pieces, three of them arrangements of segments of timbers that look like railroad ties (in fact, Andre once worked as a brakeman on the Pennsylvania Railroad, but was fired after he almost caused a multitrain collision). The other is a group of short oblong pillars of Quincy granite, from Andre's hometown of Quincy, Massachusetts. In "Shiloh," redwood timbers are neatly packed into a corner of the gallery; in "Fallen Timbers," forty unfallen timbers are arranged in monotonous rows. The elements in the wood pieces are each thirty-six inches high and a foot square; in the granite piece they are exactly half that size, as though the granite were saying, I can afford to be smaller because I'm stronger. Whereas "Shiloh" and "Fallen Timbers" use redwood, the third wood construction, "Sum 13," is made from Douglas fir—a subtle, almost unnoticeable difference that nevertheless adds to the richness of the overall effect. Otherwise, the shapes are regular and mute, the hewn surfaces all but uninflected. The magnetizing force of the group of four works comes partly from their relatively low height (not low for Andre, though: some of his floor pieces are a mere three-eighths of an inch tall), which, in making the viewer look down, forces him into a patronizing posture that is mildly disconcerting.

Once when hassled by a group of Hartfordites who asked him, "How can we be sure you're not putting us on?" Andre replied, "I may be putting myself on. If I'm deceiving you, then I've deceived myself. It's possible." A courageous statement, which ought to be required memorizing for artists. For one of the ways that experimental art moves us is by its implicit admission that all this *may* be a put-on, may not be worth your while. The poignancy of this situation heightens our response to a Newman, a Rothko, or an Andre.

New York, April 14, 1980

NEIL WELLIVER AND

ALEX KATZ

A NUMBER OF THIS country's most distinguished artists are having one-man, or, if you will, one-person, shows in New York galleries this month. They include Lee Krasner, Jacques Lipschitz, Al Held, Andy Warhol and Ben Shahn. I wish I had space to discuss a number of them, but since I don't I shall confine myself to two: Neil Welliver and Alex Katz, both in mid-career at about the age of fifty, whose new work brilliantly consolidates the promise they have long shown.

Of the two, Neil Welliver is the one to have not quite "made it big" until now, but this show ought to do it for him. It's wildly beautiful. I happened to see it before it opened, when the gallery was empty, and these almost life-size paintings of forests and streams produced a loud hush. I felt I was surrounded by nature.

For a number of years, Welliver has painted exclusively the rather bleak

landscape of the part of inland Maine where he lives. He used to plant nudes in the woodland streams; then they abruptly disappeared, and there remained nothing human—no sign of a man-made construction or habitation—to interrupt the leagues upon leagues of trees, underbrush, and mud, all recorded so scrupulously you felt the artist had taken an oath to be as truthful as possible.

He has never before succeeded so beautifully in recording the thoughtless messiness of nature and imposing, if not an order, at least the systematic logic of its own disorder on it. The endlessly twining birch twigs in "Back of Hatchet" read like the score of a harp concerto. Another great picture is "Shadow," a birch grove in the snow with the bottom half in shade, the top in sunlight—more haunting than anything Magritte ever did because of its total commitment to realism. Best of all perhaps is "Late Light," a steeply shelving patch of forest undergrowth with the light fleeing in the distance in a way that is incredibly poignant.

The surprising thing about these paintings is that their fine detail is achieved with broad brushstrokes and a very fluid oil medium. Viewed from up close, they are as luminous but ambiguous as a passage from a late Monet, except that the palette seems to have been restricted to a dozen or so hues that the painter decided on in advance. When one steps back, the coarse blobs become tiny in some mysterious way, to form a mosaic that magisterially conveys the mesh of nature.

ALEX KATZ is showing a group of his "cutouts"—a form he invented. These are painted metal silhouettes of figures in his fluent *à la page* medium. His abrupt way of diminishing some details and ballooning others, his raffish way with perspective—particularly in a portrait of his son Vincent holding a fish at an arm's length you would swear was three-dimensional—recall the tricks and illusions of the Tuscan Mannerists, but cleansed of sfumato to become the astringent vehicle of what Carter Ratcliff calls in his catalogue essay (the best piece of criticism I have ever seen on this hard-to-elucidate artist) "meanings ordinary life leaves buried in the patterns of social usage."

Katz also has a lovely small show at another gallery of portraits of his poet friends, including Ted Berrigan, Kenward Elmslie, Ann Lauterbach, Michael Lally, Alice Notley, Peter Schjeldahl and Ted Greenwald. They are aquatints, and each comes with a poem by the portrayed poet. Katz's is the kind of realism often characterized as "laid-back," but in his case it is not so much laid-back as poised, ready to strike.

New York, March 12, 1979

JENNIFER BARTLETT

JENNIFER BARTLETT IS the art world's reigning media princess. When she travels via the Concorde to join her movie-actor husband in their Paris apartment (the very one in which much of *Last Tango in Paris* was filmed), it's automatically news. She has been profiled in *The New Yorker*; *ArtNews* published a cover story, "Jennifer Bartlett's Fame and Fortune"; and a *People* magazine story is in the works. It could be only a matter of time before she joins Julio Iglesias and Cher on "Lifestyles of the Rich and Famous."

All the hoopla aside, Bartlett is one of today's most prodigally gifted artists. Luckily her work is as highly visible as she is. Since 1974 she has had eight shows at New York's Paula Cooper Gallery, including one this spring, and a large retrospective is now on at the Walker Art Center in Minneapolis.

Born Jennifer Losch in Long Beach, California, in 1941, Bartlett came of

age in the beach-bunny era and was a high school cheerleader before going on to study art at Mills College and then at Yale's School of Art and Architecture with the Abstract Expressionist Jack Tworkov. She married Edward Bartlett, who had come East with her from California to study medicine at Yale. After a period as a commuting couple, they eventually were divorced in 1972. Meanwhile Jennifer had started a career as a conceptual artist, settling in New York's newly named SoHo district.

Early on, she began using steel squares surfaced with baked enamel in lieu of canvas (subway signs gave her the idea), silk-screening them with graphlike grids and filling the squares with seemingly random arrangements of colored dots. Though at the time they seemed part of the Minimalist main-stream, one can see now how unorthodox they actually were. Her habit then — and now — is to begin with a basic concept and work it out *ad absurdum*, ultimately sabotaging its "purity" with freewheeling improvisation.

It wasn't until she exhibited "Rhapsody" at Paula Cooper's in 1976 that the madness of her method, as Marge Goldwater terms it in her catalogue essay, became apparent, along with the fact that she was an artist to be reckoned with. The 154-foot sequence of 988 enamel plates swept around the walls of the gallery, dazzling viewers with its vibrant colors and the icy brilliance of its surfaces. A huge critical success, the show launched Bartlett's career. "Rhap-sody" was an elaborate series of permutations on four motifs — tree, house, mountain and ocean — chosen because they were the first four subjects that occurred to her. She has used the same random conceptual approach in succeeding projects, like the vast "In the Garden" cycle begun in January 1980 during a dreary winter in a villa in Nice. Its unpromising view (a swimming pool in poor condition, some dying cypress trees, a statue of a urinating cherub) gets subjected to every imaginable kind of treatment short of bombardment with atomic particles.

Many of her series have been commissions (others are what critic Roberta Smith calls "self-commissions"). For Volvo's international headquarters in Göteborg, Sweden, she decorated a suite of rooms both inside and out, embel-lishing the nearby rocky landscape with a cabin, beached rowboats made of Cor-Ten steel, granite chairs and a table. These objects appear in miniature indoors, the cabin having become a cigarette box and one of the boats an ashtray. Amid a congeries of jarring styles, there are views of the sea done in a painterly manner reminiscent of Courbet. She continues to evoke nineteenth-century Realism in a new, ongoing group of pictures-with-objects called "Creek" and another that is set in the Luxembourg Gardens in Paris, with full-scale models of plaid sailboats on the floor echoing sailboats on the canvas. Why plaid? "I find plaid deeply entertaining" is her answer to that dumb question.

Since Bartlett is highly successful, sexy, articulate and female, she tends to get portrayed as the Joan Collins of SoHo. In person, she suggests how Stockard Channing might play the role of Dorothy Parker, and there is a touch of Gracie Allen as well (she used swimmers as the theme of a commission for a federal courthouse in Atlanta because she thought Atlanta was on the Atlantic Ocean). She knows she's ambitious and that her success has created widespread envy. "Jennifer is a legend in her own mind," cracked an ex-friend. Bartlett dismisses it all with a shrug. "Journalists ask me if I'm arrogant and I say no, so they write, 'She's arrogant.' Then they ask me if I like luxury."

Happily married since 1983 to Mathieu Carrière, a German of French Huguenot descent, Bartlett is expecting her first child in August. Recently the couple portrayed themselves in *The Actor's Wife*, a film made by Jennifer's studio assistant John Schabel that is part home movie, part screwball comedy. It's a typical (rainy) day in Paris: Mathieu looks unsuccessfully for work while Jennifer is "developing a finger-painting technique I learned at Yale." As the hostess of a disastrous dinner party, she locks herself in the bathroom and curls up on the floor with a book.

Will she continue to split the year between Paris and New York? Paris, she says, is "really a nice place to live if that's where you want to spend your life." "She's extremely definite about plans but can change them in seconds," explains Carrière. "She plans, she sticks to her plan, but then it doesn't matter if she fulfills it." It's a formula that seems to work for Bartlett, both in life and in the sumptuous incompleteness of her art.

Newsweek, June 10, 1985

NELL BLAINE

Lord, the Roman hyacinths are blooming in bowls and
The winter sun creeps by the snow hills;
The stubborn season has made stand.

These lines from Eliot's "A Song for Simeon" suddenly came to mind as I was preparing to write about Nell Blaine on a snowy day in New York City, having visited her the day before in her apartment on Riverside Drive. I suppose Eliot intends us to consider only the irony of the "forced" blooming, while winter has its way with the snow hills, much as the characters in Strindberg's *Ghost Sonata* delude themselves into imagining there is life in the "hyacinth room" of their house of death. Yet as I open the notebook which Nell has lent me I feel a sudden explosion of freshness emanating from her studies of potted plants and cut

flowers in vases, which leads to the larger and more distant explosions in the landscape watercolors that are also represented in the notebook: mountain peaks in Austria exhaling violet mist, or rock ledges in Gloucester surrounded by wild flowers in flaming bloom. Even the cars parked next to an ungainly summer hotel in Gloucester are into it, reveling in the freshness, breathing in color, dreaming car-dreams. I have to think that Eliot was wrong in this instance, if he meant us to look at the flowering hyacinths as something tragic; life is life, no matter artificial, how contrived the context.

Nell Blaine has been confined to a wheelchair since she was stricken by polio in 1959, so that much of the news of nature she reports on is noted from behind a window (but what a window: crammed with greenery and framing the Hudson River and the bluffs of New Jersey beyond it). Still, this infirmity hasn't kept her from visiting the landscapes of the world: Austria, where she often takes up residence in the mountain chalet she inherited from the poet Howard Griffin; Gloucester, where she has a summer cottage; Saint Lucia; Cornwall; the Tuileries in Paris; and the Retiro Garden in Madrid. These erupt into her work with a particular, acute fragrance that is perhaps the result of her knowing herself privileged to be able to taste it after a narrow escape from death and years of living in a partly circumscribed environment. Her notebooks record surroundings whose note is intimacy, whether she is seizing the shapes of clouds or zeroing in on the somewhat comic, flamingolike stateliness of a bird-of-paradise flower, recording its quirkiness with an electric line always ready to fracture its itinerary in the pursuit of ephemeral reality.

Ever since she first thought of becoming an artist, Nell Blaine has kept visual diaries in the form of sketchbooks like this one. They are a parallel activity to drawing and painting: she said she always intended to use her notebook sketches in more finished works but never got around to it. So the notebooks are like the diaries of a great novelist—Virginia Woolf, for instance—in that they offer rewards of their own, similar but apart from the work for which she is best known. Since they are a more private activity, done mainly for herself, we can feel the genius that informs her larger work here at a more tentative, spontaneous level: the work as it is just happening into being.

Nell Blaine long ago moved on from the Constructivist abstraction of her early career, when Hélion and Léger (both residents in New York during part of World War II) incited her toward a geometrical painting that looks less orthodox and more casual than much American abstract painting of the time. It was only natural, no doubt, that she would eventually move on to figuration, since nature in its liveliness and unpredictability is already latent in her abstractions. Yet the early disciplines subsist in her work today, which is never "impressionistic" even when trying to capture the subtleties of mist-shrouded mountains. There is

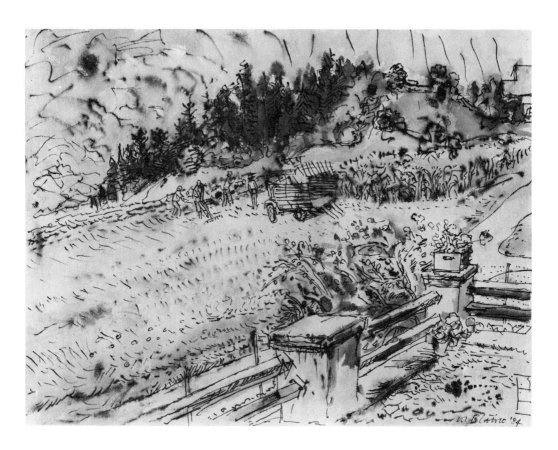

NELL BLAINE
Hay Raking,
Haderlehn
(1984)

always a firm line underlying such overall effects, as in the "Tongue Garden" sketch, where each dazzlingly-hued spike and blade remains an individual identity, even though the end result is a mass of churning color. Or in the drawing of her backyard in Gloucester, where the black line is of uniform width and solidity and yet succeeds in suggesting infinite shadings. The sensuality in these works is backed up by a temperament that is crisp and astringent, which is as it should be, since even at its most poetic, nature doesn't kid around.

The notebooks are perhaps the point in Nell Blaine's work where these two rival but friendly tendencies meet most illuminatingly for a student of her work. It is good to have this one, its subtleties perfectly reproduced, as fragile but steely as the bird-of-paradise itself.

From *Nell Blaine Sketchbook* (1986)

JANE FREILICHER

I FIRST MET JANE FREILICHER one afternoon in the early summer of 1949. I had recently graduated from Harvard and had somewhat reluctantly decided to move to New York, having been simultaneously rejected by the graduate school of English at Harvard and accepted by Columbia. Kenneth Koch, who had graduated the year before me, had been urging me to come and live in New York. He was at the time visiting his parents in Cincinnati, and told me I could stay in his loft (loft?) till he got back; his upstairs neighbor Jane would give me the keys. Accordingly I found myself ringing the bell of an unprepossessing three-story building on Third Avenue at Sixteenth Street. Overhead the El went crashing by; I later found that one of Kenneth's distractions was to don a rubber gorilla mask and gaze out his window at the passing trains.

After a considerable length of time the door was opened by a pretty and

somewhat preoccupied dark-haired girl, who showed me to Kenneth's quarters on the second floor. I remembered that Kenneth had said that Jane was the wittiest person he had ever met, and found this odd; she seemed too serious to be clever, though of course one needn't preclude the other. I don't remember anything else about our first meeting; perhaps it was that same day or a few days later that Jane invited me in to her apartment on the floor above and I noticed a few small paintings lying around. "Noticed" is perhaps too strong a word; I was only marginally aware of them, though I found that they did stick in my memory. As I recall, they were landscapes with occasional figures in them; their mood was slightly Expressionist, though there were areas filled with somewhat arbitrary geometrical patterns. Probably she told me she had done them while studying with Hans Hofmann, but it wouldn't have mattered since I hadn't heard of him or any other member of the New York School at that time. My course in twentieth-century art at Harvard had stopped with Max Ernst. (For academic purposes it was OK to be a Surrealist as long as the period of Surrealism could be seen as being in the past, and things haven't changed much since.)

Despite or because of our common trait of shyness, Jane and I soon became friends, and I met other friends of hers and Kenneth's, most of whom turned out to be painters and to have had some connection with Hofmann. (This is not the place to wonder why the poets Koch, O'Hara, Schuyler, Guest and myself gravitated toward painters; probably it was merely because the particular painters we knew happened to be more fun than the poets, though I don't think there were very many poets in those days.) There was Nell Blaine, whom the others seemed in awe of and who differed from them in championing a kind of geometric abstraction inflected by Léger and Hélion. There were Larry Rivers, Robert de Niro and Al Kresch, who painted in a loose figurative style that echoed Bonnard and Matisse but with an edge of frenzy or anxiety that meant New York; I found their work particularly exciting. And there was Jane, whose paintings of the time I still don't remember very clearly beyond the fact that they seemed to accommodate both geometry and Expressionist surges, and they struck me at first as tentative, a quality I have since come to admire and consider one of her strengths, having concluded that most good things are tentative, or should be if they aren't.

At any rate, Jane's work was shortly to change drastically, as were mine and that of the other people I knew. I hadn't realized it, but my arrival in New York coincided with the cresting of the "heroic" period of Abstract Expressionism, as it was later to be known, and somehow we all seemed to benefit from this strong moment even if we paid little attention to it and seemed to be going our separate ways. We were in awe of de Kooning, Pollock, Rothko and Motherwell and not too sure of exactly what they were doing. But there were other things to attend to:

concerts of John Cage's music, Merce Cunningham's dances, the Living Thea-
tre, but also talking and going to movies and getting ripped and hanging out and
then discussing it all over the phone: I could see all of this entering into Jane's
work and Larry's and my own. And then there were the big shows at the Museum
of Modern Art, whose permanent collection alone was stimulation enough for
one's everyday needs. I had come down from Cambridge to catch the historic
Bonnard show in the spring of 1948, unaware of how it was already affecting a
generation of young painters who would be my friends, especially Larry Rivers,
who turned from playing jazz to painting at that moment of his life. And soon
there would be equally breathtaking shows of Munch, Soutine, Vuillard and
Matisse, in each of whom — regardless of the differences that separate them —
one finds a visceral sensual message sharpened by a shrill music or perfume
emanating from the paint that seemed to affect my painter friends like catnip.
Soutine, in particular, who seems to have gone back to being a secondary
modern master after the heady revelation of his Museum of Modern Art show in
1950, but whose time will undoubtedly come again, was full of possibilities
both for painters and poets. The fact that the sky could come crashing joyously
into the grass, that trees could dance upside down and houses roll over like cats
eager to have their tummies scratched was something I hadn't realized before,
and I began pushing my poems around and standing words on end. It seemed to
fire Jane with a new and earthy reverence toward the classic painting she had
admired from a distance, perhaps, before. Thus she repainted Watteau's "Le
Mezzetin" with an angry, loaded brush, obliterating the musician's features and
squishing the grove behind him into a foaming whirlpool, yet the result is noble,
joyful, generous: qualities that subsist today in her painting, though the context
is calmer now than it was then. The one thing lacking in our privileged little
world (privileged because it was a kind of balcony overlooking the interestingly
chaotic events happening in the bigger worlds outside) was the arrival of Frank
O'Hara to kind of cobble everything together and tell us what we and they were
doing. This happened in 1951, but before that Jane had gone out to visit him in
Ann Arbor and painted a memorable portrait of him, in which Abstract
Expressionism certainly inspired the wild brushwork rolling around like so
many loose cannon, but which never loses sight of the fact that it is a portrait,
and an eerily exact one at that.

After the early period of absorbing influences from the art and other things
going on around one comes a period of consolidation when one locks the door in
order to sort out what one has and to make of it what one can. It's not a
question — at least I hope it isn't — of shutting oneself off from further influences:
these do arrive, and sometimes, although rarely, can outweigh the earlier ones.
It's rather a question of conserving and using what one has acquired. The period

of Analytical Cubism and its successor Synthetic Cubism is a neat model for this process, and there will always be those who prefer the crude energy of the early phase to the more sedate and reflective realizations of the latter. Although I have a slight preference for the latter, I know that I would hate to be deprived of either. I feel that my own progress as a writer began with my half-consciously imitating the work that struck me when I was young and new; later on came a doubting phase in which I was examining things and taking them apart without being able to put them back together to my liking. I am still trying to do that; meanwhile, the steps I've outlined recur in a different order over a long period or within a short one. This far longer time is that of being on one's own, of having "graduated," and having to live with the pleasures and perils of independence.

In the case of Jane Freilicher one can see similar patterns. After the rough ecstasy of the Watteau copy or a frenetic Japanese landscape she once did from a postcard came a phase in the mid-1950s when she seemed to be wryly copying what she saw, as though inviting the spectator to share her discovery of how impossible it is really to get anything down, get anything right: examples might be the painting done after a photograph by Nadar of a Second Empire *horizontale* (vertical for the purposes of the photograph) with sausage curls; or a still life whose main subject is a folded Persian rug precisely delineated with no attempt to hide the fact of the hard work involved. Her realism is far from the "magic" kind that tries to conceal the effort behind its making and pretends to have sprung full-blown onto the canvas. Such miracles are after all minor. Both suave *facture* and heavily worked-over passages clash profitably here, as they do in life, and they continue to do so in her painting, though more subtly today than then. That is what I meant by "tentative." Nothing is ever taken for granted; the paintings do not look as if they took themselves for granted, and they remind us that we shouldn't take ourselves for granted either. Each is like a separate and valuable life coming into being.

I was an amateur painter long enough to realize that the main temptation when painting from a model is to generalize. No one is ever going to believe the color of that apple, one says to oneself, therefore I'll make it more the color that apples "really" are. The model isn't looking like herself today—we'll have to do something about that. Or another person is seated on the grass in such a way that you would swear that the tree branch fifty feet behind him is coming out of his ear. So lesser artists correct nature in a misguided attempt at heightened realism, forgetting that the real is not only what one sees but also a result of how one sees it—inattentively, inaccurately perhaps, but nevertheless that is how it is coming through to us, and to deny this is to kill the life of the picture. It seems that Jane's long career has been one attempt to correct this misguided, even blasphemous, state of affairs; to let things, finally, be.

One of my favorite pictures from this period of slightly rumpled realism—which, in my opinion, though perhaps not in hers, reflects a quiet reaction against Expressionism, Impressionism and Realism all at once—a kind of "OK, but let's see what else there is" attitude—is a still life I own, of a metal kitchen table that she once used as a palette. It was perhaps done in a tiny cold-water flat in the East Village that was her studio in the mid-1950s. The walls were (and are in the picture) an unglamorous off-white, and there was little that was eye-catching in the apartment beyond some Persian print bedspreads, potted plants and cut flowers, which suffice to animate the pictures of that period with luscious but low-keyed arabesques that wouldn't be out of place in Matisse's Nice-hotel-room paintings of the 1920s. (One of her most beautiful works and one of the most magical paintings I know is a picture of a vase of iris on a windowsill at night, with the fuming smokestacks of a Con Ed plant in the background, proving that *luxe, calme* and *volupté* are where you find them.) Perhaps I chose the painting-table still life because of my own fondness for a polyphony of clashing styles, from highbred to demotic, in a given poem, musical composition (the "post-modern eclecticism"—unfortunate term—of David del Tredici and Robin Holloway, for instance) or picture. "The Painting Table" is a congeries of conflicting pictorial grammars. There is a gold paint can rendered with a mellow realism that suggests Dutch still-life painting, but in the background there is a reddish coffee can (Savarin?) that is crudely scumbled in, whose rim is an arbitrarily squeezed ellipse—one understands that this wasn't the shape of the can, but that the painter decided on a whim that it would be this way for the purposes of the picture. Other objects on the table are painted with varying degrees of realism, some of them—the flattened tubes of paint and the blobs of pigment—hardly realistic at all. There is even a kind of humor in the way the pigment is painted. What better way than to just squeeze it out of the tube onto the flat surface of the canvas, the way it is in fact lying on the surface of the table, reality "standing in" for itself? But she doesn't leave it entirely at that; there are places where she paints the image of the pigment too, so that one can't be exactly sure where reality leaves off and illusion begins. The tabletop slants up, the way tabletops are known to do in art since Cézanne—but this seems not the result of any Expressionist urge to set things on edge but rather an acknowledgment that things sometimes look this way in the twentieth century, just as the gold tin can is allowed to have its way and be classical, since that is apparently what it wants. The tall, narrow blue can of turpentine accommodates itself politely to this exaggerated perspective, but the other objects aren't sure they want to go along, and take all kinds of positions in connivance with and against each other. The surrounding room is barely indicated except for the white wall and a partly open window giving on flat blackness. (Is it that these

objects have come to life at night, like toys in some *boutique fantasque?*) The result is a little anthology of ways of seeing, feeling and painting, with no suggestion that any one way is better than another. What *is* better than anything is the renewed realization that all kinds of things can and must exist side by side at any given moment, and that that is what life and creating are all about.

One would expect that a painter who could give the assorted objects found on a table top at a given moment their due would not go out of her way to arrange things so as to make some point, and one would be right. It's always possible to tell whether a still life has been posed, even those that are meant to look chaotic and arbitrary, just as one can tell a *plein-air* landscape from one composed in the studio. The artists of the world can be divided into two groups: those who organize and premeditate, and those who accept the tentative, the whatever-happens-along. And though neither method is inherently superior, and one must always proceed by cases, I probably prefer more works of art that fall in the latter category. Not surprisingly, Jane Freilicher has never gone very far from home ("Wherever that may be," as Elizabeth Bishop reminds us) in search of things to paint. During the past twenty years she has divided the year between New York and a summer home in Water Mill, Long Island, and most of her paintings have been of views from her studio windows in both places, or of still lifes, self-portraits or portraits of friends. In 1975, as one of a group of artists commissioned by the Department of the Interior to paint the American scene for a show commemorating the Bicentennial, she was offered a trip to any American site she wished to paint, but settled for the landscape outside her window—a suitably American decision in the circumstances, for hasn't our popular music told us that "That bird with feathers of blue / Is waiting for you / Back in your own backyard"? Not that there is anything rigid or doctrinaire, either, in her choice. As must be obvious by now, such qualities are entirely absent from her work, but neither is there any implication that her surroundings are a bill of goods that has been paid for and must therefore make its presence known on canvas: she is capable of including a cat copied from Gainsborough in an otherwise straight-forward inventory of the studio's contents on a particular day—a shaggy bouquet of flowers with window, landscape and sky.

She has become one of those artists like Chardin, Cézanne or Giacometti who, unlike Delacroix or Gauguin, find everything that they need close at hand, and for whom the excitement of their craft comes not from the exotic costumes that reality wears in different parts of the world, but in the slight disparities in the sibylline replies uttered by a fixed set of referents: the cat, the blue pitcher, the zinnias, the jumble of rooftops or stretch of grass beyond the window. Yet how enormously, disconcertingly varied these answers can be. And how confus-ingly different replies to the same question ("What do I see?") would be if one

lost sight of the fact that each is a major piece in the puzzle, that the only single answer is the accumulation of all of them, with provision made for those still to come. We should never lose sight of what Robert Graves, in his most famous line of poetry, tells us: "There is one story and one story only." But it is even more important to remember that it is minute variations in the telling that make this situation bearable and finally infinitely rich, richer than the anxious inventions of Scheherazade. Luckily we have artists of Jane Freilicher's stature to remind us.

From *Jane Freilicher: Paintings 1953–85* (1986)

VI

GROUP SHOWS

"ART ABOUT ART"

"ART ABOUT ART," the new show at the Whitney Museum in New York, is like a musical with a lot of spiffy numbers and very little book. Actually there is a book, a book called *Art About Art*, by Jean Lipman and Richard Marshall, which is not exactly a catalogue, since it takes in much work not included in the show. In fact, Leo Steinberg's elegant and funny introductory essay, although it deals with none of the work on view but is instead a sort of capsule history of artists' "borrowings" from one another down through the ages, is one of the best things about the whole enterprise.

On closer inspection, the announced theme turns out to be little more than an extremely long and flexible peg on which are draped a number of art-inflected works from the recent past, mostly the Pop period. That's OK, since there is enough good stuff to keep the show alive even through its duller

stretches. It is provided by artists who were brought in to further footnote the theme but whose contribution to it is negligible apart from this.

The problem seems to be that almost all artists are somewhat subversive in their attitude toward art, and when you get a situation where everybody is a subversive, sabotage becomes status quo. Marcel Duchamp really did it once and for all when he put the mustache on the "Mona Lisa." Duchamp was a genius at discovering cul-de-sacs which succeeding generations have turned into crowded thoroughfares, forgetting that art can be destroyed only once. *Tout le reste est littérature.*

In this context the true subversives turn out to be artists like Larry Rivers, whose long and obsessive involvement with certain paintings of the past, while sometimes satirical, is also ambivalent enough to allow us to experience the obsession with him. There is humor in Rivers' work, but it is often enigmatic. (Why is his reworking of David's "Napoleon in His Study" titled "The World's Greatest Homosexual"? His explanation that he found Napoleon's pose in the David affected hardly seems to justify the "world's greatest" rating.)

In any case, this work cuts deeper than its humor, whereas John Clem Clarke's careful re-creation of out-of-sync reproductions of old-master paintings are like one-liners: one glance tells you all you need to know. The same applies to much of the work in the show, including Tom Wesselman's familiar send-ups of Middle American interiors, Peter Saul's horrendous parodies of Rembrandt and Picasso, and Mel Ramos' de Kooning-esque portrait of Farrah Fawcett-Majors (though I did find Ramos' playmate-of-the-month version of Manet's "Olympia" exquisitely meretricious).

Rivers' work, which was long misunderstood and criticized for not quite making it as Pop Art, when in fact it was never intended to be any such thing, has improved with age and is looking better than ever. His well-known "Dutch Masters with Cigars II," after Rembrandt, is included, as are lesser-known works such as his own solution to racial issues implicit in the same Manet, "I Like Olympia in Blackface."

Joseph Cornell's "Medici Slot Machine" also strikes a dissident stance, although, as its title implies, there is something ambiguous in Cornell's attitude toward Moroni's portrait of a young prince of the Este family. It is accorded no less, but no more, iconic importance than the other contents of the glass-lidded box: marbles, jacks, wooden counters, a toy compass.

For the rest, the show is dominated by others among today's acknowledged masters: Lichtenstein, Johns, Warhol, Dine, Rauschenberg, Segal, Grooms. In some cases they are represented by examples which have been overexposed, but more often the selections are offbeat, of works which have been more discussed than seen (Warhol's "Mona Lisa" and his do-it-yourself, paint-by-numbers pic-

tures; Dine's messy, painterly double-take of his palette called "My Cincinnati Studio").

Lichtenstein is another artist who comes off very strongly; the abundance of his work on display almost constitutes a mini-retrospective. His cool but solemn dissections of accredited modern masterworks, their brilliant industrial color undercut and anesthetized by the institutional off-white of the canvas ground, look more and more impressive and impassive.

Time has had a mellowing effect on Pop, considered so scandalous barely a decade ago. In attempting to destroy or at least deflate our received notions of art, it has become art. (It isn't, in fact, all that easy to destroy art: once you have done so, something always rushes in to fill the vacuum, and that something usually bears a close resemblance to art.)

Most of the works in the Whitney show do honor to the museum space that is sheltering them, but at the same time they wear their laurels a bit restlessly, as though nostalgic for the scrappy sixties. That, perhaps, is why there is a note of pathos lurking in the wings. No sooner has the artist dealt with his reactions to the art of the past than he finds himself being wound on the spool of art history and is done unto as he would do unto others.

New York, August 7, 1978

FOUR AMERICAN EXHIBITS OF 1968

T HIS HAS BEEN a "quiet" season in New York; foreign visitors have expressed surprise mingled with a relief at how 1966 everything looks. But unless we abandon art for theater or long-distance phone calls (something called "telephone art" is being mooted in Chicago), anything new will mean a retreat from the ultimate simplicity of Donald Judd, who recently showed at the Whitney Museum here. Yet how can this be done without resurrecting the "horrors" of Abstract Expressionism? The Castelli Gallery has been pondering this question. First there was the show of Bruce Nauman, a California "Funk" artist whose work is determined not to look like anything. There were things that dangled, neon tubing, intentionally unfunny jokes, serious platitudes. Then there was Frank Stella's beautiful show, baroque in comparison to his early austerity and even to the asymmetry of last year. It remained for Jasper Johns

and now Ron Davis to elaborate a face-saving way out of the current geometrical bottleneck (this mixed metaphor is offered as an example of critical Funk).

JOHNS HAS BEEN a dominant figure for a decade, but has anyone really thought much about him lately? It is always hard to distinguish something really new, especially when its creator is a recognized artist. And Johns has never cared much about pleasing or disconcerting his admirers. He has gone his rather leisurely way, sometimes turning out a bumper crop of flags, to the delight of those who collect them; sometimes (as in his 1966 show and now) producing work whose calculated "no look" was bound to throw off those who were proud of having assimilated the flags.

Johns knows how to buttonhole the viewer. One may puzzle over his pictures, but one does not escape them. What is there to see? Three of them were called "Screen Pieces," carelessly daubed over in "Jasper Johns gray," a color that may be as significant for the 1960s as Lucky Strike green was for the 1930s. Each panel was bisected by a silk-screen reproduction of a string from which a spoon and fork hung down; they were gray too and almost impossible to see in the intense gray of the canvas. A vertical message, "Fork should be 7 inches long," was, I gather, an instruction to the printer which got immortalized in the screening process. The rest of the show consisted of three large horizontal pictures. "Harlem Light" seemed to have come about because someone had accidentally placed some freshly painted storm windows on a piece of canvas. Later Johns had doodled a bit, filling in some of the panes with a dead peach color, daubing in places, resolving to be neat in others, tentatively placing his hand against the fresh paint. The other two pieces were more complicated. More panels, ghosts of window frames, paint-sample rainbows, neatness vs. sloppiness. There was also a new element—panels of mock flagstones suggesting rumpus-room linoleum.

One of the few people I spoke to who shared my enthusiasm, a painter, said that Johns reminded him of Anthony Caro. Johns builds away from the edge of the canvas the way Caro builds up from the ground, from something basic and primitive toward something illusory, and in doing so manages to pass through all kinds of being that can happen in painting or sculpture.

JOHNS' SHOW CAME at a significant moment. I am sure he has no interest in looking for solutions to the present avant-garde slowdown but was just painting away as usual. But it seems likely that the show of Ron Davis at the Castelli Gallery was intended as a foretaste of the 1970s. There is a cold messiness to it,

but also a lukewarm orderliness. It is not going to be anything you can pin down, at least not for a while—not even Funk.

Davis' technique, as far as one can tell, is to paint on a sheet of plastic which is then covered with more plastic; the paint, sandwiched in between, has the milky look of painted glass panels in Victorian lampshades. The one motif in this show is a shape rather like a ring mold with the center filled in, and painted with motley stripes so that it suggests a hat in an Uccello. The colors are mostly dull and applied with minor variations in technique.

In 1906 Gertrude Stein wrote apropos of interior decoration in *The Making of Americans:*

> This was all twenty years ago before the passion for the simple line and toned green burlap on the wall and wooden panelling all classic and severe. But the moral force was making then, and now, in art, all for the simple line, though then it had not come to be, as alas now it is, that natural sense for gilding and all kinds of paint and complicated decoration in design all must be suppressed and thrust away, and so take from us the last small hope that something real might spring from crudity and luxury in ornament.

This "moral force" has been with us at least since the days of Hester Prynne. In the recent climate of painting, a single drip on a canvas has been taken as a sign of white-hot passion and therefore to be expunged at all costs. Painters as austere as Brice Marden and Jules Olitski have been murmured at for leaving an infinitesimal amount of drip or impasto at the edge of their canvases, and a girl I know who is a hard-edge painter but doesn't particularly think of herself as one was depressed at being complimented on "the sharpest edges in New York." It is good to see a brand-new painter like Ron Davis ignoring today's Manichaeanism to do his "own thing."

DONALD JUDD'S WHITNEY show was one of the pleasant surprises of the season. I had remembered the work in his last show as faintly malevolent. Perhaps this was due to the curious atmosphere of the front room at Castelli, a former Edith Wharton—era living room with its windows blocked off, consecrated now to the Future. Maybe, on the other hand, the installation at the Whitney was a little too gorgeous and airy—the fun of emerging into what at first glance suggested a Martian Disneyland did not, on further inspection, have much to do with the work itself. But this larger view at least clarified the nature of the work, which is not malevolent at all. What one found was what Judd has called, speaking of Houdon, whom he admires, "that unstressed quality, that absence of any

dominant tone." In an interview with Amy Goldin he went on to comment interestingly on nineteenth-century American painting, including Bingham's "Fur Traders Descending the Missouri," whose vast unmodulated surfaces he finds characteristic of American art. Perhaps they are, and perhaps Judd's enveloping, noncommittal surfaces are really American too.

"A work needs only to be interesting," Judd has said. "Most works finally have one quality." In Judd's case it is hard to say what the quality of a particular creation is. Sometimes the work is metal cubes, painted or unpainted, usually with an unexpected detail—irregular spacing, a raised rim, some kind of elementary discrepancy. One of the most beautiful is one of the earliest—a wall of parallel boards painted red, with a concave border of galvanized iron at top and bottom. It would cause no surprise standing in the middle of a Japanese lake, where it would be experienced as a projection of the landscape having no connection with it. There are others which depart from variations on the cube motif, such as an oblong ring that sits on the ground, something like a portable wading pool, and a low ramp of perforated steel only eight inches high at the tall end of its wedge shape.

JUDD'S "A WORK needs only to be interesting" sums it up. The verdict may not be appealed. My feeling is that Gene Davis' painting, in a big three-man show at the Jewish Museum, doesn't succeed. Davis is associated with the Washington color school of Morris Louis and Kenneth Noland. If eight stripes are good in a Morris Louis, surely eighty will therefore be ten times as good? Yet the distance from Louis, not to mention Noland and Ellsworth Kelly (whom Davis suggests in "Wall Stripes," a group of several discrete monochrome panels) is immediately apparent and unbreachable. The intended conjugation of color does not take place. Noland's striped canvases are events; Davis' are stripes.

Richard Smith, the English painter who won first prize at the last Sao Paolo Biennale, has proceeded from stained shaped canvases with a certain amount of functional clutter to large, irregularly shaped (or as irregular as you can get with canvas and stretchers) ones in series. There is a "Gazebo" and you are meant to walk inside it. (The 1940s had the orgone box; we have environmental art.) They are rather casually put together, and apparently it's OK if they get a little soiled and scruffy. The most successful is a long series of twelve modules painted different colors, each with a kind of chamfered corner which lengthens as the series progresses. Perhaps it is meant to suggest a span of days or months with the light or the darkness getting longer. It is in a grand manner which seems more congenial to Smith than the medium-sized manner of the other works.

The most interesting of the three is Robert Irwin, a Californian who paints

mysterious pale disks that look like soap bubbles or rather pictures of them on the lid of a soap-bubble set. They are fixed to the end of a rod that projects outward from the wall; spotlights on the floor throw a quadruple shadow of the disk on the wall behind. At first glance the shadows annoyed me; then I grew fond of the way they propel the disk forward, giving it the air of some imperious insect balanced on long legs. What is beautiful is the way Irwin distinguishes between all-but-undistinguishable neutral tones (an earlier oil painting composed of tiny dots is also remarkable in this way). "Every moment," wrote Walter Pater, "some tone on the hills or the sea is choicer than the rest." Irwin seems to have arrived independently at this conclusion after staring straight into a cloud.

The New Republic, April 20, 1968

"ABSTRACT EXPRESSIONISM:

THE FORMATIVE YEARS"

"EVERYTHING THAT'S OLD is new again." The cheerful message of Peter Allen's song applies not only to pop music, clothes and face-lifts, but to art as well. "Old" art, i.e., the art of just yesterday, is suddenly very much with us and is being scrutinized with a new thoughtfulness.

Of course, much of the old that is new again has been around so long in its present reincarnation that it's starting to look old again. Granny glasses, for instance. And Abstract Expressionism, whose body was still warm when it was subjected to a sort of camp revival in the early 1970s. At that time younger artists like Larry Poons, John Seery and Philip Wofford started using its "hot" gestural styles in new cold ways of their own.

This irreverent resuscitation ran its course, and Abstract Expressionism

began slowly to inch its way back into institutional respectability. It was now fodder for graduate students, and even those who had once been very much caught up in the movement (myself, among others) tended to think of it as another closed chapter in art history.

The Whitney Museum's recent show "Abstract Expressionism: The Formative Years" came as a shock and a delight to many who thought they had seen it all before. So much of the painting of the 1940s and 1950s was found to be alive—not alive and kicking, exactly, but alive and breathing, and of a timeless relevance. What was surprising now was not the glop and the *Sturm and Drang* but the exquisite craftsmanship and inventiveness. Reputations are being revised on the basis of this show. Lee Krasner's early work was one revelation, but there were many others: ravishing and unknown paintings from de Kooning's quasi-Surrealist years; lovely nocturnal ones by the almost forgotten Tomlin; atypical and beautiful early work by Gorky, Clyfford Still and Pollock himself.

Several other current exhibitions show how varied and valid our recent past has been. First, there is the Guggenheim's retrospective of Mark Rothko, whose career reads like a Hollywood script about a doom-haunted genius; then there is the late Bob Thompson, a black artist who was much involved with the art of the 1960s but who avoided its main currents. Larry Rivers is anthologizing his own past at the ACA Galleries in a show he calls "Golden Oldies," and Knoedler is showing David Smith, a great modern sculptor whose work veers close to Abstract Expressionism and to an opposed formalism but finally escapes categorization.

The sudden success that befell the Abstract Expressionist painters is one reason why their work went out of fashion so abruptly. Almost overnight, it now seems, they were swept from obscurity and poverty to riches and international fame. They were overexposed. Their heads were turned. They pontificated. And in most cases, one had to ignore their statements about their art if one wanted to go on loving it.

This is particularly true of Rothko, whose stated intentions have proved frustrating to many who respond readily to his walls of vibrant light and color. He intended the color to convey "basic human emotions—tragedy, ecstasy, doom. . . . The people who weep before my pictures are having the same religious experience I had when I painted them. And if you, as you say, are moved only by their color relationships, then you miss the point."

Any art, once it leaves the studio, is going to be misinterpreted for better or worse—"misprision" is the term used by Harold Bloom for our fertile misunderstanding of the poet's aims. It often seems that the artist's role is precisely to

make himself misunderstood, that misunderstanding and appreciation are much the same. But Rothko's repeated and vehement caveats leave us uneasy. We are always a little embarrassed at esteeming his work for wrong reasons that he foresaw and continually warned against.

The effect of these pictures is truly majestic and awe-inspiring, though the awe is of a secular and aesthetic kind. Or rather, one can feel, without sharing it, the religious experience that was color manifesting itself to the painter. And perhaps this is the way it should be. One does not have to be a Dominican to appreciate Fra Angelico or a Carmelite to understand St. Teresa.

"The World of Bob Thompson" at the Studio Museum in Harlem, a few significant blocks up Fifth Avenue from the Guggenheim, celebrates another American artist who died tragically—in 1966, just before his twenty-ninth birthday. Yet Thompson was enormously prolific and this fairly small retrospective is, one hopes, only a prelude to a full-scale one.

Thompson emerged out of Louisville into the clubby New York art world of the late 1950s, when separatism—racial, sexual or artistic—existed less than it does now. He showed at the Martha Jackson Gallery and was a friend of Larry Rivers and Red Grooms, but the artist who most influenced him was the visionary Expressionist painter Jan Muller, who also died young. Inevitably one must compare Thompson's work with Muller's, and it doesn't always stand the comparison. Muller's dream landscapes, haunting as they are, would soon pall without the magical painterliness he brought to them. Thompson rarely equaled him in this respect, but perhaps he didn't care to: one feels him in the clutches of a vision which he must set down as rapidly as possible, and never mind the niceties of pigment. For this very reason, however, his raw, vibrating, shrieking colors and grotesque allegories often have a power to shock and involve that Muller's more sophisticated primitivism avoids.

Larry Rivers' "Golden Oldies" pictures form a personal anthology (to use Borges' term) rather akin to Marcel Duchamp's celebrated valise full of miniature reproductions of his own works. Both fulfill the function of an artist-traveling salesman's suitcase of samples and are also works of art of a very peculiar sort. Rivers' clusters of themes from early paintings (portraits of his mother-in-law, of Napoleon and Frank O'Hara; the Camel package and the Cedar Bar menu with its Hawaiian ham steak at $1.35) encapsulate his career, but the real excitement is in the way the leitmotivs are juxtaposed and fitted together into a crazy quilt that is crazy like a fox.

The David Smith show at the Knoedler Gallery is disappointingly small and doesn't even include all the works that are listed in the slim catalogue. Still, it is always a joy to encounter this man's work, and the show does include some

major pieces, especially the untitled 1964 sculpture that is like a collapsing tower of girders and, best of all, "Cubi III" — a sort of abstract robot (built up out of brushed stainless-steel cubes) that is one of Smith's most astonishing, engaging and hilarious inventions.

New York, December 11, 1978

AMERICAN SOCIALIST AND

SYMBOLIST PAINTING

T HE NOISE ABOUT a return to realism sometimes obscures the fact that there are painters around who never abandoned it when art went abstract several decades ago. Three of these—Aaron Shikler, Anne Poor and Henry Billings—are currently showing in New York. There is also a cornucopia of earlier figurative styles in two group shows: "The Working American" at District 1199 and "American Imagination and Symbolist Painting" at New York University's Grey Gallery.

"The Working American," said to be the first major art exhibition organized by a labor union in this country, is part of a two-year Bread and Roses project in the arts and humanities sponsored by the National Union of Hospital and Health Care Employees. (The name "Bread and Roses" comes from a slogan displayed on a banner in the 1912 textile workers' strike at Lawrence,

Massachusetts.) It was organized by Abigail Booth Gerdts and will travel to several American museums under the sponsorship of the Smithsonian's Traveling Exhibition Service. Like the two other group shows, it's a very mixed bag of chestnuts and curios, with a few outstanding pieces—all linked to a theme, in this case that of social realism.

The long tradition of American political art, never very popular with art historians until recently, is summarized starting in the early nineteenth century and continuing into the 1950s. Notable from the early period is an enormous painting called "The Strike" (1877), by the German-born Robert Koehler. Almost a novel with subplots, in the tradition of storytelling paintings like William Powell Frith's "Derby Day," it depicts a crusty capitalist being confronted on his doorstep by an angry band of workers from a nearby factory. Its scope and movement are impressive; its gray, porridgy halftones aren't, though that may be due in part to the painter's wish to emphasize the bleakness of the Pittsburgh setting: he traveled to the English Midlands to research grime and fumes.

Other high points in the show are supplied by Edward Laning, Everett Shinn, Jacob Lawrence, George Bellows, Winslow Homer, Ernest Lawson and Honoré Sharrer, whose "Tribute to the American Working People" (1951) suggests a collaboration between Norman Rockwell and the brothers van Eyck: a technical and ideological tour de force. Ralph Fasanella's pulsating, neo-primitive painting commemorating the Bread and Roses strike, while apparently not a part of the exhibition, hangs in the lobby just outside.

AN ANTIDOTE TO social realism, though a desperate remedy indeed, is provided by the solipsistic symbolists whom Charles C. Eldredge has disinterred and propped up at the Grey Gallery. George Inness speaks for the lot: "A work of art does not appeal to the intellect. Its aim is not to instruct, not to edify, but to awaken an emotion."

Is New York really ready for C. Bertram Hartman's "Pearls" or Mary Lizzie Macomber's "Memory Comforting Sorrow" (the latter on loan from the Fall River Public Library)? The answer is yes: the unending quest for camp has resulted in a situation where any work of art of a certain age is a worthy object of critical scrutiny. There's lots of genuinely weird stuff here, and a few important paintings (abstractions by Hartley and O'Keeffe; visionary landscapes by Ryder, Inness, Blakelock).

Of the work of the many artists with three names I was especially taken by Edward Middleton Manigault's "Procession" (1911), a Surreal frieze of automobiles and equestrians in a park, and George Alfred Williams' "The Marginal Way," a Dantesque convention of scarlet-haired temptresses. Haunting, too,

are "My Song," by the short-lived Rex Slinkard (who was included in the William Carlos Williams show at the Whitney Museum last year), and the deliquescent "Porcelain Towers," by Pinckney Marcius-Simons, the only American to show at the esoteric Rose-Croix salons in Paris. There's even a painting by Kahlil Gibran and two watercolors by Pamela Colman Smith, who designed a tarot deck that was to become a fixture of hippiedom.

Mr. Eldredge, whose erudition in these matters is truly staggering, has grouped the pictures according to themes: merpersons, *femmes fatales*, severed heads, etc. He deserves much credit for adding to both the gaiety of nations and the roster of hitherto forgotten eccentric American artists.

New York, November 19, 1979

THE METROPOLITAN MUSEUM

OF ART'S AMERICAN WING

ONE OF THE MANY curious exhibits that dot the spectacular sculpture-garden court at the entrance to the Metropolitan's American wing is a chimneypiece of titanic proportions from Commodore Vanderbilt's French chateau, which once occupied the site of Bergdorf Goodman at Fifth Avenue and Fifty-seventh Street. Two caryatids, carved by Saint-Gaudens from burgundy-colored Numidian marble, have the unenviable task of supporting a massive mantelpiece of the same material, topped by a John La Farge mosaic containing a Latin text that translates: "The house at its threshold gives evidence of the master's goodwill. Welcome to the guest who arrives; farewell and hopefulness to him who departs." The accompanying label points out that the work was meant "both to welcome visitors and to impress with its opulence." This double-barreled aim is

a typically American one, and not just in the case of robber barons like the Commodore. It applies to the American wing itself, the most lavish of Kevin Roche and John Dinkeloo's recent additions to the museum (including the temple of Dendur space on the north side and the André Meyer galleries to the south). The sculpture court, in particular, floors you as it greets you.

Work on the addition has been going on since 1974, when the previous American wing, dating from 1924 and given over chiefly to period rooms and their furnishings, was closed for the alteration. The new galleries wrap around the period rooms, which have been refurbished and augmented, to provide previously nonexistent permanent gallery space for the museum's collection of American art and artifacts—the richest anywhere, of which only about 15 percent at most was ever visible at one time.

Phase I, which fills about 70 percent of the new space, consists of nine painting and sculpture galleries, eighteen period rooms, eleven decorative-arts galleries, the aforementioned sculpture court, named after Charles Engelhard, and the Erving and Joyce Wolf special-exhibition gallery, which is showing a fascinating group of American watercolors, prints and drawings from the Met's holdings. Phase II will offer period rooms from the late nineteenth and early twentieth centuries, including a 1913 Frank Lloyd Wright living room, as well as a folk-art gallery and John Vanderlyn's famous panorama of Versailles. Phase III, a study-storage area, will house works not on display that will henceforth be available for study purposes. The installation has been directed by John K. Howat, curator of American paintings and sculpture and a noted authority on the Hudson River School, and Berry B. Tracy, curator in charge of American decorative arts.

Right now, the single most extraordinary thing about the new wing is the Engelhard Court, not only because it is a space unlike any other in the city (Howat thinks it will become the "lungs of the museum," as Baron Haussmann considered the green spaces he planned for nineteenth-century Paris the "lungs of the city") but for the way it epitomizes American art. The immense curtain of glass facing west onto newly landscaped grounds and the fresh foliage of the park, with Cleopatra's Needle poking through treetops like a New England steeple, already begins to suggest that American art has always been an affair of *bricolage*, an attempt to adapt "the best the classical world has to offer" to a raw, untidy new world.

The seeming cacophony of the works installed in the courtyard is actually an object lesson in how American art responds to peculiar demands of time and place. The marble facade of the 1824 United States Branch Bank on Wall Street is a perfect example of the new republic's urge to drape itself in the togas of

classical respectability, as are the cold, classicizing white marble sculptures of Hiram Powers and Erastus Dow Palmer that are placed nearby. Opposite the facade is the Moorish Art Nouveau loggia from Louis Comfort Tiffany's now destroyed Long Island estate, backed by his stained-glass depiction of Oyster Bay framed with wisteria. Close to this is a stained-glass triptych window from a playhouse Wright designed for the Coonley family of Riverside, Illinois, in 1912. On either side rise ornate metal staircases salvaged from Sullivan's 1893 Chicago Stock Exchange Building, demolished in 1972, that now again function as staircases. Each of these works is marked by the spirit of the times: Sullivan's speaks of the optimistic period when big business sought out adventurous architects to create "cathedrals of commerce." The slightly later Tiffany pieces show how a seemingly indigestible menu of foreign sources could, in the hands of a great craftsman, become something both beautiful and highly indigenous. The colored disks and squares of Wright's windows not only anticipate the Bauhaus by a decade but exemplify a fresh attitude toward childhood that is part of the American tale—instead of storybook illustrations, give the kiddies something nonobjective to mull over.

The nine galleries of American paintings and sculpture, with the paintings beautifully restored and enhanced by the fall of natural light from the skylit ceiling, are, again, something more than the sum of their parts. That is, not just a great collection of American art but an illustration of our changing attitudes toward our own past. Works like Leutze's "George Washington Crossing the Delaware" and Inness' "Peace and Plenty" are so deeply ingrained in the national consciousness that it has been difficult to think of them as art, but even Leutze's creaking machine now manages to keep its dignity intact above the ice floes, in the context of the rediscovered vitality of much that was rejected.

Thus, though it comes as no surprise that Whistler, Homer, Eakins, and Sargent (all strongly represented here) are masters, it is surprising to find a painting by John Twachtman ("Arques-la-Bataille") that can hold its own with their best work. Other once esteemed but recently forgotten artists like Paul Manship and Grant Wood again assume a rightful if modest place in an ever-widening tradition of acceptance. There now seems to be an invisible link between the forthright craftsmanship of Paul Revere's silver tankards and the apparently precious craftsmanship of Wood's "Midnight Ride of Paul Revere."

America has a tendency both to consume and to exhume its artists. The fact that much of the art in the American wing is now reemerging from limbo doesn't of course mean that all of it is going to make it. But all of it does constitute a rich illustration of how we view our own relatively short history— how we both lose sight of it and exalt it, sometimes in the same moment. One of

the period rooms from the original 1924 wing was found, in light of recent scholarship, to be anachronistically installed but has been left as is, partly as an example of art-historical attitudes from the recent past. What the American wing seems to be saying is that the uniqueness of the American tradition is a dynamic, almost omnivorous eclecticism that at first looks like no tradition at all, but that on closer inspection—now possible on a large scale for the first time at the Met—constitutes its peculiar strength.

New York, June 16, 1980

ABSTRACT ART IN AMERICA, 1927–44

I T WASN'T ALWAYS easy being an avant-garde artist in America. This is one of the points made by a disturbing and exhilarating show of early, all-but-forgotten American modernism now at the Whitney Museum in New York. Titled "Abstract Painting and Sculpture in America, 1927–1944," it should give artists and spectators of today's "art for fun and profit" scene much to ponder.

Organized by John R. Lane of Pittsburgh's Carnegie Institute (where it originated) and University of Southern California art historian Susan C. Larsen, the show covers forty-three artists during a somewhat arbitrarily defined period from 1927, the year of Stuart Davis' first "Eggbeater" painting, to 1944, the year of Mondrian's death in exile in New York. "Eggbeater No. 1" (puzzle: find the eggbeater) is as majestic and vibrant a picture as any ever painted in America. It announced the second wave of American abstract art. By

the 1920s, artists of the earlier period such as Georgia O'Keeffe, John Marin, Marsden Hartley and Joseph Stella, all greatly influenced by the Armory Show of 1913, had gone their separate ways. The "Eggbeaters" were not only the first truly abstract paintings to be made in this country in nearly a decade, as Lane says, they were also the high point of Davis' career, standing alone as an example of modernism that was all but independent of Europe. There would not be another such burst of originality until the arrival of Abstract Expressionism in the mid-1940s.

When Mondrian died, much of the art of this period died with him. The balanced geometrical grids, the carefully orchestrated colors (many painters chose to follow Mondrian in using only the primaries plus black and white), the austerity and high moral tone tinged with socialist concerns suddenly looked obsolete in the confusion and euphoria of the postwar period. Pollock and Rothko, disdainful of European formalism, were launching a raw native abstraction that was messy and surreal, the antithesis of the elegant constructs of such keepers of the flame as Burgoyne Diller and George L. K. Morris, whose reputations would soon collapse along with those of many of their colleagues. A few, such as Gorky and de Kooning, successfully bridged the two eras, but they had always been subversives—proto-action painters in a period of mandarin abstraction. Still others enjoyed a kind of mascot status in the later 1940s and 1950s. One was John Graham (born Ivan Gratianovitch Dombrowski in Kiev in 1886), a charismatic dandy whose seldom-encountered paintings of the late 1920s and early 1930s (such as "Blue Abstraction") are in themselves a sufficient reason to see this show.

Davis, Gorky, de Kooning and Graham are the undisputed stars of the event. Much of the rest is defiantly derivative, though it now has a quaint Art Deco charm that would have horrified its stern-principled makers. (Theodore Roszak's daintily crafted sculptural whodunits are one example among many.) Influential European artists who spent time in America, such as Léger, Mondrian and Hélion, are included in the show as points of reference, and their work all too often exposes the provincialism of their American followers. One room seems to be devoted to Mondrian, but closer inspection reveals that only two of the paintings are by him; others are the creations of Burgoyne Diller, Fritz Glarner and Harry Holtzman. Charles Biederman, another artist touched by Mondrian's Neoplasticism, has a distinct voice of his own, particularly in his crisp and glowing shadow-box constructions. The inclusion of six of his works amounts to a mini-resurrection.

The lives of these distinguished, if often befuddled, men and women make for cautionary reading. (Gorky, who killed himself in 1948, had perhaps the saddest career of all.) Many were leftists, like the aristocratic and autocratic

theoretician Morris, one of the so-called Park Avenue Cubists. Their dream of bringing avant-garde art to the culture-hungry masses ended in bitterness and failure; they were under constant attack not only from the art establishment (which favored the agrarian social realism of Grant Wood, Thomas Hart Benton and John Steuart Curry) and from H. L. Mencken's "booboisie," but also from splinter groups within their own movement. Yet they were pioneers who laid the groundwork for Abstract Expressionism and later American developments. For that, and for the freshness and loveliness of much of their work, they deserve this belated celebration.

Newsweek, July 30, 1984

THE PRINZHORN COLLECTION

EVEN THE MOST casual observer of contemporary art is aware by now that the Expressionist comet has made one of its periodic rendezvous with Planet Earth, unleashing all manner of spooks, demons and hobgoblins on a delighted and receptive public. It's perhaps no coincidence, then, that a generous sampling from the renowned Prinzhorn Collection of the art of the insane, housed at the University of Heidelberg, West Germany, is making its first appearance in this country. Assembled by the psychiatrist and art historian Dr. Hans Prinzhorn in the early 1920s, this legacy of haunted vision has long attracted the attention of artists and scholars, but until recently was poorly housed and unavailable for study. The selection currently touring the United States is the first showing of any of this material outside Europe.

There's a difference, of course, between the willed fantasies of sophisti-

cated artists and the compulsive expressions of sequestered mental patients whose "madness is ceaselessly called upon to judge itself," in the words of the philosopher Michel Foucault. As Prinzhorn put it, "the loneliest artist still remains in contact with humanity, even if only through desire and longing. . . . The schizophrenic, on the other hand, is detached from humanity, and by definition is neither willing nor able to reestablish contact with it. If he were, he would be healed."

Coming in the midst of a vogue for would-be "sick" art whose conviction often seems dubious at best, the Prinzhorn Collection is a shocker: it's like suddenly encountering a real wolf after having one's ears numbed by cries of wolf. Confronting roughly three hundred examples culled from the six thousand in the collection is both a painful and a deeply enriching experience. Organized by Stephen Prokopoff of the University of Illinois' Krannert Art Museum, where it originally opened last fall, this show has got to be one of the most exciting anywhere at present. The fact that its tour is confined to a few university art galleries is significant: major museums are no doubt more comfortable offering watery approximations of this apocalyptic imagery rather than the raw alcohol of the real thing.

Not everything on view is of equal interest. Just as there are geniuses who go mad, like van Gogh, there are schizophrenics who become geniuses. Prinzhorn, who classified the work with Teutonic thoroughness, was wary of aesthetic judgments. Nevertheless he differentiated "unattractive doodles" from the serious work of patients like Franz Karl Bühler, known as Pohl, in whose case "we are allowed to speak unqualifiedly of art in the fullest sense of the word."

Pohl is in fact one of the most immediately commanding of the artists represented. Trained as a draftsman, he at first produced fairly normal-seeming vignettes that recall magazine illustrations of the early 1900s. But he gradually abandoned this style for a kind of painterly Surrealism, sometimes blending ink, pencil and crayon together. "Fabulous Animals" is just that: an enormous Minotaur-like creature with a human face and big, sincere eyes has invaded a proper German parlor along with a dog and three large butterflies. Behind them, glass doors hung with ball-fringed drapery open on a sunlit garden. Despite the wide-open doors, the garden is as unattainable as the freedom Pohl doubtless dreamt of, while the parlor seethes with colorful menace.

Karl Brendel is the only sculptor included. He too is extraordinary. His carved enigmas sometimes anticipate the sculptures of Max Ernst, who knew of Prinzhorn's collection. The airy watercolors of August Klett scarcely seem the work of a suicidal schizophrenic obsessed by imagined faces of demons staring at him from wallpaper patterns. They suggest rather the serious playfulness of

Paul Klee, another artist familiar with Prinzhorn's work, who found in certain of the pictures "depth and power of expression that I never achieve in religious subjects." Indeed, the temptation to see reflections of the art of the past and especially of the present is a hindrance in viewing many of the works, although the collection probably survived the Nazis because of its potential as a yardstick for measuring (and condemning) "degenerate" modern art.

Another major figure is August Natterer or Neter, who spent his asylum years chronicling the "maybe ten thousand" visions he had during one major hallucination that lasted half an hour (though Prinzhorn found that hallucinatory material was only rarely used by artist-patients). A witch who, according to Neter, "symbolizes the creation of the world as witchcraft" appears in various guises; in "Witch's Head" her face is metamorphosed into landscape just as are the human figures in Dali's "paranoiac" paintings. The profile here becomes a grassy plain bordered by trees, which form a headband; nearby are comfortable bourgeois houses that could have come out of a German builder's manual of the time.

Still other artists, many of them profoundly touching, are known only by name or in many cases not even by that. One of the most haunting images is by Berthold L. (or L. Berthold), about whom no information is offered. (A rather slim catalogue accompanies the show; those interested should proceed directly to Prinzhorn's still-definitive 1922 monograph, "Artistry of the Mentally Ill.") A drawing of an open, upraised hand with an eye gazing impassively from the tip of one finger, it could serve both as an invitation and a warning to the viewer. For the lure of this work is strong, but so is the terror of the unanswerable riddles it proposes.

Newsweek, February 11, 1985

"REPRESENTATION ABROAD"

IT SEEMS ONLY yesterday that the American art scene was viewed from abroad as hopelessly chauvinistic, and Americans were smugly content to let that assessment stand. Today the situation has reversed, so that anyone who has a German-sounding name, paints badly and favors skulls as subject matter is all but guaranteed instant success in Los Angeles or New York. Luckily a subtly provocative show of work by sixteen foreign artists—who are for the most part little known in this country—has arrived at the Hirshhorn Museum in Washington, D.C., just in time to set things straight by filling in our knowledge of what's really happening in other parts of the world.

"Representation Abroad" (don't be put off by the punning title) was assembled by the Hirshhorn's Joe Shannon, himself a gifted representational painter with a penchant for raunchy allegory. The fact that he paints is impor-

tant. For if his show lacks the artificial shapeliness that a nonpracticing curator would have achieved by making everything fit some predetermined concept, it does have an abundance of excellent new work that may or may not be susceptible to theorizing. Shannon knows about art *and* he knows what he likes.

Of the artists he has selected, only the British painter David Hockney is well known in this country, as indeed he is everywhere. Why include him then? "Because the stuff we're showing is very different from most of his work that gets seen over here," Shannon answers, and he's right. Hockney opens the show with a blast of vibrant new pictures that sets the high tone of much that follows. They bristle with allusions, to Picasso (a polyptych of portraits with more than the normal quota of eyes and noses), to Toulouse-Lautrec ("Henry and Raymond"), to Fauvism and early Expressionism (the shrill, acidic palette of "Anne Upton Combing Her Hair"). Yet they aren't about painting, they simply are painting of a very high caliber.

These aliens form an eclectic and even discordant group, with representation the only thread linking them. Neo-Expressionism is on hand for those who like it: gross-outs don't come grislier than Wolfgang Petrick's "Magical Hood," featuring a big, bad werewolf. At the opposite pole are the almost stolid Neoclassic sculptures of eighty-four-year-old Francesco Messina. But the most exciting artists are situated somewhere in between, and they resist being labeled.

One is England's Rodrigo Moynihan, whose still lifes of mundane household objects sometimes include a sculpted Roman head, all bathed in an even, gray studio light and rendered in a firm but fluid medium. Everything looks normal, but there is an undertone of anxiety like a stifled cry. "Light Bulbs" is a close-up of two bulbs on a mantelpiece; the bright rose-pink cardboard that wraps around one of them is almost painful in the calm, neutral context. Sandra Fisher, an American who lives in London, specializes in small portraits done with a bright painterliness that sometimes evokes Sickert, Manet or America's Ashcan School. Yet she too strikes a faintly subversive note that is at odds with the proceedings on the canvas.

One hears much about the vitality of realist painting in Spain today, and the work of several Spanish artists proves it isn't hype. Antonio Lopez-García, the best known, strives for old-masterish effects; then, when he is at the point of achieving them, gives the whole thing an unsettling modernist tilt. "Mirror and Basin" focuses on a bathroom sink apparently shared by a man and a woman. On its glass shelf are a razor, shaving brush, lipstick and bottle of nail polish, all tensed like pieces in a chess game whose players have momentarily left the table. The same sense of mystery behind everyday appearances lurks in Isabel Quintanilla's beautiful Madrid cityscapes. It is safe to say that no artist has ever

rendered smog more delicately. Luis Marsans, a Barcelona painter, offers still lifes that suggest nineteenth-century American trompe-l'oeil painting. Steeped in the light of memory, a Coke can and a Bic lighter become votive objects in "Varia." A folded-over letter in "Books" captures the mood of Robert Penn Warren's lines "Despised with the attic junk, the letter / Names over your name, and mourns under the dry rafter."

If the more wild-eyed artists in the show come across less strongly, it may be because they have formidable competition elsewhere from the international heavyweight champions of Neo-Expressionism: Petrick, Nino Longobardi and Klaus Fussmann have their moments but simply aren't in the same league as Francesco Clemente, Anselm Kiefer and Rainer Fetting. One exception is Luciano Castelli, born in Switzerland in 1951 and now living in West Berlin. Pinups and slick commercial illustration figure in his razzle-dazzle sendups of pouty nudes and masked S&M revelers. His brilliant, acerbic talent promises much for the future. The Australian Arthur Boyd, who paints grotesque figures and smoldering allegorical landscapes, may or may not be a Neo-Expressionist, but he is definitely an eccentric visionary, and an arresting one.

The other participants in the multinational enterprise are Avigdor Arikha and Tibor Csernus, born respectively in Romania and Hungary and now fixed in Paris; Glasgow-born Leonard McComb; and the Colombian Juan Cárdenas. They and their colleagues all have much to tell us about representation, a game that apparently isn't over till it's over. As Arnold Schoenberg, the father of serial music, once said, "There is still a lot of good music to be written in the key of C major." The artists at the Hirshhorn are telling us that much "traditional" art is still to come, and some of it is going to knock our socks off.

Newsweek, July 22, 1985

VII

RECURRING FIGURES

SAUL STEINBERG

WHEN SAUL STEINBERG met Henry Moore last year, the latter happened to mention that he had decided to be a sculptor at the age of twelve. "I was unable to tell him at what point I decided to become an artist," Steinberg recalled recently, "because I never decided and I still have not done so." After allowing a pause to accumulate he added, "I decided to become a novelist when I was ten. I prepared my life in terms of causing the sort of actions that would make me a novelist. But then I became something else."

Steinberg made these remarks in a suitably novelistic setting, the living room of his house at the Springs, the artists' colony near East Hampton, Long Island, where he spends his summers. It's a little old shingled house which he says looks like "a Chaplin dream of happiness." D. W. Griffith would no doubt have felt at home in it too, and the front screen door seems to be waiting for Mary

Pickford to fling it open and rush ecstatically down the steps, all curls to the wind. One thinks too of the novels of Gene Stratton Porter and Harold Bell Wright from which these old flicks were made, or at least of the perfectly accurate idea one has of them without ever having read them, just as one need not try to decipher the insane calligraphy in a Steinberg official document to guess its import. The furnishings of this fictional bungalow were found by Steinberg, but they look as though he designed them: their shapes are eccentric but crisp and somehow definitive. A Tiffany-style lampshade over the dining-room table has an insistent design like ribbon candy. Underneath it is a platter with an unusually clean-cut example of the blue willow pattern, with which Steinberg apparently has a love-hate relationship. Two carefully chosen specimens of Art Deco furniture copy the vehemence of Steinberg's line, and suggest that rectilinearity had been achieved only after a struggle.

The role that narrative plays in Steinberg's art is a crucial but behind-the-scenes one. For a hundred years painters have cringed at the idea of "telling a story," and it is only recently that we have been able again to appreciate pictures like the Victorian ones discussed elsewhere in this volume. Except for Expressionism the major movements in the art of our century, from the Fauves to the Minimalists, have shared the premise that art is something uniquely visual, an idea that to me seems as farfetched as the currently accepted notion that poetry should use as few adjectives as possible, presumably because description belongs to the domain of the visual arts. But why shouldn't painting tell a story, or not tell one, as it sees fit? Why should poetry be intellectual and nonsensory, or the reverse? Our eyes, minds and feelings do not exist in isolated compartments but are part of each other, constantly crosscutting, consulting and reinforcing each other. An art constructed according to the above canons, or any others, will wither away since, having left one or more of the faculties out of account, it will eventually lose the attention of the others.

But for Steinberg, whose wit and success have delayed his recognition as a serious artist, the case must present itself somewhat differently. For this frustrated novelist turned draftsman, "art" is something that gets in the way of narration, impeding it and finally, as though by accident, enriching it to the point where it becomes something else—the history of its own realized and unrealized potentialities, a chronicle of used time on a level with Giacometti's histories of his hesitations or Pollock's diaries of change. The finished product is an ambiguously whole record of experience, a verbal proposition that puts up with the laws of visual communication merely so as to confound them more thoroughly. The message of a Steinberg picture is therefore offstage, but for it to exist the stage has to be set.

This is Steinberg's situation. It is the reason why he has adapted the form

of the cartoon to his own purposes. The drawings are not cartoons, but they produce the same reflex—one looks, thinks and reaches a decision. It is an art that appeals to the intellect through the senses. And it is doubtless the only kind of art that an artist of such peculiar refinement as Steinberg would produce. He is interested, he says, in understanding—the last of the three stages (sensation and perception being the first two) by which we are classically supposed to acquire knowledge.

"The bourgeoisie is happy with perceptions. They see a Vasarely, their eyeballs twitch and they're happy. I am concerned with the memory, the intellect, and I do not wish to stop at perception. Perception is to art what one brick is to architecture." And he went on to elaborate by telling about a disappointing childhood experience. The boy next door was the son of a contractor, and one day there was a large pile of bricks in the yard. His friend told Saul that the next day they would make a house. He spent a sleepless night anticipating this adventure, and the next day found that his friend had already begun work on the house—which, with a rusty nail, he was carving out of a single brick.

The information-gathering character of all of Steinberg's work becomes almost a paroxysm in certain instances—notably his now widely imitated abstract comic strips, where lines, shapes, blips and unintelligible words are the vectors of a seemingly precise message; and in the rebuslike drawings he has done recently. One of these consists of a sort of chorus-line of radical signs ($\sqrt{}$) facing an array of question marks. The "message" is: "Radicals Question Marx." Yet the pursuit of understanding continues throughout his oeuvre, even at its sweetest and most sensuous-seeming, such as a drawing called "Autobiography," which presents elements from his childhood (a sexy lady in a park, his father's shop, a trolley lettered "Westinghouse"—it seems they had Westinghouse trolleys in Bucharest in the 1920s) in a Proustian ambience of juvenile eroticism. The line refers the image to the brain by the directest route.

Prompted by my interest in "Autobiography" to speak again of his early ambition to be a novelist, Steinberg added:

Rumania is a perfect place for a novelist, because you're not protected. At five or ten you already have a full knowledge of human nature. You didn't have to be told the facts of life, you saw brutality, goodness, sex—all the human facets. I have friends who went to school in Lausanne and who will never know about life. Our system of overprotectiveness precludes the development of *Wunderkinder*. It's impossible to become an intellectual if you haven't been a *Wunderkind*. What you learn from books and meditation is much less important than what you learn fresh from the egg.

With such a philosophy, it is not surprising that Steinberg turned into what he is: an artist animated by an amiable, if difficult, directness.

The directness has been honed by the discipline of producing for an upper-middlebrow mass medium like *The New Yorker*. Steinberg considers the *New Yorker* drawings as separate from his other work. He calls them "homework" and "calisthenics," since

> everything has to be understood at once. I have built a muscle through homework, so that everything else is child's play. So did Seurat, who thought of himself as a scientist. What is great in him is his vision, but technique was his camouflage. I believe in Eliot's advice to poets: Do something else. Left to your own devices you get fat and start slumming. In the Renaissance artists were workers—builders and constructors had their say, and the artist was part of a team. Since the Impressionists (except for Seurat), art has become no homework.
>
> *The New Yorker* is my "political" world. My duty. I am formulating a subversive political message. My other drawings are political only in the sense that I am concerned with autobiography. I mind my own business, talk about myself. When I make a drawing for myself I use only my pleasure.

At the moment his pleasure consists in reconjugating the themes that have always preoccupied him: time, space, history, geography, biography. They are always emerging in new and amusing ways, but together they form the fixed center of his work: a kind of organ point, something too wry to be called nostalgia but certainly close to it—perhaps the effort of a wry mind to come to terms with its nostalgia. And so we have "biographies" like the one of Millet, an artist whom Steinberg likes because he was born exactly one century before him, in 1814, and because "he tried to combine Raphael with socialism." (Currently Steinberg is fascinated by the two figures in "The Angelus," and has had a rubber stamp made of them so he can place them in all sorts of unaccustomed environments, such as the beach at East Hampton or the desert at Gizeh.) The biographies are actually certificates, certifying life by means of official seals and rubber stamps, portrait medallions and passages of handwriting that is illegible but looks as though it ought to be legible ("Biography gets confused with calligraphy. One's life is a form of calligraphy—blunt, brush, et cetera.") And the biographies are related to history, especially art history, which he is always mercilessly codifying: "The history of art history is based on the government taking over art and making a political avant-garde *de choc*." One "Biography" illustrates the various stages in the life of an artist. A tiny,

Giacometti-like figure is seen progressing from a sort of monumental preexistence resembling a Bayreuth set to "cliché reality" or "vernacular reality"—a picturesque little cabin somewhat suggestive of Steinberg's own house, and in fact he explains that "the vernacular is the street you were born in. Once you get out of it you are into 'political' or 'hearsay' reality," which is represented in the drawing by a balloon filled with unintelligible scribblings and a somewhat utopian landscape with a rainbow. This leads to abstract reality, which comes when a man has decided on his principles and which is indicated by clusters of concentric circles. From here one may proceed either to a labyrinth ("total confusion"), to a sort of coat-of-arms ("power and glory—another *cul de sac*") or to a spiral ("a beautiful symbol"). Down below, the same figure is pictured seated at an easel painting the spiral, suggesting both that he has found the true way and that the process, having crystallized back into geometry, is about to begin all over again.

So time is continually cropping out, organizing space and biography according to its cruel whims. In one drawing a figure of a cat is marching down a slope, followed by what looks like a millstone inscribed with a calendar: the cat must keep moving or be crushed by time. Or, again, Steinberg imagines an autobiographical map with the names of all the places where he has spent time neatly lettered and situated by dots with no regard, of course, for geographical reality: Amagansett is lettered much larger than Edinburgh; Mantova, Malaga and Odessa are close together; Milano is situated all alone on an island in a lake on whose shores are London and Paris; and throughout the country meanders the river (of life), its banks dotted with picturesque ports like Laramie, Roma, Anchorage, New York, Leadville, Gallup, Wellfleet and Rochester. Or a moment will be preserved with ironical care: a 1948 receipt from the Paris art supplier Sennelier et Fils is glued to a sheet of drawing paper and its contents copied in Steinberg's painstaking hand, yet despite all the precautions Sennelier et Fils finally becomes Steinberg et Fils, showing how hard it is for the outside world not to recast itself in one's own image. Or autobiography is seen through the refracting lens of art history as in "Steinberg Self-Portrait," which he calls a "cubisterie"—his own name is given the treatment the Cubists used on words like "Byrrh" and "Le Journal." Or the ever-recurring blue-willow landscape is invaded by foreign autobiographical incrustations such as Long Island saltboxes, a factory and a duomo from a primitive Italian painting. Or one's life is seen as an allegorical "cabinet" in "Il Gabinetto del Proprio Niente"—an alchemist's study furnished with such objects as a huge letter "S," a drafting triangle whose three sides are inscribed "Oh," "Hm" and "Bah," and a chest whose drawers are labeled, "Crime, Punishment, Rouge, Noir, War,

Peace, Bouvard, Pécuchet, Pride, Prejudice, Fear, Trembling"—the furniture of life, in Steinberg's phrase.

This last is for me one of Steinberg's most moving drawings, and perhaps epitomizes his strange, comfortably uncomfortable world. Life is a room, empty except for the furniture (no person can enter it because it is already inside us). The furniture is both useful and ornamental, but none of it will be used because no one will ever descend the steps marked with the days of the week or enter through the open door, beyond which one glimpses a tree whose trunk and branches are marked with inscriptions, too far away, alas, to be readable. Yet it all does have a function, that of a symbol, the only function we need concern ourselves with, since it includes everything by telling about it. The act of storytelling alone is of any consequence; what is said gets said anyway, and manner is the only possible conjugation of matter. Or, in Robert Graves' terse summation: "There is one story and one story only."

ArtNews Annual, October 1970

SAUL STEINBERG OCCUPIES a position in American art like that of Satie in French music. A combination of mascot and confessor for some of the great musicians of his day, Satie became in his lifetime the object of a slightly patronizing cult. Today his importance for composers is equal to Debussy's and he has definitely outstripped contenders like Ravel. (Satie's marvelous *mot*, "Ravel has refused the Legion of Honor, but all his music accepts it," has become posterity's verdict.) In view of his refusal to take his work seriously, Satie's latest reincarnation as a hippie hero alongside such unsmiling deities as Hermann Hesse and Dr. Timothy Leary is even a little alarming. It is similarly disconcerting to find that Steinberg, court gadfly to the New York School, has filled the Janis Gallery (where humor has never been one of the principal commodities offered for sale) and the Parsons Gallery in New York with works that are a good deal more "serious" than what one is accustomed to see there. What has happened? Simply that Steinberg's genius has, over his and everyone else's protestations, gently but firmly transformed his inspired doodles into art. This is not to say that they are no longer funny—they are funnier than ever. But their humor has now reached the point where it is powerful enough to sweep

away any lingering doubts one might have had about the possibility of humor in art as we now know it. In fact, future generations may end up wondering, as has happened with Satie, just what his contemporaries were being so serious about.

Steinberg elaborates a number of his favorite themes and some new ones as well. Those incomprehensible official seals and signatures, familiar from his book *The Passport,* are still much in evidence—in "Certified Landscapes" they lend their sanction to a series of skinny horizontal landscapes with clouds in delicately garish colors that suggest Courbet's sparser seacoasts. His fascination with rubber stamps is becoming a mania, and it would seem that some obliging rubber-stamp manufacturer had let him roam through the warehouse un-molested (he orders some from his own drawings). Particularly memorable are two large factory- or prison-scapes at Parsons, in which everything from the outlines of buildings to machinery and groups of sinister little figures is done with rubber stamps. In this case he does not use a wash background as he does elsewhere (notably in "East Hampton," a dreary beach and sky in gouache with the same figures—no doubt the local artists at their annual Fourth of July picnic—standing about singly or in wary proximity). The effect of all those exasperatingly sharp lines with the solid black areas—blurred from the un-evenly inked surface of the stamp—against the dead white of the paper is unlike anything one has seen before. And when, after taking in their prickly oddity, you slowly become aware of their subversive content (contemporary urban bleakness, both spiritual and architectural, has been caught definitively), they give you quite a turn. Medium becomes message which in turn becomes medium again. That is to say that the anecdotal part of the pictures is not something detachable as in most cartoons, but strikes its own note in an indissoluble chord or total look.

Some of the most fascinating of the new Steinbergs are those in which he uses stylistic echoes of Cubism and Art Deco. One, a "Still Life" of cylinders, cones and discs shaded with colored pencil, looks like a Léger until one notices the illegible seals of authenticity and the nonfunctional penmanship that are starting to invade it like lichen. The Art Deco motifs come on strong in a "Diner" series, such as "Biloxi Diner" in red, yellow and silver, which is more suggestive of the Arps' "Aubette" café in Strasbourg, except for the presence of a member of the local fuzz and a busty Mississippienne. Elsewhere the Cubist themes turn up in the paintings and artifacts of modernistic apartments in which curious couples recline, wordlessly and mindlessly communing. Though they are neighbors in space, Steinberg's people tend not to be made of the same substance—a man can be solid India ink while the girl on his lap emerges out of a palimpsest of close-set parallel lines or a cloud of dots. It is as though

creatures from many different planets had settled down in New York and gradually forgotten their extraterrestrial origins, and that may be what New York is like. But, clever and pointed as Steinberg's contemporary genre scenes are, it is their bizarre physical beauty that counts most—an effect that only an artist too intent on his work to notice could have achieved.

ArtNews, November 1969

JOSEPH SHANNON

At dinner every Friday, at M. Rouart's, Degas would be the soul of the evening; a constant, brilliant, unbearable guest, spreading wit, terror and gaiety.

The jumps and gambols of a child, for example, or a dog—walking for its own sake, swimming for its own sake . . . *are all activities whose only purpose is to modify our feeling of energy, to create a certain condition of that feeling.*

<div align="right">

Paul Valéry, Degas, Dance, Drawing

</div>

Well, aren't we all yearning for a little stopping power, *with which to chase these spooks away?*

The Firesign Theater

L
IKE DEGAS, WHOM he admires to the point of pastiche (he has written: "I consider Degas' 'Spartan Boys and Girls' the pivotal painting of the modern age"), Joseph Shannon is obsessed by the particular gestures made by individuals carefully selected from a particular class. The Impressionists felt that any old haystack or field of poppies was a suitable pretext for a painted demonstration of how reality looks. The novelty (and greatness) of Degas in their midst is his gift for producing Impressionist spontaneity out of careful research. For him, the slapdash look of emerging happening was not to be achieved without Balzacian knowledge of the details of Semiramis' Babylon or the New Orleans Cotton Exchange; or, in his portraits, without complete, almost possessive understanding of the subject's soul as well as his appearance, mannerisms and habits of dress. Without careful study and without particularization, the spontaneity wasn't free to be itself. It could never realize its potential as the *one* special moment different from all others, but must resign itself to remaining the typical moment of the Impressionists.

These are some thoughts suggested by Shannon's fascinating paintings in his recent show at the Poindexter Gallery in New York. They are a series of views of our forlorn, transistorized age that, except for their polemical side, recall Degas' candid looks at seamy and sophisticated Paris. But the stakes have changed somewhat. Impressionist objectivity has mutated as facelessness, as art-as-object, and is the spirit of the time; while Degas' selective objectivity as it reemerges in Shannon is something quirky, tendentious and political, and very much off in left field. Shannon knows this, and inveighs against the status quo with a peevishness that may be part of the lesson of the master:

> My work is the opposite of what Barbara Rose calls High Art. . . .
> Greenberg implies that a painting is no more than it is, a painting should be
> "literal, and concretely sensational." Emotional, my painting is always more
> than it is; ideally, it should interfere with the onlooker's life and give clues to
> trigger associations, tell stories, make myths, guilts and solicit sympa-
> thies. . . . Emotional polemic art of quality is the new wave.*

*This and other quotations from Shannon are from a letter about his art he wrote to Walter Hopps, director of the Corcoran Gallery in Washington, D.C., who organized a show of Shannon's work there in 1969.

Polemics, yes, but what is the argument? Unlike other critics who have found Shannon's work overloaded with sociopolitical message, I am fascinated by the ambiguity of this message. Is it really political? Much politically engaged art of these times ends up ambiguous because of the artist's muddled ideology or a tendency to cop out at the last moment and produce a work of "art." Shannon's is different. The atmosphere is charged; there are signs of modern cruelty and ugliness everywhere, but the ambiguity remains, a purposeful one, electrifying these images from a dream that cannot be dismissed. The parables are open-ended; in the words (again) of The Firesign Theater, "There is no one to blame." Shannon diagnoses the sickness of our time as few artists have done, placing an exploratory finger on places we never knew were hurting, but he offers no solutions, perhaps because he considers the sickness incurable.

Moreover he is careful to distinguish his painting from "protest" painting. In the autobiography he supplied for the Corcoran's catalogue, the years 1962–64 are chronicled with subliminal humor:

> 1962 Quits Smithsonian to paint full time. Back to Tucson after short stay in Harper's Ferry, W. Va. Runs into money problems almost immediately. Unable to get work, the family subsists at poverty level. Turns to social-protest subjects. . . .
>
> 1963 Returns to Washington and the Smithsonian.
>
> 1964 Chastened, he retrenches, destroys most previous work. . . .

Thus, apparently, existence at the poverty level is enough to make an artist turn to social protest; the return to financial security "chastens" him and incites him to destroy that work. But in Shannon's case the spirit if not the letter of protest remained. In a few recent works, like the 1969 "Helicopter," in which a naked, androgynous policeman confronts a presumably Vietcong youth hanging from a tree, it is blatantly spelled out and far less effective than in those paintings where the terror is dissolved throughout, in the sky, the trees, the furniture, the socks.

Shannon is an articulate observer of his own ambiguity. In the letter to Hopps he says:

> I stress in my set pieces the "free" nature of the real images in their "roles." The "fantastic" circumstances of the manipulation and the limited control I have until the "roles" are defined. Deliberate ambiguity has dominated modern art since Mallarmé. Accidents of ambiguity occur, as well as intended ambiguity in the relationship of "roles." The accidents I cannot explain. Mistakes are mostly made when the intended purposes are obviously

political, and when the "roles" are not developed unconsciously, the painting becomes strained and the image "roles" collapse in banalities of archetypes. Freedom is bought by hazard.

So that, working intuitively with a delicate set of relationships to be adjusted by the "controlled accident" method, Shannon is actually related to aleatory music, Action Painting and other phenomena of our time, which evidently believes that a lot of chance and a little organization reflect its temper.

The "roles" in Shannon's field of folk are dominated by the Caliban–Sancho Panza–Père Ubu figure of the "shoe salesman." Shannon says:

He is the prototype "honky." This is the "role" image I reinforced. He is greedy, cruel, selfish — puzzled. What I didn't say but hoped to imply was that in many ways he had no control, that in spite of what I made his "role," he was a son, a lover, an optimist, became a pessimist, later bogged in despair he dies of a stroke. As it is possible for him to change — become "nice" — so it is possible for me to change and make sympathetic use of him.

Other role figures are: Announcer, Sugar Daddy, Old Bitch and Aging Art-Groupie, while "cross referencing" can result in hybrid figures such as: "The Announcer, my Father, the Gorilla (like the Gibbon — a witness), Dogs (man's best friend), the Jet Plane, the 'Finger,' the Diplomat. And last but not least — myself."

There are two kinds of Shannon paintings, the large groups of figures with their overlapping casts of characters, and the quieter, "objective" paintings usually of a single figure, often in a closed, more reassuring domestic space. In these the irony and savagery are generally muted into something wry or even comic (as in the blustering self-portrait "Myself"). Shannon says of them that "as a 'commonly skilled' artist I also have the play and game of 'challenges.' Mere rendering of the thing I like or even the thing I dislike as responses to 'fresh' nature and as an exercise of my 'common skill.' Thus I do nudes, portraits and studies, etc." (Shannon here asserts his claim to what most artists would take for granted with the pleasant belligerence that tinges these smaller paintings.)

But these quieter pictures are interludes or rests between the large *machines* or groups, which express him best. In these he has assembled a Hogarthian portrait gallery, with a décor that is constantly threatening to impinge on the portraits. The twisted American faces, like Martha Mitchell's caught in mid-grimace by a flash bulb (Shannon is said to work from news photographs and to be inspired by Mrs. Mitchell and other celebrities of

Washington, where he lives), or Arthur Godfrey's as he stoops benignly to inspect a child's teeth, polarize intensity here and there amid the shifting choreography. The figures are in a curious relation to each other. At times they look as though they were on intimate terms, but then it becomes a question whether they even see each other or are actually occupying adjacent spaces. Though the pictures are crammed with events, the main event seems to be happening somewhere else, and the figures are often gazing outward—toward the viewer—as though at the point where reality and the action coincide. Meanwhile their own territory is being invaded—by animals, very often: dogs and apes whose movements are on a plane of life parallel to that of the people, as the activities of rats somehow form an obscure background to our own—and one feels that one is glimpsing a scene in the moment before its destruction, which may well overflow the confines of the frame.

Shannon's "wit, terror and gaiety" are nowhere mustered more brilliantly than in the large, ambitious "Pete's Beer," the masterpiece of his recent show. It is a strange painting, even for him. Its mood is tinged with the atmosphere of certain great *kermesse* pictures of the past. One catches whiffs of the delicate world-weariness of Bellini's and Titian's "Feast of the Gods," the bleary-eyed merriment of Velázquez's "Los Borrachos," the tristesse of "The Bar at the Folies-Bergère," and echoes of the great mundane allegories in painting, from Giorgione to Courbet's "The Studio." A number of living creatures, humans and animals, blacks and whites, old men and children, the naked and the clad, have joined together in some nameless and woozy celebration on a hillside. The time could be early spring; the ground is gray-green, the sky dull gray. The foreground is dominated by two large figures: a black lady in a yellow dress and flowered hat and a drunken-looking white man rather resembling Joe Namath, who embraces her as they step forward in a kind of dance. Directly to the left a naked white child leaps into the air: Shannon has caught and characterized his movements perfectly, so that it seems we always knew this is how a child jumps. Behind is an assortment of other figures including a fiddler, a black boy playing with a dog, the artist himself (another nod to tradition), a nude woman with her back to us, and a young man on a horse whose elegant gesture suggests a Degas jockey or one of the mounted archers in his allegorical painting "The Misfortunes of the City of Orléans." And indeed, the boy seems to be pointing out an airplane in the distance that is heading directly at this curious but happy group, perhaps to annihilate them: there seems no other explanation for its presence. The continual movement that characterizes Shannon's work and the counterpoint of different kinds of movements are worked up with his usual expertise, a combination of Degas-like shorthand and the sophisticated brushy technique of certain popular magazine illustrators of the past, like Gilbert Bundy. Particu-

larly apt are the flat blue of the fiddler's shirt in the background and the vague scumble that is the left hand in motion of Pete (so I take the male figure in the foreground to be) as compared with the Ingres-like precision of his right hand, resting on the lady's shoulder.

Shannon's commitment to technical virtuosity and a complicated, arresting vision are undeniable strengths. Even more so is his unabashed homage to the great art of the past, a homage which somehow includes him as a worthy successor to it. It is an ambition that few artists today would care to claim and even fewer would qualify for. But Shannon proves himself the rightful heir to the academy, and it is good to see that he has no intentions of leveling the doddering structure, even though he obviously plans to throw some pretty wild parties there.

ArtNews, March 1971

THE TERM "WASHINGTON SCHOOL" means the cool abstractions of Morris Louis, Ken Noland, Howard Mehring and others — unsized canvas streaked and stained with meandering, translucent pigment. Very beautiful, some of it, but the "Washington" epithet hardly describes it in the way that "New York School" somehow takes in the light and commotion of that city.

One artist whose work *is* truly indigenous to our nation's capital is Joe Shannon, now showing recent paintings at Tibor de Nagy in New York. The bureaucratic madness endemic there is the very stuff of art for Shannon. He is one of your erudite, articulate artists. Too much so, some might say; don't his quasi-surreal storytelling pictures verge on — horrors — the "literary"? Maybe, but narrative art, along with so much else, was liberated during the past decade and is now respectable again. Besides, the stories Shannon tells aren't really stories but undecipherable bits of life as it flashes past. In his own way, he is doing for today's lobbyists and secretaries what Degas did for his laundresses and *petits rats* — if one takes into account the way we live now and the way things look to us.

In Shannon's "Memo," for example, a paunchy bureaucrat in a short-sleeved shirt and rep tie is charging horizontally across the canvas, directly in the path of two figures who are approaching the viewer — one an old man with a dazed expression who seems barely able to stand, the other a woman with partly closed eyes who is extending one arm sideways in an enigmatic gesture. This vignette of everyday life at (possibly) the Pentagon is painted in Shannon's usual snapshot style, except for some sketchy business on the right: a wall and part of

the running man's "hind" leg are unfinished, perhaps to reflect the tension implicit in the title.

"Memo" is straightforward compared to the complex, enigmatic action in some of the other paintings. In "Magician I (for Pete)," a nattily dressed black man with a basketball at his feet is barring the way, apparently, to four civil servants—two men who look like twins, a haggard woman who seems to be suffering some kind of motor disturbance, and another, younger woman wearing a tie and vest. Behind them is a menacing figure of a man with a top hat and clown face. Both the black man and the clown are somewhat larger in scale than the others; all are weeping and all have the luded-out look of the actors whom Werner Herzog hypnotized before filming them in his movie *Heart of Glass*. What's happening here is anybody's guess, yet somehow it all has the look of a slice of daily life.

Besides these genre scenes, Shannon shows a number of more or less straight portraits, though even here something is usually askew. Some of his sitters are clutching a highball or a can of beer, as though this were the price of their momentary calm. A portrait of the painter R. B. Kitaj has him seated in a modern office chair with eyes closed, as though he had, for the time being, seen enough. Even the sparkling still lifes have subversive overtones. In "Still Life with Glue" a skull, a spider plant and a bottle of glue cohabit all too comfortably on a shelf. "Still Life with Camera" includes a human and an animal skull and an old tobacco tin whose brand name—Edgeworth—strikes a strangely ominous note.

There is in his new work a discreet tactility, at times approaching but never actually embracing painterliness. The pictures are bright and fresh even when they are nasty. If Baudelaire were around today, he might well consider Shannon a leading contender for the title "Painter of Modern Life" which he bestowed on Constantin Guys.

New York, June 2, 1980

JESS

THE MUSEUM OF MODERN ART in New York recently showed a series of twenty-six "translations" by Jess, a painter who is, one gathers, something of a living legend in San Francisco. Though the paintings, some of them at any rate, were shown here previously in 1971, they make a much stronger impression now, perhaps because of the increasing beneficial fragmentation of schools and ideas here and the consequent decline of newyorkthink, that suppressed longing for big grand abstractions that shall be at once both public and personal, which is part of the legacy of Kline, Rothko and Pollock. New York and California are part of the same continent, but so are Poland and Portugal, as someone remarked recently. West Coast artists have generally been able to draw the lessons they needed from developments in the East (Jess studied with Still,

who might be seen as a kind of mediating figure between the two cultures); but to New Yorkers, when they look, the work of Westerners often seems merely curious. This might have happened in the case of Jess; after all, his work *is* curious. That it is also on a much grander scale than its quirkiness at first seemed to allow of was evident on a second viewing.

In a marvelous catalogue text which is a part of the exhibition, as are Jess' titles and the texts that accompany the pictures, Robert Duncan tells us:

> The whole sequence is a picture book belonging then to the great primary tradition that extends from the illustrated walls of the Cro-Magnon man's galleries to the emblematic and magical art of the Renaissance and the revival of enigma and visionary painting in the Romantic movement. Its original may have been a child's coloring book, for each painting is a picture translated from a drawing, an engraving, a lithograph or a photograph, in sepia or in black and white, into the density and color of oils.

It is also, among other things, a "complex game of associations, in which the paintings are cards, the arcana of an individual Tarot, a game of initiations, of evocations, speculations, exorcisms . . . a play with the properties of paints and picturing."

The paintings are literal translations of old illustrations and snapshots into a strange medium whose built-up pigment at first seems highly inappropriate and tinged with allusions (subversive, perhaps) to Abstract Expressionist and *matière* painting. But the neat, workmanlike transpositions ignore the anomalies of surface, as though a magic lantern slide were projected on a lunar landscape. The accompanying texts are taken from Plato, Plotinus, Wordsworth and Gertrude Stein, and also from *Scientific American,* a letter of Burne-Jones, J. J. McGrath's *Operative Surgery for Students and Practitioners* (1913) and the Abbé Noël-Antoine Pluche's *Histoire du Ciel* (1748). Like Duncan, Jess is a snapper-up of unconsidered but considerable trifles.

These are the materials the painter offers the viewer, but also important are those he doesn't provide (i.e., anything to do with specific intentions or explications), which have the function of "negative space." For if the relation between picture and text is sometimes direct (as in the translation of Hubert Draper's "Lament for Icarus," one of the high points of the series), it is as often tenuous (the Gaelic incantation accompanying a portrait of Mrs. Winchester, the eccentric widow of the rifle tycoon) or almost invisible (the Aztec inscription for a photo from the 1944 University of Montana yearbook). All of these elements, the given and the withheld, contribute to the experience of the work,

which is not whatever the viewer wishes to make of it, but what he has to make of it once he has consented to play the game. Jess, unlike so many contemporary artists who would elicit the spectator's participation, compels it.

The prejudice against "literary" painting is perhaps a typically East Coast one. In any case it is difficult for New Yorkers to conceive of art as something hybrid: there is abstraction and there is perhaps something called "information art," but an art in which equal importance is accorded to a number of unrelated components is hard for us to grasp. The role of color and painterliness in Jess' work will probably only exasperate further those for whom painting is something exclusively retinal. Yet it enchants even as it instructs and misleads. The artist is quoted as saying: "Every point of color is autonomous, but still it is within the total relationship, the total network of color. . . . In most contemporary color, intensity is what they aim at. I am concerned not with the intensity but with the identity of the color in the total; it may be intense, but it may be dim or ambiguous, seeming to change in relationships with different other points of color." And part of the excitement of the work is the way Jess makes distinctions among almost identical or equal colors, or the way he lumps seemingly unrelated ones under a single "heading." But the interdependence he speaks of is apparent not only in his handling of color but in all the varied elements that enter into one's experience of the sequence of pictures. Against Verlaine's artificial distinction between *musique* and *littérature* one may place Jess' synthesizing approach which sees no reason to give up either. His *tout le reste* is a sumptuous remnant indeed for those who accept art for what it is: hybrid, transitional, impure and magically alive.

Art in America, March–April 1975

I N NEW YORK, there seemed to be a swing of the pendulum away from Abstract Expressionism toward the various realist modes of today. The same thing happened in California, too, only differently. A striking case in point is the career of the fifty-eight-year-old San Francisco painter named Jess (he long ago dropped his last name, California-style).

Early and recent works of his are currently brightening New York's Odyssia Gallery with strange magic-lantern shapes and colors. His work in some ways incorporates an intellectual artist's reaction to Abstract Expressionism, but it is not a reaction that will mean much to New Yorkers who like to see everything in terms of styles and movements emerging so fast that they trip over

each other. For better or worse, quirky individualism seems to be more highly prized in California than in the East, and Jess is certainly one of the most individual artists that fertile breeding ground has produced.

Born in 1923 in Long Beach, California, Jess studied painting at the California School of Fine Arts with such abstract painters as Clyfford Still, Edward Corbett and Hassel Smith. The California Abstract Expressionists were annoyed at being called the "drip and blob school" by one journalist, but Jess delighted in the epithet, and one can see how it helped him articulate a realism all his own. In 1959 he began a series of pictures called "translations"—copies of ready-made images such as children's-book illustrations ("Mort and Marge") or old snapshots ("Melpomene & Thalia"). Though they look straightforward in reproduction, they are actually built up out of layer on layer of pigment that resembles a bas-relief. The contour-map surface has a life of its own, unrelated to imagery. Jess' longtime friend, the poet Robert Duncan, describes it as "a grammar of purely visual depths and heights orchestrated by actual depths and heights of paint, embedded figures and raised backgrounds, conglomerations of pigment that cast actual light and cast actual shadows." The unearthly tinted glow that results is far removed from naturalism.

Jess works in at least two more genres of his own naming. There are the "paste-ups," his modest term for enormous collages that are bewilderingly complex, sometimes incorporating embroidery or sections of partly assembled jigsaw puzzles laid over each other like geological strata. And there are the "salvages," early paintings of his own (or in one case a painting found in a junkshop) that in recent years he has transformed with strange new encrustations.

The New York show includes earlier "romantic" paintings, left as they were or "salvaged." "Valerie: A Reminiscence" (1960) looks untampered with. Its handling is romantic in the blurred 1920s style of Pavel Tchelitchew or Christian Bérard, but what is happening? In the foreground a girl seems to be jabbing at a vase of flowers with a feather duster, while in the background a nude androgynous figure is aiming an arrow at the ceiling. "When We Will Tempt the Frailty of Our Powers" (a quotation from *Troilus and Cressida*) is one of the most striking of the large salvages. Its cast of characters and many changes of scene include a prayerful portrait of the artist, a veiled female angel, a portrait of a man (Robert Duncan?) blowing soap bubbles and a sepia "photograph" of an anonymous housing development that one discovers only on close examination is a trompe-l'oeil painting of a photograph.

That discovery is an example of a fascinating "temporal" quality in Jess' art that makes looking at it more like watching a theatrical performance. After taking in its major outlines, you get lost in a maze of detail and then emerge to

find yourself looking at a different work. Jess' more ambitious pieces remind me of the snail's-pace action in a Robert Wilson play, where attention wanders and eventually wakes up to find that the whole scene has changed.

Yet despite their seductive images these are pictures that are painted objects, and they are not "about" anything except themselves. The fabulous fabulations that are always about to occur are reduced to a single tale: the autobiography of the picture as it came progressively into being.

Newsweek, April 24, 1982

R. B. KITAJ

AMERICAN ARTISTS WHO choose to expatriate themselves face a precarious fate. Confronted with the xenophobic indifference of both their adopted country and their homeland, always suspicious of its émigrés, they run a greater risk of living out obscure careers than their compatriots who stay put.

It wasn't always so, and it would be hard to imagine the difference for our culture if Whistler, Sargent, Henry James, Gertrude Stein, Pound and Eliot had elected to live in the United States. A certain kind of American sensibility had to extricate itself from America in order to realize itself. Nowadays, however, America no longer feels itself the cultural inferior of Europe—quite the contrary, in fact—and American artists who choose to work there are now viewed with a suspicion compounded by sincere perplexity. A few have managed to flourish on both sides of the Atlantic—Sam Francis and Joan Mitchell in France,

Cy Twombly in Italy—but the majority are eventually forced to choose between repatriation and neglect.

One artist whose American reputation seems to have suffered in part because of his immense success in England is R. B. Kitaj, a forty-seven-year-old Ohio-born painter, who is currently having one of his rare shows here. His twenty-five-year residence in London is, however, only one of the reasons why he isn't better known in America. A more important one, perhaps, is his highly articulate aversion to the established art here, from abstraction in its various phases to our "new" realism. (In England, where Bacon is the dominant figure, Kitaj's temperament has thrived and also become influential—his position in London has been likened to Pound's in the early years of this century.) Bookish, belligerent, passionately in love with certain great art of the past, sophisticated yet a firm believer in a *human* art that is both politically and morally committed, he is the antithesis of our laconic, supercool culture heroes like Johns or Stella, for instance. Yet he is as important an artist as they and, despite his romantic involvement with things past, as modern as they are too.

What is precisely new and exciting in Kitaj's work is the immense culture which saturates it but seldom appears there frontally. The works teem with references to films, poetry, novels and photography, but they make their effect with purely plastic means. One example in the present show is a large drawing called "The Jew, Etc."—a title lifted from a volume of short stories by Turgenev. This Jew is like the embodiment of a fragment of Eliot's poetry. (Kitaj once said in an interview: "In a way I regret that Pound and Eliot often had more of an influence on my pictures than previous painting did," but on another occasion he remarked: "I'm always looking over my shoulder at Joyce and Pound and Eliot and Giorgione and Lotto and Sassetta and Giotto.") The figure is seated in profile in a railway compartment (Kitaj's figures are seldom stationary, even when caught only in mid-act or mid-*pensée*). His body is thrust anxiously forward, though the face wears a dreamy expression. His clothes are correct yet sad—laced-up shoes, a clumsy suit, a dull fedora. His lips are parted as though he were considering speech, and, like several of Kitaj's figures, he wears a hearing aid, a sign of our increasing reliance on mechanical intermediaries between our senses and our sensations. He personifies a specific modern European *malaise*. All this sounds like pretty heavy symbolic baggage for one passenger, but the power of the work stems entirely from Kitaj's superb draftsmanship—the delicate whiplash of outline, the melancholy smudges of shadow. An image has been deftly but firmly coaxed into being, and it will stay around to haunt you.

The show includes a few paintings, notably a double portrait of his friends the poets Robert Creeley and Robert Duncan, and another called "The Hispa-

nist," one of a series of portraits of sitters surrounded by the emblems of a culture which is not their own. But most of the works are drawings and pastels celebrating, in Kitaj's very special and oblique way, the human figure, which has taken on a new importance for him in recent years. Several are from a group called *Bad Faith* and depict figures in confinement: a political prisoner in Chile, with an upside-down clock on the wall behind him; another in a Gestapo interrogation cell in Warsaw; a woman in a Russian gulag haunted by a rat eyeing a piece of cheese labeled "cheese," nursery-rhyme fashion. One of the best is "The Philosopher-Queen," a double study of a nude, seated and disappearing up a stairway, done during the year he has just spent in New York.

The new work is perhaps less Surrealist, less purposely disjunct, more focused on isolated moments in the lives of the strange individuals who comprise humanity. Kitaj once wrote of his friend Jim Dine: "Unusual human form derived from usual human form often equals high art for me." These new drawings are a kind of anthology of "usual" human dreams, suffering, and errors, transmuted by the hand of a master draftsman into a bizarre but genuine "high art."

New York, April 16, 1979

We lose our way in cities; we get lost in books, lost in thought; we are always looking for meaning in our lives as if we'd know what to do with it once we'd found it. . . . Nothing is straightforward. Reducing complexity is a ruse.
—R. B. Kitaj, A Return to London

"ONLY CONNECT," urged E. M. Forster in *Howards End;* this exhortation was the theme of his novel. A decade later Yeats noted that "Things fall apart; the centre cannot hold," while T. S. Eliot appears to be replying directly to Forster through the persona of a seduced stenographer in *The Waste Land:* "I can connect / Nothing with nothing." By this time the dislocations tried out by other artists before the war had become real, as yet again life imitated art with disastrous results. The world itself, and not just a pictured mandolin and bottle on a table, had become unglued.

Faced with an altered reality, Eliot reacts as though in a stupor. Despite all his craft and scholarship, *The Waste Land* achieves its effect as a collage of hallucinatory, random fragments, "shored against my ruin." Their contiguity is all their meaning, and it is implied that from now on meaning will take into account the randomness and discontinuity of modern experience, that indeed

meaning cannot be truthfully defined as anything else. Eliot's succeeding poetry backs away from this unpleasant discovery, or at any rate it appears to, though *Four Quartets* may be just as purposefully chaotic beneath its skin of deliberateness. Yet the gulf had opened up, and art with any serious aspirations toward realism still has to take into account the fact that reality escapes laws of perspective and logic, and does not naturally take the form of a sonnet or a sonata.

It is not unusual to begin a discussion of R. B. Kitaj's work with a mention of Eliot's; Kitaj himself has done so. Questions of politics aside, there are obvious parallels. Both left America in their twenties and brought to Europe a sensibility that was still unknown in the country of their birth but that, surprisingly, took root and flourished in their adopted one. In the work of both, the picturesque is at the service of a deep-seated sense of cultural malaise that seems distinctly European (Kitaj's title "The Autumn of Central Paris" captures it nicely), though presented with a directness that seems distinctly American. Like Whistler, Eliot and Pound, the crusty gentleman from Ohio plays the role of resident Yankee gadfly in London, warning the locals of the perils of both Americanization and their own imminent stagnation. And, of course, in Kitaj's work, his earlier work at least, the fragmentation and randomness of *The Waste Land* are there, long before he painted it in "If Not, Not" (1975–76). His cast of characters is similar: crude businessmen, prostitutes, neurasthenic fräuleins, ineffectual professors, even a "Smyrna Greek," who is perhaps a relative of "Mr. Eugenides, the Smyrna merchant." If his pictures could, in some cases, be illustrations for Eliot's poetry, the poetry itself often sounds like an approximation of Kitaj's brushwork:

> The river sweats
> Oil and tar
> The barges drift
> With the turning tide
> Red sails
> Wide
> To leeward, swing on the heavy spar.

Such a passage is less a description than a miming of a way of seeing wherein objects will clear for a moment and then blur, adjacent phenomena are compressed into a puzzling homogeneity, and clear outline abruptly turns illegible.

In addition, Kitaj is a man for whom modernism flourished and ended earlier in this century: the modernism of Eliot, Pound, Joyce and Yeats, of Matisse, Picasso and Mondrian—more radical than anything that has come

along since (he would argue) and hallowed by the rich patina of the old masters. In other words, he holds a position that is both conservative and, if his identification of the modern is correct, radical at the same time. The "strange moment" he is always saying we live in is not so much strange for him as banal; what is strange is the way Kitaj's appropriation of images and attitudes of the recent past has produced a modernism unlike any other.

It is, fittingly for our late century, a work shot through with oppositions that Kitaj is able to indicate but never quite resolve satisfactorily, which is as it should be: "Reducing complexity is a ruse." (One is reminded of Scriabin's exhortations to the young Boris Pasternak, cited in Pasternak's memoir *Safe Conduct*, to simplify art as much as possible—this from the master of some of the most disturbingly convoluted music ever written. Simplicity is the ideal, but complexity is the reality.) First there is Kitaj's situation as a wanderer and expatriate, freighted with memories and attitudes from the homeland in which he had no wish to reside permanently, yet not entirely understood or accepted by his adopted country, eager as it is to welcome artistic refugees from America. As a displaced person, he is well qualified to serve as a spokesman for our century.

A further exemplary contradiction—which, like the others, enriches his work as it seems to short-circuit it—is the conflict between moral and aesthetic concerns. Kitaj has frequently stated his desire to create a democratic art that could be assimilated by a large public, yet there is always something fishy about these protestations. Clearly he has no intention of "painting down" to the public and seems hopeful that he will be allowed to have his patrician cake and let "them" eat it too. The disparity between his intentions and practice has not gone unremarked. A reviewer of Kitaj's 1963 show at the New London Gallery sniffed: "It is excellent that an artist has arrived on the scene whose work shows a profound involvement with the moral issues of our day. What is not yet established is that Kitaj has discovered how to organize his imaginative powers to express this involvement." And in 1975 Gerald Nordland wrote: "Looking at his work one sees a superficial stringing together of images for an elite, growing out of an art for art's sake esthetic. . . . The line he gives us might be all right at a cocktail party but is hardly appropriate to an exhibition catalogue when it is so blatantly out of line with his own practices."

Even supposing the existence of a proletarian public conversant with Unity Mitford and Walter Benjamin, not to mention Pound, Joyce and Bonnard, it is unlikely that Kitaj's work could ever succeed in being populist, for its allusions to figures such as these are so oblique that even intellectuals find them baffling. Besides which (as another Kitaj heckler wrote in *Artforum*), "The fact that not everybody, or even many, care about art (*any* art, not just modern), seems self-

evident. . . ." Yet Kitaj's stance, one foot planted in humanistic theorizing, the other in a practice that seems to contradict it, is again symptomatic of modernism. Picasso and Léger were both members of the French Communist Party, to cite but two obvious instances of radical chic. And it is likely that in the case of their work as well as Kitaj's, the *will* to produce art for the people—even if it fell short of its goal and produced an art of extreme sophistication—nevertheless inflected, deflected their work and made it something very different, something far better, than if they had ignored social issues and remained willingly in the fold of self-referential art for art's sake. The failure is an honorable one, and far richer and more involving than success would have been.

Then there is the tension between the extremely fragmented look of Kitaj's early work and the apparently more unified and single-minded character of the late work, particularly the recent pastels. To a reviewer who pointed out the difference between the earlier "collaged" imagery and the later isolated figures, Kitaj replied, "Collage emphasizes *arrangement*, an aesthetic of conjoining, at the expense of depicting, picturing people and aspects of their time on scorched earth, which was what I always wanted to represent. Arranging a life of forms on a surface will always be the bread and butter of picture-making . . . but the meat and drink?" Finally, there is Kitaj's ambiguous celebration of the figure, where, again, he seems to have taken up a position at a vital crossroads in modern painting.

Certainly there is nothing ambiguous in his statements about painting and drawing the human form. He told an interviewer:

> The notion of a *return* to the figure is just media-talk. For some of us, it's the only art we know. . . . Manet and before, Cézanne, Degas, Picasso, Matisse, Bonnard, Brancusi, Mondrian . . . were all trained, roughly speaking, in the same way. Over long periods in their youth they gave themselves to the study of the human figure, to that age-old instinct, that instinct I feel in my bones, that we've been talking about, drawing from the human form.

In recent years Kitaj has cleared his stage of extras to concentrate on one or two figures, as in "From London (James Joll and John Golding)" (1975–77) and "The Orientalist" (1976–77). But not until the drawings and pastels in his 1980 London show do we see just how deeply ingrained "in his bones" is the urge to draw the figure. These remarkable pictures scarcely rely at all anymore on effects of décor, on the presence of significant extraneous objects, but zero in on the figure with a new directness. Though the drawing is hardly academic and is sometimes bizarrely skewed, for purposes one cannot immediately distinguish (but which need no justification), there is an atmosphere of the studio and a

consuming will to "get it right" for the professor who might at any moment peer over one's shoulder.

Yet there is more to Kitaj's figuration than his pious statements might indicate. Note that he slips the names of Brancusi and Mondrian into his list as if they were best known as figurative artists. In the same way, he introduces "nonobjective" rectangles at the center of his "Sorrows of Belgium" (1965), letting the war happen in the margins; or enunciates an entirely abstract Mondrianesque composition in "Chelsea Reach (First Version)" (1969), which is neither homage nor parody but merely Kitaj speaking in another voice— something he is always doing, but seldom so noticeably. One is reminded of late tonal works by Schönberg, such as the Suite for String Orchestra, in which he seems to be saying, "I can do that too when I feel like it."

But the spirit of abstraction as well as the letter has always been a foil for Kitaj's acute presentations of the figure. Johns, Rauschenberg and de Kooning are names he also cites admiringly. Gene Baro has pointed out that the work is "alive to contemporary ideas, to the problems that gave rise to Pop Art, to the protean quality of Abstract Expressionism." This has allowed Kitaj to introduce raw "literature" into his work, a practice that still shocks otherwise openminded critics, especially in the case of the silk-screen prints shown in 1970, some of which were merely reproductions of unadorned book covers (*Bub and Sis, Rimes No. 3*) from the library of a most eclectic bibliophile.

The all-over picture in which no element matters more than another, as proposed by the Abstract Expressionists and disconcertingly reformulated by the Pop artists, has perhaps helped Kitaj to come to certain conclusions about the surface of a picture. Sometimes he lets it take the form of a grid, as in the 1963 silkscreen "Photography and Philosophy," in which a row of photographs taken in 1941 of heads of Russian prisoners of war is balanced with a group of six portrait drawings. More important, it has helped him to develop a surface that is different every time, in which his figures have their being—a sort of magma or "scorched earth," like the hellish swamp in which fragmentary people, animals and objects float in "If Not, Not": a landscape not devoid of picturesqueness, but whose mountaintop in the background is crowned not with a castle but with the "gate of death" at Birkenau-Auschwitz. One whiffs an era's bad breath. This ground cannot be characterized, as it varies from picture to picture, but it is always there, even in the recent figure drawings, as a medium in which the figures can be most themselves. If it accomplishes this best by self-effacement, it does so; if, on the other hand, it can best serve the figure by overpowering it ("Ninth Street Under Snow" [1979]), it will do that too. What I have been saying is that at every key point, Kitaj seems to be occupying a place from which divergent paths rush off to different destinations. I have neglected to

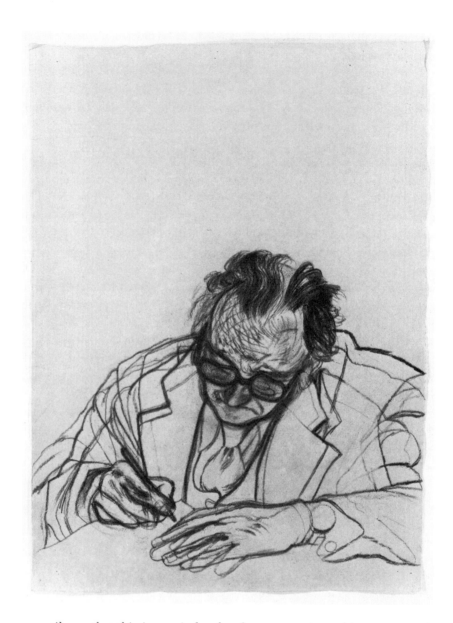

R. B. KITAJ
Poet Writing
(Robert Duncan)
(1982)

say until now that this is precisely what for me constitutes his greatness. As often as Kitaj the grouch proclaims the need for a narrow new approach to the figure, as often is he undercut by Kitaj the philosopher, the hedonist or any of the artist's other Mabuse-like disguises. A spirit of genuine contradiction, fertile in its implications, thrives in the work, though not in the discussions of it between Kitaj and his critics. ("I'm an old sea-dog. Some reviewers seem to choke on my awful personality.") Gene Baro enumerates further anomalies:

The way in which silhouettes become masses and masses become transparencies in some of his paintings is part of Kitaj's *stable world of change* [my italics—the oxymoron is the triggering mechanism of his work]. . . . Threats of disorder are contained to be exhibited; . . . disparities are stabilized, or at least can be seen arrested in instability; an act of synthesis has taken place, and a personal impulse has yielded an impersonal meaning (which the viewer translates once again for the self).

And then there is Kitaj's often quoted but ill-understood comment (he was discussing the silk-screen prints, but the statement has implications for all his work): "SOME BOOKS HAVE PICTURES AND SOME PICTURES HAVE BOOKS." Those who dismiss Kitaj for his "literary" qualities (actually one of his major and most daring innovations) have perhaps taken this to mean that the picture has a libretto, that it is in fact a kind of illustration after all. But to conclude this is to ignore Kitaj's passionate explorations of literature— twentieth-century literature and poetry in particular. Nowadays few painters are literary scholars and even fewer are "bookish" in Kitaj's jackdaw way (which allows Walter Benjamin to coexist on the same bookshelf with Bub and Sis). And those who are probably don't think of it as an ingredient of their art—painting, as we know, being merely areas of color arranged on a flat surface.

It wasn't always this way. The English aesthetician and art collector Richard Payne Knight expressed a general view current in the late eighteenth century when he wrote in his *Analytical Inquiry into the Principles of Taste* (1805):

The means . . . which sculpture and painting have of expressing the energies and affections of the mind are so much more limited, than those of poetry, that their comparative influence upon the passions is small; . . . and when more is attempted, it never approaches to that of poetry. The artist being not only confined to one point of time, but to the mere exterior expressions of feature and gesture.

Poetry can "put a girdle round the earth in forty minutes." Its stock of idea-images is endless, yet they are visible only to the mind's eye. For some, these are the highest categories of imagery, yet poetry will never have the weight and inevitability of painting or sculpture, limited though their scope may be by comparison. How wonderful it would be if a painter could unite the inexhaustibility of poetry with the concreteness of painting. Kitaj, I think, comes closer than any other contemporary, and he does so not because he is painting ideas, but because he is constantly scrutinizing all the chief indicators—

poetry, pictures, politics, sex, the attitudes of people he sees, and the auras of situations they bring with them—in an effort to decode the cryptogram of the world.

Of many examples I select one that is for me one of Kitaj's most haunting scenarios, the pastel "Study for the World's Body" (1974). Again a title from Kitaj's bookshelf intrudes—John Crowe Ransom's 1938 elaboration of "the new criticism" wherein, as in this picture, we are shown that "the object is perceptually or physically remarkable." What we see is a couple embracing in what is apparently an empty house: a light socket with no bulb hangs from the ceiling, a coathanger hangs from a nail in the bare wall. The uncurtained window admits light but frames no view; it is partially blocked by an ominous black rectangular shape whose position in space is ambiguous—is it standing next to the couple or behind them, against the window? They have just been disturbed, apparently; the man, who has his back to the viewer, is turning around to look at something that the woman, restraining him with a white hand on his shoulder, gazes at too. Perhaps there is danger; perhaps it was only a creak in the floorboards. The characters of both are sharply indicated—these are specific people, not allegorical lovers: the man's nose is long and pointed, yet his air of intellectual alertness renders him almost handsome. The woman's face is perhaps excessively round and broad, but her expression of delicate apprehension is beautiful too. They are an unforgettable modern couple—sophisticated to the point of paranoia, perhaps, but able to deal with the world which made them turn out this way; more than a match no doubt for the unnamed thing that has just entered their lives, yet vulnerable and touching, almost pathetic, in their strength. Beautiful because exemplary. One thinks of Auden's "A Bride in the 30's":

> Summoned by such a music from our time
> Such images to audience come
> As vanity cannot dispel nor bless;
> Hunger and love in their variations . . .

Such is Kitaj, the chronicler not of our "strange moment" but of how it feels to be living it.

Art in America, January 1982

FAIRFIELD PORTER

FOR YEARS CRITICS and artists alike bemoaned the fact that there has never been a major retrospective of the work of the late Fairfield Porter (1907–75). Part of the problem has been that Porter, one of the foremost realist painters of his time and the main influence on a generation of "painterly realists," simply doesn't look modern enough. Although he has passionate partisans among artists of every stripe—and was himself strongly drawn to the work of Willem de Kooning and other avant-garde contemporaries—he is also admired by solid citizens who "can't see anything" in modernism, which may be why curators have shied away from him. Porter is one of those innovators whose originality can come perilously close to seeming old-fashioned.

Now the situation has been remedied, and from an unexpected quarter.

Kenworth Moffett, curator of twentieth-century art at Boston's Museum of Fine Arts, has thoughtfully assembled a lavish show of Porter's work that at least enables us to see it whole. The irony is that Moffett is an ardent supporter of the "color field" abstraction that Porter detested and of its chief critical exponent, Clement Greenberg, who was one of Porter's *bêtes noires*.

No matter. This exhibition of Porter's airy, light-filled landscapes, interiors, portraits and still lifes is dazzling, a shocker—in the good sense—even to those who have followed Porter's work closely. It roars through the museum's handsome new Graham Gund Gallery like a mammoth blast of oxygen. And it should not only result in an updating of critical assumptions about Porter but give added impetus to the strong painterly-realist movement that is at present a dominant mode in contemporary art.

At times Moffett seems a little uncomfortable with his refractory charge and perhaps secretly wishes him an abstractionist. He is obviously distressed by Porter's oft-quoted statement that he became a figurative painter because he overheard Greenberg tell de Kooning that you could no longer be one. "He said, 'You can't paint this way nowadays,'" Porter once recalled. "And I thought: If that's what he says, I think I will do just exactly what he says I can't do. . . . I might have become an abstract painter except for that." If this is indeed true, then modern painting owes an even bigger debt to Greenberg than was previously imagined.

Porter was born to cultivated, affluent parents in the Chicago suburb of Winnetka. Summers were spent in the rambling summer house his father designed and built on Great Spruce Head Island, Maine, a house Porter loved and painted many times. At Harvard he came in contact with the enlightened, if conservative, art historians Arthur Pope and Kingsley Porter and, even more important, with the philosopher Alfred North Whitehead. He had already begun to paint (a tentative, Hopperesque watercolor of 1927 called "Cambridge Rooftops" is the earliest work in the show). But he did not begin working in earnest until more than two decades after that. He married the poet Anne Channing, got caught up in the intellectual ferment of the 1930s (he was active for several years in socialist politics) and was faced with the material problems of raising a family of five children. (His first son, John, suffered from an incurable nervous disorder that drained Porter to such an extent that it probably hampered his early development as a painter.)

Porter had already met the young Dutch émigré de Kooning and as early as 1934 had begun to collect his work. De Kooning, at that time a highly unorthodox figurative painter, was to remain, with the French intimist Vuillard, the major influence on Porter's work. In 1949 Porter moved his family from New

York City to Southampton, New York, an area that had begun to be "colonized" by painters like de Kooning, Pollock and Motherwell and the critic Harold Rosenberg. In 1951, thanks to de Kooning's influence, Porter had his first one-man exhibition in New York and, at forty-four, his career began in earnest, intensified by his encounters with contemporary painting as an art critic for *ArtNews* and then *The Nation.*

The works from the early 1950s are Impressionist in handling and subdued in color. These have an undeniable charm. But the drama of Porter's achievement is the slow conquest of a looser, broader handling and the storms of joyous color that erupt in his late work, which still takes place within the comfortable confines of life as he saw it around him daily: a farmhouse on the island in Maine; his young daughter Elizabeth dressed to go out in a stylish red coat; a brilliantly crisp "Ice Storm" painted during a winter when he taught at Amherst. In all these, his subject matter, as one critic put it, "does not appear sought after so much as simply happening to one."

The show does reveal occasional awkwardnesses, particularly in large figure paintings like "Iced Coffee," in which the apparent lack of interrelation among the figures gives the whole a somewhat creepy air. But Porter's devotees seem to prize these flaws, if such they are, and they have Porter's authority to do so. What he once wrote of the painter Jane Freilicher is also true of him: "When she has to choose between the life of the painting and the rules of construction, she decides to let the rules go." Certain irregularities are essential to a picture's "life": Porter once indignantly refused to remove a chance drip of pigment that bothered the purchaser of a picture, saying that to do so would be tantamount to "removing a mole from a beloved's face."

But any imperfections are overcome by the sustained passages of technical assurance, even bravura (a quality Porter disliked), that occur throughout the more than 140 works in the show, particularly in the later paintings. One of them, "Interior with a Dress Pattern," is a technical tour de force that has few parallels in his *oeuvre.* Here Porter seems to be looking over his shoulder at the pyrotechnics of Velázquez's "Meninas" and the complex spaces of de Hooch's Dutch interiors. Yet life goes on as usual in the big living room of the house on Great Spruce Head—one daughter is emerging from the kitchen while another tends the fire in the fireplace; assorted chairs join in games of perspective that no one would ever have noticed if the painter hadn't been there. The dress pattern of the title is the last thing you see, spread out on a table, a fragile, fluttering reminder of work to be done.

Porter once remarked that he preferred to paint air rather than space, and that is what he gives us: life-sustaining air, blazing with color and a sense of the

immediacy of experience. It is a vision we haven't been able to take in before this wonderful show arrived, and it argues strongly for a new assessment of Porter as perhaps the major American artist of this century.

Newsweek, January 24, 1983

A COMMON TOPIC of conversation among Fairfield Porter's friends was his youthful appearance. "I saw Fairfield the other day and he was looking five years younger than he did six months ago—it's *disgusting!*" one would say enviously. In the twenty-three years that I was privileged to be his friend he seemed to grow simultaneously younger and more mature, as did his painting. So the news of his sudden death on September 18, 1975, seemed even more than it usually does a ghastly, correctible error. He was someone for whom aging was a problem that simply never arose.

The *New York Times* obituary called him "a realist in an age of abstract art," but his position was both odder and less anomalous than that sounds. Though it isn't exactly true, as the *Times* also said, that he "tended to shun the art scene," he certainly felt free to select from what he found there, and the friends who came to his funeral reflected the diversity of his enthusiasms: Willem de Kooning and Esteban Vicente; Larry Rivers and Roy Lichtenstein; younger realists who had learned from him, such as Alex Katz, Jane Freilicher, Neil Welliver, Robert Dash, Rackstraw Downes; a number of poets, and, perhaps the majority, neighbors and townsfolk who knew him less as a painter than as a kind and concerned citizen. Somehow his place of residence was analogous to his position in contemporary painting: he moved his family from New York to Southampton in 1949, before the Hamptons became the artists' colony of today; and he lived not near the ocean nor the fashionable potato fields, but in a roomy, comfortable old house close to the town's main intersection. He was both contiguous to the art scene and a little apart from it, but never in the sense of shunning it: his friendships as well as his admirations in painting were selective and idiosyncratic.

This is perhaps the lesson of his painting too: that there are no rules for anything, no ideas in art, just objects and materials that combine, like people, in somewhat mysterious ways (in his book on Eakins he quotes the latter as saying that the painter "combines, never creates"); that we are left with our spontaneity and that life itself is a series of improvisations during the course of which it is possible to improve on oneself but never to the point where one

doesn't have to improvise. In a time when art has become pathetically dependent on dictums, dogmas and manifestos, he was a fierce defender of his right not to entertain them. Which isn't to say he couldn't himself be dogmatic in his refusal to buy the art historian's bill of goods: his unorthodox opinions were delivered with the most charming vehemence I have ever known, and frequently followed up with a fragmented giggle—not to undercut the sincerity of what he had just said, but in approval of his own successful delivery. In this way he was, for his friends, a marvelous guide through the mazes of art, and also of poetry, politics and science, on all of which he held strong opinions. Is Vuillard a greater painter than Cézanne, as Fairfield maintained? Perhaps, perhaps not; perhaps in one hundred years' time this opinion will have become the accepted one; perhaps also Fairfield's painting will have come to seem part of the mainstream of painting in our time rather than an attractive alternative to it. The point isn't whether or not his opinions were "true," but that he opened up ways in which one could arrive at one's own notions of aesthetic truth.

In the catalogue of his last exhibition at Hirschl & Adler, he wrote:

> It is better that the painter does not achieve a plan, and that the painting eludes him with the life of its own. The painting unfolds, gradually and with difficulty, and he doesn't know quite what it is even for quite a while after he stops painting it. Then it falls into place for him, or it doesn't; but for another person who looks at it, it may have a peculiar character right away. So far as it has merit, a painting is a fact, arbitrary and individual.

For his Promethean wresting of the arbitrary and individual back from the powers of dullness and for passing them on to those who knew him personally or through his work, we shall long be grateful.

Art in America, January 1976

I N HIS INTRODUCTION to Fairfield Porter's posthumous collection of art criticism, *Art in Its Own Terms*, Rackstraw Downes quotes a remark Fairfield Porter made around 1952, during what must have been one of the more Byzantine discussions at the Artists' Club on Eighth Street. The members were arguing about whether or not it was vain to sign your paintings. With the flustered lucidity of Alice in the courtroom, Porter sliced this particular Gordian knot once and for all: "If you are vain it is vain to sign your pictures and

vain not to sign them. If you are not vain it is not vain to sign them and not vain not to sign them." We do not know the reaction of his colleagues; quite possibly this *mise au net* fell on the same deaf ears that ignored the urgent but plain and unpalatable truths that Porter voiced again and again in his writings on art, at a time of particularly hysterical factionalism. No one likes to be reminded of the obvious, when half-truths are so much richer and more provocative; thus it was Porter's fate both as critic and as painter to play the role of a Molière gadfly, an Alceste or a Clitandre in a society of stentorian *précieuses ridicules*. And to a certain extent, his reputation as an eccentric remains, though it stemmed from a single-minded determination to speak the truth. Handsome is as handsome does; actions speak louder than words: who, in the course of the Artists' Club's tumultous sessions, could pause to listen to such drivel?

I hadn't known this statement of Porter's before reading Downes' preface, but somehow it caused all my memories of the man I knew well for more than twenty years (without, alas, pausing very often to look or listen well) to fall into place. Porter was, of course, only the latest of a series of brilliant know-nothings who at intervals have embodied the American genius, from Emerson and Thoreau to Whitman and Dickinson down to Wallace Stevens and Marianne Moore. Her title "In Distrust of Merits" could stand for all of them and her preference for winter over summer reminds me of Porter's saying in a letter to a friend: ". . . November after the leaves have fallen may be one of the best times of year on Long Island. That is, I like the way the trees don't block the light anymore." And I realized after such a long acquaintanceship that his paintings, which most people like but have difficulty talking about (are they modern enough? too French? too pleasant? hasn't this been done before?), are part of the intellectual fabric that underlay his opinions, his conversation, his poetry, his way of being. They are intellectual in the classic American tradition of the writers mentioned above because they have no ideas in them, that is, no ideas that can be separated from the rest. They *are* idea, or consciousness, or light, or whatever. Ideas surround them, but do not and cannot extrude themselves into the being of the art. Porter wrote of de Kooning: "His meaning is not that the paintings have Meaning. . . . The vacuum they leave behind them is a vacuum in accomplishment, in significance, and in genuineness," and, as so often, the critic's words apply to his own art as well.

Porter had a horror of "art as sociology," of the artist who "treats art as though it were raw material for a factory that produces a commodity called understanding." For art and that commodity are one, and art that illustrates an idea, however remotely or tangentially, has forfeited its claim to be considered art by introducing a fatal divisiveness into what can only be whole. "I can't be distracted from paying the closest possible attention to what I am doing by

evaluating it ahead of time," he wrote in a letter to the critic Claire Nicolas White. "What one pays attention to is what is real (I mean reality calls for one's attention) and reality is everything. It is not only the best part. It is not an essence. Everything includes the pigment as much as the canvas as much as the subject." Although Porter's work is in some ways the product of an idea—the idea that ideas have no place in art, or at any rate that they have no separate life of their own in art, no autonomy that might siphon off part of the "reality" of the ensemble—it is in accord, appearances to the contrary, with the seemingly more "advanced" work of the contemporaries he admired: de Kooning, Johns, Lichtenstein, Brice Marden, the music of Cage and Feldman—artists whose work at first seems worlds apart from the backyards and breakfast tables that were Porter's subjects but were only a part of "everything."

Even today there are admirers of Porter's painting who are bemused by his apparently wayward tastes in art, just as there are those who can't understand how Cage and Virgil Thomson can see anything in each other's music, forgetting how art submerges categories. "You can only buck generalities by attention to fact," Porter continued. "So aesthetics is what connects one to matters of fact. It is anti-ideal, it is materialistic. It implies no approval, but *respect* for things as they are." This last point seems hardest to digest for artists who believe that art is "raw material for a factory that produces a commodity called understanding." Thus, politically "concerned" artists continue to make pictures that illustrate the horrors of war, of man's inhumanity to man; feminist artists produce art in which woman is exalted, and imagine that they have accomplished a useful act; and no doubt there are a number of spectators who find it helpful to be reminded that there is room for improvement in the existing order of things. Yet beyond the narrow confines of the "subject" (only one of a number of equally important elements in the work of art, as Porter points out) the secret business of art gets done according to mysterious rules of its own. In this larger context ideology simply doesn't function as it is supposed to, when indeed it isn't directly threatening the work of art by trivializing it, and trivializing as well the importance of the ideas it seeks to dramatize.

For Porter, the enemy was "idealism," which was very close to something called "technology." As a citizen he was preoccupied—almost obsessed, in fact—with questions of ecology and politics, and politics of a most peculiar sort; he had been something of a Marxist in the 1930s but in later life his political pronouncements could veer from far left to extreme right without any apparent transition. And in conversation he could become almost violent on subjects like pesticides or fluoridation, to the extent that his friends would sometimes stifle giggles or groans, though one almost always had to agree with him, and the years since his death in 1975 have proved him even righter than he knew.

Nevertheless, this passionately idealistic man felt threatened by idealism. "Technology . . . has only to do with evaluation and usefulness. Technology is what threatens all life on this planet. It is idealism put into practice." If I understand him, it is not idealism that is dangerous, far from it, but idealism perverted and destroyed by being made "useful." Its uselessness is something holy, just like Porter's pictures, barren of messages and swept clean, in many cases, by the clean bare light of November, no longer masked by the romantic foliage.

In an earlier letter to Mrs. White, Porter complained about several sentences in an article she had written about him and submitted to him before publication. One was: "Since he does not like the white, misty summer light of the Hamptons he goes to an island in Maine in the summer." This nettled him because: "the fact is, we go to Maine in the summer because I have since I was six. It is my home more than any other place, and I belong there. . . . The white misty light would never be a reason for my doing anything." And no doubt the suggestion that he would travel to paint in a place where the light was better was inconceivable, since the whole point was to put down what was there wherever he happened to be, not with approval but with respect. "Subject matter must be normal in the sense that it does not appear sought after so much as simply happening to one," writes Louis Finkelstein in what is the best discussion I have ever seen of the technique and content of Porter's paintings. (Finkelstein is not giving a prescription here, merely characterizing Porter's "naturalness.")

Another sentence that Porter objected to in Mrs. White's article was this: "The Porters are quiet, intense and rather fey and seem to live on an enchanted planet of their own." He did not give a reason for his objection, and perhaps none was necessary. But Mrs. White could not really be blamed for her assessment; there was an element of truth in it despite the discomfort it caused Porter. His house in Southampton was an enchanting place: large and gracious but always a little messy and charmingly dilapidated. One of the bathrooms was more than dilapidated, while in an upstairs hall the wallpaper hung in festoons and no one seemed to mind. The children were strangely beautiful, wide-eyed, and withdrawn, and they spoke like adults. There were idiosyncratically chosen paintings by de Kooning, Larry Rivers, and Leon Hartl (a little-known artist whom Porter admired enormously) on the walls, along with Audubon and *ukiyo-e* prints and a strange Turner drawing; there was a lovely smell in the house, made up of good cooking, oil paint, books, and fresh air from the sea. All of which might lead one to see Porter as a homespun Intimist, a view that his trumpeted admiration for Vuillard would seem to reinforce. (Characteristically, he tended to prefer the late woolly Vuillards to the early ones everyone likes.) And it may be that Porter's unexplained objection to Mrs. White's "enchanted

planet" line was prompted by his unwillingness to have his work thus construed and thereby diminished.

For, the more one looks at them, the less the paintings seem celebrations of atmosphere and moments but, rather, strong, contentious and thorny. He painted his surroundings as they looked, and they happened to look cozy. But the coziness is deceiving. It reverberates in time the way the fumbled parlor-piano tunes in the "Alcotts" section of Ives' *Concord* Sonata do. The local color is transparent and porous, letting the dark light of space show through. The painting has the vehemence of abstraction, though it speaks another language.

In the same letter Porter quoted from memory a line of Wittgenstein that he felt central to his own view of aesthetics: "Every sentence is in order as it is." And he went on astonishingly to elaborate: "Order seems to come from searching for disorder, and awkwardness from searching for harmony or likeness, or the following of a system. The truest order is what you already find there, or that will be given if you don't try for it. When you arrange, you fail." I think it is in the light of statements like these that we must now look at Porter's painting, prepared to find the order that is already there, not the one that should be but the one that is.

From *Fairfield Porter (1907–1975):*
Realist Painter in an Age of Abstraction (1982)

VIII

ARCHITECTURE AND

ENVIRONMENTS

FRANK LLOYD WRIGHT

FRANK LLOYD WRIGHT was not only the greatest architect America has yet produced, but one of our greatest creators in any branch of the arts. Furthermore, he was, with Whitman, Jackson Pollock and a few others, an American genius who could only have been an American. For this reason we prize him.

But architecture, unlike poetry and painting, is a particularly fragile, vulnerable, and ephemeral art form. The greater the architect, the stronger the repressive forces that mean to see to it that his work lasts no longer than a generation at most. And Wright's work seems to have had a fatal magnetic attraction for the wrecker's ball.

In New York we tend to shrug off this situation and are even, sad to say, a little proud of it. New York never stands still but is constantly rising and falling—"a fountain of bricks and mortar," as E. M. Forster wrote of contempo-

rary London in *Howards End*. Our recently vanished architectural patrimony can fill a large volume like Nathan Silver's *Lost New York*. New Yorkers even feel a cautionary thrill at the thought of the evanescence of such monuments as McKim, Mead and White's Madison Square Presbyterian church, which stood for scarcely a dozen years before succumbing to progress. We feel a secret admiration, mixed with terror, for the giant who does things in such a big way, and we pride ourselves on scarcely noticing the gaps in the city's skyline that weren't there yesterday, for example the breezily modernistic Airlines Building on Forty-second Street that is now almost razed, and whose demise has, to my knowledge, elicited nary a sigh from the press.

That's New York, and, given the fact, we can be grateful that Wright built only one major building here. As it is, Wright's buildings haven't had an impressive survival record, even in Chicago, the city from which his work sprang and which has always been known for its encouragement and preservation of modern architecture.

These are thoughts prompted by a visit to "The Decorative Designs of Frank Lloyd Wright," now at New York University's Grey Gallery, for, without the high mortality rate of Wright's creations, the show could scarcely have been assembled at all. This is actually an assortment of flotsam and jetsam—of *inspired* flotsam and jetsam: plans and photographs, stained-glass windows, and fragments of masonry, with furniture, dishes and table linen from his interiors, *none* of which, we are told, has survived intact, while very few have been preserved to any considerable degree. A white cup and saucer, chastely ornamented with a band of geometrical red "confetti," are among the rare remaining objects from Wright's Midway Gardens, a vast but short-lived restaurant-and-entertainment complex built by him for Chicago in 1914. The cup and saucer seem as remote in time as a Pompeiian goblet. They belonged to the architect's son John, who wrote in his book *My Father Who Is on Earth:* "To me, all that marks the spot is a single white cup and saucer. . . . Dad designed it especially for the Gardens—I drew it—Shenango China made it. I love to drink from its lips."

The earliest piece in the show is a fretwork panel from the Harlan House in Chicago (1892, demolished 1963), whose abstract leaf pattern still shows the influence of Wright's master, Louis Sullivan: its striking, conceptual modernity is as yet tempered by a *fin-de-siècle* lushness. As Wright advanced into the period of his "prairie" houses, the designs, still based on natural forms, become more stylized and geometrical, as in the circa-1893 copper "weed holder" (Wright was very fond of weeds) or the two terra-cotta blocks from the Francis Apartments in Chicago (1895–1971). By the first decade of this century his genius for deriving essentials from nature, then reinventing them while sup-

pressing the inessentials, had resulted in masterpieces such as the Robie House in Chicago's Hyde Park section, whose dining-room table and chairs are on display in this exhibit (as always with Wright's dining-room furniture—he is said to have considered dining as something of a liturgical experience—they are impressive and a little forbidding), and in the beautiful but no less hieratic office furniture for the Larkin Building in Buffalo—another recent casualty. The armchair shown here as well as the photographs of the Larkin Building's interior suggests a working space dignified by vertical shafts of light and air.

Wright's next "period" began after a trip to Europe in 1909 and, for purposes of architectural historians, lasted until 1930. It included such major projects as the Midway Gardens and the also-demolished Imperial Hotel in Tokyo, razed only ten years ago, from which a few tantalizing fragments have been resurrected here: dishes with a lovely, spirited design of interlocking circles; a side chair; upholstery fabric dotted with circles that suggest flowers; a cream pitcher from a tea service that was Wright's only work in silver. Among the stained-glass windows which have been beautifully installed in the Grey Gallery's windows on Washington Square are three from the Avery Coonley House in Riverside, Illinois, including one from the children's "kindergarten" whose festive geometrical design suggests a parade.

In the 1950s, Wright designed furniture and fabrics for a mass market; the former were manufactured by Heritage-Henredon, the latter by Schumacher. These have a certain distinction, although one wonders if this may not be because we know that Wright signed them; in any case they are a distant echo of the early important work. The show also includes a number of objects by artists working in a spirit parallel to Wright's: Mackintosh, Josef Hoffman, Aalto, Mies van der Rohe.

Wright never conceived of decorative design as something separate from architecture: furniture, carpets, plants and on occasion even his clients' clothing and the landscape outside their windows were taken in hand by him to become part of the overall experience of living within his work. This exhibition, therefore, has a fragmentary character, since the objects in it can never be experienced as complete in themselves. By the same token it is an exciting experience because it does bring the architecture, through details that allude to and marvelously evoke the whole, within the confines of an art gallery.

New York, October 23, 1978

FANTASTIC ARCHITECTURE

CONTINUING THE VEIN of the fantastic that has dominated the art scene in Paris this fall, the Bibliothèque Nationale is showing the work of eighteenth-century "visionary architects": Ledoux, Boullée, Lequeu and others. They are sometimes called the "accursed architects," and apparently the curse endures even today, since this fascinating exhibition is being offered for barely three weeks without benefit of a catalogue, photos or other documentation.

Some idea of the work of these men can be gained from a statement by one of them, Marie-Joseph Peyre, to the effect that architecture "should inspire strong emotions, such as fear and terror." Peyre studied in Italy, where he fell under the spell of Piranesi's grandiose interpretations of Roman ruins, and Peyre's "Piranesian" book of designs called *Oeuvres d'Architecture* strongly influenced Ledoux and Boullée.

Ledoux is almost the only one of the visionary architects who occasionally had a chance to realize his projects. One can see vestiges of his work in Paris at the former tollgates at the Place Denfert-Rochereau, Place Stalingrad, Place de la Nation and the Parc Monceau.

His grandiose conceptions of what the ideal tollhouse should look like were modest in comparison with his plans, shown here, for a saltworks at Arc-et-Senans, near Besançon. Although only a small section was actually built, it remains the finest surviving example of his work. Nikolaus Pevsner defines it as "a perfect marriage of the classical and the romantic, attracted to one another by a shared worship of the elemental and primeval."

Ledoux was one of the first architects to be concerned about housing for workers, though it is not certain how the latter would have liked living in the spherical or pyramidal dwellings he designed for them. His plans for the Arc-et-Senans complex include a house for the surveyor of the Loue River in the form of a cylinder through which the river pours in a thundering cascade. Scarcely a humanitarian project, perhaps, but interesting as a distant anticipation of Falling Water, Frank Lloyd Wright's famous house built over a waterfall.

Ledoux's work seems a monument of eighteenth-century rationalism next to that of his contemporary Etienne-Louis Boullée, whose nightmarish projects mostly remained at the drawing-board stage. His plan for a cenotaph for Newton, shown here, is in the form of a hollow sphere about five hundred feet in diameter, the ceiling pierced with holes to give the illusion of stars. He favored horizontal terraces and colonnades which appear to be several miles long. His plans for overhauling the terrace at Saint-Germain-en-Laye are a masterpiece of agoraphobia, and his megalomaniac scheme for remodeling the Palace of Versailles would have intimidated even Louis XIV.

But the weirdest of this mad triumvirate of architects is certainly Lequeu, who was apparently addicted to the gothic novels of Horace Walpole and Mrs. Radcliffe. His beautiful watercolor drawings of palaces replete with sliding panels and secret passages are annotated with descriptions in his own hand. One is a clubhouse for some unknown secret society, with hair-raising trials by fire and water and a giant machine-operated statue.

In his more practical moments he too designed houses for the laboring classes, such as a "Turkish Pavilion" intended for a woodcutter and his family. But his masterpiece is a villa called the "Rendezvous de Bellevue," a wildly asymmetrical structure which is probably the finest example of Surrealist architecture ever imagined.

THE ARCHITECTURE OF Ledoux, Boullée and Lequeu seems to exist on a plane where the subconscious and the concrete mingle on equal terms. The recent

paintings of Marie-Laure explore the inner reaches of the dreams which these architects tried to encompass with stone and masonry. These paintings are like snapshots of the shifting imagery of dreams. Their shadowy depths always seem on the point of resolving into landscapes, figures or fantastic birds and animals. They epitomize moments of life as it is lived by someone sensitive both to physical appearances and to the layers of mystery behind them.

What dominates her work, however, is not this surrealistic imagery, fascinating as it is, but the haunting virtuosity with which it is rendered. Echoes of artists as diverse as Rembrandt, Carpaccio and Corot merge into a kind of medium, where effects of light, distance, transparency are all-important.

These effects are accentuated in the new paintings, such as "The Land-scape," a kind of natural bridge with transparent bands suggesting forests in the distance. Elsewhere promontories surge out of fantastic depths, as in "The Soul of Bronze," or pterodactyl-like forms cleave radiant space, as in "Aeration." In these and others, Marie-Laure emerges as one of the foremost painters of "imaginary reality" working today.

New York Herald Tribune (International Edition), December 1, 1964

PIRANESI AND MICHAUX

THIS YEAR MARKS the two-hundredth anniversary of the great engraver, antiquary and sometime architect Giovanni Battista Piranesi. It is being celebrated with considerable assiduity, as anniversaries go. There have been exhibitions at the National Gallery in Washington, the Hayward Gallery in London and the Cini Foundation in Venice, as well as the publication of a new and definitive study by John Wilton-Ely: *The Life and Mind of Giovanni Battista Piranesi*. Now the Morgan Library in New York has begun its fall season with a show of its collection of Piranesi drawings, the largest in the world.

Such an interest in the moody illustrator of Roman ruins and imaginary prisons would have been unlikely twenty or thirty years ago, when Piranesi was revered chiefly by interior decorators. Rare was the apartment-house lobby with aspirations to status that didn't have a Piranesi *veduta* or two framed against

dark-green walls above an urn of rhododendron leaves. Today he has been rescued from the limbo of chic, thanks to a new fascination with artists "born under Saturn" who might serve as ancestor figures for such twentieth-century artists of *malaise* as Henri Michaux, whose work is now being shown at the Guggenheim Museum.

Sir Kenneth Clark has called Piranesi "the first Fifth Columnist of the eighteenth century," and placed him with Goya, Fuseli and Blake as a precursor of Romanticism. He sees Piranesi's prison interiors, his most powerful and haunting works, as announcing the nightmarish qualities of industrial-revolution architecture, such as London's great railway stations, where:

> You must go up the stairs to obtain a permit, then take it over to one of those little round towers to be stamped; unfortunately this office is closed, and you are instructed to go up to the top gallery, but in doing so you have taken a wrong turning and have infringed the regulations, so you must come down and visit the office of the security officer.

Admirers of Piranesi's more saturnine side will be disappointed that the Morgan's collection of drawings contains so little material relating to the *carceri*, or prisons—only a hastily laid-down sketch in chalk and wash of a prison stairway, and a comparatively tame one at that, and a one-level vista of prison arches with some tiny, huddled figures. It is Piranesi's Roman views and his sketches for interior decoration, as well as his abbreviated career as an architect, that are chiefly documented here.

In view of his immense activity as an engraver, it has always been surprising to art historians that so few drawings by Piranesi have survived. Predictions that many more would eventually be discovered were partially fulfilled in the 1940s when Mrs. J. P. Morgan's collection of some 130 drawings became known. They were exhibited at the library in 1949 and donated to it in 1966 by Mrs. Morgan's sons.

The drawings reveal Piranesi as something more than a master orchestrator of perspectives and architectural forms. He was a mercurial draftsman as well, equally adept at suggesting the shimmering bulk of impossible wedding-cake palaces ("He piles palaces on bridges, and temples on palaces, and scales heaven with mountains of edifices," wrote Horace Walpole enviously) and at capturing the attitudes of the lowly bystanders who, in the engravings, give an exaggerated scale to the architecture.

One drawing, apparently done at the printer's while one of his engravings was being pulled, shows three different takes of a workman, whose attitudes, though dictated by the task at hand, nevertheless have the germ of something

awesome: one cringing pose in particular suggests a Blake or Fuseli demon swayed by a greater force.

Piranesi's feathery but incisive touch could ennoble anything from a design for a chimneypiece (included in the show is a letter from Lord Hamilton thanking him for one such design, with the mention that "chimneypieces are much used in my country") to the solemn emblems of the Order of Malta, which figure in his airily theatrical plan for redesigning the nave of San Giovanni in Laterano, a project that was never undertaken. (The collection also includes five drawings for his one realized project, the restoration of the church of Santa Maria del Priorato.)

With only a few examples of the melancholy Surrealism that it pleases us to discover in Piranesi today, the show is a revelation of Piranesi the instantaneous draftsman, and it points to the almost Impressionist origins of the deliberate engravings. The transition is difficult for a spectator to make, and indeed Piranesi's eighteenth-century biographer, Legrand, wrote that he "never produced finished sketches. . . . It is almost impossible to distinguish his thoughts on paper because it is nothing but a chaos from which he only extracted a few elements for his plate with consummate skill." And he quotes Piranesi as saying (which may explain why there are so few drawings), "Can't you see that if my drawing were finished my plate would become nothing more than a copy?"

THE FIGURES LURKING in the shadows of Piranesi's ruins have moved to the foreground in the work of the French writer and artist Henri Michaux, who seeks to chronicle "internal space" and the passing of time by recording merely movement and the traces of movement. A retrospective of his paintings and drawings from the 1920s to the present that originated at the Centre Georges Pompidou in Paris is at the Guggenheim.

Born in Belgium in 1899, Michaux was briefly connected with the Surrealist movement in Paris in the 1920s. He has traveled widely and chronicled both his terrestrial wanderings (most notably in the brilliant *A Barbarian in Asia*) and his cerebral ones (in such books as *The Space Within, Night Stirs* and *Life in the Folds*, titles which give a clue to the nature of his poetry).

He is also known as a predecessor of "psychedelic art," having taken mescaline in controlled experiments during the 1950s. A group of "mescaline drawings" — wiry grids of lines with a central furrow usually dividing the sheet vertically — are included in the show. They are both less exciting visually and less "*mescalinien*" — his term — than the more typical Michaux drawings: alphabets that resemble rows of figures and vice versa; featureless heads; shrouded "presences"; darkling plains where ignorant armies clash by night.

HENRI MICHAUX

Untitled, 1959

(1959)

Michaux's aim in painting and drawing is for "a continuum, a continuum like a murmur," which is realized in "pictograms, or rather pictographic coursings, but without rules. I want my tracings to be the very phrasing of life, but flexible, but deformable, sinuous." He seems much less at home with oils and acrylics than with India ink and wash, which allow him the continual surging-and-dissolving movement that his poems record. He is first of all a writer, but the pictures can be taken as an illustration, though not an essential one, of his strangely subterranean poetry. Like Piranesi's, Michaux's art is, to quote Octavio Paz, "a testimonial to the unreality of every sort of realism."

New York, September 25, 1978

"VISIONARY DRAWINGS OF

ARCHITECTURE AND PLANNING"

"As one of my college professors said, 'many have visions but only a few are able to depict them,'" wrote the architect Eric Mendelsohn. Perhaps, but judging from "Visionary Drawings of Architecture and Planning" at the Drawing Center in New York, the talent for depicting their visions comes naturally to architects, and notably to Mendelsohn himself.

The show has been directed with genius by the Columbia University architecture historian George R. Collins, whose task was complicated by the ephemeral nature of such drawings: it has never been the custom to preserve them. What we have is a broad and sometimes riotous selection of plans, sketches and renderings by twentieth-century "visionaries." Mr. Collins himself has trouble defining the term, and I am certainly not going to try, beyond noting that visionary or "paper" architecture has been produced by architects

who never built a building (Hugh Ferriss), or who built only one (Antonio Sant'Elia), or who left behind a substantial legacy of built architecture (Wright, Le Corbusier and many others in the show).

Some of these drawings can be appreciated for their aesthetic qualities, though more are highly technical and difficult for a layman to construe or to misread as art. Even so, just as we can sometimes intuit genius in a poem in a language we don't understand, the record of a moment of intensity is almost always there.

Although all artists are visionaries in some sense, architects are perhaps the most radically visionary, since their aim is to alter the world and our lives. They are, as Ada Louise Huxtable wrote of those in this show, "benevolent despots," though I did wonder a bit about the benevolence in certain cases. One was the German Expressionist architect Hermann Finsterlin, whom Robert Rosenblum calls "the Walt Disney of visionary architects." His sketch for a cathedral looks as though two UFOs had collided and fallen into a volcano. Nor was I cut out for the salubrious life in the "Cité Industrielle" of Tony Garnier, whose drawings could not be obtained for this show but who is the subject of an exhibition elsewhere. Yet the visionaries are mostly concerned with our welfare, which is perhaps why we tend to refer to them familiarly as Mies, Bucky, or Corbu.

Mr. Collins points out that visionary architecture, while ahead of its time, is not always pure fantasy, and cites Mies van der Rohe's 1922 glass skyscraper as an example of a project that was technically unfeasible in its day but became practicable later on when technology had caught up with the architect's vision. Still, it's going to be a long time before we get to see the realization of some of the more recent and woollier projects, such as Henry Hollein's skyscraper in the form of a spark plug or Michael David Webb's playful "Cushicle Suitaloon."

Actually, the fantastic is already present in Charles R. Lamb's turn-of-the-century visions of a future megalopolis of colossal skyscrapers interconnected by streets high in the air: beautifully and touchingly rendered by Lamb and by his friend Vernon Howe Bailey, they are straight out of the dreams of Little Nemo. The fantastic emerges again in the pre-World War I drawings of the short-lived Sant'Elia, who has been posthumously linked to the Futurist movement and who seems a latter-day Piranesi, intoxicated with the charm of titanic electric-power stations and stepped-back skyscrapers.

The Expressionist phase in Germany, in Collins' words, "derived, ambiguously, from both the optimism and despair that marked the years 1918–23." It resulted in Finsterlin's unlikely structures and in the apocalyptic visions of Hans Scharoun, who, after World War II, saw the realization of major designs such as the Berlin Philharmonic Concert Hall.

Beside the frankly Surreal projects are others which seem even more fantastic because they could conceivably be built and in some cases are closely related to work that has been realized. These include Paolo Soleri's sketches for arcologies, or urban habitats, in the Arizona desert, Wright's "Usonian" Auerbach house and Richard Neutra's futuristic but homey Rush City. And there are also the beautiful if enigmatic sketches of Mendelsohn, one of which slightly suggests his famous Einstein Tower in Potsdam.

New York, February 12, 1979

ALDO ROSSI

Drawings by Aldo Rossi, one of Europe's most original and controversial architects, are being exhibited at the Max Protech Gallery and the Institute for Architecture and Urban Studies in New York. These drawings, or sketches, really, are not renderings or footnotes to Rossi's built projects. As Peter Eisenman says in his introduction to the catalogue (*Aldo Rossi in America: 1976 to 1979*): "Rossi's drawings are not merely drawings 'of' architecture, nor are they to be taken as metaphors 'of' architecture, they are architecture. They do not demand to be built."

If drawings can be equated with architecture, then architecture itself must be something quite different from what we commonly take it to be, and that is precisely what Rossi is proposing. For him architecture is "construction," and construction itself is a broad heading that covers many kinds of activity. For

instance, it is somewhat like the act of writing, and Rossi says he has "always been struck by the fact that great works like *War and Peace* . . . were written in longhand. The manuscripts themselves, as objects, as works, are descriptions and frescoes of a society, laden with the same physical fatigue as the ceiling of the Sistine Chapel." Or construction might be cinema: Rossi has claimed to be tiring of architecture and ready to try "other techniques" such as filmmaking or painting. The word "technique" is important here. These two branches of the arts, as well as architecture itself, are for him merely ways of doing *something;* none is more valid than another.

In the same way Rossi sees the city itself as a model for the architect's activity. Not the utopian concept of an urban planner but the city as it is continuously coming into being—a concept perpetually modified by the exigencies of everyday reality, where what is unbuilt or incomplete has a function no less important than what is actually there, as part of a never completely visible or measurable totality. For the city, at any rate the "analogous" city of Rossi's sketches, is both physical and metaphysical, a set of imperfectly realized concepts and a physical plant which evolves through misuse or misunderstanding. (A paradigm of his city would be the Yugoslavian seaport of Split, constructed out of the ruins of Diocletian's vast palace, which finds a contemporary analogue in SoHo warehouses recycled as artists' living space.) Architecture, in Rossi's broad sense, is conceived by the eye and seen by the mind. Thus, for him and for other members of the group Tendenza, or Tendency, it is a question of supplanting the narrow functionalism of the glass box with a superior rationalism which must take account of the irrational as well.

Rossi's work has engendered a formidable critical literature, much of it difficult, some of it merely silly (such as this comparatively lucid passage from a recent monograph by Francesco Moschini: "Rossi distorts the cynical razings of Man Ray into tragic and shrewd solidarity between the parts over which hang the ghost of murder, disorder, necessity to survive a situation of supreme indifference and total alienation"). But since Rossi made the drawings precisely to compensate for the shortcomings of theoretical writing, one should probably proceed directly to their visible evidence in order to find out what the work "says."

The sketches, as opposed to the projects for architecture built and unbuilt, are bold and whimsical, sometimes suggesting a collaboration between de Chirico and Saul Steinberg. And Steinberg's famous New Yorker's-eye view of the map of the United States is an example of the kind of perception that Rossi assumes in our intuiting of a concept such as "the city." Among the many leitmotivs that circulate throughout his repertory of drawings is a colossal coffeepot that turns adjacent skyscrapers into objects in a domestic still life, an

example of how he brings abstract feelings into focus through mundane imagery. Some of the motifs are less scrutable: the striped beach cabanas, each with a triangular pediment pierced with a round aperture; the statues of saints whose hands dominate the sky over parts of the city, imposing their own notion of monumentality; the smokestack blocking a perspective; the enigmatic "poet's windows in New York." But it isn't necessary to interpret these elements in order to seize the equation that they form: the "analogous city," which, in Rossi's words, is "a natural development of the idea of the architecture of the city."

One has to keep the unseen dimensions of the architecture in mind when considering the built projects, such as an elementary school in the town of Fagno Olona. This murderously symmetrical hangar set on a flat, stubbly field would make an Agway complex look cheerful by comparison, and at first glance seems designed solely to stunt the spiritual growth of the kiddies forced to attend it (this is belied by photographs which show a group of remarkably well-adjusted and radiant children enjoying the facility). Or a project for a student center in Trieste that looks like a set for the film *Big House.*

It's as though Rossi had gone a drastic step farther than American architects such as Venturi and Rauch who have rehabilitated much that was previously ignored as "vernacular." He has purged his work even of their sparing anecdotalism to create buildings that look devoid of visible charm or *agrément*, but that for this very reason function as the concrete basis of the partly imaginary proposition that all architecture is.

New York, October 15, 1979

SARAH WINCHESTER'S

LLANDA VILLA

THE ECCENTRIC, rambling mansion built by Sarah Winchester stands amid the sun-drenched gloom of a commercial strip on the outskirts of San Jose, California. Hemmed in by a shopping mall, movie theaters, and Mexican restaurants, it has itself become a tourist attraction, though when construction began in the 1880s it stood in open country and was soon surrounded by towering hedges that shielded it from public view. Ironically its popularity with tourists has obscured its importance as an architectural monument. Among my Bay Area acquaintances who are architecture enthusiasts, I found very few who had ever been to see it (two notable exceptions are the poet Robert Duncan and his friend the painter Jess). Most had long ago written it off as an *attrape-nigaud* for large families in Winnebagos, a sort of pre-Disney Disneyland. Yet, by a further twist of fate, this reputation has undoubtedly saved it from the wrecker's

ball or worse. A crumbling near-ruin in the early 1970s, the house is now maintained by a private group of investors that oversees both its exploitation and its (for the most part) thoughtful restoration.

Unfortunately exploitation has brought with it embellishments such as a "museum" displaying waxworks and collections of Winchester rifles, a large souvenir store that dispenses T-shirts and tote bags with the Winchester Mystery House logo, and a snack bar dubbed Sarah's Café. Horrified as she might justifiably have been by these posthumous additions, Mrs. Winchester might also have appreciated the respect shown by the restorers, who have gone so far as to leave unfinished parts of the house which may well have been intended to remain that way. And, all in all, she might be glad that her labyrinthine palace, which was seen by very few people in her lifetime (even Teddy Roosevelt was refused admittance when he came calling unexpectedly), is now giving pleasure to so many people.

Sarah Pardee was born in New Haven, Connecticut, in 1840; at eighteen she married William Wirt Winchester, whose father manufactured the repeating rifle that helped "win the West." Obsessed by the death of an infant daughter and by the premature death of her husband a few years later, she concluded that the ghosts of victims of the rifle, Indians in particular, were out to get her. Her fears were confirmed by a medium in Boston, who told her she would be safe only if she undertook to build a house on which work would continue eternally, night and day, in which case she could expect to live forever. Such a project was not beyond her means in 1882, when she disposed of a fortune of $20 million and a tax-free income of $1,000 a day. Accordingly she transplanted herself from Connecticut to the Santa Clara Valley — it is not known why she chose this particular location — and began remodeling an existing eight-room farmhouse, a project that would last until her death in 1922 finally stilled the continual noise of the hammers.

Since no one really knows why Llanda Villa, as she named it, was built as it was, one is forced to rely on tabloid articles distributed at the house. Sarah Winchester, the story goes, wanted to keep out nasty spirits but encourage friendly ones, and made a number of overtures toward the latter. Among these were the suppression of mirrors in the house (only two in the 160-odd rooms); a "séance room" reached through a secret door in a cupboard, where apparently the friendlier spirits gave her nightly advice on how to proceed with the building; and a belfry whose tolling bell reminded them when to appear and depart. Many of the odder devices are explained by the guides as booby traps meant to confuse evil spirits. These include certain doors too small for anyone but the proprietress (who was four feet ten); others with bars across them to trip up the ghosts; stairs with risers only two inches tall, which mount to nowhere

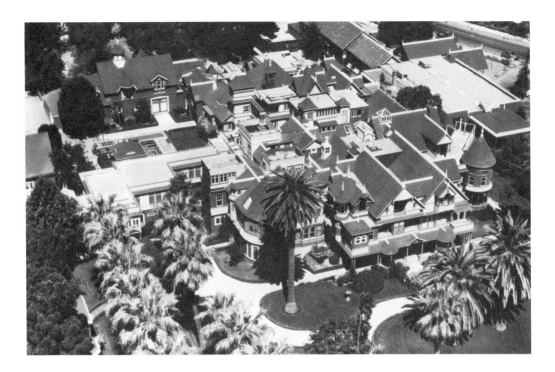

and then descend; and another stairway which rises to a ceiling and ends there. Surely the spirits weren't all that dumb, however, and Sarah, who by some accounts was a sensitive and cultivated person, fluent in four languages, must have suspected this. A more commonsense explanation of the low-rising stairs is the severe arthritis from which she suffered, which made climbing stairs painful (the house also boasts three elevators, one rising but ten feet). This would account also for the accumulation of fireplaces and hot-air registers in a room dubbed the Hall of Fires by the management, since the dry heat there no doubt brought her some relief.

The house seems to have gone unnoticed by architecture historians except for Susana Torre in her *Women in Architecture*. Ms. Torre makes a laudable attempt to demystify the house and its designer, suggesting for example that the dead-end stairs were eventually destined to lead to rooms for nieces who never came to visit. But she offers no more evidence for her assertions than the promoters of the house do for theirs, and in the absence of any testimony from Mrs. Winchester it is unlikely that we shall ever know what she had in mind. Like the character Orlando in William S. Wilson's novel *Birthplace*, Sarah could have said of herself: "I feel that I belong to a secret society of one, and that the secret is all too safe with me."

Meanwhile, paradoxes abound in the house as it survives today. (At one

time there may have been as many as 750 rooms: since the workmen had to be kept busy, destruction, or perhaps de-construction, was as important an activity as building.) Columns are installed upside down, perhaps to befuddle further those easily confused evil spirits. Accretions of thirteen occur throughout: thirteen steps here, thirteen palms lining the driveway, thirteen skylights in the greenhouse, and so forth. But at least in the case of a sink drain with thirteen drainage holes arranged in the form of a daisy, Mrs. Winchester could have satisfied her penchant for symbolism at the local hardware store, since the drain was a common model frequently found in homes of the period.

Today the highest point of the house is an observation tower four stories high. But old photographs show a forest of minaretlike towers, some as many as seven stories high. This was before the 1906 earthquake, which did extensive damage to the mansion and apparently caused Mrs. Winchester, who was trapped by debris in one of the bedrooms for several hours, to rethink her construction plans. We are told that she viewed the earthquake as a personal admonition from the good spirits, angry that too much money was being lavished on the front of the house. On the other hand, it is possible that having realized the site's potential for earthquakes, she altered her project accordingly. At any rate, she sealed off the elaborate front door with its Tiffany panels and devoted her energies to expanding the back, prudently directing this stage of building from a houseboat anchored in San Francisco Bay.

The maze as it stands today (viewed from the air, it looks like a late-Victorian village) seems a purposeful hodgepodge. One visitor described his tour of the place as "like wandering through the corridors of a schizophrenic mind." This is perhaps true of some of the gloomier parts, where windows give directly on walls, and doors open on cupboards barely an inch in depth. But elsewhere there is a strange joie de vivre: in the conservatory, for instance, with its ingenious devices for watering plants and recycling the water for the garden; in the "grand ballroom," with its dazzling marquetry and daisy-patterned stained-glass windows set with "mysterious" quotations from Shakespeare. One of the pleasantest, brightest spots is the back door of the original farmhouse, through which one perceives an airy vista of cozy and quite ordinary domestic interiors; any weirdness is the result of their random, seemingly effortless proliferation.

It is too bad that Robert Harbison didn't include the Winchester house in his marvelous book *Eccentric Spaces*, for it certainly belongs there. But his remarks on the space in paintings by the late-Baroque painter Francesco Solimena precisely evoke the mansion's air of lugubrious comedy. "For a number of reasons it is almost impossible to remember afterward what the subject of a Solimena is," he writes. "It is almost impossible to remember this

when one is standing in front of it. They are indecipherable not because they are so crowded . . . but because they are deliberately decentralized and unfocused." The impossibility of orienting oneself in the Winchester house is, improbably, part of the charm. Another element is the lack of strong color. Such notes of it as there are come mostly from the exotic woods buffed to a steely glitter and combined in elaborate marquetry patterns whose effect is often one of simplicity, like the herringbone-paneled walls of the ballroom — run-of-the-mill Victorian board-and-batten gone sybaritic and slightly berserk. The impression one retains is of a strong absence of color, or a color like that of ectoplasm: even the Tiffany windows are mostly restrained and pale, while certain other windows made of large sheets of Belgian optical glass slightly magnify the palms and shrubbery outside and draw into the rooms what can only be described as an intense pallor.

The exterior of the house is now painted a rather stifling combination of olive green, ocher and tan (Victorian colors, the guide assures one). Perhaps the colors chosen by Mrs. Winchester were similarly turgid. In any case the multiplication of forms, stately at first but increasingly frenzied as one circles the house, upstages the paint job. The front facade is close to traditional Queen Anne and to the isosceles fronts of San Francisco with their "Palladian" and bull's-eye windows, their balconies and oriels for surveying the scene below. The two main gables overlap slightly, and this perhaps accidental "mating" produces strange progeny: two large turrets on either side and between them a jumble of minarets and belvederes whose inspiration seems by turns Hindu or Greek or a combination of both. Behind these the profusion of towers, skylights and ridgepoles, all without apparent aesthetic or functional *raison d'être*, is staggering. The grandiosity of "paper buildings" like Brueghel's Tower of Babel, Boullée's funerary temples, Piranesi's prisons, or Sant'Elia's Futurist power stations has been realized, and by an amateur, a fanatically motivated little lady from New Haven whose dream palace was crafted with Yankee ingenuity.

Some have suggested that the incongruities of the house are due to Sarah's ineptitude as an architect. How else account for skylights built where the light of the sun would never strike them; for doors that open on blank walls or a sheer drop; for a chimney, connected to several fireplaces, that rises four stories and stops just inches short of the roof? Perhaps. But in my opinion neither the ghostbuster nor the hopeless-amateur theory can account for the house: one senses immediately on entering it that Sarah Winchester, with all her peculiarities, was an artist. For her house is an enchantment, and that could be exactly what she intended all along.

House and Garden, March 1987

ENVIRONMENTAL ART

Environmental art has been with us for a long time, perhaps since antiquity. At the moment in New York, it seems to be about all there is to look at. From the Met's new installation of the Temple of Dendur, to Oldenburg's Mouse Museum at the Whitney, to Anne and Patrick Poirier's miniature ruined city of Ausée at the Modern, and so on downtown, everything, with the possible exception of the environment itself, is suddenly an environment.

This is partly due to the way New York is set up: the weird boxed and numbered space we live in is already fantasy. Artists have only to start with what's there and give it a few fillips for the truly fantastic to emerge, and then it is sometimes almost invisible against the city's protective coloration. Some years ago, Oldenburg designed a series of satirical projects for monuments, among them a colossal sculpture of an ironing board to be erected on the Lower East

Side. Such is the blasé assimilating power of New York that it would probably have attracted attention only for a week or two if built, and then achieved semi-invisible status as a tourist attraction.

That's more or less what has happened to Ned Smyth's "Arcades," which has been on view at the Hammarskjöld Plaza sculpture garden. At first glance these rows of masonry arches and columns with capitals in the form of stylized palm fronds look like a perfectly normal extension of Manhattan's peculiar décor, such as the needle of the Chrysler Building, which everybody accepts unthinkingly. On closer inspection the slight irregularities in the "Arcades" become apparent: the number of columns or arches in each section varies slightly; there are anomalies, too, in the way the elements echo one another without actual repetition. On even closer inspection, the oddities recede into the background and end up seeming more natural than the pedestrians using the park or the traffic on Second Avenue.

That is the risk that "environmental" work runs in New York: it has tremendous competition from nature, or what passes for it. Much public outdoor art can't stand up to the city. Wherever the developers have been forced to leave an empty space, somebody has thoughtfully tucked in a vest-pocket park with a Nevelson, a Noguchi fountain, a colossal Picasso head, hoping in this way to alleviate the insane visual congestion and cause us to think beautiful thoughts. But this sort of "humane" environmental art usually misses its mark because we aren't the potentially well-adjusted cliff dwellers whose daily lives could be redeemed by it, and we know it. A Le Corbusier space full of light, air, primary colors and straight lines torments us with the specter of the normal people who might be able to thrive in it; a Zen garden reproaches us with the vision of a spiritual concentration we know we'll never attain.

PERHAPS IN RESPONSE to this dilemma, recent environmental work has moved away from humanist visions to the dark, private, neurotic ones that most of us, unfortunately, feel more at home with. "Architectural Analogues," at the downtown Whitney, calls itself an exhibition of recent sculpture but is actually a bunch of artists telling us their nightmares about space—not "space" as a requisite plastic ingredient in sculpture but the inner kind.

None of these sculptures is intended to improve your mental health, and some may be hazardous to it. Alice Aycock, whose carpentered whodunit "Untitled (Shanty)" is currently on view at the uptown Whitney, is represented in the downtown show by a photodocumentation of a "Building with Dirt Roof"—a structure designed to induce spasms of suffocation and claustrophobia. Jackie Ferrara's "Mantel Structure" suggests a staircase inside a chimney

but these gothic overtones are subtly erased by the patient, arduous craftsmanship. Jared Bark's "Cold Light House" is a Mylar-draped house the size of a tourist cabin; in the green phosphorescent light inside you can see your shadow on the wall after you have moved away from the spot, thanks to a phenomenon of physics ill understood by me but carefully explained by the artist in an accompanying text.

More subtly angst-producing is Donna Dennis' cell-like monument, "Subway Station with Blue and Yellow." She has caught the look of our local architecture that was built only because it had to be and doesn't expect to be looked at. Unfortunately, we do have to look at it, which causes a sort of bond of mutual embarrassment to spring up between us and it. This painful and curiously personal relationship is beautifully isolated in Ms. Dennis' ghastly construction.

For some reason women seem particularly drawn to large-scale architectural follies (other examples here are a photodocumentation of an inscrutable "Sunken Pool," by Mary Miss, and a large fired-clay maquette of a mosque by Katherine Sokolnikoff). The men are often miniaturists, as is the case here with Siah Armajani, Michael Hurson, Joel Shapiro and Ira Joel Haber. An exception is Rafael Ferrer's painted carnival tent called "Sahara La Vida Secreta," in whose depths a sinister "reader and advisor" no doubt waits.

ANOTHER LARGE and puzzling environment has been created at the Hamilton Gallery by Louise Bourgeois, the French-born sculptress who now, in her late sixties, is finally being acclaimed as a major artist. "Confrontation" is a sort of wooden Stonehenge: painted boxes or crates grouped around a large oval space which contains a strange "altar" heaped with ceramic or plastic objects resembling breasts and other parts of the body that never got off the drawing board. A sort of enclosed garden, meant to be contemplated but not necessarily enjoyed.

A highly recommended recent book called *Eccentric Spaces*, by Robert Harbison, traces the background in nature, art and literature that informs much of this recent work. Contrasting art and nature, the author points out in his foreword that "art is troublesome not because it is not delightful, but because it is not more delightful: We accustom ourselves to the failure of gardens to make our lives as paradisal as their prospects." In the gap between what formal spaces such as gardens are supposed to do and what they actually do, work like that of Ms. Bourgeois can flourish—troublesome because it isn't even more delightful.

CLAES OLDENBURG'S Mouse Museum is a structure roughly the shape of Mickey Mouse's head (with two circular "wings" where the ears are), designed by the artist to contain his large collection of proto-Pop ephemera: counterfeit objects found in joke shops and trash cans, such as plastic bananas, hamburgers, ice cream sodas, etc., and ranging through articles of clothing and parts of the body, including the reproductive organs, to what The Firesign Theater calls "little plastic doody-bricks from Outer Space." Many of these have long since taken their place in the artist's pantheon of viable forms: the clothespin, the cigarette butt, Mickey himself, whose "head" Oldenburg has raided time and again for motifs.

Adjacent to the Mouse Museum is Oldenburg's Ray Gun Wing, housing a definitive collection of Buck Rogers-type ray guns and objects whose shape vaguely suggests them—bits of driftwood or squashed tin cans. The "wing" itself is, of course, in the shape of a ray gun.

This repertory of found objects is useful if you are a student of Oldenburg's work. It shows you how carefully and selectively he has set about establishing the Pop iconography for which he is famous. And the distance between the raw objects and his transformations of them reminds us once more of the consummate draftsman and stylist that Oldenburg is. It is possible that the way we and our environment look may one day be known chiefly through his characterizations.

Still, the Mouse Museum isn't meant to be that serious, and it isn't. Stepping inside is, once again, to fall into a gap—the abyss separating the real from the bogus, which fools no one but is nevertheless a source of strong, slightly illicit pleasure.

AS AN ANTIDOTE to these claustrophobic spaces, try Cass Gilbert's 1907 Beaux-Arts confection, the U.S. Custom House at the Battery, currently housing "Echoes of the Drums," a selection of some five hundred artifacts from the Museum of the American Indian. The centerpiece is Sitting Bull's square drum, with attached buffalo horns, which looks as though Klee had helped stretch it.

New York, October 16, 1978

SIAH ARMAJANI

ONE OF THE more visible trends in recent avant-garde art has been architec-
ture as sculpture or, if you wish, sculpture as architecture. Curiously, no
critical label has as yet attached itself to this school, though one of its leading
practitioners, Siah Armajani, calls his own work "architecture/sculpture"—a
serviceable if not exactly exciting definition.

 While many of the architect/sculptors are women—Alice Aycock, Ursula
von Rydingsvard, Donna Dennis, Jackie Ferrara, Alice Adams among them—it
is Minnesota-based Armajani, a forty-three-year-old transplanted Iranian, who
seems to be currently emerging as a front runner. At the moment he has work in
three trend-monitoring shows on the East Coast—"Directions 1983" at the
Hirshhorn Museum in Washington, D.C.; "Connections" at the University of
Pennsylvania's Institute of Contemporary Art in Philadelphia; and "Habitats" at

New York City's "alternative space" gallery, the Clocktower. At the same time he has a one-man show at New York's Max Protetch Gallery (a clearinghouse for architecture/sculpture) that, along with the new pieces on display in Washington, significantly deepens his already challenging work of the past decade.

Armajani first gained wide attention in 1978 when he built a small house, entitled "Lissitzky's Neighborhood," on the floor of the rotunda of the Guggenheim Museum in New York as part of its "Young American Artists" show. Since then his structures, which often suggest covered bridges or spartan office interiors built of unpainted wood, corrugated metal and Plexiglas, have become a familiar feature of other "new talent" group exhibitions. Their alienating perspectives, windowless inner spaces, gloomy prefab materials and frustrating design (stairs that lead nowhere, windows opening on walls) exude a vague sense of menace.

That's not the idea, though. When asked about the seeming inhospitableness of his sculptures, he replied matter-of-factly, "Then I've failed"—as though the idea had occurred to him before and been quickly dismissed. In fact, he views his work as the décor of a utopian democratic landscape, founded on principles formulated by Tom Paine and Jefferson, Emerson and Thoreau, Whitman and Robert Frost. Maxims from these writers are sometimes emblazoned on his works, as they used to be carved in library mantelpieces at the turn of the century. One, from the writings of John Dewey, perhaps sums up Armajani's philosophy: "As long as art is the beauty parlor of civilization, neither art nor civilization is secure."

Reexamined in this light, Armajani's art takes on new dimensions and even radiates a certain joy. For its actual appearance is only a secondary aspect; the main one is the associations touched off in the viewer as he negotiates new and secret spaces. The reverie that sometimes overtakes us as we absentmindedly contemplate a storm window or a partly open garage door becomes lyrical as orchestrated by Armajani. Unlike many artists who attempt "public" sculpture, he has remembered that the public is made up of individual private persons and has left messages for them throughout his open and monumental constructions.

Armajani's new work is exciting because he has dared to advance beyond the austerity of the earlier "bridges" and "houses" that made his reputation, with their rectilinearity, reticence, low-tech construction and typical red-black-white color scheme alluding to Russian constructivist graphics. The new pieces, from a "dictionary for architecture" that Armajani has been compiling in his head, inspired by encounters with the native-vernacular architecture of his Minnesota, are just as intransigent, perhaps even more so. Yet they employ surprisingly subtle arrangements of color and texture, even a trompe-l'oeil

picturesqueness in "Window in Window," where etched-glass panels cast the shadow of dining-room furniture on the wall behind, as though the room had been turned inside out.

"Fireplace Mantel with Window" is ornamented with a mysterious couplet from Frost that can be construed only by walking behind it. Its varnished raw-wood surfaces evoke the elbow grease a subscriber to *Popular Mechanics* might have put into fabricating his *chef-d'oeuvre*, while a cupboard door fastened permanently shut by hinges suggests that he might well have to go back to the drawing board. In "Garden Gate," one wing of a tall, narrow double door is held shut behind a fence of red palings. The other is wedged open by a chair. The colors, like those of building blocks, are both serious and lighthearted; the whole distills a strong sense of a specific place (or "address," to use his term).

For Armajani, who came to America in 1960 to study at Macalester College in St. Paul and has remained in Minnesota ever since, becoming a U.S. citizen in 1967, the Midwest, with its plain folks, plain buildings and plains, is of prime importance. At the moment he is excited over a new commission for a bandstand in Mitchell, South Dakota. Improbable as it seems, this man from the East is explicating the aesthetic message of Middle America to its people and doing so in work of dazzling originality and inventiveness.

Newsweek, April 4, 1983

ROBERT WILSON'S DRAWINGS

I T'S TOO BAD THAT some of today's most exciting and ambitious avant-garde art has become so expensive to produce that only a fortunate few ever get to see it. Such is the case with Robert Wilson, who is becoming famous for being famous in countries other than his own. Since 1976, when *Einstein on the Beach*, the opera he collaborated on with Philip Glass, was given a few performances at the Metropolitan Opera in New York, he has had only a couple of his small-scale works done in America, while Europe has seen his epic *Death Destruction and Detroit* and the complete version of *Edison*. His work can now be glimpsed outside New York City at the Neuberger Museum at the State University of New York in Purchase.

Those who have been seduced and dazzled by Wilson's plays find it hard to convey their enthusiasm to others. "The actors hardly move . . . hardly any-

thing happens . . . it went on for twelve hours. . . ." You don't make many converts that way. Unfortunately, as with any mystical experience, you have to have it before it can mean anything to you. The show of Wilson's sketches and scenic elements at Purchase will probably not do much to widen his audience. But it will delight Wilson freaks, who will experience these artifacts as neither working drawings nor independent works of art but as something halfway between thought and realization, of a piece with his work as a whole, just as the house Wittgenstein designed in Vienna for his sister seems in its exactitude a three-dimensional embodiment of his thinking.

The drawings, beautiful in themselves though meant as memos from the artist to himself, include a number of the "train" sketches from *Einstein* and designs for the triple-arched backdrop of *I Was Sitting on My Patio This Guy Appeared I Thought I Was Hallucinating;* that décor itself is also in the show. Even more evocative of the plays are a number of sinister pieces of furniture. Two armchairs swathed in lead draperies from *The Life and Times of Joseph Stalin* (1973) suggest the magic and menace of that sublime, demented pageant. Two more from *A Letter for Queen Victoria,* halfway between electric chairs and Edwardian club fauteuils, eloquently evoke their context, as do the stainless-steel chaises longues from *Patio* and the painfully tall and emaciated chair of galvanized pipe from the trial scene of *Einstein.*

The austere, monochromatic, but strangely sensual environment created at Purchase from bits and pieces of Wilson's theatrical past is immediately engaging, though it will probably be more so for those with some experience of the plays. The fragments of décor look nostalgic for the stage movement that once raised them above the category of objects, however grand they are in themselves. Fortunately, you can also catch one of Wilson's dramatic works on television at the museum, though seating space is limited. It's *Video 50* (1978), one of his most accessible and hilarious spectacles. Reveling in the sickly pinks, tans and aquas of cheap color TV, he has fabricated a series of ever-dissolving vignettes that draw on the visual vocabulary of soaps, commercials, and late-night horror movies but "purify the language of the tribe" in ways that Mallarmé never thought of and would have tried to forget if he had.

New York, July 18, 1980

OWEN MORREL

W<small>E DON'T HEAR</small> much about struggling young artists anymore. That stereotype has been replaced in the public imagination by the artist who becomes a millionaire at thirty by painting soup cans. The garret has become a half-acre loft with white floors.

This is an oversimplification. But it is true that at some point in the last thirty years the traditional wariness of the art-collecting public reversed itself and became bland acceptance of anything new that called itself art. The more outrageous you got, the better it was liked, and a young artist suddenly was faced with the pitfall of becoming instantly rich and famous.

This Midas syndrome has prompted dissident artists to invent ingenious flanking stratagems: earthworks in inaccessible sites, wall drawings which cannot be removed from the gallery, "information art" consisting of a nonnego-

tiable sheet of statistics—just about anything, in fact, that can't be bought or sold. Some of this work is as suspect as the commercialism it was reacting against, but some, such as the late Robert Smithson's spiral jetty in the Great Salt Lake or Christo's "Running Fence," an eighteen-foot-high nylon curtain billowing for miles and miles through the ranchland of northern California, is extraordinary. At its most imaginative, the anticapitalist movement has dispelled the avant-garde doldrums of the 1960s and resulted in a new romanticism, wherein the romantic artist's traditional *folie des grandeurs* is carried to dizzying new heights.

Perched atop the dizzying height of the former American Thread Building at 260 West Broadway in New York is the latest irrational monument by a much-talked-about and respected young conceptual artist, Owen Morrel. It's called "Asylum" and consists of metal fire-escape stairs which mount giddily toward a "cell" at the top. But this asylum is none too confining: while two of its walls are made of recycled prison bars, a third is almost open, blocked only by a vertical and a horizontal bar. Opposite this is a mirrored wall in which you are surprised to see yourself reflected against a backdrop of the harbor and New Jersey. The open grating of the floor contributes further to a feeling of insecurity which gradually becomes euphoria.

"Asylum" is the fourth major piece of Morrel's to be constructed. The others look quite different, but each has as its point of departure the intention to force the viewer, reluctant though he may be, into a new experience. What the work actually looks like is of secondary importance.

Morrel was born twenty-eight years ago in Massapequa, Long Island, and grew up close to the Great South Bay and the ocean. Two childhood activities which were to influence his later career were building mud huts and climbing trees— "Whenever they couldn't find me they'd look up into the trees." (His first constructed work, on a friend's property near Poughkeepsie, was a sort of constructivist tree house.)

He dropped out of Colgate after two years and hit the road, spending time in Greece and Mexico. Eventually he wound up in Detroit, teaching clay modeling at Flint Institute. At that time he was thinking of "making statements" in clay and was experiencing difficulty—the clay would blow up or break under the stresses he brought to bear on it. Also, even when he made something as conceptual as a clay room, he was troubled by the solid, weighty, object-y quality it had. He wanted to make experiences, not objects.

This finally happened in the 1975 piece at Poughkeepsie called "Telescopic Reference Points." (It has since been destroyed by "hunters and natural elements.") The intrepid viewer was expected to climb a forty-foot ladder to a steel platform built around a live hickory tree (Site I). From there he could look

through a telescope at Site II—a fallen tree in a valley a mile and a half away. He was then to proceed to that tree, in which was concealed, as in an old Fritz Lang movie, another telescope, which pointed back toward Site I but was focused on the horizon line. End of experience.

Morrel's next two pieces incorporated the cloak-and-dagger romantic aura of the concealed telescopes in a more overtly "political" context. (Both of these elements are important in his work, which is meant both to entertain and to instruct.) One was an executive's desk and chair mounted on a ten-foot tripod on a roof in Brooklyn. In Morrel's description:

> The viewer climbed a precariously minimal ladder built into the support structure and mounted the seat of the desk. Just underneath the surface of the desk (concealed in a tear in the desk blotter) was the eyepiece of a telescope, which, upon leaning forward, would reveal to the viewer the Statue of Liberty (slightly tilted), three miles away in New York Harbor.

In a similar vein was "Catapult 70," which he built in 1977 on a rooftop in SoHo. This time he cantilevered a psychiatrist's couch and chair out into space. The viewer was to lie on the couch, looking up into an overhead lamp in which another concealed telescope focused on the city. Morrel explains this work as another attempt to undermine the "paternalism" he sees as rampant in our society.

The ideological content of "Asylum," the new piece, is more difficult to construe. First of all, the piece is on a much larger scale than the earlier ones and it looks magnificent. (The visual elements in the earlier works were strikingly put together but seemed chosen for their polemic potential.) The whole construction is painted a neutral gray, but its lines are anything but neutral. Its purposefully staggering upward motion recalls, perhaps not coincidentally, Tatlin's "Monument to the Third International."

Once inside the cell, one feels both elated and confused. If these bars do not a prison make, then what exactly are they up to?

Is it summed up by the artist's own description? "If the room/cell becomes the confines of the light/energy of the mind, the open wall points to the future beyond the self—to no mind or one mind. 'Asylum' becomes a gateway to a specific kind of freedom always available to those who open the right door."

Hence, "Asylum," for all its institutional look (which resembles what a computer might come up with if asked to produce an institution), seems less of an attack on institutions than the earlier pieces, and a more private and transcendental experience. The jail he has set up is less menacing than the real thing, since escape is possible, either through the open wall or the mirror.

Confinement is also possible if one confronts the barred walls — the wrong door, evidently.

None of this really matters very much while you are taking "Asylum" in, however. What does matter is the exhilaration of the experience, whose intellectual complexity emerges only afterward. But the immediate sensation is one of light, air, traffic, gulls, the city and the sky.

Morrel wants to make more "building pieces," despite the formidable technical and legislative barriers he had to overcome to produce this one. He imagines one constructed between two buildings — perhaps a long "reassuring" office corridor with gilt-lettered doors that ends, once again, in vertigo and self-abnegation. If you visit "Asylum," you may find yourself impatient for whatever may be forthcoming from this young artist, who seems, in more ways than one, on his way to the top.

New York, August 28, 1978

Owen Morrel's "Asylum" was a stairway to nowhere, or, more precisely, to a precarious platform whose view of New York Harbor and the sky was made even more disorienting by a system of mutually reflecting mirrors. Before that there were "Desk Axis" and "Catapult," two rooftop pieces that seemingly could be examined only at peril to life and limb.

"Omega," which has occupied all his energies for the past two years, is by far the most ambitious to date. Built on the stone pilings of a long-gone suspension bridge over the Niagara River seven miles below the falls, it perches at the edge of the gorge like an inquisitive brontosaurus. Two four-story metal staircases mount toward an arrowhead-shaped platform where again mirrors shoot the river below into the sky and vice versa. The tilt of this scary but somehow heroic structure, its handsome industrial finish and its site far above the fast, silently seething river don't quite account for the overload of tension and drama. For once poetry and technology are no longer strange bedfellows but partners in a common adventure.

As is the case with Robert Wilson, Morrel's grandiloquent schemes oblige him to deal continually with problems of funding and other practical issues; all kinds of geologic and other studies had to be undertaken before "Omega" could begin to take shape on paper. Which is too bad. At thirty, Morrel has been able to realize a mere handful of astonishing monuments. Perhaps "Omega," the first to be displayed in a public space, will pave the way to future realizations.

New York, July 18, 1980

SCULPTURE IN GARDENS

WAVE HILL IS one of New York City's best-kept secrets. Though it gets raved about in the press from time to time, this twenty-eight-acre estate perched above the Hudson in Riverdale, facing the Palisades, remains undiscovered, to judge from its handful of visitors on a recent balmy weekday afternoon. And this is probably just fine with those who do go there. As you wander through its glades, glens and formal gardens, it's hard to believe you are "technically" in the Bronx.

There are two stately homes on the property. One is a fieldstone manor built in 1843, which has sheltered the likes of Thackeray, Herbert Spencer, Mark Twain and Arturo Toscanini and is now used for concerts and art exhibitions. The other, Glyndor, is a twentieth-century Georgian facsimile; it is occasionally open for exhibitions, as now. But the real charm of the place is its outdoor spaces, which nudge you gently toward unexpected, undemocratic vistas.

For the third successive summer, the estate is the backdrop for an exhibition of outdoor sculpture, chosen by curators Linda Macklowe and Suzanne Randolph. I've always had an aversion to sculpture gardens, even that of the Kröller-Müller Museum near Amsterdam and the Middleheim in Antwerp. There is something depressing about nature and art squaring off for unequal combat. Only God can make a tree, but lots of people can turn out pseudo–Henry Moore monuments. But the show at Wave Hill is different. For one thing, the garden has been a garden for so long that the art now displayed there couldn't compete with it if it wanted to. More important, the artists invited to collaborate did so with the idiosyncrasies of the site in mind. Each has responded to his or her chosen location without rubbing it the wrong way, yet with originality. Also, you really have to look to find the sculptures (a map is available), and the sense of gradual unfolding, like the finding of clues in a treasure hunt, is an important part of the generally felicitous experience. Maquettes and in some cases original sculptures, together with the artists' notes on their work, are being exhibited at Glyndor.

My favorite entry is also the best-hidden: Alice Adams' "The Lost House," set in a secluded and bee-loud glade. It's an assemblage of rough-hewn, sweet-smelling timbers like fragments—not ruins—of a house existing in someone's memory. It is apparently meant as an homage to Alain-Fournier's *Le Grand Meaulnes,* from which Ms. Adams quotes several passages by way of commentary—e.g., "I would not love the nameless country to the point of vertigo, were I not convinced that it does exist somewhere in the universe." And this work, which actually springs out of the ground at one point, has the magic and the pathos of a fantastic fiction on the threshold of being.

Other artists reacted to the landscape in more complex ways. Roeluf Louw's "Caracole" is strung along a path in a grove of hemlocks, which you enter through a gate made of wooden beams and mirrors. One mirror reads as part of the tree in which it is lodged, until you notice that it is actually reflecting the ground-cover plants underneath. And so the romantic, somewhat lugubrious site gets slyly altered little by little, until it is difficult to say where nature leaves off and man-made intervention begins.

Similarly, Robert Lobe hasn't condescended to the flattery of imitation. His "Visions on a Purple Beech" suggests rather than resembles a tree, as though the sculptor had tried to put himself in touch with processes analogous to those that produced the tumbling irregularities of the magnificent, plum-colored, century-old tree against which it stands. Like the beech, his sculpture looks different from every angle and defies efforts to seize or characterize its basic shape: it is what it is, not something like it. "Visions" alternately suggests

a flight of rickety wooden steps, a shipwreck, and bleachers caught in a tornado, yet it finally stands alone as an affirmation of its own singularity.

Replying to aspects of the more formal part of the Wave Hill gardens, John Willenbecher's tetrahedron of white wooden lattices over which vines have been trained alludes to the dream geometry of Piranesi or Ledoux, while Ned Smyth's slender cement colonnades topped with palm-frond motifs for once don't look satirical but are rather a reverent scansion of the terraced space they occupy.

Set apart from the rest of the garden, Tom Doyle's "Winchester" makes the most of its backdrop of cliffs and sky and is one of the strongest and most satisfying exhibits. Raw planks form a sloping platform like the entrance to a covered bridge, or fan out protectively like palings, while the supporting timbers fasten purposefully on one another with their notched "jaws." And Siah Armajani again offers one of his bridges to nowhere, complicated by the ambiguities of "forbidden" spaces that cannot be entered and, opposing this elitism, humdrum details such as a sloppy paint job, crudely fastened joists, and walls of corrugated tin. This work, "Bridge #5," is also silhouetted against the Hudson and is perhaps wryly commenting on it.

Other sculptors participating are Donna Byars, Martin Puryear and Ursula von Rydingsvard; all are worth seeing.

IT'S INSTRUCTIVE TO see the Wave Hill show in conjunction with "Contemporary Sculpture: Selections from the Collection of the Museum of Modern Art." The curator, Kynaston McShine, who chose the show, has been criticized by some for what is construed as his love affair with the 1960s to the detriment of the 1970s, and for the prevailing tone of antidisestablishmentarianism. And, indeed, there is a somewhat funereal air of corporate jollity hovering over the occasion which makes it hard to love this selection, much as one admires many of the individual pieces. Perhaps what is missing is the sense of surprise one finds in the works of the Wave Hill people (who are in some cases older than the "1960s" sculptors at the Modern), though it could hardly be otherwise: one cannot reproach a Caro or a Judd for looking familiar, when it does so precisely because of the solid worth that brought it to our attention in the first place.

This said, one can find much to enjoy in this handsome, if overedifying, collection. Sugarman, Paolozzi, Chris Wilmarth, Lichtenstein and John McCracken, as well as the aforementioned Caro and Judd, are seen in particularly fine form. And Claes Oldenburg's "Giant Soft Fan"—a "collapsing" electric fan of understuffed black vinyl—though done a dozen years ago, looms as the ultimate comment on the *Zeitgeist* as of July 1979.

New York, July 23, 1979

IX

OBJECTS

"ASTROLOGICAL AUTOMOBILES"

T HE AUTOMOBILE SALON is over, but addicts can see the "Astrological Automobiles" of a young Parisian architect and designer, François Dallégret. The copper plates for his designs and a life-size cardboard replica of his "Super-Leo" model are being shown through the end of October at the avant-garde Iris Clert Gallery.

A slim, bespectacled youth who somewhat resembles both Harold Lloyd and Yves Saint-Laurent, Dallégret began designing his "dream cars" after his experiences as an architect had left him fed up with the soullessness of today's assembly-line living. The present group of celestial limousines, which he claims are technically realizable, is conceived as homage to the great Italian car magnate and individualist Ettore Bugatti. Dallégret's chief source of inspiration has been the Bugatti Royale, which was discontinued in 1929 after only six

had been manufactured. The Royale weighed more than three and a half tons, had a gas reservoir of two hundred liters and was worth $43,000 in 1931.

Dallégret goes Bugatti one better by designing each model to harmonize with the astrological attributes of its future owner, thus ensuring the personal touch lacking in Detroit. One of his more fantastic creations is the "Scorpio." "Scorpio people are uneasy and shifty," he says. "They make good spies or detectives." Accordingly, the "Scorpio" car is camouflaged to resemble Isola Bella in Lake Maggiore. "So as to pass unnoticed [*sic*], the driver sits in an iron bandstand provided with a periscope and surrounded by foliage cut out of seven different red metals and a balustrade of Indian almandite. The car is amphibious for strategical purposes."

The flashiest of his models is the "Super-Leo," because Leo-ites are natural-born cuff-shooters. His plans call for "deep seats with multiple positions, upholstered in sheared black ermine, thick lynx carpet on the floor of rare marble; red-gold air conditioner designed by Bucheron; onyx telephone; disappearing bar sheathed in ostrich skin by Harsème."

The mechanical fittings of his cars are also dictated by the stars. Dallégret himself is born under the sign of Libra, and since Librans are always hesitating between alternatives, his "Libra" limousine is equipped with two steering wheels and can be driven either frontward or backward.

As might be expected, the "Taurus" is especially powerful, with "an electric diesel engine of the kind used in American trains. Six motors (one for each wheel) turn around a nave which forms the stator. The brakes function by reversing the current."

Some of the drawings first appeared in the magazine *Marie-Claire*, whose feminine readers are passionately interested in both astrology and expensive cars. Dallégret has caused a sensation, but he is in despair over admirers who insist on regarding him as a humorist. "My cars may look fantastic, but they're perfectly feasible," he claims. "All I need now is backers."

New York Herald Tribune (International Edition), October 19, 1960

GALLÉ'S VASES

Lıke the names Tiffany and Fabergé, that of French glass craftsman Emile Gallé has become almost a generic term, though his case is somewhat different. The styles of the first two have been so widely counterfeited and imitated that one hardly expects authenticity. Gallé was copied too, but the Gallé vases that glut the antique markets of the world are more apt to be genuine in the sense that most were made at the firm that his father founded in 1845 and that continued operating until 1935. Recognizable by their cameo glass technique and floral motifs, they are attractive and certainly "collectible," though in many cases Gallé had nothing to do with their design or realization.

Gallé's own creations, the ones that caused a contemporary critic to call him "the most conspicuous figure in the French world of art," are rare and seldom seen. Now forty of them are being exhibited at the Corning Museum of

Glass in Corning, New York, in a show titled "Emile Gallé: Dreams into Glass." Almost all the works on display are masterpieces, if bizarre ones. Some have been lent by the Musée de L'Ecole de Nancy in France, the city where Gallé chiefly worked; others are from public and private collections here and overseas. Major pieces like the often illustrated mushroom lamp and the Pasteur coupe, a goblet presented to Louis Pasteur on his seventieth birthday, make a trip to the small upstate city almost obligatory for anyone interested in the delirious decorative excesses of *fin-de-siècle* France.

Raised by his father to take over the family glass-and-ceramic business, Gallé was an anthology of contradictions: an ardent republican and Dreyfusard whose work was sought after by the aristocracy; a "naturalist" in the spirit of Zola who derived his shapes from nature but then subjected them to strange refractions; an enlightened employer who wrote that art "must be a struggle for justice in us and justice around us," but also a decadent who declared that he "happened to like anemia. If everything were all strength and force, we would have to bid adieu to grace, adieu to harmony." (Ultimately, he died of leukemia.)

Even for a Symbolist, Gallé's symbols are extravagant. The Pasteur coupe, appropriately rendered in "inoculated glass," swarms with such iconography as a pterodactyl, a microscope and a slavering rabid dog that prefigures Disney's Big Bad Wolf. The coprinus mushrooms that form the mushroom lamp are unequivocally phallic but also surreally overscaled.

Gallé experimented constantly with new techniques. He encouraged accidental flaws like cracks and bubbles and then utilized them in the finished design. Corroded and discolored, the layers of glass all but conceal motifs sandwiched between them. Often a flower or an insect will start out in opaque relief and then fade to a translucent ghost, as in the dragonfly coupe, on which a sculpted dragonfly turns into a black silhouette, pursuing a phantom mayfly visible only on the inside. Many pieces change drastically according to the way they are lit. Seen in reflected light, the dead leaves on the surface of the autumn vase are wan and placid; when light shines through the glass, they become sinister, airborne phantoms.

A thread of duality, of life intertwined with death, runs through the work. An orchid vase is encrusted with a vibrant specimen that metamorphoses into a drooping, dying one; the same treatment can be seen in other vases showing barley, pine branches and magnolias. A tadpole vase is circled at the top with a band of living and decayed duckweed; from it descend skittering tadpoles that mature into frogs as they approach the murky primordial soup at the base. "The enigma in which being dissolves," a line that Gallé quoted from his favorite poet, Victor Hugo, is the backdrop for these whimsical plays of form.

Gallé's reputation, like that of other craftsmen of the period, has fluctu-

ated. He was worshipped by great creators of his own time, including Proust, who wrote in *Remembrance of Things Past:* "Soon winter, and at the corner of the window pane, as on a piece of glass by Gallé, a hardened streak of snow." Today he remains little known compared with contemporaries like Tiffany and Guimard, largely because his best work is inaccessible.

The Corning show, which comes with a handsome catalogue, should do much to correct this. Given the symbolism that is a major element in art today, there is much to be learned from the artisan who could write: "My own work consists above all in the execution of personal dreams: to dress crystal in tender and terrible roles, to compose for it the thoughtful faces of pleasure or tragedy."

Newsweek, May 28, 1984

THE JAPANESE TEA CEREMONY

OF ALL THE CULTURAL institutions of Japan, none has proved more intriguing and mystifying to foreigners than *chanoyu*, the tea ceremony. New Yorkers currently have a rare chance to participate in a ritual tea, performed by students from the Urasenke Institute in Kyoto, perhaps the most famous "tea academy" in the world. The ceremony is being performed several times a day in conjunction with an exhibition of traditional objects used in the preparation of tea which is now at Japan House as part of "Japan Today," a celebration of contemporary Japanese culture being held here and in a number of other American cities.

What is puzzling to a Westerner is precisely the fact that the tea ceremony does have, in a way, its counterpart in the English rite of tea — "the little feast," as Henry James called it. On occasion, as in feudal Japan, matters of state are touched on as tea is consumed — Queen Anne in Pope's *Rape of the Lock* "did

sometimes counsel take—and sometimes tea." And there is a Western tradition of tea services piously handed down from generation to generation, though the fact that they are frequently made of silver explains why. In Japan the cherished objects can be made of humble materials and be of a purposely coarse design (*zan gurishita*, or "agreeably rough," characterizes a certain kind of tea bowl). And what to make of the revered tea scoops, simple curved strips of bamboo suggesting a very slender shoehorn? These functional utensils were elevated to the status of works of art in the sixteenth century by Sen no Rikyu, who is revered as the greatest of all tea masters. They seem unlikely objects for devotion, yet a scoop presented by Rikyu to his disciple Oribe was so venerated by the latter that he had a special case with a window made so that he could pray before it.

At present, according to Japan House's director, Rand Castile, there are about thirty-six thousand teachers and seven million students of tea throughout the world. The courses are elaborate and demanding, aiming at connoisseurship and practical knowledge of every object used, so that the student attains not only understanding of the aesthetic properties of teakettles but also a knowledge of how they are made. The tea-brewing ritual itself is practiced endlessly; only after performing it something like ten thousand times does the novice begin to be considered an adept.

In the West we would expect so much effort to culminate in the ability to pass a bar exam or perform *The Well-Tempered Clavier*. The motions involved in the tea ceremony are precise and elegant, of course, but scarcely seem to require the immense study that goes into them. Ten times, surely, even a hundred times, before one begins to get it right, but ten thousand? Just to be able to serve tea correctly? It is here that the Western mind boggles, and is forced to take on faith the larger meaning that the simple ritual alludes to. Sherman E. Lee, director of the Cleveland Museum of Art, formulates it as "a basic type of aesthetic education available to all," and laments the lack in our society of "some device, some discipline, some system analogous to it that makes it possible for things humble to become things sophisticated, for things available to all to become means of high aesthetic expression." An unschooled Occidental can guess at the importance of these things in the presence of the celebrant and his ritual objects; really to feel it is another matter and one that only becomes clear, no doubt, after prolonged immersion in tea.

Tea was introduced into Japan from China in the year 805 and enjoyed a vogue until a reaction against things Chinese set in late in the century. Reintroduced some three hundred years later, the serving of tea became a rather snobbish occasion for displaying and discussing Chinese works of art.

Gradually a simpler and more austere form of the tea ritual, emphasizing

the preparation of tea by the host for his guests, arose under the first great tea master, Murata Shuko (1423–1502), who served under the shogun Yoshinasa. The latter became converted after exhausting the delights of his other pastimes, which included moon viewing, fan matching, and "the writing of verse that includes the names of grasses or insects," when a wise counselor pointed out that "the sound of a boiling kettle rivals that of the wind in the pines and is a charming thing whatever the season may be."

The form of tea ceremony called *wabi* or "poverty tea" (as opposed to the opulent *daimyo* or "warlord" tea) was first developed by Shuko and brought to its perfection by the celebrated Rikyu. Here emphasis was on severity: the setting was a bare "two-mat" room; simple but elegant bamboo whisks and rough raku bowls were used, and the portable stand was dispensed with so that the utensils were placed directly on the mats. The influence of Zen Buddhism is obvious, and Rikyu characterized this sort of tea service as "an ascetic discipline, based on the Buddhist law, that is aimed at achieving spiritual salvation."

The ceremony as performed at Japan House is an austere though hardly humble affair. The tea is prepared in a portable teahouse by a master and served by an assistant. The tea, a bright green powder, is whipped to a froth with the bamboo whisk, which looks something like a shaving brush; the taste, a little bitter and "grassy" though very refreshing, is subtly modified by that of a dry, faintly sweet cake that one eats before drinking the tea. The traditional setting includes a jar with a flower that is meant to look as though it were still growing in the field — in my case a few "dewdrops" still nestled in its leaves. A fine piece of calligraphy is the only other decoration, though ink drawings are sometimes used. The various utensils — flower containers, incense and charcoal containers, kettles, braziers, tea caddies and scoops, water jars, tea bowls (for drinking), serving dishes and "slop basins" — are chosen by the host to complement each other and the mood of the moment (again, a decision which the uninitiated must accept on faith). The tea bowl, often irregular in shape and "agreeably rough" to the touch, is presented to the guest so that he may admire its pattern, and is returned to the assistant in the same manner. Although perhaps not fully appreciable in a New York museum setting, the simplicity and precision of the rite do manage to suggest the way to spiritual refreshment that it can become for the adept.

Among the objects and works of art on loan from Japanese public and private collections are many of outstanding quality. One particularly celebrated work is a hanging scroll by the thirteenth-century Chinese priest-painter Mucch'i, showing the imaginary Haha bird, in a bleak setting of pine boughs and with its head tucked under its wing so that only one eye is visible, like an illustration for Wallace Stevens' lines

Among twenty snowy mountains,
The only moving thing
Was the eye of the blackbird.

There is a magnificently plain flower container of bamboo by Rikyu, which epitomizes the spirit of *wabi* or poverty tea. Another, also of bamboo, is supposed to have been fashioned by his patron, the warlord Toyotami Hideyoshi (who for unknown reasons eventually compelled Rikyu to commit suicide). It is a startling object, made from a segment of bamboo with the roots still attached, as though ripped from the ground. Another famous object (labeled "Important Cultural Property") is the *yaburebukuro* (or "burst bag") water jar, its sides deeply fissured due to an accident in the kiln. The jar is said to leak, but this defect in no way dims its luster or prevents its use in the tea ceremony.

This is an unusual and provocative exhibition. If it falls short of conjuring up the meaning which the tea ceremony has for those who have made a lifelong study of it, it does help clarify the aesthetic that informs the rite and has kept it a vital force in Japan for more than five centuries.

New York, May 28, 1979

JAPANESE FOLK ART

I REGRET HAVING WAITED so long to visit the show at Japan House called "Folk Traditions in Japanese Art." Brooms, bowls, and baskets fashioned by anonymous artisans for strictly utilitarian purposes yet exquisite in their plainness *do* interest me, I kept telling myself, yet I always found excuses not to go. A mistake. This is a lovely and very unusual exhibition, and a nominee for sleeper of the year. It has been masterfully installed by Cleo Nichols, turning the somewhat somber gallery at Japan House into an enchanted space.

The exhibition documents a reappraisal of Japanese folk art which has occurred quite recently, in reaction to the *mingei* (folk crafts) movements initiated in the 1920s by the famous connoisseur Yanagi Soetsu. Aesthetically oriented and somewhat analogous to the Arts and Crafts revival in late-nineteenth-century England and America, it opposed the systematic, scientific

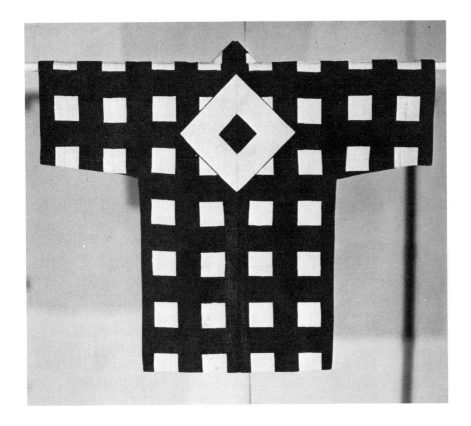

approach of the *minzoku* movement founded under the aegis of the scholar Yanagida Kunio, whose thirteen-volume *Bunrui Minzoku Goi* ("Classified Glossary of Folklore") had already begun to stimulate the interest of the Japanese in their folk heritage. The aesthetic-versus-scientific dispute continues, but there have been recent signs of a rapprochement, which the present show seeks to illustrate. One result has been a closer look at Yanagi's idealized view of folklore. Objects which he had claimed as part of the folk tradition turn out to have been made by well-known artisans for a fairly privileged class. It's rather as though William Morris wallpaper had been misunderstood as decoration for the average workingman's home in nineteenth-century England.

But this de-aestheticization has in turn brought out the truly beautiful and noble character of supposedly humble objects such as those on display here. Looking at them, one feels that "good design" in the Museum of Modern Art sense really hasn't made much progress in the last two hundred years.

Besides rugged bowls and jars with bold, classy designs; elaborately ironclad wooden chests and strongboxes built to survive earthquakes or float in case of shipwreck; dazzling scarlet lacquer ware (such as a lantern from the

Yoshiwara red-light district which has the eccentric but functional look of a Westermann assemblage), there are more unusual objects here. The most striking of all is a massive wooden kettle hook, scorched and polished from years of use, which might have been sculpted by Noguchi.

Fascinating too are the small *ema* prayer paintings from Shinto shrines, somewhat similar to Christian ex-votos. Their iconography is ingeniously allusive. A painting of a smiling infant in a bathtub was apparently commissioned by a mother whose child refused to take baths. Another showing dice pierced with a padlock was offered by a repentant gambler, or perhaps by his wife. An upside-down pine tree indicates that the problem was ingrown eyelashes, while a painting of a skate (the fish), slightly resembling the Tasmanian monster in the animated cartoons, has a very special symbolism: for obscure reasons the skate was associated with hemorrhoids. One hopes that the painting at least brought the donor what today's ads call "prompt, temporary relief."

The forthright geometric textile designs are a far cry from the elaborate refinement of those used by the upper classes, and they look very modern. There are embroidered hand towels intended to show off a marriageable maiden's needlework, rather like our samplers, and a kimono in a fabric new to me: banana-fiber cloth. A nineteenth-century fireman's uniform is startling in its austere sophistication, and a workman's jacket in an indigo-on-white lattice pattern reminded me of Matisse's costumes for Stravinsky's *Song of the Nightingale*.

New York, January 8, 1979

TEXTILES AND PATTERN ART

Two TRENDIER-THAN-THOU exhibitions have just opened: one in Philadelphia, the other in Washington. Together they provide a sort of answer to the vexed and frequently asked question: where—assuming it is still alive at all—is art heading? The answer: every which way, especially loose.

The disorienting heterodoxy of today's art is sometimes deplored by critics (of course, it makes their work even harder). Writing about the Whitney Biennial in a recent *Art International*, Eric Gibson hazarded, "One feels that this pluralism will persist for a few years, to be followed by a period of rapid consolidation and, shortly thereafter, a major breakthrough which will set the tone for a decade or more. . . . Art cannot endure in its present atomized condition forever." If history does indeed repeat itself, this will be the case, and it is true that strong periods in art have often been characterized by a certain

uniformity, by artists who happened to pursue the same goals. Until I see what the breakthrough is going to be like, though, I'll take the current state of chaos: It may be uneven, but it isn't dull.

The Philadelphia show, at the University of Pennsylvania's Institute of Contemporary Art, is actually two shows. One, "Material Pleasures," displays textiles created by various artists-in-residence at Philadelphia's Fabric Workshop. The other, "The Decorative Impulse," takes in work that is closer to traditional painting and sculpture. Both branch out from "pattern painting," a term that no one seems very happy with.

"Material Pleasures" is perhaps the best place to start, since it best illustrates the extent to which artists are mixing up categories in art. Painting, sculpture, crafts, one's environment, one's body and the way it moves, are all being marshaled under the adjective "decorative," which has taken on a new polemical significance. In designing fabrics which may then become costumes or scenic elements for their own "performances," artists such as Jeff Way and Robert Kushner are abolishing genres in a way which can be seen as incestuous or fecund. There is a prevailing note of frivolity, but it's serious, coming as a corrective to the puritanical excesses of Minimalism, just as Pop Art was a reaction to the seriousness of Abstract Expressionism.

So we have works like Way's green-and-fuchsia, leopard- and zebra-patterned pajamas called "Ubu Punk"; or Scott Burton's "anti-claustrophobic" curtains which have windowpanes printed on them; or Marjorie Strider's "Painter's Pants," decorated with carefully simulated paint splotches; or Jody Pinto's "Hair Shirt," made of pigskin silk-screened with "unwanted" hair. But this nonchalance has its serious side. Sam Gilliam's "Philadelphia Soft"—a canvas wall-hanging swooning under multiple silk-screened patterns—and Joyce Kozloff's "Untitled Silks"—panels of iridescent silk in a peacock-feather pattern, separated by thin panels of mosaic—are high points and possibly among the first classics of this still fledgling genre.

The other wing of the show, "The Decorative Impulse," includes younger pattern people such as Kushner, Kim MacConnel and Cynthia Carlson (whose "outrageous" midnight-blue wall studded with gold starfish dominates this part of the gallery). But it also takes a look at older, more established artists whose work has evolved independently and somewhat coincidentally toward a certain decorative mode. These are George Sugarman, Lucas Samaras, Miriam Schapiro (whose ravishing "Phoenix" is pieced together with acrylic, charcoal and "tissue-thin found fabrics") and especially Frank Stella, a central figure here because of his exemplary progress from the sensual asceticism of his early work to the ascetic sensualism of his recent *Tropical Birds* series.

The Washington show, at the Hirshhorn Museum, was organized by

Howard N. Fox and is called "Directions." Five directions from among many are singled out and labeled: "Brute Sculpture," "Imitations," "Eclectic Surfaces," "Fictions" and "Shrines." Again the tone is a restless, aggressive hedonism, bent on breaking down and bastardizing traditional forms. (One painter from the Philadelphia show, Kim MacConnel, also turns up here.) Some of the artists, such as Robert Hudson and Barbara Rossi, are moving toward whatever lies beyond decoration: Hudson churns up bits of wallpaper pattern, fragments of illustration, and abstract noodling in the interests of a *mélange adultère de tout*. Rossi isolates bits of traditional or invented pattern against smooth surfaces made complex by layers of finely sanded acrylic pigment and transparent layers of Plexiglas; she is perhaps the ultimate hybrid among all these exotic species.

Other entries range in size and spirit from Gargantuan (Lorin Madsen's ton of bricks—a ton and a half, actually—suspended on wires in midair; Donna Dennis' almost half-scale maquettes of a tourist cabin and a subway entrance, like Edward Hopper in three dimensions) to minute (Jud Nelson's series of Popsicles in varying stages of disarray, carved from pristine white Carrara marble; the late Donald Evans' postage stamps of fictitious countries; Dottie Attie's sly narrative illustrated with matchbook-size details from old master paintings). Some, such as Eleanor Antin's video soap opera "The Adventures of a Nurse" and the accompanying "Set from the Nurse and the Highjackers," can hardly be characterized at all: "Must see to appreciate." And in fact, the one unifying trait running through the eclecticism of these shows is the urge to create a totally self-referential work which can be experienced only by experiencing it, and not through a critic's distorting lens.

New York, July 2, 1979

AMERICAN CERAMICS

CERAMISTS ARE a strange lot. On the one hand, they are always complaining that the world considers them craftsmen rather than artists. On the other, they seem to feel somewhat superior to their colleagues in the other arts. One reason for this snootiness is that they produce—or used to—beautiful objects which are also useful. Another is that shaping clay on the potter's wheel is apparently a kind of mystical experience, not to be compared to using a brush or chisel or typewriter. Nietzsche said that it is not the business of the gods to make clay pots, but few potters would agree with him.

At the Cooper-Hewitt Museum in New York right now is a large show called "A Century of Ceramics in the United States, 1878–1978," which is intriguing not only for the works assembled and the obscure artisans brought to light, but also as a kind of aesthetic history of America during the past century. Like

architecture, pottery seems a direct expression of contemporary ideologies. The mat-green, no-neck Grueby vases in this show, for instance, tell us a great deal about the modernist spirit of their time: they are puritanically plain yet strangely sophisticated, in a primitive way—contradictions which linger on in our avant-garde art today.

The show has been chosen by the art historians Garth Clark and Margie Hughto, the latter a curator of ceramics at the Everson Museum in Syracuse, a city which, together with Cincinnati, New Orleans, and Alfred, New York, is one of the oldest centers of ceramic activity in the country. From 1932 to 1972 the museum put on the annual Robineau Memorial Ceramic Exhibition—a momentous event that was the ceramist's equivalent of the Salon d'Automne in Paris. Clark and Hughto have really done their homework, and their catalogue is an impressive piece of scholarship which discovers and then traces a continuity of art pottery in America from the beginnings to the present. For instance, the raunchiness of recent California "Funk" ceramics is shown to have a prototype in the work of George E. Ohr of Biloxi, Mississippi, whose curious conceits include a toy bank in the form of a vagina and a combination teapot and coffeepot with snakelike spouts that prefigures the pornographic teapots that Robert Arneson and others have recently created for mad tea parties in California's Marin County.

In fact, raunchiness seems to be another quality that is indigenous to potters, though the apparent misogyny of Ohr's bank fortunately isn't—in fact, many of the major figures have been women. They include Adelaide Robineau of Syracuse and Cincinnatians Mary Chase Perry and Maria Longworth Nichols, the last-named the founder of Rookwood, the first American pottery to receive international acclaim. Another Cincinnatian, Mary Louise McLaughlin, who started it all when she organized the Cincinnati Pottery Club in 1879, once offered a clue for the early preponderance of women ceramists: "It may be imagined with what abandon the women of that time, whose efforts had been directed to the making of antimacassars or woolen afghans, threw themselves into the fascinating occupation of working with wet clay"—at that time a novel pastime in America. Barely thirty years later the ladies were tackling projects as daunting as Adelaide Robineau's excised and carved porcelain "Scarab Vase," one of the masterpieces in the show, which is also known as the "Apotheosis of the Toiler," since it took her one thousand hours to complete.

One would like to linger over the early period, which also includes work by Tiffany, Artus van Briggle, Hugh Cornwall Robertson and Charles Binns, but the curators are eager to bring us up to the present, and if the last two decades are somewhat overrepresented, that is because they believe that the recent surge of vitality in the field requires it. After a long period of doldrums, lasting

from World War I through the 1940s, came the 1950s — "the decade of liberation," as the curators put it, which saw the arrival of major artists such as Peter Voulkos and Rudy Autio, both influenced by Abstract Expressionist painting, and, later, of *funkistes* like Arneson, David Gilhooly and Clayton Bailey.

The school's-out whimsy of the last two decades (perhaps a holdover from the cutesy animal sculptures done in the thirties by Carl Walters, among others) can be cloying, though it is carried to a high degree of paradoxical elegance in Adrian Saxe's wonderful neo-Deco compote topped by a handle in the form of a mountain goat, and it is challenged by a new austerity that is more involving than the Shaker pieties of some of the utilitarian potters of the 1940s.

Strong among recent works is Kenneth Price's eerie cabinet of fake Mexican pottery, as well as ceramic works by several well-known painters of the color-field persuasion, especially Helen Frankenthaler's fractured clay "Mattress." The show, a traveling exhibition, is an important one, for it not only documents but virtually creates a continuing tradition in American ceramics over the last century, which few of us were aware of.

New York, March 17, 1980

FANTASTIC BRITISH ILLUSTRATION

AND DESIGN

Just as some of the less visible forms of discrimination and neglect are continually coming to light, thanks to the work of activist groups (militant prostitutes are demanding the social advantages their clients enjoy; children may no longer be spanked in Sweden after July 1), so too in the world of art. What was despised and kept hidden in museum reserves is out of the closet today, partly because of the expansionist itch of art historians, always on the lookout for new colonies to annex to their fluctuating empire. One example was a show of Victorian storytelling art at the Brooklyn Museum, put together with all the scholarly expertise and panache formerly reserved for pedigreed "high art." Another and delightful new example is an exhibition called "Fantastic Illustration and Design in Britain, 1850–1930," at the Museum of the Rhode Island School of Design in Providence.

Illustration is one of the most discredited genres of art. The trouble is, we all like it. Most people first experience art in the form of a comic strip or illustrated children's book, and the heat of that first encounter, like that of first love, is never entirely equaled afterward. Later on we become aware that illustration isn't quite respectable, and the love no longer dares speak its name.

But this is changing. The word "decorative" has finally been liberated, with a vengeance, by pattern painters; "illustration" may be next. Talking of his own illustrations, Larry Rivers recently told an interviewer, "I enjoy these projects. But if you've grown up in an era where the worst thing you can accuse someone of is doing *illustration*, you wonder. 'Well, it has an illustrative quality' was like saying, 'It stinks.'" And R. B. Kitaj, noting that "illustration is considered one of the most criminal activities in painting," approvingly quotes the English painter Sickert, who said, "All serious painting is illustration and illustration all the time."

According to Diana L. Johnson, who put together this show, fantastic subject matter "has tended likewise to exist under a cloud, in part because it has become too easy to approach or categorize all such imaginative material by invoking Freudian revelations about the subconscious." Another reason may be that children today are exposed to massive doses of fantasy in daily life, television being only one example. Most of the artists in the Rhode Island show flourished in late-Victorian England, when fantasy must have been a vital safety valve for adults as well as children. It was a society that produced not only Tennyson and Matthew Arnold, but Lear, Carroll and Beardsley, who are as characteristic of their time as were the guardians of its orthodoxy.

Ms. Johnson has taken to her task like a Jemima Puddleduck to water (yes, Beatrix Potter is in the show, naturally, with some rare works including two illustrations from an unpublished set for *Alice in Wonderland*), and her catalogue text and another essay by George W. Landow of Brown University are models of sober scholarship, perhaps just a bit too much so, given the material under consideration—one wonders what Alice would have had to say. Idle to carp, however, when the result is so much pleasure—from which the academic seal of approval has removed any lingering trace of guilt.

Most of the illustrators one would expect to find are present, though a few aren't, of course, perhaps because of the ephemeral nature of this work (wherever possible Ms. Johnson has come up with originals, though these have been supplemented by reproductions, usually rare ones too). It would have been nice to have had Thackeray's illustrations for *The Rose and the Ring* alongside the drawings of Lear and Ruskin, or some George Du Maurier, or E. V. Lucas' proto-Dada collages for his book *What a Life*. Yet there is a superabundance of work by obscure and fascinating artists.

To name just a few: The French-born Ernest Henry Griset was obviously indebted to Grandville, but he adds his own suggestion of the macabre to the latter's anthropomorphic vignettes. Harry Clarke's illustration for Poe's "The Facts in the Case of M. Valdemar" is Beardsley-derived but has a special gruesomeness that would have pleased the author. There is an exquisitely if weirdly tinted "automatic" drawing by a Mrs. Alaric Watts, who communed with spirits; and an example of "spirit photography" — "Mr. and Mrs. Lacey with a Spirit," attributed to Frederic A. Hudson.

There are "fairy paintings" by mid-Victorian artists not known primarily as illustrators: Danby, Paton, William Bell Scott and Richard Dadd—the last-named represented by a small and even more eccentric watercolor version of his masterpiece in the Tate, "The Fairy Feller's Master-Stroke." There is furniture (a "medieval" cabinet decorated by Burne-Jones, as well as a tapestry after one of his designs); strange ceramics by William de Morgan and others; fabrics and wallpaper including a frieze from *Winnie-the-Pooh* by the illustrator of the Pooh books, Ernest H. Shepard. And there are the major figures like Tenniel, Dulac, Caldecott, Cruikshank, Rackham and Walter Crane, all of whose magic is as potent today as when we were very young.

New York, April 23, 1979

WALLPAPER

"WHAT SHALL WE Do with Our Walls?" wondered the American art critic Clarence Cook, in the title of a promotional pamphlet published for a New York wallpaper firm in 1880. About 150 answers to his question are assembled in the Cooper-Hewitt Museum's new show of wallpaper and other wall coverings from its rarely seen collection in New York—the largest in the country and one of the finest anywhere.

Wallpaper, being both utilitarian and fragile, is one of the most ephemeral artifacts. Often it survives only because somebody decorated a trunk or a hatbox with it. Its origins and history are sketchy, and it is frequently impossible to ascertain its provenance, period, or even nationality.

It is also a stepchild even among the decorative arts. A few noted artists have tried it, among them Marie Laurencin, Graham Sutherland, and Andy

Warhol (who has a roll of super-contented cows in the show). Many of its best designers have been better known in other fields, including William Morris, the illustrators Walter Crane and Kate Greenaway, and the English architect C. F. A. Voysey. But in the twentieth century, few serious artists have been drawn to it, largely because of a prejudice instilled by functionalists like Wright and Le Corbusier. (Oddly, each of these men did produce wallpapers—Corbu some mostly solid-colored ones in 1932, before he proclaimed the moral superiority of white walls, and Wright his Taliesin Line papers in 1956. A roll of one of the latter is displayed, and remarkably dull it is, too.)

Perhaps the recent vogue of Pattern Painting is partly behind the museum's decision to show its papers now. SoHo is awash with wallpaper- and fabric-inspired art that revels in the repeats that were anathema to designers of the past and are of course not foisted on these painters by mechanical necessity. ("It is important to mask the construction of our patterns enough to prevent people from counting the repeats, while we manage to lull their curiosity to trace it out," wrote Morris, who would have shuddered at Pattern Painting.)

Or maybe the museum just wanted to put out some pretty flowers, animals, and birds for late summer. The curator, Elaine Dee, says that these have always been the most popular subjects for wallpaper since its beginnings, which go back at least to the fifteenth century. She suggested that the aim of the show was to illustrate as variously as possible the two main trends in wallpaper design—the illusionistic one and the strictly two-dimensional, geometrical one.

The two strains have always coexisted and have long been the subject of aesthetic controversy. Charles Eastlake, the great self-appointed tastemaker for late-nineteenth-century Britain and America, prescribed that a wall "should be decorated after a manner which will belie neither its flatness nor its solidity. . . . All shaded ornament and patterns, which by their arrangement of color give an appearance of relief, should be strictly avoided." But the general public hasn't always agreed. Many people's first aesthetic experience is triggered by wallpaper, and it is usually the illusionistic, break-through-the-wall kind. One of my earliest memories is of trying to peel off the wallpaper in my room, not out of animosity but because it seemed there must be something fascinating beyond the surface pattern of galleons, globes and telescopes. It is the figural kind that is given prominence in the show, just because at its best it is more spectacular than anything devised by a geometer. Another kind of illusionism is also highlighted: trompe-l'oeil papers imitating marble, textiles, wood, tile, wicker—for at various times wallpaper has imitated just about everything.

One of the major illusionist works on view is a floral panel from the set entitled "Le Jardin d'Armide," designed by Edouard Muller for the Paris firm of Desfossé and Karth. The series won a first-class medal at the Exposition

Universelle in 1855 and was one of the hits of the Second Empire show at Philadelphia two years ago. A well-known flower painter, Muller surmounted formidable technical problems to create a printed surface that is eerily close to painting. Another tour de force is Laffitte and Blondel's "Les Amours de Psyché," excerpts from a series of twenty-six panels that required 1,500 wood blocks to print, even though it is entirely in tones of gray. The effect is a pearly limpidity that again seems beyond the reach of any printing process.

One room is allotted to a set of paper panels from China showing birds on branches with a seascape behind. Although of great delicacy, it seems somewhat cold and stilted next to the lush products of France and late-nineteenth-century England—possibly because wallpaper, though manufactured in China for export, wasn't used there as such but as isolated decoration.

The *fin-de-siècle* room is dominated by the English—not just Morris but also Voysey, a transitional figure between Morris' Arts and Crafts aesthetic and Art Nouveau, and later between that and a sort of proto-Art Deco (charac-

terized by one of his enemies as "patterns made of cockyolly birds inspecting with surprise square trees slightly smaller than themselves"). I especially liked an anonymous—as, alas, are the majority of wallpapers—English one, circa 1880, "Birds and Oranges," in soft gray-greens and golds, which would foil the most persistent insomniac's efforts to locate the repeats.

Somehow the later twentieth century seems a little thin and gimmicky after all this. Even Saul Steinberg's "Steinberg's Flowers" would be hard to live with on a daily basis, not to mention Warhol's bovines—and they are among the few "serious" modern examples. Others of less moment would be easier to take as wall coverings, for instance a design of pale-sepia clouds and airplanes produced in 1927 to commemorate Lindbergh's flight. (We are told that airplanes were used as wallpaper motifs as early as 1912, and that is my favorite bit of trivia for the week.) But even at its most inconsequential or officious there is always something oddly fascinating about this exhibition and about wallpaper in general. The English art historian Brenda Greysmith has pinpointed it nicely, I think, in stating that old wallpapers "give an insight, no matter how slight, into history."

New York, September 8, 1980

X

POETS AND PAINTERS

THE INVISIBLE AVANT-GARDE

T HE FACT THAT I, a poet, was invited by the Yale Art School to talk about the avant-garde, in one of a series of lectures under this general heading,* is in itself such an eloquent characterization of the avant-garde today that no further comment seems necessary. It would appear then that this force in art which would be the very antithesis of tradition if it were to allow itself even so much of a relationship with tradition as an antithesis implies, is, on the contrary, a tradition of sorts. At any rate it can be discussed, attacked, praised, taught in seminars, just as a tradition can be. There may be a fine distinction to be made between "a" tradition and "the" tradition, but the point is that there is no longer

* This lecture was given at the Yale Art School in May 1968, one of a series of talks by writers and critics organized by the painter Jack Tworkov as an attempt to explore the phenomenon of the avant-garde in present-day art.

any doubt in anyone's mind that the vanguard *is*—it's there, before you, solid, tangible, "alive and well," as the buttons say.

Things were very different twenty years ago when I was a student and was beginning to experiment with poetry. At that time it was the art and literature of the Establishment that were traditional. There was in fact almost no experimental poetry being written in this country, unless you counted the rather pale attempts of a handful of poets who were trying to imitate some of the effects of the French Surrealists. The situation was a little different in the other arts. Painters like Jackson Pollock had not yet been discovered by the mass magazines—this was to come a little later, though in fact *Life* did in 1949 print an article on Pollock, showing some of his large drip paintings and satirically asking whether he was the greatest living painter in America. This was still a long way from the decorous enthusiasm with which *Time* and *Life* today greet every new kink. But the situation was a bit better for the painters then, since there were a lot of them doing very important work and this fact was known to themselves and a few critics. Poetry could boast of no such good luck. As for music, the situation also was bleak but at least there *was* experimental music and a few people knew about it. It is hard to believe, however, that as late as 1945 such an acceptably experimental and posthumously successful composer as Bartók could die in total poverty, and that until a very few years ago such a respectable composer as Schönberg was considered a madman. I remember that in the spring of 1949 there was a symposium on the arts at Harvard during which a number of new works were performed including Schönberg's Trio for Strings. My friend the poet Frank O'Hara, who was majoring in music at Harvard, went to hear it and was violently attacked for doing so by one of the young instructors in the music department, who maintained that Schönberg was literally insane. Today the same instructor would no doubt attack O'Hara for going to hear anything so academic. To paraphrase Bernard Shaw, it is the fate of some artists, and perhaps the best ones, to pass from unacceptability to acceptance without an intervening period of appreciation.

At that time I found the avant-garde very exciting, just as the young do today, but the difference was that in 1950 there was no sure proof of the existence of the avant-garde. To experiment was to have the feeling that one was poised on some outermost brink. In other words if one wanted to depart, even moderately, from the norm, one was taking one's life—one's life as an artist—into one's hands. A painter like Pollock for instance was gambling everything on the fact that he *was* the greatest painter in America, for if he wasn't, he was nothing, and the drips would turn out to be random splashes from the brush of a careless housepainter. It must often have occurred to Pollock that there was just a possibility that he wasn't an artist at all, that he had spent his life "toiling up

the wrong road to art" as Flaubert said of Zola. But this very real possibility is paradoxically just what makes the tremendous excitement in his work. It is a gamble against terrific odds. Most reckless things are beautiful in some way, and recklessness is what makes experimental art beautiful, just as religions are beautiful because of the strong possibility that they are founded on nothing. We would all believe in God if we knew He existed, but would this be much fun?

The doubt element in Pollock — and I am using him as a convenient symbol for the avant-garde artist of the previous school — is what keeps his work alive for us. Even though he has been accepted now by practically everybody from *Life* on down, or on up, his work remains unresolved. It has not congealed into masterpieces. In spite of public acceptance the doubt is there — maybe the acceptance is there because of the doubt, the vulnerability which makes it possible to love the work.

It might be argued that traditional art is even riskier than experimental art; that it can offer no very real assurances to its acolytes, and since traditions are always going out of fashion it is more dangerous and therefore more worthwhile than experimental art. This could be true, and in fact certain great artists of our time have felt it necessary to renounce the experiments of their youth just in order to save them. The poet Ron Padgett has pointed out that the catalogue of the recent Museum of Modern Art exhibition of Dada and Surrealism praises Picabia's early work but ruefully assumes that with his later work he had "passed out of serious consideration as a painter." Padgett goes on to say:

> A parallel example is provided by de Chirico, who many feel betrayed his own best interests as a painter. Possibly so. But in Picabia's case, the curiosity that compelled him to go on to become a less "attractive" painter is the same that carried his adventure into Dada in the first place, and it is this spirit, as much as the paintings themselves, which is significant.

I think one could expand this argument to cover de Chirico and Duchamp as well. The former passed from being one of the greatest painters of this century to a crotchety fabricator of bad pictures who refuses to hear any good said of his early period, but he did so with such a vengeance that his act almost becomes exemplary. And Duchamp's silence *is* exemplary without question for a whole generation of young artists.

Therefore it is a question of distinguishing bad traditional art and bad avant-garde art from good traditional art and good avant-garde art. But after one has done this, one still has a problem with good traditional art. One can assume that good avant-garde art will go on living because the mere fact of its having been able to struggle into life at all will keep it alive. The doubt remains. But

good traditional art may disappear at any moment when the tradition founders. It is a perilous business. I would class de Chirico's late paintings as good traditional art, though as bad art, because they embrace a tradition which everything in the artist's career seemed to point away from, and which he therefore accepted because, no doubt, he felt as an avant-garde artist that only the unacceptable is acceptable. On the other hand a painter like Thomas Hart Benton, who was Pollock's teacher, was at his best a better painter than de Chirico is now, but is a worse artist because he accepted the acceptable. *Life* used to have an article on Benton almost every month, showing his murals for some new post office or library. The fact that *Life* switched its affections from Benton to Pollock does not make either of them any worse, but it does illustrate that Benton's is the kind of art that cannot go on living without acceptance, while Pollock's is of the kind which cannot be destroyed by acceptance, since it is basically unacceptable.

What has happened since Pollock? The usual explanation is that "media" have multiplied to such an extent that it is no longer possible for secrets to remain secret very long, and that this has had the effect of turning the avant-garde from a small contingent of foolhardy warriors into a vast and well-equipped regiment. In fact the avant-garde has absorbed most of the army, or vice versa—in any case the result is that the avant-garde can now barely exist because of the immense amounts of attention and money that are focused on it, and that the only artists who have any privacy are the handful of decrepit stragglers behind the big booming avant-garde juggernaut. This does seem to be what has happened. I was amazed the other night while watching the news on television when the announcer took up a new book by the young experimental poet Aram Saroyan and read it aloud to the audience from beginning to end. It is true that this took only a couple of minutes and that it was done for purposes of a put-down—nevertheless we know that the way of the mass media is to pass from put-down to panegyric without going through a transitional phase of straight reportage, and it may be only a matter of weeks before Aram Saroyan has joined Andy Warhol and Viva and the rest of the avant-garde on *The Tonight Show.*

Looking back only as far as the beginning of this century we see that the period of neglect for an avant-garde artist has shrunk for each generation. Picasso was painting mature masterpieces for at least ten years before he became known even to a handful of collectors. Pollock's incubation period was a little shorter. But since then the period has grown shorter each year so that it now seems to be something like a minute. It is no longer possible, or it seems no longer possible, for an important avant-garde artist to go unrecognized. And, sadly enough, his creative life expectancy has dwindled correspondingly, since artists are no fun once they have been discovered. Dylan Thomas summed it up

when he wrote that he had once been happy and unknown and that he was now miserable and acclaimed.

I am not convinced that it is "media" that are responsible for all this—there have always been mediums of one sort or another and they have taken up the cause of the avant-garde only recently. I am at a loss to say what it is, unless that it is that events during the first decades of this century eventually ended up proving that the avant-garde artist is a kind of hero, and that a hero is, of course, what everybody wants to be. We all have to be first, and it is now certain—as it was not, I think, before—that the experimenting artist does something first, even though it may be discarded later on. So that, paradoxically, it is safest to experiment. Only a few artists like de Chirico have realized the fallacy of this argument, and since his course was to reject his own genius and produce execrable art it is unlikely that many artists will follow him.

What then must the avant-garde artist do to remain avant-garde? For it has by now become a question of survival both of the artist and of the individual. In both art and life today we are in danger of substituting one conformity for another, or, to use a French expression, of trading one's one-eyed horse for a blind one. Protests against the mediocre values of our society such as the hippie movement seem to imply that one's only way out is to join a parallel society whose stereotyped manners, language, speech and dress are only reverse images of the one it is trying to reject. We feel in America that we have to join something, that our lives are directionless unless we are part of a group, a clan—an idea very different from the European one, where even friendships are considered not very important and life centers around oneself and one's partner, an extension of oneself. Is there nothing then between the extremes of Levittown and Haight-Ashbury, between an avant-garde which has become a tradition and a tradition which is no longer one? In other words, has tradition finally managed to absorb the individual talent?

On the other hand, perhaps these are the most exciting times for young artists, who must fight even harder to preserve their identity. Before they were fighting against general neglect, even hostility, but this seemed like a natural thing and therefore the fight could be carried on in good faith. Today one must fight acceptance which is much harder because it seems that one is fighting oneself.

If people like what I do, am I to assume that what I do is bad, since public opinion has always begun by rejecting what is original and new?

Perhaps the answer is not to reject what one has done, nor to be forced into a retrograde position, but merely to take into account that if one's work automatically finds acceptance, there may be a possibility that it could be improved. The Midas-like position into which our present acceptance-world

forces the avant-garde is actually a disguised blessing which previous artists have not been able to enjoy, because it points the way out of the predicament it sets up—that is, toward an attitude which neither accepts nor rejects acceptance but is independent of it. Previously, vanguard artists never had to face the problems of integration into the art of their time because this usually happened at the end of a long career when the direction their art would take had long been fixed. When it took place earlier it could be dealt with by an explosion of bad temper, as in the possibly apocryphal story about Schönberg: when someone finally learned to play his violin concerto he stormed out of the concert hall, vowing to write another one that *nobody* would be able to play.

Today the avant-garde has come full circle—the artist who wants to experiment is again faced with what seems like a dead end, except that instead of creating in a vacuum he is now at the center of a cheering mob. Neither climate is exactly ideal for discovery, yet both are conducive to it because they force him to take steps that he hadn't envisaged. And today's young artist has the additional advantage of a fuller awareness of the hazards that lie in wait for him. He must now bear in mind that *he*, not *it*, is the avant-garde.

A few remarks by Busoni in his book *The Essence of Music* seem to apply to all the arts and also to the situation of the experimental artist today. Busoni's music has the unique quality of being excellent and of sounding like nobody else's; it has not even been successfully imitated. The essays that make up the book were written about the time of World War I when a crisis had developed in German music, involving on the one hand Expressionists like Schönberg, of whom he disapproved, and of conservative Neoclassicists like Reger, of whom he equally disapproved—a crisis which, without going into details, rather parallels that in the arts today. Somehow Busoni alone managed to avoid these extremes by taking what was valid in each and forging a totality.

He wrote:

I am a worshipper of Form—I have remained sufficiently a Latin for that. But I demand—no! the organism of art demands—that every idea fashion its own form for itself; the organism—not I—revolts against having one single form for all ideas; today especially and how much more in the coming centuries.

The creator really only strives for perfection. And as he brings this into harmony with his individuality a new law arises unintentionally.

The "new" is included in the idea of "Creation"—for in that way creation is distinguished from imitation.

One follows a great example most faithfully if one does not follow it, for it was through turning away from its predecessor that the example became great.

And finally, in an article addressed to his pupils he wrote, "Build up! But do not content yourself any longer with self-complacent experiments and the glory of the success of the season; but turn toward the perfection of the work seriously and joyfully. Only he who looks toward the future looks cheerfully."

ArtNews Annual, 1968

AN INTERVIEW WITH

HENRI MICHAUX

Henri Michaux is hardly a painter, hardly even a writer, but a conscience—the most sensitive substance yet discovered for registering the fluctuating anguish of day-to-day, minute-to-minute living.

Michaux lives in Paris on the rue Séguier, in the heart of a small district of crumbling but still aristocratic palaces that seems strangely hushed and dull in spite of the proximity of St. Germain-des-Prés and the Latin Quarter. A wooden scaffolding has been put up in the stairway of the seventeenth-century *hôtel particulier* where he lives, to keep the stairs from collapsing. Michaux's apartment seems to have been carved out of a larger one. In spite of the character of the architecture and some beautiful old furniture, the effect is neutral. The walls are no-color, even the garden outside looks ghostly. Almost no pictures—a Zao Wou-ki and a Chinese painting of a horse more or less

happen to be there: "Don't draw any conclusion from them." The only remarkable object is a large, brand-new radio: like many poets, many painters, Michaux prefers music.

He detests interviews, and seemed unable to remember why he had consented to this one. "But you may as well begin, since you're here." He sat with his back to the light so that it was difficult to see him; he shielded his face with his hand and contemplated me warily out of the corner of his eye. Michaux will not be photographed, and refuses to allow even a drawing of himself to be reproduced. Faces have a horrible fascination for him. He has written: "A man and his face, it's a little as if they were constantly devouring each other." To an editor who once wrote asking him for a photograph to publish in a catalogue with others, he replied: "I write in order to reveal a person whose existence no one would ever have suspected from looking at me"—this statement was published in the space that had been intended for his portrait.

Yet Michaux's face is pleasant and gentle. He is Belgian, born in Namur in 1899, and if he has the pale complexion of northern peoples, and something of their phlegm, his face can still light up in a broad Flemish grin, and he has a charming, unexpected giggle.

Has painting supplanted writing as a means of expression for him?

Not at all. In the last few years I've had three or four shows and published three or four books. Since I took up painting I do more of everything—but not at the same time. I write or paint in alternating periods.

I began painting in the mid-1930s partly as a result of a Klee show I saw, partly because of my trip to the Orient. I once asked a prostitute for directions in Osaka and she did a lovely drawing to show me. Everybody draws in the Orient.

The trip was a capital experience in Michaux's life: out of it came *A Barbarian in Asia* as well as the discovery of a whole new rhythm of life and creation.

I had always thought there would be another form of expression for me—but I never thought it would be painting. But then, I'm always wrong about myself. I always wanted to be a sailor when I was young, and I tried it for a while, but I simply didn't have the physical strength necessary. I had always thought I didn't want to write, either. *C'est excellent, il faut se tromper un peu.*

Then the *cuisine* of painting annoyed me. Artists are such prima donnas—they take themselves so seriously, and they have all that *cuisine*—canvas, easel, tubes of paint. If I could, I would still prefer to be a composer. But you have to study. If there were only some way to enter directly into a

keyboard. . . . Music hatches my dissatisfaction. My large ink drawings are already nothing but rhythm. Poetry doesn't satisfy me as much as painting— but other forms are possible.

Who are the artists who mean the most to him?

I love the work of Ernst and Klee, but they alone wouldn't have been enough to start me painting seriously. I admire the Americans less—Pollock and Tobey—but they created a climate in which I could express myself. They are instigators. They gave me *la grande permission*—yes, yes, that's very good—*la grande permission*. Just as one values the Surrealists less for what they wrote than for the permission they gave everybody to write whatever comes into their heads. And of course the Chinese classical painters showed me what could be done with just a few lines, just a few indications.

But I don't think very much about influences. You enjoy listening to people's voices in the street, but they don't solve your problem for you. When something is good it distracts you from your problem.

Did he feel that his poetry and his painting were two different forms of expression of the same thing?

Both of them try to express music. But poetry also tries to express some non-logical truth—a truth other than what you read in books. Painting is different—there is no question of truth. I make rhythms in paintings just as I would dance. This is not a *vérité*.

I asked Michaux whether he felt his experience of mescaline had had an effect on his art, other than the drawings he did under its influence, which he calls "mescalinian drawings" and which, with their hypersensitive massing of insubstantial, filament-like lines into zones, look different from the bold, abrupt work he does under normal conditions.

"Mescaline gives you more attention for everything—for details, for terribly rapid successions." Describing such an experience in his recent book, *La Paix dans les Brisements*, he wrote:

My trouble was great. The devastation was greater. The speed was even greater. . . . A hand two hundred times more agile than the human hand would not have sufficed to follow the accelerated course of that unquenchable spectacle. And there was no question of anything but following. You cannot seize a thought, a term, a figure, to work them over, get inspiration from them,

improvise on them. All power is lost on them. This is the price of their speed, their independence.

He also spoke of the superhuman detachment he felt under the influence of mescaline, as though he could observe the machinery of his own mind from a distance. This detachment can be terrible, but on one occasion it resulted in a vision of beatitude, the only one in his life, which he describes in *L'Infini Turbulent:* "I saw thousands of gods. . . . Everything was perfect. . . . I hadn't lived in vain. . . . My futile, wandering existence was at last setting foot on the miraculous road. . . ."

This moment of peace and fulfillment was without precedent in Michaux's experience. He hasn't sought to renew it—"It was enough that it happened." And he hasn't taken mescaline in over a year, now that he "knows." "Perhaps I'll take it again when I'm a virgin once more," he said. "But this sort of thing should be experienced only rarely. The Indians used to smoke the peace pipe only on great occasions. Today people smoke five or six packs of cigarettes a day. How can one experience anything that way?"

It had begun to grow dark in the room and the trees in the gray garden outside seemed to belong on the oozy metaphysical terrain he describes in *Mes Propriétés*. I mentioned that nature appears rarely in his work. "That is not correct," he said. "At any rate, animals do. I adore animals. If ever I come to your country it will no doubt be to visit the zoos." (His only visit to America was as a sailor, in 1920, and he saw only Norfolk, Savannah and Newport News.)

I once had two hours to spend in Frankfurt when I had a show there, and I shocked the director of the museum by asking to see the botanical garden rather than the museum. As a matter of fact, the garden was lovely. . . . But since mescaline I can no longer feel a sense of fraternity with animals. The spectacle of my own mind at work somehow made me more conscious of my mind. I can no longer feel empathy with a dog, because he hasn't one. It's sad. . . .

We discussed the mediums he uses. Though he works with oils and watercolors, he prefers India ink. The large white sheets of drawing paper studded all over with hard black little knots, or strewn with vaguely human figures that suggest some hopeless battle or pilgrimage, are typical of Michaux. "With India ink I can make a small, very intense little mass," he said. "But I have other plans for ink. Among other things, I've been doing some India ink paintings on canvas. I'm enthusiastic about this, because I can be both precise

and blurry with the same brush, at the same moment. It's direct; there are no risks. You're not up against the ruses of oil, the *cuisine* of painting."

In these canvases Michaux often paints three wide vertical bands, using little ink to give a dusty effect. In this vague medium swim dozens of desperately articulate little figures: birds, men, twigs, more deliberately drawn than in the drawings but animated by the same intense energy.

More than his other work, they seemed to realize his intentions for painting as he expressed them recently in the magazine *Quadrum:*

> Instead of one vision which excludes others, I would have liked to draw the moments that, placed side by side, go to make up a life. To expose the interior phrase for people to see, the phrase that has no words, a rope which uncoils sinuously, and intimately accompanies everything that impinges from the outside or the inside. I wanted to draw the consciousness of existence and the flow of time. As you would take your pulse.

ArtNews, March 1961

A DE CHIRICO RETROSPECTIVE

W HILE MOST OF the Museum of Modern Art in New York remains shut as the building undergoes extensive renovation, a new ground-floor exhibition space has just opened with a wonderfully apt show of Giorgio de Chirico, a master for whom less is definitely more. About one hundred paintings and drawings from his early and best period fill the new gallery without overcrowding, and the spacious addition, the work of architect Cesar Pelli, works especially well for him. Besides functionality, its main feature is a gauze-curtained window giving directly onto the sidewalk of West Fifty-third Street. The unexpected light from the street and the veiled backdrop of traffic and passers-by produce one of those subtle dislocations of everyday life that are at the heart of de Chirico's art, which he termed "metaphysical."

The last sizable de Chirico exhibition in New York, in 1972 at the now

defunct New York Cultural Center, was a sorry affair. The artist supervised it himself, and the emphasis was on his later work, which few of his admirers have been able to take seriously. Flaccid pastiches of Rubens and Veronese alternated with sad attempts to recapture the magic of the "metaphysical" paintings of 1911–17. The result, in one critic's words, was "a prodigious adventure in self-parody."

This is the first large-scale showing of the early work. William Rubin, the museum's director of painting and sculpture, who organized the exhibit, feels that it definitively places de Chirico "just under Picasso and Matisse in twentieth-century art, along with Kandinsky and Miró." (There are those, myself included, who would place his work higher than that, in a special Elysium of its own.) Ironically, the Museum of Modern Art, which after recent bequests from Nelson Rockefeller and the art historian James Thrall Soby now has the largest and best collection of the early de Chiricos, was one of the painter's favorite *bêtes noires*. "For horrors it beats even our own Museum of Horrors in Valle Giulia [Rome's Gallery of Modern Art]," he wrote in his cantankerous *Memoirs*. Much of the last sixty years of his life he spent lambasting modern art since Courbet, and the proximity at the museum of works by artists he detested, like Matisse, Cézanne and van Gogh, would have occasioned yet another attack of bile.

Rubin's choices are exemplary. There are the major metaphysical masterpieces, whose arcaded squares and dreamlike spaces have been paradigms — like Kafka's fiction — of twentieth-century anxiety. Rubin also includes two earlier pictures done in the romantic academic style of the German-Swiss Arnold Böcklin, a discriminating sampling of more problematic work from the 1920s and even a couple of intriguing oddities from as late as 1935. Thus, though the show is small in comparison with previous retrospectives, it is the first to fully establish de Chirico as the major artist he is.

Like Picasso, Gertrude Stein, Guillaume Apollinaire and others who played vital roles in the astonishing artistic ferment in Paris on the eve of World War I, de Chirico was a displaced person. He was born in 1888 to Italian parents in Greece, where his father worked as a civil engineer designing railroads in the province of Thessaly. (Childhood memories of the Greek landscape and of the tools of his father's profession were to haunt the painter's canvases throughout his life.) After the father's early death in 1905, the family moved to Munich, where Giorgio studied at the Academy of Fine Arts and discovered Böcklin's painting and the philosophy of Schopenhauer and Nietzsche.

It was Nietzsche who was to have the most decisive influence on de Chirico. The philosopher's greatest innovation, according to the artist, was "a strange

and profound poetry, infinitely mysterious and solitary . . . based on the *Stimmung* of an autumn afternoon when the sky is clear and the shadows are longer than in summer. . . ." Before moving on to Paris in 1911, de Chirico visited Turin, where Nietzsche had lived, and the vast arcaded piazzas and public statuary of that predominantly nineteenth-century city, which resembles no other in Italy, soon began appearing in his paintings. The young Italian was shortly caught up in the artistic turmoil of Paris. Through the influence of the poet-critic Apollinaire, de Chirico gained entry into the important annual art Salons and soon had a contract with the influential dealer Paul Guillaume.

And his style underwent surprising mutations. Abandoning the buxom nymphs of Böcklin's Teutonic classical Greece, he began a series of "enigmatic" pictures in which vast perspectives and strangely empty colonnades were enlivened only by an occasional tiny figure in the distance and the slightly sinister presence of a train releasing a puff of white smoke into a demented blue sky. "The Anguish of Departure," "The Mystery and Melancholy of a Street" and particularly "Gare Montparnasse (The Melancholy of Departure)" are among the masterpieces in this vein. The last picture is interesting as well because it shows affinities with Cubism and other contemporary avant-garde currents that de Chirico was later to denounce. The outlined shadow in the foreground has a life of its own as an element in an abstract composition, and so, partly, does the slanting street leading up the side of the station, which indicates perspective even as it hews close to the picture plane.

Rubin's catalogue essay sensitively relates de Chirico's painting to other contemporary avant-garde tendencies. The painter's seeming naturalism, he points out, is consistently undermined by devices such as the introduction of multiple vanishing points into what looks like straightforward perspective and the placing of highlights where shadows logically ought to be. Other critics have made similar comparisons, but Rubin's is the first major attempt to drag de Chirico, kicking and screaming, into the mainstream of modernist painting.

But the complex play of weightless planes and contradictory perspectives in a work like "Gare Montparnasse" is dissolved in a Nietzschean *Stimmung* or atmosphere that anticipates both Dada (what is that oversized bunch of bananas doing sitting in front of a railroad station?) and Surrealism—and renders most of their visual achievements unnecessary. De Chirico was the first artist to dwell on such seemingly arbitrary confrontations of inanimate objects, and if the symbolic meaning of recurring images like the bananas, clocks, gloves and artichokes remains unknown, they are obviously repositories of deeply personal feelings and experiences. It is a world that is *sui generis*, unrelated to any "isms," and here one can sympathize with de Chirico's defiant rejection of the rest of modern art.

Although most of his great pictures were painted before the outbreak of World War I, there was more to come. Starting with the searingly beautiful "Song of Love," de Chirico began to combine still life with landscape in a startling way: this composition brings together a locomotive, a rubber glove, a tennis ball and a fragment of Greek statuary as though they had always been meant for each other. Later, while stationed in Ferrara during the war, he began a series of still lifes in interiors like "Great Metaphysical Interior" and "The Jewish Angel," whose hard-to-read shapes could be the drafting tools of his engineer father or bits of painted jigsaw work or abstract shapes of the concurrent decorative Cubist phase of Picasso and Juan Gris.

And then, at the end of the war, decay starts to set in. Gradually de Chirico turned from his radical style and obsessive visions to investigate the techniques of old masters like Rembrandt and Raphael, and in doing so sank into the flatulent "Renaissance" classicism he practiced until his death in 1978 and which today has but few partisans.

It was a curious end to a career that was in every way curious. Luckily, it is the young de Chirico who now has the final say in this long-overdue celebration. Seeing it brings to mind one of the many unforgettable landscapes he described in his great dream novel *Hebdomeros*, published in 1929: "Though autumn had stripped bare the century-old trees, this whole vast horizon spoke of everlasting life."

Newsweek, April 12, 1982

INDEX

PICTURE CREDITS

Alfred Gilbert: *Eros* (1886–93), cast aluminum and bronze, Piccadilly Circus, London. Photo courtesy of Courtauld Institute of Art, London • Harold Gilman: *Woman Combing Her Hair* (1911), chalk and pen on paper, 30.5 × 22.9 cm, from the collection of the Arts Council of Great Britain, courtesy of the South Bank Centre, London • Willem De Kooning: *Sting Ray* (1970), lithograph, 51 × 36¼ inches, courtesy of the artist • Leland Bell: *Self-Portrait* (1959), oil on paper on masonite, 24 × 18 inches, courtesy of the Hirshhorn Museum and Sculpture Garden, Smithsonian Institution, the Joseph H. Hirshhorn Bequest, 1981, Washington, D.C. • Larry Rivers: *Wedding Photo (Social Patterns)* (1979), acrylic and charcoal on canvas, 78 × 96 inches, from a private collection, courtesy of the Marlborough Gallery, New York • Red Grooms: *Danny's Hero Sandwich* (1981), alkyd paint on wood and canvas, 94 × 79 × 41 inches, courtesy of the Marlborough Gallery, New York • Nell Blaine: *Hay Raking, Haderlehn* (1984), ink and stick drawing with wash, 18 × 24 inches, courtesy of the Fischbach Gallery, New York. Photo ©1984 O. E. Nelson • R. B. Kitaj: *Poet Writing (Robert Duncan)* (1982), charcoal on paper, 31 × 22½ inches, from the collection of Paine Webber, Inc., New York, courtesy of the Marlborough Gallery, New York • Henri Michaux: *Untitled, 1959* (1959), India ink on paper, 29¼ × 41 inches, courtesy of the Edward Thorp Gallery, New York. Photo © Zindman/Fremont • Sarah Winchester's *Llanda Villa* (ca. 1882), photo courtesy of the Winchester Mystery House, San Jose, California • Anonymous: *Workman's Jacket* (Meiji period, nineteenth century), stencil-dyed cotton. From the collection of Mr. Keisuke Serizawa, Tokyo, courtesy of International Exhibitions Foundation and Japan House Gallery, New York • Edouard Muller: *Le Jardin d'Armide* (panel) (ca. 1855), from the collection of the Cooper-Hewitt Museum, New York, Courtesy Art Resource, New York.

COLOR INSERT

Joseph Cornell: *Untitled (La Favorite)* (1948), mixed-media construction, Mr. and Mrs. Edwin A. Bergman, extended loan 284.1983 ©1988 The Art Institute of Chicago, all rights reserved • Yves Tanguy: *Multiplication of the Arcs* (1954), 40 × 60 inches, oil on canvas, collection, The Museum of Modern Art, New York, Mrs. Simon Guggenheim Fund • Constantin Guys: *Three Women in a Carriage* (ca. 1863), from the collection of the Musée des Arts Décoratifs, Paris, courtesy of Art Resource, New York • Jean Baptiste Chardin: *The House of Cards* (1737), from the collection of the Louvre, Paris, courtesy of Art Resource, New York • Joan Mitchell: *Girolata* (1964), oil on canvas, triptych, 76¾ × 118¾ inches, courtesy of the Robert Miller Gallery, New York • James Bishop: *News from Ferrara* (1964), oil on canvas, 40 × 40 inches, courtesy of the artist • André Derain: *The Artist* (ca. 1930), oil on canvas, 11⅜ × 9⅛ inches, courtesy of the Grace Borgenicht Gallery, New York • Georges Mathieu: *The Drawing and Quartering of François Ravaillac, Assassin of Henry IV, King of France, May 27, 1610* (1960), oil on canvas, 250 × 400 cm, courtesy of the artist • Anne Dunn: *Studio Interior I* (1980), ink on paper, 49½ × 29 inches, from the collection of Mr. and Mrs. Robert Miller, courtesy of the Fischbach Gallery, New York • Edwin W. Dickinson: *Villa La Mouette* (1938), oil on canvas, courtesy of the Metropolitan Museum of Art, George A. Hearn Fund, 1938, New York. Photo copyright ©1980 The Metropolitan Museum of Art • Brice Marden: *Blue Painting* (1972), oil and wax on canvas, 72 × 72 inches, courtesy of the Mary Boone Gallery, New York • Alex Katz: *Frank O'Hara* (1959), cut-out: oil on wood, 60 × 14 inches, courtesy of the Robert Miller Gallery, New York • Jane Freilicher: *Circle of Fish* (1981), oil on canvas, 24 × 24 inches, from the collection of Mr. and Mrs. John F. Walsh, Jr., courtesy of the Fischbach Gallery, New York • John D. Graham: *Blue Abstraction* (1931), oil on canvas, 25⅝ × 36⅛ inches, courtesy of the Phillips Collection, Washington, D.C. • Sandra Fisher: *Reading Baudelaire* (1983), oil on canvas, 10 × 8 inches, courtesy of the artist, ©1983 The Smithsonian Institution • Luis Marsans: *Varia* (1983), tempera on wood, 7⅞ × 11 inches, courtesy of private collection, Norway • Saul Steinberg: *Life of Millet* (detail) (1969), oil on canvas, 14¼ × 30¼ inches, from the collection of the Whitney Museum of American Art (gift of the artist), reproduced courtesy of the artist and of the Whitney Museum of American Art, 69.175 • Joseph Shannon: *Pete's Beer* (1970), acrylic on canvas, 84 × 96 inches, courtesy of the artist and the Institute of Policy Studies, Washington, D.C. • Jess: *The Bridal Spell* (1979), paste-up, 44 × 63 inches, from the collection of the Worcester Art Museum, courtesy of the Odyssia Gallery, New York • Fairfield Porter: *Interior with a Dress Pattern* (1969), oil on canvas, 62 × 48 inches, from the collection of Mr. and Mrs. Austin List, courtesy of the Museum of Fine Arts, Boston • Aldo Rossi: *Teatro del Mondo with Objects* (1980), courtesy of the Max Protetch Gallery, New York • Emile Gallé: *Dragonfly Coupe* (1903), blown marquetry and metallic foil inclusions, external marquetry and applied bits; patination; multilayered foot with applied bits; cut; engraved; height: 18.3 cm; diameter: 19.7 cm; courtesy of the Corning Museum of Glass, Corning, New York • Giorgio de Chirico: *The Song of Love* (1914), oil on canvas, 28¾ × 23⅜ inches, Collection, The Museum of Modern Art, New York. Nelson A. Rockefeller Bequest.

A NOTE ABOUT THE AUTHOR

John Ashbery, born in Rochester, New York, in 1927, is Distinguished Professor at the City University of New York's Brooklyn College campus, where he teaches creative writing. His 1975 volume, *Self-Portrait in a Convex Mirror*, won the Pulitzer Prize, the National Book Award, and the National Book Critics Circle Award. His most recent collection of poetry is *April Galleons* (1987). He is a member of the American Academy and Institute of Arts and Letters and the National Academy of Arts and Sciences. Twice named a Guggenheim Fellow, he was awarded the annual fellowship of the Academy of American Poets in 1982 and received Yale University's Bollingen Prize in 1984. In 1985 he received a MacArthur Prize Fellowship and the Lenore Marshall/Nation Poetry Prize. He lives in New York City.

A NOTE ABOUT THE EDITOR

David Bergman is the author of *Cracking the Code*, winner of the George Elliston Poetry Prize, as well as a number of college texts and critical essays. He lives in Baltimore, where he teaches at Towson State University.

A NOTE ON THE TYPE

This book was set in a digitized version of Bodoni Book, named after Giambattista Bodoni (1740–1813), son of a printer of Piedmont. After gaining experience and fame as superintendent of the Press of the Propaganda in Rome, in 1768 Bodoni became the head of the ducal printing house at Parma, which he soon made the foremost of its kind in Europe. His *Manuale Tipografico*, completed by his widow in 1818, contains 279 pages of type specimens, including alphabets of about thirty languages. His editions of Greek, Latin, Italian, and French classics are celebrated for their typography. In type designing he was an innovator, making his new faces rounder, wider, and lighter, with greater openness and delicacy, and with sharper contrast between the thick and thin lines.

Composed by The Sarabande Press,
New York, New York

Printed and bound by Halliday Lithographers,
West Hanover, Massachusetts

Designed by Julie Duquet